CIMABUE

EUGENIO BATTISTI

CIMABUE

Translated from the Italian by
ROBERT and CATHERINE ENGGASS

THE PENNSYLVANIA STATE UNIVERSITY PRESS
UNIVERSITY PARK and LONDON

to Lionello Venturi
a rare representative of intellectual freedom

PREFACE

In this English edition certain clarifications have been made of the iconography of the Assisi cycle and — through the extraordinary resources of the Frick Collection, the great Widener Library at Harvard, and libraries of universities in New York — the bibliography has been considerably enlarged. I have also been able to see personally the works attributed, although doubtfully, to Cimabue in the Frick Collection and the National Gallery of Art in Washington, D.C. My opinion has not changed, other than to hold the small Frick *Flagellation* to be Sienese and of high quality.

In the first edition of this monograph, relying merely on what anybody could see on the poorly-lit landing in the Louvre where the altarpiece from Pisa has been relegated (Pl. 67), I had passed a judgment which I now consider too negative. I suggested at that time that it could only be a poor translation of the Master's drawing executed by some assistants. More precisely, I said: " The suspicion of substantial repainting, as well as the numerous noticeable incongruities — the clumsy disproportion of the very long, rigid Christ Child is perhaps the most apparent — prevent me from accepting it as autograph."

I have recently been offered the opportunity — thanks to the kindness of the Directors of the Louvre and of the Restoration Department (I should like to thank especially Mr. Germain Bazin, Madame Silvie Béguin and Mr. Roullet) to examine the altarpiece more closely, and to look through the files concerning the restorations of this painting. Mr. Roullet has given me the assistance of his highly specialized expert knowledge in the exploration of the surface layer of the painting.

Two vertical cracks, somewhat clumsily filled in the last century, are the cause of the more noticeable incongruities I lamented. One of these has spoiled the profile of the side of the Christ Child towards the Madonna, conferring upon it an awkward geometrical rigidity and an excessive elongation. There was to be here, instead, as in the Madonna by the so-called Maestro di San Martino, a loose or puffed up dress. Also the hand of the Madonna, just below, has been destroyed and another crack runs all along the faces of the Angels to the left.

Overpainting is extensive, even though discontinuous. In places it is laid clumsily, in others

it darkens the original colors (see for instance the Madonna's dress, the hair and the wings of the angels, the throne curtain covered with a dark varnish which has by now lost every trace of chromatic luminosity).

A lengthy review of the Italian edition of *Cimabue* by Carlo Volpe in *Paragone* (173, May 1964, pp. 61-74), and an issue on Cimabue by Ferdinando Bologna in a popular series which came out after the Italian edition of my book, merely support the ideas Roberto Longhi expressed in his "Giudizio sul Duecento." These are ideas which I did not share then and obviously still do not share. There was also criticism from Volpe for using radiographs rather than the skillful eye of a connoisseur to attribute "that indecipherable daub," the Dossal for Santa Maria Nuova [Figs. 6, 7], to Cimabue. Aside from the fact that this work actually is included in documentary lists and that it is in the process of being restored (now apparently possible), it seems to me that the connoisseurship of today must avail itself of all possible scientific means of external assistance. However, these are secondary problems. The problem to be emphasized, notwithstanding the splendid photographs included in this book, is the inadequate photographic documentation of the Assisi transept—angel by angel, decorative motif by decorative motif, fragment by fragment—without which any discussion (for example, of a collaboration by Duccio or by Cavallini, the latter being possible if not probable) is academic. Unfortunately, the connoisseur's eye is not adequate for great heights, and a large part of the observations that I made concerning the vaults was based on the much clearer and more legible color photographs. The same is true, although for different reasons, for the *Madonna* in the Lower Church, which can be judged only after a complete cleaning. What I am pointing out is the insufficiency of technical means at hand; the book inevitably is affected by the fact that the economic means had to be limited by what was allowed from a generous private publisher.

My attempt to reconstruct Cimabue's artistic and even his iconographic program must be considered equally provisional. I have tried to push further back the problems raised by the history of Renaissance criticism, the point of departure for which is by consensus usually found in Giotto. In a certain sense the purpose of my book has been to re-create a culturally pre-Giottesque Cimabue. Its program is therefore limited and exclusively monographical. In other words, it tries to collect data around Cimabue for a general re-examination of the general situation of the second half of the Dugento, rather than extract data from him. Perhaps it would be well to recapitulate the controversies the Italian edition of *Cimabue* has aroused. They can be summed up in the antithetical positions of Carlo Volpe and Ferdinando Bologna. My book, unexpectedly, changed implicit debate concerning the meth-

odology intrinsic to the school of pure connoisseurship (a methodology which still rules over the Italian university professorships and which defends its disinterest for modern historiography in the name of Croce) into an explicit debate. For example, to use the prescriptions of the Franciscans which were formally published and, it appears, immediately abrogated by the Pope, is in Volpe's opinion digressive and invalid. He particularly maintains that cultural history and figurative questions must in some way be discussed in terms of the " problematic of personalities." This position elicits the image of an artist as nothing more than an eye and a hand, unresponsive to any relationship with society. At the most it allows a connection with reality, although still without conscious motivations, in relation to a provincial interpretation of socialist realism. Historiographic specialism has an essentially negative character—it is nothing more than the identification of photographs and the making of expert opinions. The only relationships it makes are groupings according to formal characteristics, almost in the manner of Berenson's schematic lists. The opposite position is taken by Ferdinando Bologna who, in particular, responds to another of Volpe's objections: " The same holds true for the connections that one would attempt to draw between Cimabue's painting or the Dugento in general and the theological, ethical, or political manifestations of contemporary thought. How deeply the creative artists, the pioneers—and Cimabue was one—drew or felt the effects of them can probably never be sufficiently proved. In any case the artist's spiritual history, which is undoubtedly made up of agreements with and rejections of these historical agents, is not considered so that the critical evaluation will be in line with the poetic results on the basis of those tangents or externalities." In other words, in examining a painting such as Picasso's *Guernica* (certainly no more documented as to motivations than were the controversies between wealth and poverty and the architectural programs of the two factions that only exploited and continued the splendidly theorized polemic between Saint Bernard and Abbot Suger) we would have to give up the attempt to clarify, for ourselves above all, the subject matter and the interpretation of it and, secondly, we would have to give up making a judgment that is not only aesthetic but moral: that is, a judgment not of so many square feet of canvas, but rather of an important document for posterity of one of the most dramatic moments of human civilization.

Nevertheless Ferdinando Bologna transforms these cultural relationships into some sort of supernatural relationship with the patrons: the minute a Pope is elected Cimabue starts to paint for him; his style appears to originate from a purely emotive and generic acceptance. Bologna bases himself on elementary points of reference and ignores as not germane " those sorts of investigations . . . (the study of proportion, of literary sources, of religious ideas,

of aesthetics) which rarely succeed in uncovering secure, specific facts," that is, all that is comprised in the long and difficult passage from the conception of an idea, the adherence to a new concept of reality, and the creation of a visual form to represent it. Picasso's *Guernica* is certainly not the account of a military action, nor was it so intended, as is demonstrated by the preliminary sketches where the factual data progressively acquire a universal dimension. It was a masterpiece of new rhetoric.

To go back to my book, its purpose is exclusively to examine how Cimabue had created a style so typical and powerful; what problems he confronted; how he reacted against tradition; and why he often encountered difficulty in expressing himself. My judgment, even at the cost of being ambiguous at times, was arrived at with his personal history and his action on the culture of his time in mind. I still feel that either a negative or positive judgment can be made of certain of his works, depending on which of these two possibilities is considered. Perhaps there is another clarification that should be made. My examination of Cimabue as the return to the reality working through him and Giotto (the reader will find a discussion of this in the first chapter of my book *Rinascimento e Barocco*, as well as the reason for the employment of a special terminology, particularly in regard to the process of the Gothic refinement of sacred images) was not motivated by a contempt for abstract painting, in contrast to Roberto Longhi's " Giudizio sul Duecento ": quite the contrary. Perhaps my position is that of one who, observing that the periods of realism in the history of art are extremely restricted and of short duration, asks what the motivations were that almost violently ushered them into Western civilization particularly. Longhi's essay joins his position against abstraction to an excessive nationalism. Volpe criticized me for not sharing this attitude. But apart from the fact that Italian Byzantinism is extremely composite it has, at least during the Dugento, the significance of a return to the Antique. In any case it cannot be judged either from the modern nationalist point of view or with the same phrases used against a Kandinski or a Malevich. I believe the greatness of Italian art has always depended on the broad possibilities of graftings from neighboring cultures and interchanges with them. The tension in Cimabue's work in great part derives from the fact that he participates both in the Byzantine symbolic religiosity and the modernity of the French Gothic.

Cimabue's art would have probably not gone so far forward without the presence of great competitors such as Coppo. The limitations in my book are in great measure due to the absence of colleagues or adversaries with the interest that as a rule characterizes the American university faculty and student body. Almost everyone who comes to the United States feels a widening of horizons. It therefore seems proper, after having attempted an explana-

tion of the reasons for the limitations of my monograph, intentional or environmental, to indicate those points that, given more time, I might have improved. I pointed out the necessity for a broad photographic campaign: if the scaffolding for such a campaign were utilized it might be possible, with the assistance of a restorer, to establish the days of work for the Assisi cycle as L. Tentori and M. Meiss did so well for Giotto's frescoes. However, much library research remains to be done. The Dugento and Trecento artists, it is true, did not leave behind any treatises other than technical ones. However, that is not to say that a conceptualization of artistic work did not exist. It is simply that the conceptualization availed itself of the same literary categories or "schemes" as those drawn on by contemporary philosophy. I would like to give just one example: Saint Bonaventure speaks of three faculties of the spiritual life of man that make him recall, see, and desire God—memory, intelligence, and will. He insists on this triple distinction at great length and I perceive on rereading my text after the lapse of some time that contemporary religious painting essentially displays three analogous functions: it serves to recall sacred personages by the employment of a remarkably and broadly memorized iconography; it describes them, that is, it defines them within a particular liturgical occasion; and it embellishes or exalts them in order to arouse an affective or emotional participation. This is not a conjecture, but simply a suspicion that by reading more widely and deeply an artistic poetics, rather than simply a general aesthetics, might be extracted. This is all the more true for certain iconographic details. With reference to the *Crucifixion*, and particularly to the Magdalen with the upraised arm [Pl. 28], I insisted on an affinity with the protagonists of Antique tragedy rather than with the contemporary mystical lauds. This might seem to be an exaggeration. However, having reread Saint Bonaventure I now feel I should have stressed the idea more. Saint Bonaventure writes directly of the Magdalene in *Lignum Vitae, De Mysterio Gloricationis* VIII, 80 b, "of the women, Mary Magdalen was so carried away by the burning love of her heart, so affected by the sweetness of her deep devotion, so drawn by the strong bonds of love, that, forgetful of her woman's weakness, she braved the darkness of the shadows and cruelty of the persecutors to visit the sepulchre." In Seneca we find the following lines spoken by Andromache:

> But I, even though woman,
> Will resist
> With my unarmed hands.
>
> I will rush among you,
> I will fall to the tomb
> That I have so strongly defended.

Moreover, Gillet had earlier emphasized precise parallels between the *Crucifixion* and the *Meditations* written by the Franciscan Order. I would like to add that in the Apocalyptic scene the "court-like" atmosphere within which the Last Judgment unfolds corresponds to the finalities of the Last Judgment as Saint Bonaventure described them in the *Breviloquium* VII, 1, where Christ the Judge is said to appear to the just in his loving-kindness, and in VII, 2, where this attitude appears inherent to the universal ceremony: "Therefore, in order to manifest the loftiness of power, the rectitude of truth, and the plenitude of goodness, there must necessarily follow a universal judgment bringing about a just distribution of rewards, an open declaration of merits, and an irrevocable passing of sentences: so that the plenitude of supreme goodness may appear in the distribution of rewards to the just, the rectitude of truth, in the open declaration of merits, and the loftiness of might and power, in the irrevocable passing of sentences." The person who planned the program of the cycle, that is, the theologian who worked with Cimabue, seems to have been well grounded in the writings of Saint Bonaventure, and perhaps was himself the author of writings such as the *Meditations* which imitate the style and the ideas of Saint Bonaventure. I believe that Cimabue resorted to the Greek Apochryphos *De Dormitione B. M. Virginis* for the Marian cycle as well, rather than to the *Golden Legend* as was presumed up until now, while the scene of the Assumption and of the Coronation is a compendium of motifs from Saint Bonaventure. It would be valuable to know more, but in order to shed light such research should be carried out with a Franciscan historian and should aim contemporaneously at reconstructing the library which almost certainly existed at Assisi and from which the iconography was derived. The possibility that the texts also included illuminations cannot be excluded.

Unfortunately, as everyone knows, the greatest difficulty of such studies is the absence of sufficient links with other disciplines and, generally, the scarcity of research on devotion which is the real point of contact between the arts and theology. Examination of relevant documents would also be useful in explaining more precisely the patronage of Rome (the investigation carried out by an excellent student of mine at the University of Genoa, Elena Caciagli, who collected all of the prescriptions of the Orders and the texts suggesting iconographical elements is of great use although limited to the subject of the painted cross). The *Rationale divinorum officiorum* by Guillaume Durand (Durandus de Mende) was probably written while the disputes between wealth and poverty were taking place. It contains an unwavering defense of the use of sacred images as *laicorum lectiones et scripturae* and even goes so far as to give an absolute priority to them: "Hic etiam est que in ecclesia non tantam reverentiam exhibemus libris quantam imaginibus et picturis." He insures the same dignity

and, if I understand correctly, the same liberty to the painters as to the poets. With respect to the general course of the building and decoration of the churches of the Franciscan Order, which I was uncertain about, not knowing whether it had to be imputed to the Pope himself, or to the Cardinal-Protector of the Order, or to decisions in accordance with majorities established in the different localities, it now seems after reading M.D. Lambert's excellent summary, *Franciscan Poverty, The Doctrine of Absolute Poverty of Christ and the Apostles in the Franciscan Order, 1210–1323* (London, Holy Trinity Church, 1961), that great importance should be given to the Generals of the Order who were not always submissive to the Pope. Thus Cimabue's decorations were started under Bonagratia of S. Giovanni in Persiceto (1278), who is connected with the Papal Bull *Exiit qui seminat* for which the future Pope Boniface VIII supplied juridical advice. In 1283, the year in which he died, I estimate that the paintings had been unexpectedly, or at least hastily, interrupted. In 1285 Arlotto of Prato was made General. His preference for absolute poverty appears to me to be demonstrated by the fact that he appointed Ubertino da Casale lector at the *studium* of Santa Croce in Florence. In 1287, the new Franciscan General, Matteo of Aquasparta, must have had the same attitude as he appointed Olivi the lector at Santa Croce. In 1289 the Provençal noble, Raymond Gaufredi, a supporter of the rigorists against whom Pope Nicholas intervened, was made General. The controversy must have been violent since Boniface VIII deposed Gaufredi in 1295, appointing his friend John Minio de Murrovalle just at the time it appears Giotto was called to Assisi. What progress was made in the Church between 1285 and 1295? Was any work actually going on? I recall that plans made in 1285 in Florence for what is now Santa Croce were put off until 1295. I am becoming ever more sure that the dispute between wealth and poverty is one of the very important ideological struggles (which is why I am so interested in its history); the kind of struggle that divides society into opposing camps. I have noted with pleasure that an analogous opinion in regard to the arts has been independently expressed by Peter Hirschfeld, who recently commented on Giotto's poem against poverty that I had earlier used as a key to the antipoverty interpretation of the Franciscan cycle at Assisi. It will be helpful to discover, along with the documents, the state of spiritual tension of which the mysticism of Cimabue in the Assisi *Crucifixion* is certainly a reflection—as is also the compliant iconography of the Crosses. Perhaps it would be well to recall, in conclusion, that the positive estimate of Cimabue does not arise solely from the connoisseurs but also from German Expressionism, that is, from another period of ideological conflicts that is mirrored in the arts.

Cimabue works with the awareness and the pride of one who has a highly positive conception

of mankind's function in the world; however, he has an equally intense awareness of a fate against which the only possible reaction is an irrational anarchy. Perhaps, if it would be an exaggeration to say that just because of these contradictions he is a compendium of the whole artistic history of the West, it is right and proper to state that he is truly the greatest representative of at least one crucial period of European civilization.

EUGENIO BATTISTI
The Pennsylvania State University

January, 1967

CONTENTS

LIST OF PLATES

LIST OF FIGURES

INTRODUCTION

But at any rate I have loved the season
Of Art's spring-birth so dim and dewy,
My sculptor is Nicolo the Pisan,
And painter who but Cimabue?

Robert Browning

There are two types of research in every discipline. One is to attempt as definitive a study as possible by bringing together all previously completed specialized work on a subject; the other, impelled by a dissatisfaction either with the judgment, methodology, or historical interpretation, has as its primary purpose the exposure of the contradictions and gaps in the present state of knowledge. The pages that follow belong to this second category, although it might appear that all possible historical and critical paths to an understanding of the greatness of Cimabue have already been followed and the resulting panorama made definitive.[1] The systematic culling of the early literary sources was done by Ernst Benkard in 1917 and the few documents concerning the artist were published still earlier.[2] These documents did little to fill the singularly empty background; they provided only the information that Cimabue was in Rome in 1272 and was later active in Pisa.

The only remaining possibility appeared to lie in distinguishing more exactly Cimabue's autograph works through a series of stylistic comparisons. The salient results have been the identification of Duccio as the author of the Rucellai Altarpiece, formerly attributed to Cimabue; the recognition by Toesca in 1927 of Cimabue's hand in the Crucifix in the church of San Domenico in Arezzo; and the recovery, by means of a careful restoration, of the altarpiece in the Chiesa dei Servi in Bologna in 1937. Notwithstanding these clarifications of the Master's work there is still some uncertainty concerning the attributions of a few paintings, in part because the work of assistants lessened their quality, but in greater part because they are often in such a ruined state as to be illegible. Nevertheless, the critical assessment of Cimabue will probably remain unchanged. Many of the pages of commentary on the artist written by Longhi, Oertel, Ragghianti, Salmi, Salvini and most recently by Bologna could well be gathered into an anthology. However, successive, often ludicrous, attributions have added nothing new to the corpus of Cimabue's work.[3]

The paths of historical research are as infinite as those of providence. Recently, due especially to the pioneering efforts of great international scholars, an improved methodological concordance of the various humane studies has been achieved. The confines of specialization

are dissolving, and problems which seemed secondary, such as the attitudes of the Monastic Orders and the Medieval courts toward the figurative arts and the multiplicity of the concomitant consequences — aesthetic, philosophical, religious, political and economic — that their patronage involved, have now emerged in full relief. Collateral studies, such as the fully documented research of Hellmut Hager[4] on the beginnings of the altarpiece in Tuscany, the work of White on perspective,[5] the increased awareness of scholars of the relationship between literature and art, the recognition finally given to the extraordinary importance of the study of proportions, of the Antique, of Vitruvius, of the rules — in short the total aesthetic reflection of those long ago centuries — enable us to place Cimabue in a precise cultural line, defining by means of his style the options, the negations, and the innovations he introduced. Using such a complex of approaches may provide unforeseen possibilities of giving again to the legendary Cimabue — legendary because of the scarcity of documents — the solidity of history. The following pages are almost wholly directed toward this end. In this connection I recall with a sense of obligation and pride that the first organic monograph of the great master, that by Josef Strzygowski of 1888, although unfortunately forgotten by subsequent scholars, contains all of today's research premises, has this same orientation. Today, however, we have less certainty and more caution than did Strzygowski. We know that works of art are documents, even composites, that allow new and disparate readings. The very personalities of the artists have little coherence, but like stars in their conjunctions are mutually influenced and at times substantially modified. Although the interpretations of their careers may be cautious they will, nevertheless, be schematic and historically amendable. Within a few years the words written now will seem as ingenuous as the previous discussion of the authorship of the Rucellai Altarpiece, which the whole world praises today as a masterpiece by Duccio. On the other hand, without ingenuousness, without errors, and above all without the courage to plunge into insufficiently explored areas, no progress is possible.

The reader who may be bored by the exhaustive descriptive and documentary analysis of separate works which are viewed in a chronological order based on external objective elements, or by the philosophic discussions, will certainly find relief and pleasure in the plates. The achievement of the photographer, my good friend Andrea De Giovanni, who was aided by the counsel of Prof. Egidio Viterbi, and received the complete cooperation of the Franciscans of the Basilica (Padre Palumbo *in primis*), is finer than I had dared hope. I began with the idea of attempting a partial reconstruction of the illegible Assisi frescoes by inverting the tones that the white lead oxidation (due to the chemical composition of the local

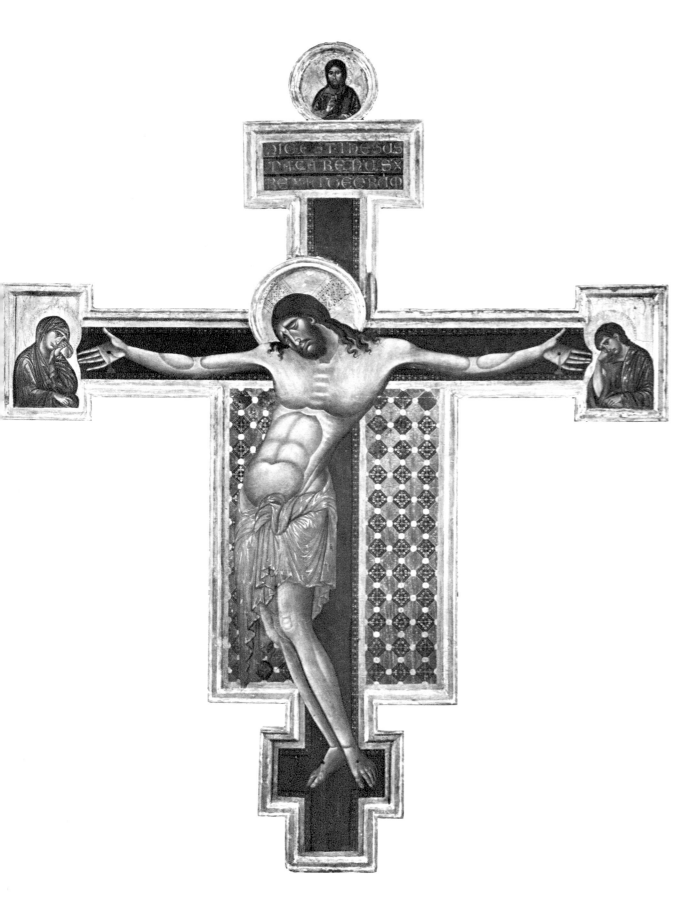

1 - CRUCIFIX - *Church of San Domenico* - AREZZO

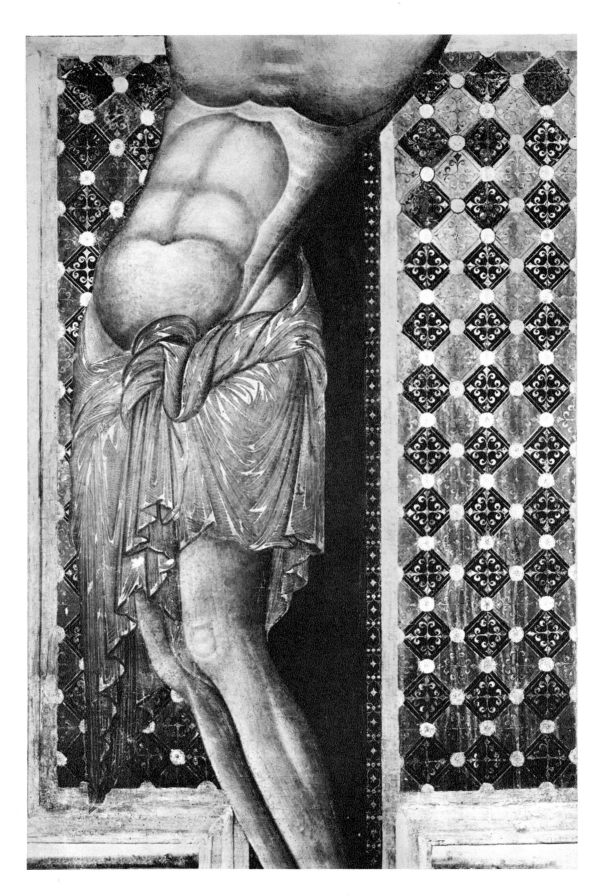

2 - CRUCIFIX *(detail)* - *Church of San Domenico* - AREZZO

stone and the insufficiency of the plaster surface) had reversed, rendering the most important sections unreadable and giving them the appearance of photographic negatives. We were able to reveal almost two-thirds of the lower part of the frescoes. Apart from the heightening of certain lights and shadows, nothing was introduced in the printing process to falsify the frescoes. For the first time after many centuries we again see Cimabue of Assisi. Here is a world so vast and complex that it seems to be outside present interpretative possibilities.

I said at the beginning of this preface that my study sets out more to pose problems than to provide answers. That the first step should be the greatest recovery possible of Cimabue's work, a recovery that today can be done rather better with photography than by an eventual restoration, is certainly consistent with the most thorough and accurate methods of art history. A more extensive utilization of available technical means in the future will almost surely allow a new examination of the general picture of Italian art. In this instance much has re-emerged from ruin to demonstrate that the millennary fame — more mythical than historical — of Cimabue is commensurate with his actual greatness. But also, history today has more elaborate means: first of all, the impulse for comparative work. Even the most superficial parallel study of texts dealing with contemporary people and ideas brings to light the tremendous cultural context in which Cimabue lived with complete awareness and energy. Returning to the wonder of the scholars who were able to see Cimabue and Assisi with minds opened by the first discussions of mannerism and expressionism, I feel it is legitimate to repeat that Cimabue was, as Vasari stated, a precursor of Michelangelo, as he too expressed concepts rather than words. One is never prepared for the emergence of those stupifying images, never seen before or after him. And it is my hope that in the future the documentation of the wall frescoes and the library research will proceed in tandem and, in turn, provide illumination for a more complete judgment of the great progenitor of our pictorial history.

CIMABUE AND HIS SOCIETY

The Name and the Artist

The first clue to Cimabue's nature emerges from possible etymological interpretation of his nickname, and from an examination of the earliest sources. His real name, as documents prove, was Bencivieni di Pepo — in modern Italian Benvenuto di Giuseppe. He was neither named Giovanni, an error first made by Villani, nor was he of noble birth. Analogous nicknames even as late as the seventeenth century were fairly common; Volterrano, for example, was called Cima de' buoi. *Cima* has two meanings: the noun "summit" or "head" which with the addition of *bue* or "ox" could mean Oxhead; and the verb *cimare* meaning to "shear" or to "cut". According to the verb, "Cimabue" would signify a boldly scornful and ironical man.[7] The second interpretation is the one accepted by C. Battisti in his *Dizionario etimologico*. Further support appears in a lively aside in the *Ottimo Commento della Divina Commedia* of 1333-34, one of the sources previously mentioned. Its early date is assurance that the contemporary view of the great painter was still very much alive:

Cimabue, of Florence, a painter of the time of our author (Dante), knew more of the noble art than any other man; but he was so arrogant and proud withal, that if any discovered a fault in his work, or if he perceived one himself, as will often happen to the artist who fails from the defects in the material that he uses, or from insufficiency of the instrument with which he works, he would instantly abandon that work, however costly it might be.

The artist who started Italian painting on a new course is presented to us with all the qualities, both good and bad, of a strong individuality. He emerges as a disdainful adversary not only of ignorance, but also of the submissive mentality of the artisan with his deference to the patron, to tradition and to commercial considerations. He was a man able to put his ideas into sharp biting words, one always seeking, no matter what the financial sacrifice, the highest expression of his art. Not only was he the creator of a personal poetry, he also had the critical power to defend it. In short, if not a humanist, he was a man learned enough to follow Cicero's pungent concept "Honos alit artes", implying that honor means great self respect. In the face — dramatic and proud but still a *homo mecanicus* — that is partly concealed by the stylized figures of elderly attendants or disciples [Pl. 37] do we see Cimabue's self portrait?

The hypothesis, suggested to me by Guglielmo Capogrossi, seems confirmed in the photographic reconstruction by the face's unusually strong character, its naturalistic rendering, and, above all, by its fierce, almost hostile tone. Dante corroborates the interpretation of Cimabue as an arrogant man, sharp tongued toward his adversaries and stupidity, by placing the artist in Purgatory with those guilty of the sin of pride (Canto XI); where, as Burckhardt has observed, he justifies himself, "by his great desire for excellence", rising above human limitations by the force of his ambition. In this canto for the first time, as has been noted, figurative artists, illuminators and painters were placed with poets, thus realizing the theme of "ut poësis pictura". Also in its concept of the struggle between different generations, and of a perennial artistic evolution which could only be interrupted by historical catastrophe, it is already completely Renaissance in feeling.[8] This homage to an individual aware of his originality, to an artist whose dignity removes him from the artisan, whose determination for the uniqueness of his work is such that he leaves it unfinished if his aspiration is not fulfilled; to the initiator of a new direction in art as well as the venerated father of the "uso moderno", and to one who may, as we shall see, be evaluated analogously to Dante's judgment of Guido Guinizelli, makes the nickname Cimabue the artist's spiritual horoscope. During this period with its outpouring of artistic historiography the painters and sculptors reached the point where the immediate universal fame of the poet could also be theirs; not the mere recognition of great capacity as was accorded to Guido da Como in 1250 in San Bartolomeo in Pistoia: "Sculptor laudatur qui doctus in arte probatur"; nor the praise "docta manus" given to Giunta Pisano in the inscription of the Bologna Crucifix whose iconography Cimabue was to use. But Cimabue the individual, with his multiplicity of experiments, did not limit himself to accepting praise but demanded it. De Bruyne[9] ends his chapter on Romanesque aesthetics with a group of laudatory declarations whose aim, on the one hand, was to separate the most talented from the common mediocrity, and on the other, to impose on the artists a rivalry with the artists of the ancient world, with the assurance that thus they would gain eternal fame, not only as standard bearers, but because they had reached the summit of art. This is far removed from the rule of St. Benedict that insisted on the humility necessary in artists employed in work for monasteries, and, above all, required that their lives be conducted as outlined in the *Schedula Artium* by Teofilo. Cimabue's art was designed exclusively for ambitious purposes and it was during these very years that the nobility of painting was equated in dignity by the Dominican General Humbert de Romans to poetry and preaching as it, too, served divine ends. On this point we can also call on another, although later historical source. Cristoforo Landino's elogy of 1480[10] develops the same ideas that

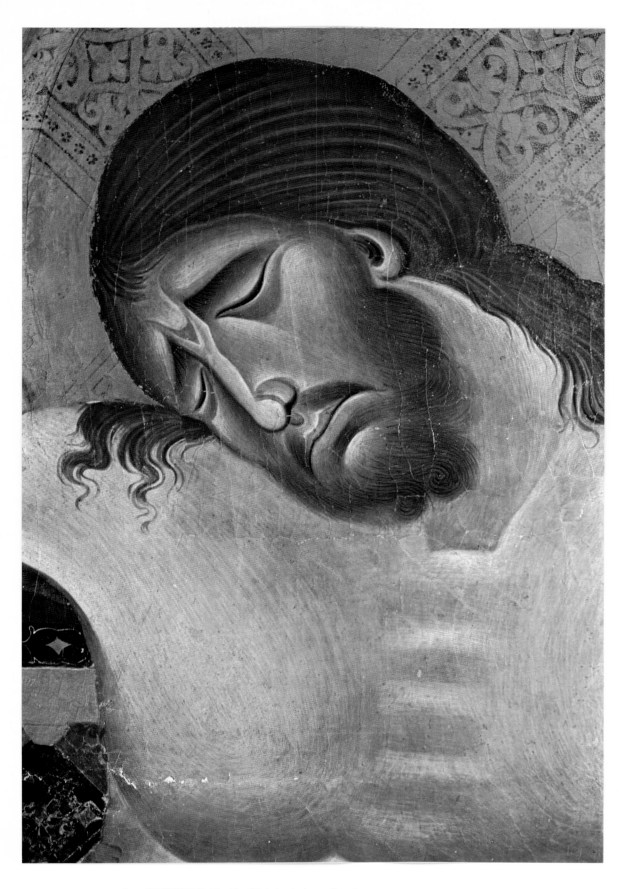

3 - CRUCIFIX (*detail, Christ's face*) - *Church of San Domenico* - AREZZO

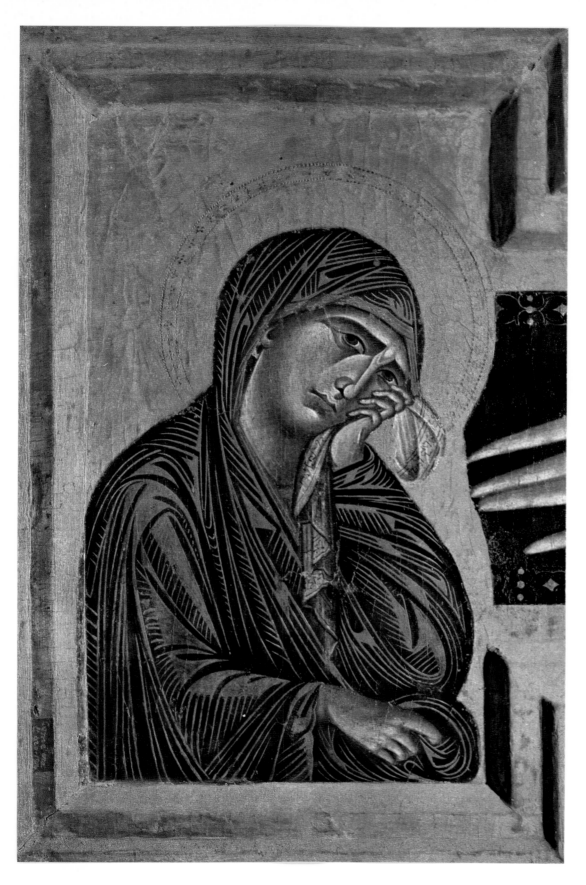

4 - CRUCIFIX *(detail, the Madonna)* - *Church of San Domenico* - AREZZO

Villani put forth at the beginning of the fifteenth century — ideas that seem an exact reflection of Cimabue's art and which the succeeding pages will attempt to demonstrate:

It was the first Giovanni from Florence called Cimabue who rediscovered the natural lines and the true proportions which are found in the best painters of Antiquity and which the Greeks called symmetry; and he rendered the figures so alive, that in the earlier painters are so dead, and with such varied gestures that he left great fame. But his fame would have been much greater, if he had not had such a noble successor, Giotto Fiorentino, contemporary of Dante.

Landino's comment is not a reworking of Pliny's interpretation of the art of Polycleitos or of Lysippos, but, perhaps using Ghiberti's *Commentarii*, seems rather a recast, with some emendations, of the biography of Parhasios, the painter who according to Pliny:[11]

Primus symmetriam picturae dedit, primus argutias voltus, elegantiam capilli, venustatem oris, confessione artificum in liniis extremis palmam adeptus.

Symmetry, liveliness of countenance, elegantly arranged hair, beautiful mouth: these are Cimabue's most noticeable and relatively banal qualities as the Santa Trinita Madonna, now in the Uffizi, demonstrates. However, the text as a whole is much more convincing: Parhasios, similarly as the early Dante commentators wrote of Cimabue, is treated as the first complete artist, one who did not limit himself to the imitation of nature but created devices that overcame the physical limitations of art as, for example, by the use of foreshortening, "as if by some means he wanted to show also those parts which of necessity remain hidden". An exact parallel of course cannot be made between the mysterious Greek artist and Cimabue who was praised in a like manner. It should be remembered, nonetheless, that Cimabue was not only the first master in Europe whose biography was compiled, but that he was also accorded the credit of conceptualizing the dignity of his profession. Cristoforo Landino's words are confirmed by an analysis of the symmetry and proportions of the paintings, and another notable confirmation may perhaps be found in a study of critical history.

A Change of Generations

We turn again to Dante and that curious parallelism between Cimabue and Giotto on one side and Guido Guinizelli and Guido Cavalcanti on the other. This parallel does not extend to chronology. Cimabue was born about 1250. His style was superseded by Giotto's around 1295, while Guinizelli was already dead in 1276 and Cavalcanti in 1300. In Dante's view then, poetry was close to a generation ahead of the advances in painting and presumably he also felt himself to be in advance of Giotto. The works of art which Dante describes in

Canto XII of Purgatory, by the complexity of their subject matter, strangely anticipate the taste of the late Quattrocento and Cinquecento. They not only "mirar farieno ogn'ingegno sottile", but could not be compared to any master "di pennel o di stile", that is, with any painter or illuminator. The asynchronism of poetry and painting, considered only from the naturalistic point of view ("naturalism" obviously in Gothic terms which was Dante's point of reference) is conclusively demonstrated. Only in sculpture, with Giovanni Pisano, was there a conjunction in time — a conjunction that was also topographical.[12]

Why then did Dante compare Cimabue to Guido Guinizelli and Giotto to Guido Cavalcanti? A personal relationship is indicated: Guido Cavalcanti was a close personal friend of the great poet. And even though it is only a legend that Giotto was a friend of Dante — he did not paint his portrait[13] — it is now certain that during the period when this restless future rival was presumably a part of his studio Cimabue had a commission of a certain importance from Folco Portinari, father of the famous Beatrice, to paint a dossal for the Ospedale di Sta. Maria Nuova in Florence. Dante's frame of reference, as with almost all ancient writers, and with newspaper and literary reviewers today, was governed by friendships and personal esteem. However, the differences in style between Guido Guinizelli and Guido Cavalcanti, and between Cimabue and Giotto are so marked that considerations of friendships and personal inclination must be left behind to trace with exactness the gulf between the two styles. The most striking quality in the work of the first Guido is its rigorous geometrical structure based on the insistent repetition of similar phonic cadences or conceits such as in "Donna, l'amor mi sforza": the theme of the torture of love is repeated in six lines out of the twelve lines of the first stanza. It is unlikely that this reiteration has an expressive purpose, such as the rhythmic transcription of an obsessive emotion, since it is also used where the tone, on the contrary, is one of "gioia ed allegranza". It is a response to the need to relate, by slow, logical, successive, highly conceptualized transitions, a detailed analysis of every possible phase of love. Guinizelli today would be considered full of redundancies in his attempt to transfer a banal love theme to a philosophical and esoteric plane. The formal convention of the stylized drapery folds and the repetition of angel heads is very close indeed in that masterpiece of poetry, Cimabue's Santa Trinita altarpiece. Guinizelli's insistence on the use of conceits of fire, light and sun in his completely symmetrical forms recalls the recurrent abstract lighting one sees in Cimabue, and still more in Coppo di Marcovaldo. The spiritual tone, apart from the hardness conveyed by the insistence on logic and development, is dark and full of frustrations: "o voglia o non voglia così este". He describes himself as "Angoscioso e pien di doglia — e di molti sospiri e di rancura", uncertain of his desires and his future, "disnaturato"

8

as a fallen leaf in a world where death reigns and "ogni cosa muta stato". Once again we are reminded of the harsh drama of Coppo di Marcovaldo that Cimabue is to refashion for himself. In successive readings of Guinizelli's poetry one becomes aware that its elaborated and insistent structure ends by creating an abstraction of reality: a reality that only has the value of a background or, more exactly, it functions as a lyrical *souvenir* useful as an initial diapason. One need only consider the degree of re-elaboration of rhetoric that the sweetness is subjected to in, for example "al cor gentil ripara sempre amore com'a la selva augel in la verdura" and how the musicality of the first line in this stanza and the ones that follow becomes a geometry of interfolding conceits. This is not only the modern viewpoint. Bonagiunta da Lucca, although recognizing in Guinizelli an innovating force, accused him of excessive "sottiglianza", of difficulty of interpretation, of strangeness and unsuitability, of academic doctrinairism and bookish philosophy.

> You surpass every man for subtlety
> And it is impossible to find anyone to explain
> Your way of speaking, so obscure is your discourse
> And all consider it strange (although your learning
> Comes from the University of Bologna) that you
> Make your song by bookish means

For Dante then, Cimabue belonged to a stylistic period dominated by conceptualism and learning, in this case geometry, proportions and perspective; while Giotto by his assimilation of the culture, was able to conceal it, just as did the "second" Guido. It is certainly true that the outlook changes radically when one passes from Guinizelli to Cavalcanti. The tone is less exalted. The conceits are more precise and exact, and employed with such grace that the casuistry and the course of the courtship gain in narrative value. There is no longer conflict between elaborated artificiality and realistic suggestions. The treatment is homogeneous, integrated; the polarities reconciled. Anguish and psychic instability are reduced to an almost Arcadian range. Even the dramatic vicissitudes of exile are softened by the lover's elegant farewell. But the chase for labored conceits still continues under the composed and refined facade. While in Guido Guinizelli the woman becomes a *Magna Mater* and love like the cult of the Holy Grail, in Cavalcanti the image of divinity, the miraculous icon of the Virgin of Orsanmichele, is visually identified with the loved one's face. It would be irreverent to attribute a similar profanity to Giotto, but we can well believe that Cavalcanti represents, similarly, the serene, easy, perfectly adjusted mental outlook of the Gothic world to which, at least in his naturalistic investigations, Giotto also belonged.

9

Today it can be said with a more reasoned critical judgment that Cimabue occupies an intermediate position between the formalism of Guinizelli, which was scorned by Dante, and the naturalism of Cavalcanti, which the poet praised. Cimabue's stylistic development oscillated from one pole to the other, but the essential nucleus of his art is found in the rigor of his study of form, the conceptual nature of his creativity, and in the urgent massive rhythms — in short not in mimesis, but in geometry itself. That by such contrary means he was able to give new life and vigor to pictorial representation reconfirms the singularity of his grandeur and allows us to experience again the amazement of the first visitors to Assisi.

A Visionary and a Rationalist

But one must not attribute to him aesthetic qualities he could not possess. He was, to use De Bruyne's words in commenting on very similar ideas of Grossatesta,[14] a visionary and a rationalist at the same time, one who repudiated spontaneous and irrational figurations conceived by empirical contemplation as a result of didactic demands, in order to immerse himself in a highly reflective and intellectualized constructivism. Cimabue "bears witness to the struggles of art on the point of becoming knowledge and of knowledge on the point of incarnating itself in the artistic creation". If he cannot be properly termed a humanist as Arnolfo and Giotto deserve to be called because of their more salient interest in classical civilization; nor a painter with poetic interests as Simone Martini seems to have been, he was certainly a philosophical artist. His capacity for synthesis, his dramatic concentration, the graphic coherence of his iconography is evident when compared to the sacred narratives of his contemporaries which are always a bit confused and void of an organic structure, whether one speaks of the Florence Baptistry mosaicists or the mosaicists and the fresco painters of Rome. The most recent art criticism restores the credit due Cimabue on the specific basis of his exceptional culture. "The spirit that animates his world... is a cultivated spirit, one that had an extremely conscious foundation, rooted, in the power of his poetic awareness of his innovatory contribution and its historic significance".[15] A concomitant in his art is the sharp reduction, for Florentine art at any rate, of symbolic and allegorical aspects: the passage from the image to the discourse — from poetry to prose. Sometimes he is at the point of creating a new style, but he stops at the decisive moment. He appears irresolute in accepting the taste of his time. We do not see in Cimabue direct reflections, or exact visualizations of the ideas of a St. Bernard or a St. Bonaventure. Gothic theories, although plain in his representations of the Madonna, are weakened and diluted. This is

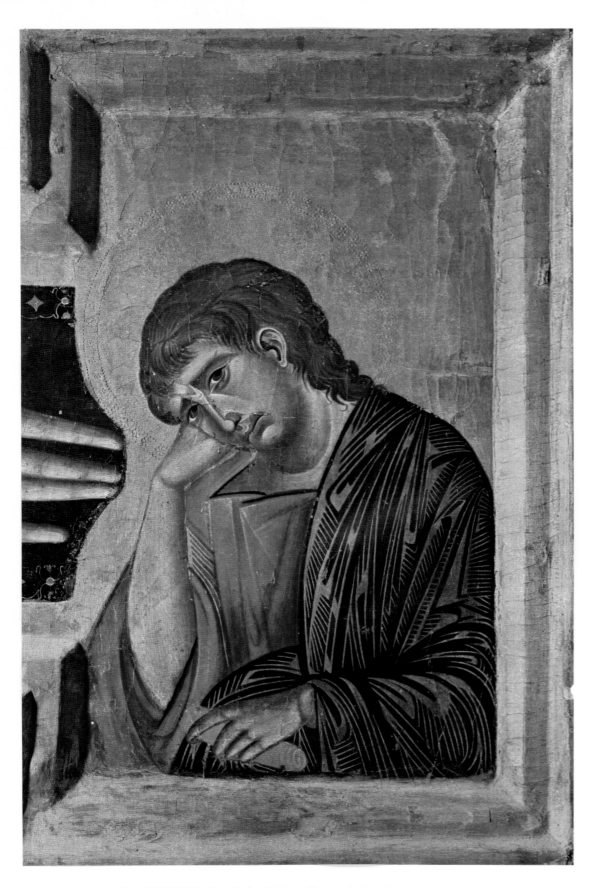

5 - CRUCIFIX (*detail, St. John*) - *Church of San Domenico* - AREZZO

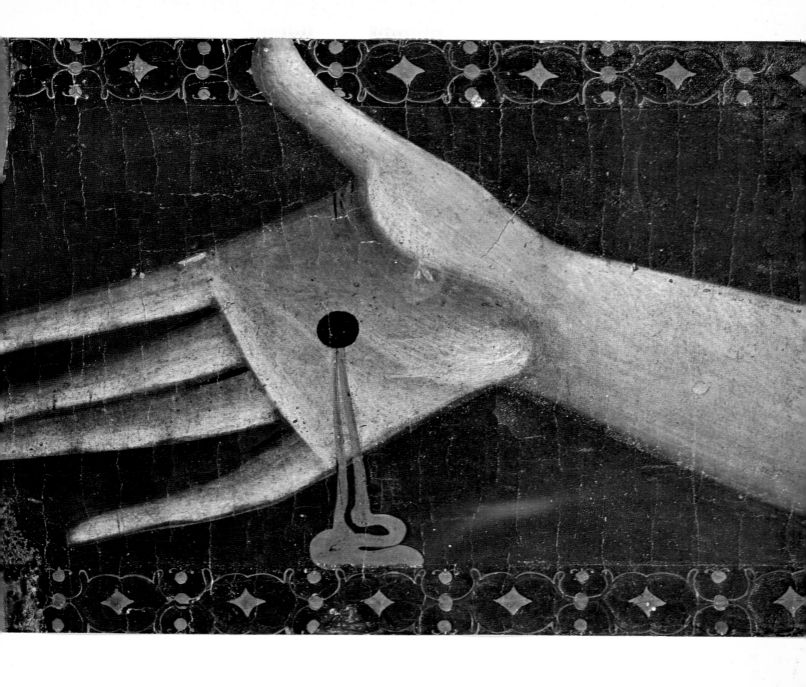

6 - CRUCIFIX (*detail, Christ's hand*) - *Church of San Domenico* - AREZZO

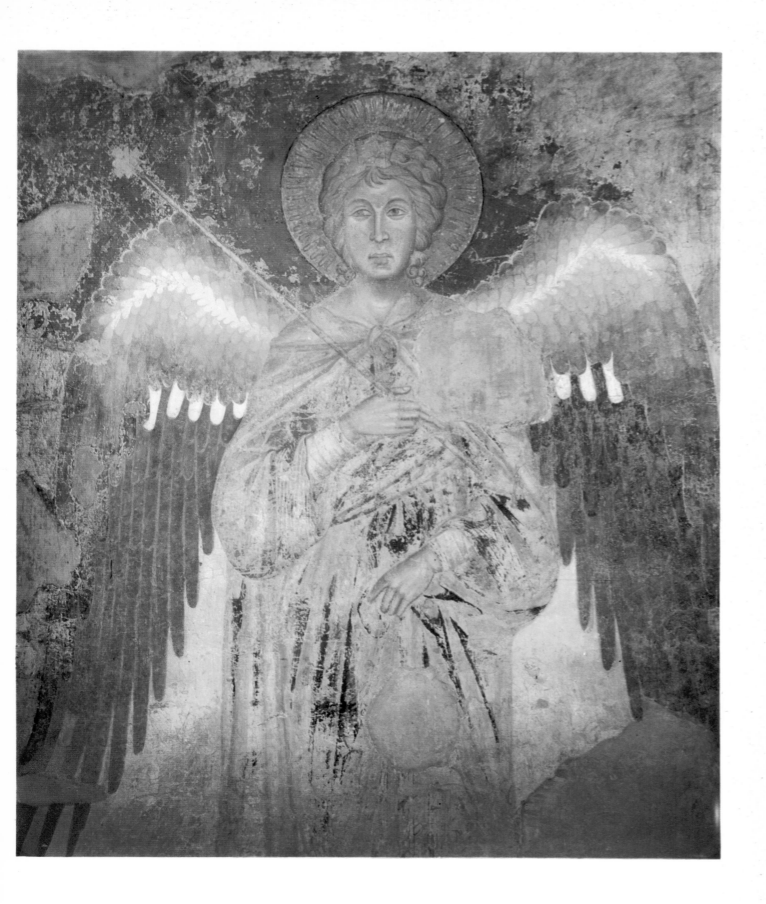

7 - GIANT ANGEL - *Upper Church of San Francesco* - ASSISI

due perhaps to the fact that his patrons, no matter how illustrious, had neither the capacity to set their mark on their age nor could they assume an international concordance of poetic insights. Cimabue's art, despite its superb grandeur, was restricted to a small geographical area. It was not destined to create a new style, even though it stands between Giotto on the one hand and Duccio on the other, at the origin of modern art. His limits were those of the society of the time. He was essentially, as were all preceding artists, at the service of the Church and the papacy, while artists who followed him had the added advantage of the patronage of the nobility and the bourgeoisie. Cimabue saw during his lifetime the end of that close relationship between religious and cultural life which for almost a millennium had characterized Italian civilization. He oscillates continuously between an acceptance and a repudiation of the contemporary situation. His faithfulness to Byzantine art provided him not only the context but also the point of departure for pictorial innovations. His faithfulness to Byzantium — at times an impediment — was an internal mystical vocation, a longing, the sincerity of which is evident when we see the powerful forms he created for religious reform and syncretism. It is easy to denigrate the Byzantine painters with the label "Balkanized"[16] but it should not be forgotten that this very Byzantinism coincides with the desperate and repeated attempts by Rome and Byzantium to find a religious unity valid for the entire Mediterranean basin, and to regain, by political and military efforts through the Crusades, possession of the cradle of Christianity. The Byzantinesque style of the Dugento is the expression of this dream of a common religious idiom and not simply the consequence of an exodus of artists from Constantinople. In this same way, three centuries later, Expressionism, in part confused with Mannerism, became the figurative language for attempts at reform in both the Catholic and Protestant world. The Byzantine vocabulary allowed an immediate leap from reality to the divine to the extent that its fundamental stylizations were collectively recognized as indications of divinity. In other words, on the level of artistic creation it served for a time both to reinvoke the world of nature and to transcend it. The task outlined for Dugento artists by the theorists was in fact "to paint and to sculpt on the outside in accordance with what is imagined on the inside". The quality of the style was recognized to be not in a mimetic correspondence with nature, but in the degree to which the painting reflected a mental image: "Dicitur imago quod alterum exprimit et imitatur".

In respect to the Italian painting of the 12th century which is characterized by narrative subject matter, mostly of an anecdotal nature, and icons of a highly simplified naturalism, the Byzantinism of the 13th century is a sign of spiritual recovery in which we witness a

11

process clearly contrary to that which for some time characterized the general evolution of Western culture as it approached the modern age: i. e., the breaking up of schematism for the ever more free flowering of physical reality. The opposition culminated in the religious and mystical crisis of 1260. This movement, though supported by a broad popular base, contrary to what happened in the Mendicant Orders in their beginnings, excluded and isolated contacts with reality. The formalism and conceptualism of Coppo di Marcovaldo and of Cimabue himself are a resounding repudiation of the convictions of those who believed it possible, without remorse or sacrifice, to reconcile nature and idea, recognizing a large autonomy of the first in respect to the second. They held, in other words, that the accord of the profane and the sacred could be realized by the tranquil integration of the two elements as exemplified by the continuously renewed spontaneous harmony of the universe.

Diverse social conditioning can justify in a parallel way the freer and more progressive position taken by sculptors. Not until the beginning of the 14th century were painters able to organize their own corporation with freedom to develop their own artistic directions and to impose them on the market. In Florence Giotto was the first to successfully undertake a syndical action.[17] He was also the first artist who worked with great freedom from monastic trends and local traditions. Sculptors, on the other hand, since for some time the patronage of the Monastic Orders was closed to them because of iconoclasm, turned to cathedral workshops, the administration of which progressively passed from the hands of the clergy to those of laymen, who guided them, for obvious reasons of civic pride and dignity, toward representing contrary ideals of monumentality, archaeological evocation and naturalism. It was communal taste, as Assunto has pointed out,[18] which gave the primary impetus to the great building programs, fostering competition and a rapid evolution of taste. Since civic pride demanded an imperial investiture or stately tone, the classical world had to be reinvoked. The workshops spoke the common language in every sense, while the monasteries continued to converse in Latin until the middle classes gained control and great merchants commissioned painters to cover the walls of the naked churches with narratives as vivacious and pleasing as tapestries, as plastic and manifest as the sculptured pulpits. This was the moment in which not only Giotto, but all the new generation overleapt Cimabue and isolated him in history as in a cell.

THE CROSS OF SAN DOMENICO IN AREZZO

The unwritten history of Cimabue is hidden in the great Crucifix [Pls. 1-6] which at one time probably stood behind the altar of San Domenico in Arezzo. It is the only work that can be attributed to a pictorial phase precedent to the fresco cycle of Assisi. Unfortunately, all documentary evidence is lacking:[19] the date of 1275 that Vasari gives for the construction or consecration of the Dominican church is unfounded. Although there are no clearly non-Florentine elements in the cross, it could well be subsequent to Cimabue's stay in Rome in 1272. Moreover, we do not know when he went to Rome or how long he remained. The religious and political history of Arezzo is of no help. However, the Arezzo Crucifix seems to be contemporary with a very similar one in Pistoia attributed to both Coppo and Salerno di Marcovaldo, but executed for the most part by Salerno from about 1274. It is difficult to ascertain whether Cimabue personally influenced Salerno's style which, as the Pistoia Crucifix demonstrates, is clearly distinguishable from that of Coppo, his father. Furthermore, it would be more convincing to conjecture that Salerno was influenced by a Cimabuesque work in Florence rather than by the distant Arezzo masterpiece. But it is possible, of course, that Cimabue sent his painting to Arezzo from Florence. The uncertainty of the dating of the Cimabue cross is less grave for a critical evaluation because of the subject matter. The style Cimabue used in depicting the Crucifixion theme remained relatively constant, representing the most archaic and traditional side of his art. On seeing the extraordinary freedom exercised by the painter in his treatment of crucifixion in Assisi, where a cosmic emphasis, especially in the movement of the drapery takes the place of the rigidity of the Arezzo cross, it is reasonable to infer that outside pressures were quite heavy in the earlier work. For that reason we must try to distinguish where in the various details he made innovations and where he submitted to the iron rule of sacred representation.

The Dominican Rules of Art

It would be ingenuous to consider his actions either as resulting from an unconscious option or in terms of outside stylistic influences. Since it was a work, not only for a Dominican

13

church, but an indispensable part, for reasons of liturgy, of the church furniture,[20] it would fall under the control exercised by the Order on works of art: a control demonstrated by the numerous solemn proscriptions issued during the meetings of the general chapters. A single example will be sufficient;[21] in Paris in 1239 the Order decreed that the convents could house neither sculptured images, painted glass, nor gold illuminated letters in the codices.[22] The only concession was the inclusion of the cross on plain glass. The prohibition was repeated in 1240, and in 1243 they were forced to remove the great silver crosses and banners; only in 1256 were the images of St. Dominic and St. Peter allowed. The famous proscriptions of St. Bernard regarding the austerity necessary in Cistercian life and its outward expression in the buildings of the Order echo with the same severity. At the end of the century (1298) while such ideological barriers, for the most part, were crumbling in Italy, partly as a concession to popular demand — preaching in the south-central section of Italy had traditionally been accompanied, through Benedictine initiative, by illustrations — the provincial chapter house in Chartres decreed that no innovation or curiosity could be introduced in painting, sculpture or minor art destined for the monasteries ("nullae curiositates notabiles fiant").

The rigorous attitude of the Dominicans and the Franciscans, who had similar ideas regarding art until the last decade of the 13th century, is the principal reason for the scarcity of stained glass, sculpture in the round, as well as the poverty of precious metal work; panel paintings of the Madonna and the Crucifix took their place. At the same time the slight artistic variations, the strict iconographic conformism, the static mediocrity were such that even today these works are more conveniently treated as types and families rather than as single masterpieces of individual personalities. Except for the coastal area of northern Tuscany there are in fact no noticeable instances of innovation (if the more differentiated and often more vigorous fresco production is eliminated, being *a priori* banned by churches of the Monastic Orders). This was due in part to the initial poverty of the Orders, who were opposed by the bishops, impeded in receiving bequests, hearing confession and holding public ceremonies. Moreover, we know that they consisted of very small communities which, in the beginning, consisted of twelve friars and a master. Particularly in Arezzo, where the tradition that the monastery of San Domenico occupied the site of the *studium locale* was considered legendary — a point to which we will return — the hostility towards the friars by the ecclesiastics was still strong in 1259, seventeen years after the convent's foundation. It was perhaps only under the pontificate of Clement IV, a Dominican, that they were able to build a church large enough to house Cimabue's large cross. The enlargement of the Dominican

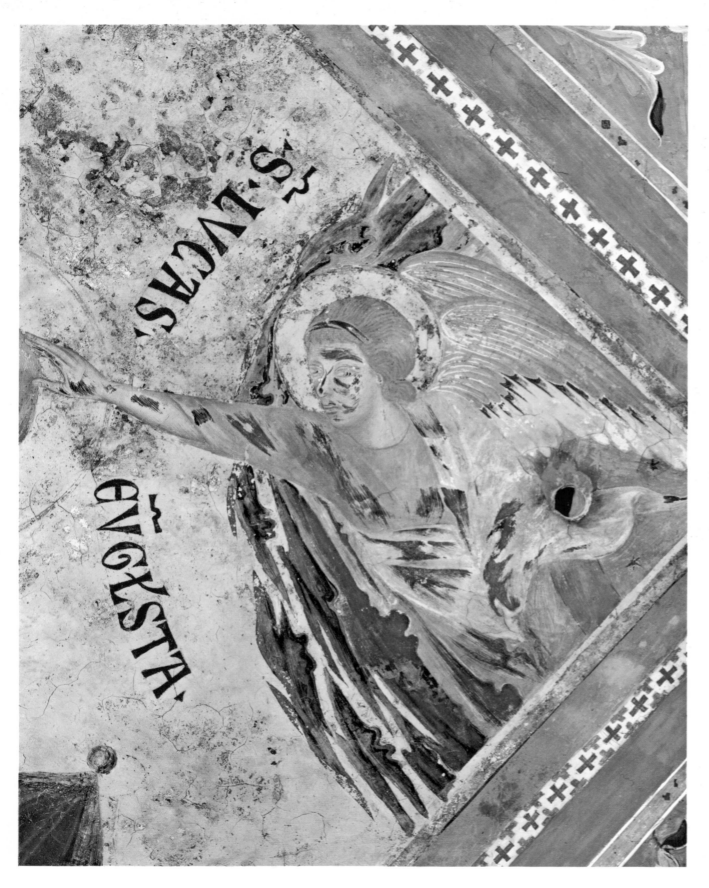

8 - ANGLE WITH ST. LUKE (*detail, Messenger Angel*) - *Upper Church of San Francesco* - ASSISI

churches, connected with the permission to hold all religious ceremonies, came about in the last decades of the 13th century and more or less coinciding with the two great "Gothic" popes, Clement IV and Nicholas III who, for diverse political and religious reasons, were patrons and promoters of an architectural renewal which was destined to determine in an essential way the profile and urban development of Italian cities.

The Influence of Giunta's Cross

At least in the beginning of the undertaking that was to have such a great social and urban impact, the Dominican and Franciscan Orders still showed signs of their rigid tendencies. The fundamental characteristics of monastic architecture[23] are rationalism and a sense of proportion that is at times exceptionally sensitive. These characteristics are perhaps due to the fact that the planning, as in the case of the Cistercians, was done from a main center, if not directly under the Curia. The altarpieces, on the other hand, being less costly were left to local control and are characterized by the mystical apocalyptic entreaties of the provinces. They express the ever burning fire of rebellion in the heart of the monasteries toward the high mission the papacy gave to the Orders. The principal crosses painted both for the Dominicans and the Franciscans in the second half of the century, for instance those painted for the satellite churches of Assisi by the Master of St. Francis, were based with the greatest fidelity on the masterpieces of the "heroic pauper" period of the Orders: that is on the Giunta Pisano crosses which were painted with the direct assistance of the earliest followers of St. Francis and St. Dominic [Fig. 3]. They are the only works that genuinely represented the early devotional orientation and reflected the French ideas. As Carli has written: "The reverent solemnity, indeed the severity of the religious vision in the Giuntesque crosses which isolated the image of God... does not detract from a most passionately felt identification with Christ's martyrdom: and if it is in the concentrated intensity in which he is absorbed in the drama of the cross that Giunta most clearly places the mark of his strong individuality, the bitter eloquence of the two compositions certainly found a profound echo in the new sentiment of the fraternity of Christ in suffering which the teaching of St. Francis had aroused in the hearts of the contemporary crowds".[24] The widespread recopying of the original prototypes by imitators active in the years 1270-80 certainly must signify the desire to rescue the primordial anarchic religious fervor from doctrinism and protocol. But the paintings are proof that even in the most rebellious sections of the Order such a return was impossible. A double aspect of schematism is seen in the Giuntesque imitative work of some thirty or forty

years after his great flowering, being, indeed, much more Gothicizing than Byzantinizing. These works demonstrate a notable absence of human solidity, particularly apparent in the reduced volume of Christ's crucified body, while Giunta unquestionably took part in the anatomical recovery. Such increased scientific knowledge, as Maria Velte has observed, also characterized the evolution of sculpture in the round between 1215 and 1235 in the great Gothic cathedrals.[25] After Giunta, typically in the case of a personality so aggressive and dramatic, Coppo di Marcovaldo both flattens and hardens the volumes of the Christ Crucified. The very contortions lose their emphasis, and thus no longer serve to break, or more accurately, to mask the geometric stylization to give a sense of organic value.

Another negative aspect of what we might term a kind of neo-Romanesque reaction against the general European Gothic evolution, is the loss of the happy unity of vision, that was in part due to the prevalence of the curve over the straight line and the absence of excessively strong chromatic contrasts between the image of Christ and the geometric drapery of the background, characteristics which give to Giunta's work an exceptional position. The paintings of the 1270's are more laboriously constructed. They demand an analytical reading and are abstract even in the details. It is not simply a minor divergence but a different orientation of taste. Devotion turned from the popular and poetic to the conventional and literary; mysticism seems more an intellectual surrogate to reality than the appropriator of the world. Paris, wrote Jacopone, has killed Assisi; the university overwhelms the simplicity of the "bonhomme"; tradition sets itself against the modern taste.

There is, however, a third very positive point of differentiation that is pertinent not only to conventional works of art, but to all Italian sacred imagery. It is the darkening of the mood, the increased heaviness and rigidity of the lines, the traces of bitterness, the introduction of dark touches in the hair and in the shadows. If the details of a face by Giunta are compared with those of the face of the San Gimignano Christ by Coppo, one senses a profound lowering of the moral tone in the latter. The apocalyptic terror of the end of the world predicted for 1260 by Joachim of Floris separated the first artist from the second. Worship was transformed into a pessimistic, destructive, self-wounding frenzy with the movements of the flagellants, whose headquarters and whose origins, like the Mendicant Orders, were in Umbria, but whose roots lay basically outside Gothic mysticism in pre-Christian and perhaps pre-Classic forms.[26] Painting in the second half of the Dugento is an increasingly terrifying visual expression of this feeling. It sets aside the refinements of the improved civil conditions and contradicts the optimism manifest in the unheeding activity of the new religious construction that was underway in a building program more ambitious than the Church had

16

attempted for centuries. Even so by its very harshness this painting represents one of the high points of Western spirituality. In the sacred scenes surrounding Coppo's image of Christ there is also an impetus, an aggressiveness that, though derived from schematism, violates all its rules and customs. Such qualities go a long way in justifying and transforming into merit the flattening out of the body, especially noticeable in the two-dimensional loincloth. This insistent geometrical obsession succeeds in giving an extraordinary religious transference function again to the image.

Cimabue and Giunta

Cimabue, in this context (a more detailed investigation of a sociological-statistical character would undoubtedly be extremely illuminating[27]) made a series of very controlled decisive options which permitted him by means of small alterations to create a more proportioned type of cross that was widely copied until early in the 14th century. His freedom to modify iconographic conventions presumably was very limited. Through these limited modifications, setting aside the qualitative effect, we can follow, step by step, Cimabue's method of constructing the image, based on imposed or suggested models, by means of these sometimes slight and sometimes substantial modifications.

Without doubt, Cimabue's prototype for the Arezzo cross is the Crucifix by Giunta, the date of which is unknown, for the great Mother Church of the Order in Bologna, where, a few years before Cimabue's commission, the body of St. Dominic was solemnly placed in the fine marble sarcophagus made by Nicola Pisano and his helpers. Cimabue completely accepted the conventions both plastic and chromatic: the contrast of the red of the loincloth according to contemporary texts alludes to the mystical passion, the gold refers to the celestial majesty of Christ, and the equally symbolic blue to the physical cross. In the details such as the draping of the loincloth the correspondence to Giunta is so close as to suggest a copy. There is a slight iconographic variant in the pose of St. John, who, however, symmetrically repeats the gesture that the Madonna makes with her hand to indicate her tears as in the crosses Giunta painted for the Franciscans. This act, on the basis of the ancient miming annotations of the *Planctus Mariae*[28] of Cividale, involves the moving and solemn supplications of Mary the Mother of Christ:

> O vos omnes qui transitis
> *Hic ad oculos suos ponat manus*
> per viam, simul mecum flete,

Hic ostendat Christum
　　et meum dulcem filium
　　pariter lugete,
　　et videte
Hic se percutiat
　　si est dolor similis,
Hic se percutiat
　　sicut dolor meus!*

and from St. John the apocalyptic warning:

Tempus est lamenti.

Consequently the iconographic modification demands the collective participation of the faithful in the drama. There is, however, in the Arezzo cross a more fundamental alteration of the Giunta model. This change removes to an entirely different plane the relationship between the image and the faithful. It lies in the very different way Cimabue delineated the face. Here we seem to pass into another culture and Cimabue's explicit reference to the work of the contemporary Coppo di Marcovaldo only increases this feeling. The extraordinary emotional attraction of Giunta's arabesques, which seem to have an almost musical flow, are not totally abolished, but there are substitutions of hard and heavy zones of shadows upon which the highlighting has an almost phosphorescent quality. Giunta's Christ is still luminous despite the corpse-like color that contrasts with the living flesh colors of Mary and St. John. Cimabue's Christ, in which Coppo's expressionistic agitation becomes more hidden and interiorized, is a Divinity sinking into the shadows whose face, deformed by suffering, reveals desperation and a desolate grief rather than the promise of redemption [Figs. 1, 3]. Coppo, a Florentine like Cimabue, worked not far from Arezzo in the town of Siena. He was more modern and for that reason was interpreted with a greater freedom than was shown toward Giunta Pisano, the imitation of whom Cimabue abandoned in the most crucial section, that is in the head of Christ, to follow Coppo instead. Cimabue's image of Christ at Arezzo is above all more plastic, more enclosed and compact. In Coppo the eyes, beard, moustache and ears fragment and divide the oval face [Fig. 2], while in Cimabue these elements are elegantly extended curves — directly inspired by Giunta — in a general, almost spheroid, scheme that gives an unusually powerful fullness of outline to the cheeks and chin. This treatment occurs in a less highly stylized way in the lateral figures where the predilection for solid volumes is

* Oh, all you who pass by — *Here put her hand to her eyes* — Weep with me in like manner through the street, — *Here point out Christ* — And my sweet son likewise weep, — And see — *Here beat her breast* — If there is grief — *Here beat her breast* — Such as my grief!

18

9 - ANGLE WITH ST. MARK (*detail, perspective plan of Rome*) - *Upper Church of San Francesco* - ASSISI

demonstrated by many details, such as the rigid bare arm of St. John and the regularly curved pleating of the Madonna's mantle. The plasticity found in the Arezzo cross derives from the rounded highlights and the repetition of curved lines. As Cimabue was fully conversant with the means to serve his powerful conception, he was able to reinforce it, when opportune, with the contrast of a hard rectilinearity and a harsh symmetry.

Cimabue and Coppo

At this point it would be well to consider whether Cimabue's and Coppo's relationship was not that of student and master. Chronological and geographical considerations make it appear quite probable. Coppo was not only an artist of great power, but one who also enjoyed great fame, as is shown by the fact that scarcely had he arrived under detention in a hostile Siena, after the battle of Montaperti, when he was commissioned to paint one of the most celebrated icons of that city and of all central Italy. We are able to follow him through works or documents to Orvieto and Pistoia, although Florence remained his home. Unlike Giunta, he did not work exclusively for the Monastic Orders, but accepted quite varied commissions, more often from municipalities than from single monastic groups. Without doubt he was the finest artist to whom one could turn for instruction in Tuscany. Moreover, in Cimabue's work we find influences that are non-generic and definitely traceable; for instance the relatively less nervous staccato highlighting of the drapery by decisive repetition of gold appears in Coppo's Orvieto Madonna [Fig. 4] datable c. 1265-68. The lateral figures of the Arezzo cross are particularly close to Coppo's manner of that period.[29] But it was the method rather than the manner of the only slightly older Coppo that was the stronger influence. Coppo's overpowering force is in the inflexibility of the geometric stylization, even of the smallest detail. With the ruler and compass, one feels, Coppo juxtaposed linear motif to linear motif with the same elaboration of exposition as Guido Guinizelli employed in his exhaustive treatment of the love theme. Not a single decorative detail is casual or inspired by lyrical or intuitive abandon. Through a comparative study of their proportions, along with a logical reasoning process, we will find convincing evidence of the differences in the three crosses we have considered: Giunta's in Bologna, [Fig. 3], Coppo's of San Gimignano [Fig. 1] (even though it is a prototype, only the face valid for the Arezzo work), and that by the youthful Cimabue in Arezzo.

The first cross, that painted by Giunta, is indeed relatively exceptional and, again, we note its direct relationship to French culture. The great majority of the crosses — those showing

19

the eyes open as well as those with the eyes closed — followed Byzantine proportions, based on the division of the body in nine modules[30] corresponding to the length of the face: the torso is divided into three parts with the first division at the pit of the stomach, the second at the navel, and the third at the groin; the legs have four divisions, two above the knee and two below; the feet have the same length as the face. In the case of Christ *patiens*, where the head is bent forward, the length of the entire head is sometimes used as the module rather than the face. However, in Giunta's cross we find that he uses, instead of the Byzantine system, that of the *homo quadratus*, following it strictly. According to the principle of the quadrature of the body, derived from a vast theoretical system dating from the resumption of Vitruvian studies already under way in the Carolingian period, the body with arms outstretched fits into a square, that is to say, the distance between the hands is the same as the height of the body. The *anchement* of the body, a slight bending of the outstretched arms, eliminates the risk of a too stocky appearance. The quadrature system followed by Giunta in Bologna was also employed, more or less accurately, by his late followers. The Crucifixion by the Master of St. Francis, in the Perugia Pinacoteca, for example, follows this principle except that, unlike Giunta, the height of the image includes the nimbus. This demonstrates the diffusion of these concepts, which were also repeatedly expressed in the texts of the mystics, in the circle of friars who commissioned the crosses. Giunta, however, availed himself of an important corrective, which Vitruvius would have defined as eurythmic, by placing the bent, gaunt head of Christ quite a bit below the upper terminal of the square thus giving a sense of anguished disequilibrium. Giunta used the *homo quadratus* scheme only in works executed for the Dominican Order. In fact his Crucifixion in Santa Maria degli Angeli is extremely elongated, being based on a module of ten face lengths, still Vitruvian and with cosmological symbolism, but void of the possibility of geometric stylization. The inference that the quadratura system was imposed or suggested by the Dominicans seems reasonable because of their doctrinal predisposition as well as their position as heirs to the geometric architectural planning of the Cistercians and the relationship the Dominican theorists established between the mystical quadratura canon with that of Vitruvius.[31] It was a Dominican, Vincent of Beauvais, a contemporary of Giunta, who cited Vitruvius' theory of proportions with the greatest accuracy (De Arch. III, 1). He wrote that there was to be found also in the human body a "quadrata designatio", that if one measured the distance from the feet to the top of the head it would be the same as the distance between the ends of the hands with the arms extended, as if traced out on squared paper. On the same subject, according to St. Hildegarde of Bingen, this equidistance is the symbol of the equilibrium of moral beauty,

10 - ANGLE WITH ST. MATTHEW (*detail, a Palestinian city*) - *Upper Church of San Francesco* - ASSISI

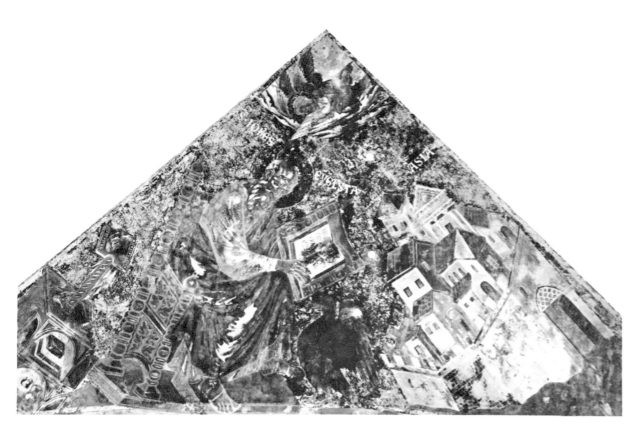

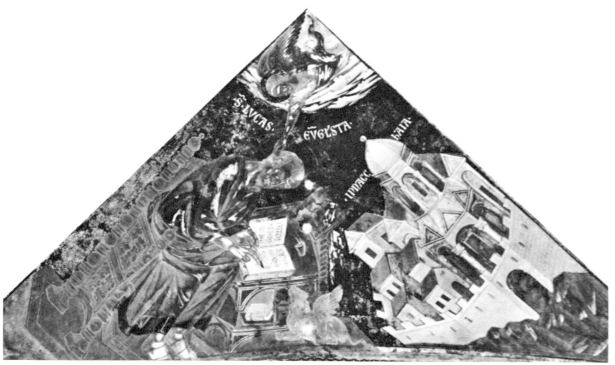

11 - ST. JOHN THE EVANGELIST AND ASIA AND ST. LUKE AND GREECE
Upper Church of San Francesco - ASSISI

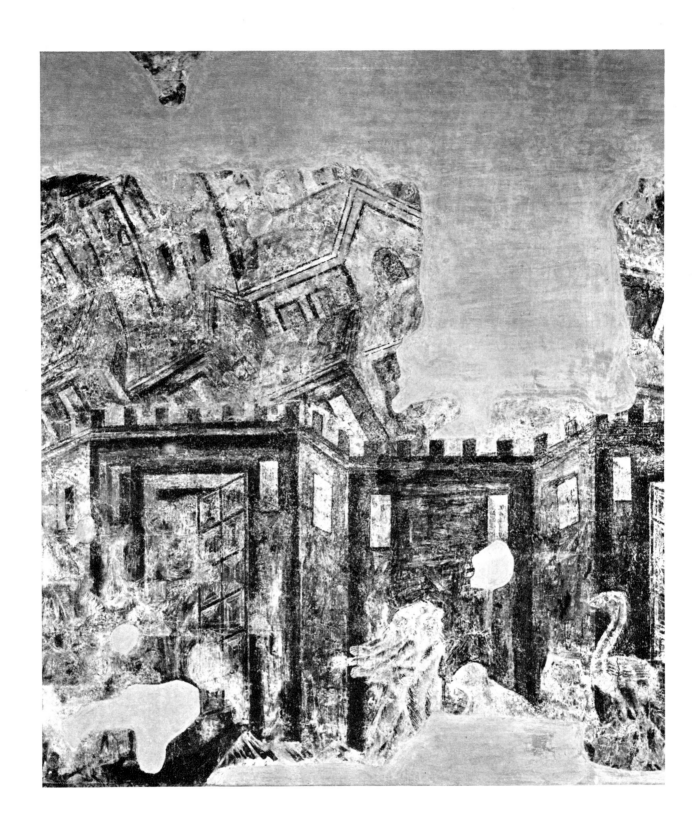

12 - THE FALL OF BABYLON (*detail*) - *Upper Church of San Francesco* - ASSISI

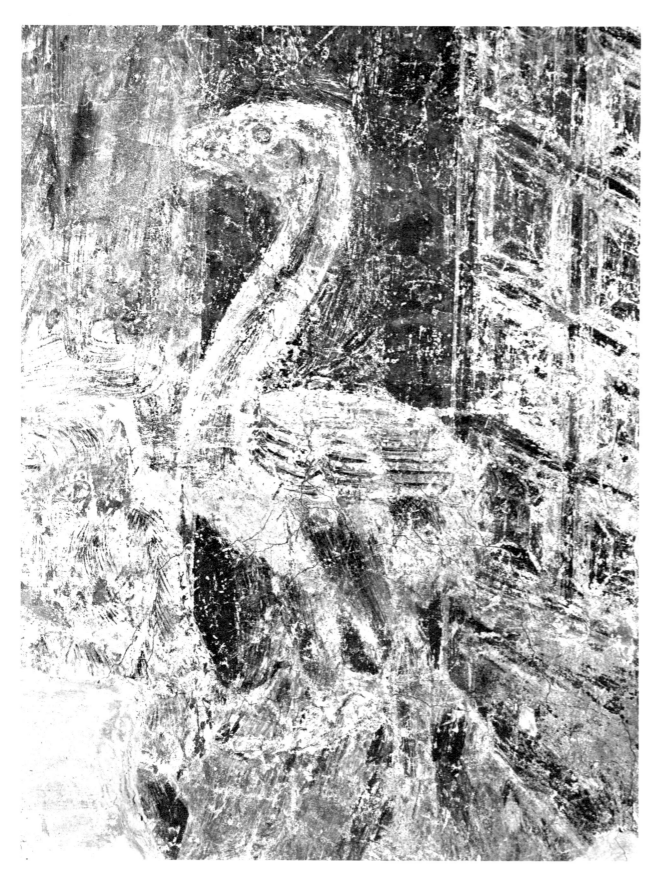

13 - THE FALL OF BABYLON (*detail, the demonic swan*) - *Upper Church of San Francesco* - ASSISI

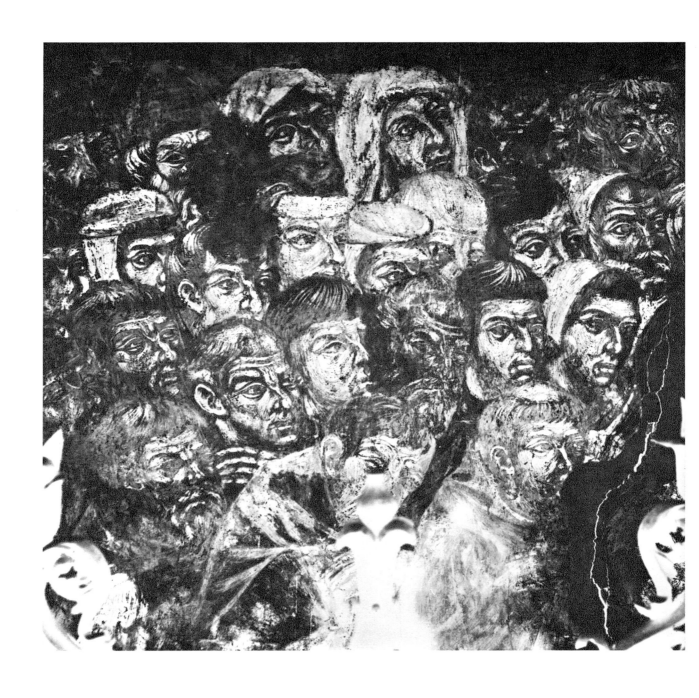

14 - CHRIST THE JUDGE (*detail, the arisen*) - *Upper Church of San Francesco* - ASSISI

as well as a reflection of the cosmos: "quemadmodum etiam firmamentum aequalem longitudinem et latitudinem habet" (Lib. Div. Operum, cap. 15, c. 814). The quadrature system was reserved almost exclusively for representation of the Crucifixion, which naturally portrayed the body erect with the arms outstretched. Following Vitruvius and conforming to his modular application, the middle of the body in the Crucifixion had to fall at the groin, the one rule followed even by those who disobeyed all the others. These theories of proportions would seem to be of little importance in themselves, being only the preordained conditions of pictorial representation. However, in the Dugento the homage to the various modules is clear enough: the arms are divided at the elbows in a mannequin-like articulation and, notwithstanding the body's contortions, the intermammillary ribs are shown as perfectly horizontal, descending with a plumb-line exactness down the center of the body as well as the center of the cross. The divisions of the body suggest decorative stylistic cadences. They would be more readily apparent if we knew the level of anatomical drawing in the Dugento. It was certainly more advanced than has been supposed if one considers those miracles of nature — the drawings of Guido da Vigevano of 1345. After a millennium of indecipherable graphic stylization they are inconceivable without some sort of groundwork in addition to those mentioned by early sources. In fact, the Franciscan, Salimbene, records a dissection that took place in Cremona in 1286.[32] The hierarchy of the various parts of the body: those with only a useful purpose and thus concealed; those both beautiful and useful such as the sense organs, feet and hands; and those wholly decorative, such as the navel or the nipples, find a correspondence in the artist's treatment.[33] Could the realistic inconsistency and the graphic elegance of the Dugento treatment of the chest perhaps, in great measure, derive from its theoretical interpretation as solely a decorative part?

But leaving aside this digression we go on to the second cross [Figs. 1-2], that by Coppo. It is an example of Florentine rationalism and, particularly, of that marvelously geometric proclivity which owed so much to the abstract disposition of the marble of the Baptistry and of the Fiesole Abbey. For Coppo, geometric knowledge is the reason for the absence of rigid schematism so that the proportional structuralization is limited to the framework. Without its moulding, the cross is as wide as it is long and the figure of Christ follows neither a strictly geometrical nor quadrature scheme except that the ideal center of the body coincides with the horizontal and vertical center of the cross. In a certain sense the body proportions are realized in relation to the ambient. Cimabue proceeds in quite a different way. He returns to the rigorous proportions of Giunta, but the center of the body also coincides with the center of the cross. Within this framework in which the human body is the starting point rather than

21

the cross as in Coppo, Cimabue, while respecting the general rule, allows himself a series of licenses. The most important is the tension created by the asymmetry of the left shoulder which compensates and justifies the bent head. And, in order to accentuate the verticalism, the module adopted for the arms is less than that used for the legs, allowing the body's torsion to push almost to the edge of the apron while at the same time remaining balanced by the accentuated verticalism of the whole. Although employing the same rules as Giunta, though with a greater conceptualism, Cimabue arrives at a diametrically opposite result: dynamic instead of static, expressive instead of contemplative. One recalls the freedom of the Mannerists, especially Michelangelo, who chose the measurement with their eyes rather than by mechanical means. All the same, Cimabue is an excellent Vitruvian: the length of the face corresponds to that of the hands and of the feet, even the nimbus has a module which is proportionally twice that of the face. The total height of the body is made up of ten parts which Ristoro of Arezzo, the learned naturalist and contemporary of Cimabue, had declared proper for the cultivated artist:

And the skilled designers to whom Nature gave and conceded the ability to conceive and draw the things of the world representing man's body by dividing it into ten equal parts; in the topmost part they fashioned the head and from it nine parts below were counted, and by means of the length of the face they proportioned the hands, the feet, and the chest, and all the body so that it consisted of ten equal parts. And there was seen and recognized by them the form of a person well proportioned and perfect; this was achieved by nobility of imagination and the intellective soul.[34]

We recall with increased interest at this point the homage Landino paid to Cimabue for rediscovering symmetry, that is for availing himself of an objective system of proportions. Cimabue certainly went rather far in the conceptualism of the image, but it must be added that he made use of rational means which he was able to arrange in a decisively personal manner for expressive ends. By a comparison with Giunta's Crucifixion, the distortion of the rules in the Arezzo cross soon becomes clear. In Cimabue's work there is a great asymmetrical expansion of the chest and an elongation of the figure which is emphasized by the long narrow side aprons. The construction seems more analytical than was the general tendency in the latter half of the century. Cimabue had less belief in transcendent verities, and even in this tragic painting he did not allow himself to be seduced by symbolism. The image of Christ is quadrate but not obviously so. There are also moderations in the use of color. Red is used to a greater extent than in Giunta's Bologna cross. In Dominican symbology red stood for Faith, Charity and the Passion. While Giunta seems to dissolve the materiality of the figure in a background of red and gold, Cimabue surrenders very little to symbolic stress.

His red has a rigidity which limits and defines and blocks in more effectively the image. This derives from the caesura created by the blue field which is larger on the right; by shifting the color center of gravity toward the top, where the letters of the infamous inscription seem to blaze; by the more noticeably green tint of the flesh and by the sharp distinction between the gold and red of the side aprons, whose diamond pattern is separated by disks. Perhaps it derives also from the fact that the painting as a whole is less homogeneous and unified, precisely because of its more analytical construction. But as in all artists inclined toward conceptualism, the design and the effects of light and shade have greater importance and more vivacity than the color whose function is subservient. By the chiaroscuro which creates an almost oil-brilliance of the flesh, the physical side of the divine agony is presented with brutal clearness.

The Culture of Arezzo

The exploration of the Arezzo cross gives us not so much the prehistory of the latent genius of Cimabue, but shows us an artist already mature with his principal and distinctive characteristics: "a feeling for plastic interpretation, one of the reasons Cimabue has always been named as one of the founders of Italian painting".[35] Other critics have used terms such as pathos, energy, violence, and these too seem to reflect the same idea. The rebirth of tragedy with the first Senecan commentaries is not many years away and constitutes one of the most noticeable manifestations of the human and emotive renewal of the Dugento. But it is possible to follow the same development in the Dominican Order for whom Cimabue worked in Arezzo.

It was only with St. Thomas Aquinas that the typical Medieval disdain for the individual and his passions lessened in the attitude of the Church. He recognized that these emotions could not be suppressed or eradicated, but must be understood and directed. In this regard Herschel Baker[36] writes: "For Aquinas, every fact of nature is organically related to the total pattern of the great design. Thus the body, so cordially detested by a Neoplatonist like Augustine, is viewed by Aquinas as merely an instrument of the soul. Even the sexual organs have their proper 'end', and 'that which is the end of any natural thing, cannot be evil in itself; since that which is according to nature, is directed to an end by divine providence'". St. Thomas' respect for human dignity, his defense of sentient cognition, his efforts to build a theology natural to man, his rehabilitation of self-esteem and of man's faith in himself, signal the true beginning of the Renaissance.

23

This also was Cimabue's path. While Giotto could work in a world where, visually at least after Boniface VIII, eschatological and symbolic values were downgraded, Cimabue was able to rediscover human physicality in the face of a literature, both popular and devout, which exalted the opposition of the body to the soul, during a period when he witnessed the self-abuse of the flagellants in an Italy deranged by the moral consequences of the Albigensian and Catharist heresies that found in the body the beginning of every evil. Cimabue overcame with one leap the opposition between the criterion of moral beauty, represented by the broken bodies of the martyrs, and physical beauty, considered loathsome and sinful, represented by muscular development, wide shoulders and beautiful hair, by showing that expressive intensity and edification can come also from physical excellence if it is interpreted as an attribute of the heroic.

Because of its imposing size[37] the Arezzo Crucifix must have been painted in a studio set up in the convent, or in a workshop of the church itself. At least a year of residence in Arezzo seems to be indicated—not long enough to establish a school, but certainly useful in enabling Cimabue to form an acquaintance with the local intelligentsia of poets, philosophers and scholars. It is easy to imagine a relationship, at least conversational, with the strolling players such as Maestro Bandino, Mino del Pavesaio, Giovanni dall'Orto, Arrigo Testa, Ubertino di Giovanni del Biano (some of whom were, however, very young) who in following their leader's example were to repudiate the amorous and allegorical Gothic for mystical denouements with a hardness of style and content which, like many contemporary devotional pictures, was of an archaizing taste. Ristoro, the Aristotelian scholar who was well-versed in Arabic culture, was also in Arezzo and perhaps in the Dominican convent itself. In 1282, about ten years after Cimabue's sojourn, he wrote the eight books comprising the *Composizione del mondo colle sue cagioni* in which we find, besides the page on proportions already cited, a splendid description of the Aretine vases that were found in great number "at this time whenever and for whatever reason one digs inside the city or for some distance around it".

We find sculptured and drawn most beautifully and perfectly all the types of plants, leaves, flowers and genus of animal and other fine things which make the connoisseur lose himself in delight... There are sculptured images both thin and fat, some laughing, some crying, some dead, some alive, both old and young, naked and clothed, armed and unarmed, on foot and mounted on almost every sort of animal. Crowds and battles are marvelously shown in every sort of attitude and every sort of wantonness, and we find battles of fishes and birds and other animals in every kind of movement. Hunting, bird catching, fishing are most marvelously seen in every possible way one could imagine. There are putti flying in the air like nude boys carrying garlands of every kind of pome, some of whom battle amongst themselves. And in some we find chariots drawn by horses. Flying through the air in every attitude. Battling on foot and horseback in every diverse action.[38]

24

Ristoro not only describes the evocative iconography, to which we will return, but captures with an enviable sensitivity the Hellenic scenographic skill as exemplified in the style and diversity of the Aretine ceramics decorated with reliefs:

> They are designed and sculptured so marvelously that we see in the sculpture the seasons, clear or gloomy weather and whether the figure is near or far. And we find every variation of mountain, valley, stream and river, together with wild and domestic animals that are perfectly appropriate in every action.

Beyond the Alps in France the discovery of antique ceramics was one of the essentials for 13th century Classicism. The celebrated Visitation Group of Rheims Cathedral has, as has been noted, precedents in several Tanagra statues, whose diffusion, as far back as Antiquity in Northern Europe, has been confirmed.[39] It is quite possible that a votive head, like the one, for example, in the National Museum in Gela[40] stimulated the archaistic revival of Bamberg. But, obviously, for a Central Italian artist, who had perhaps already visited Rome, then still rich in murals of the Antique and Late Medieval periods, the effect of the Aretine vases would have played a secondary rôle. But, however, Ristoro's description immediately suggests a comparison of the "putti flying in the air like nude boys carrying garlands of every kind of pome" to the angels that at Assisi repeat the iconography of Cupid in flight, although Cimabue endows them with a dynamism of anguish and mystical fervor in exactly the same way that Latin erotic lyrics were transformed by contemporary poets writing in the vernacular into a motif of mystical sublimation and devotion.[41] Ristoro's comments have an interest beyond the relatively crude Aretine ceramics. They constitute an extremely precious indication of how much an artist, during the time of Cimabue, was able to understand and appreciate archaeological objects. The vases on which were sculptured "such natural and fine things" sending the connoisseurs into ecstasy "when they see them because of their great delight... exclaiming aloud and so beside themselves as to be almost stupified". And "when one of these pieces came to the hand of a sculptor or painter or other connoisseur they held it as one does a sacred sanctified thing, marveling that human nature was able to have such great subtlety in artifice, that the form of the vase, the colors, and the high relief was such that they said the artists were divine or that the vase descended from heaven". Richness of natural detail, realism, a variety of themes which were largely secular and a multiplicity of characterizations, from age to youth, from the warrior's fire to amorous copulation, a vast exploration of the world of plants and animals, perspective effects of distance, and within the limits of bas-relief technique a certain atmospheric effect that was almost impressionistic: all this on a red or black ground was recovered from the earth during the excavations for new palaces.

25

After a millennium of strict iconographic imitation with only timid ruptures the conceptual and expressive liberty of a more modern and revolutionary civilization reappears — the Hellenistic civilization. Was Cimabue one of the enthusiastic excavators or antiquarians? Or did it fall on him to introduce to the city, that only in the last decades of the century saw arise around the Pieve its own monumental nucleus,[42] the veneration for these recovered objects "the ignorant shatter or throw away"? At the risk of slipping into romanticized biography he may be imagined in conversation with Ristoro, discussing Arabic science, geometry, perspective, reading the passages in Pliny on the Aretine ceramicists and the celebrated painters of the Antique, with whom he already felt in rivalry. It is not a bad thing to hypothecate if by so doing we are further convinced that Cimabue's work in the erudite and invigorating atmosphere of 13th century Arezzo signaled an essential turning point in art history. Moreover, if his stay was before his trip to Rome, it certainly enabled him to learn and see a thousand more things in the Antique than the followers of the Byzantine manner could possibly imagine.

THE ASSISI FRESCO CYCLE

It is much more difficult to understand the originality of Cimabue's Assisi frescoes [Pls. 7-48] than to relate the Arezzo Crucifix to the Dugento and the Dominican aesthetic. In the Mother Church of the Franciscans we find not a further phase of an already functioning evolutionary process, but a foundation and system that are totally new. Only in a generic sense do we find precedents in the great Roman cycles in St. Paul's Outside the Walls and Old St. Peter's where the narration was continuous like an unwound scroll. In addition, the problems that faced Cimabue at Assisi were much more complex and in part unexplored. A new pictorial system had to be devised to conform with the French Gothic character of the architecture which as originally conceived was to be left undecorated. The arrangement of the paintings had to conform with particular religious ceremonies as well as with the exigencies of pomp and splendor appropriate to a pilgrimage church. The complex, even if one limits it to the apse where Cimabue worked, is highly composite, both from the standpoint of the fresco themes, and the stylistic treatment that their varied subject matter demanded. Four themes of notably diverse character are represented. There are Scenes from the Life of the Virgin in the apse, Scenes from the Apocalypse in the left transept arm, Scenes of the Apostles in the right transept arm. On both of the walls of the transept arms opposite the choir, there are great Crucifixions. Any artist called upon to paint a range of subjects running from the agonized expressionism of the Crucifixion, to the descriptive symbolic abstraction of the Apocalyptic scenes; from the moving idealization of the story of the Virgin, to the heroic nobility of the scenes of the Apostles, would have to provide great stylistic variation. No painter in all of the Medieval period was confronted with such a varied and diversified task nor, it may be inferred, one so vast. The Upper Church was to become within a few years the richest in painting and decoration of all Europe. Cimabue succeeded magnificently in those sections which are autograph. As almost all the Roman painting of this period (of which Cimabue presumably had a part before coming to Assisi) is lost, these masterpieces remain isolated summits. Their quality and originality, at times supreme, separate him so completely from the rest of the Dugento that convincing parallels

are difficult. And, unlike the relationship of the Arezzo Crucifix with its precedents, here, at Assisi, such precedents are surpassed in one leap. No suggestions as to derivations and outside factors could ever satisfactorily explain its organic nature, the passion that animates it, and the great spaciousness that constitutes it.

Assisi's culture at the time of Cimabue was a ramification of the culture of Rome, and it is in the papal city that we must search for Ariadne's thread. Moreover, a complex like the Assisi frescoes, in which there are confrontations and felicitous resolutions of narrative problems as well as of representation, is not the consequence of the work of the painter alone, but of an enlightened patron and, presumably, of the plan of a theologian also. The true Italian Gothic was just beginning and various factors indicate that those same people who promoted the wave of building activity, the direction of which, unlike that of the Cistercians, came from inside the peninsula, were also the patrons of Cimabue.

Strzygowski has already pinpointed the problem by his insistence on the importance for Assisi of Rome and its Court. He bases his theory on the 1272 document in which the artist appears as a witness, in the presence of Cardinal Ottoboni Fieschi (the future Adrian V), high church dignitaries, and members of the Dominican Order, at an important adjudication concerning a religious order. Strzygowski underestimates the artistic activity of the Dominicans and the political-economic situation of the papacy, while conjecturing that Cimabue's trip to Rome was in answer to a summons by Charles of Anjou, whom Strzygowski considered the only outstanding patron of the period.[44] A re-examination of the document allows, as will be demonstrated, a less peremptory conclusion. And, as we have seen, the artistic activity of the Orders was not so negligible as to preclude the possibility that they might have commissioned some altarpieces, notwithstanding their customary strictness. A re-examination from the biographical point of view is also illuminating. Cimabue, as has been noted, was a witness along with some Dominicans for whom — according to a tradition reported centuries later by Vasari — he had already worked in Florence, Arezzo and perhaps Rome. The juridical action concerned a nunnery of the Order of St. Damian whose comportment had aroused controversy, perturbation and worry among the Franciscans. Because of the Order's name it seems likely that they insisted upon the rule of absolute poverty. St. Peter Damian, in fact, was violently opposed both to simony and to culture, and in those years of religious battles his fame was widespread. Dante placed him in Paradise among the contemplatives, and had him deliver an invective against luxury loving priests. In order to cut short the quarrel the Pope, soon after his election, placed the reluctant sisters under Augustinian rule. The Dominican witnesses were evidently present as pacifying interme-

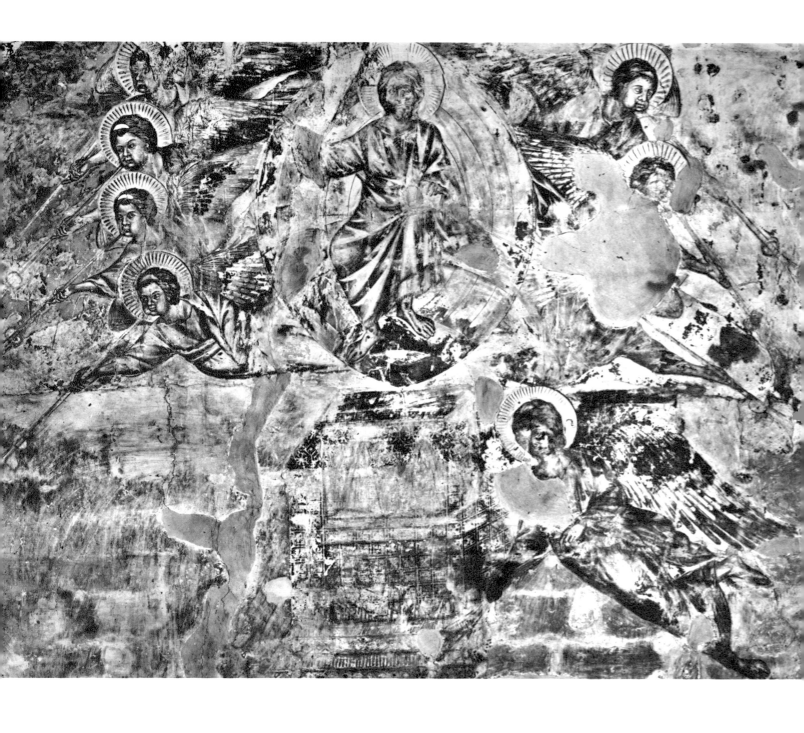

15 - CHRIST THE JUDGE *(detail)* - *Upper Church of San Francesco* - ASSISI

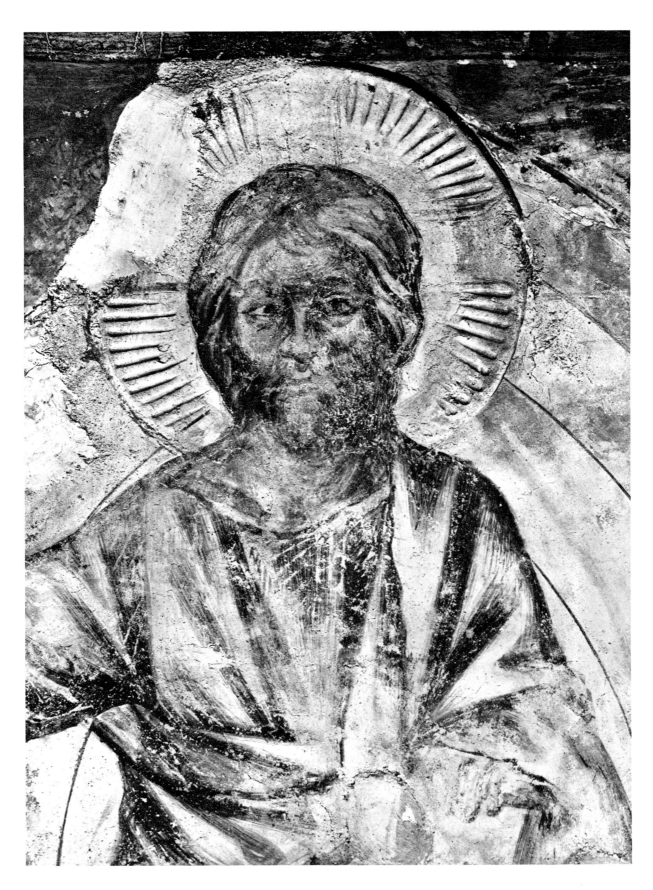

16 - CHRIST THE JUDGE (*detail*) - *Upper Church of San Francesco* - ASSISI

diaries. Cimabue's presence may also be explained as that of an intermediary, but between the two Orders, the Dominican and the Franciscan, that is, he must have been invited because he was known and liked by both. The document conserved in Santa Maria Maggiore concerning a monastery near that basilica permits us to deduce, with caution, that a collaborative relationship already existed with the Franciscans resident in the famous church. It is certainly a sign of great esteem for an artist to be called from the scaffolding in order to participate as an equal in such a select company. A year later a similar incident happened to Cavallini, but only as a witness to a banal sale of farm land to a canon of the same church.[45] The dignity of the artist in Rome was, then, quite considerable, at least with the Curia and the great religious orders.

Conversion to the Imagery

Though vague, there are illations deducible from the document of 1272 that lead us to suppose that it reflects also Cimabue's passage from his beginning work with the Dominicans to his great career with the Franciscans. We are obviously unable to ascertain when this transition took place, nor do we have documentary evidence which would help us to definitely date the Arezzo cross either before or after Cimabue's trip to Rome. At any rate, the cross represents, in respect to the successive stylistic development of the artist, not only a phase in itself, but in spite of the prophetic foreshadowings it contains, a chapter notably separate and distinct. If we can say that the ideas of the Dominicans reflect the precepts of St. Bernard, the Roman Court, because of its increasingly successful attempts at cultural and political revival, was dominated by the completely opposed and irreconcilable ideas of the Abbot Suger[46] — that is, by the artistic program of the French Court. Under the guidance of Late Medieval mysticism as transmitted by Dionysius the Areopagite, the French Court promoted decorative splendor, considering it an instrument of collective religious ecstasy and an efficacious lever for popular devotion. It was exactly this sensual, coloristic, emotive fascination of art, so hated by St. Bernard, that Suger placed at the service of the Church which thus became a small universe for the quantity and rarity of its accumulated treasures — the still intact collections of the great Spanish cathedrals are examples — and for its richness of human experience. The philosophic justification for this resumption of aestheticism was that the human mind can "raise itself to that which is immaterial only if it is guided there by way of the material". The problem was recognized by St. Francis, when, for example, he imported from the Holy Land the liturgical drama of the crèche which, although

29

serving no ceremonial function, was an emotional and impassioned call directed especially to the humbler and simpler classes. Aided by the high cultural level of the Court in which he participated, there predominated in Suger a form of aesthetic appreciation which strangely recalls certain attitudes of oriental aestheticism. He wrote:

When—with my great delight in the beauty of God's temple—the enchantment of the precious multicolored gems has pulled me away from my external cares, and a worthy meditation has induced me to reflect, transferring that which is material to that which is immaterial, on the diversity of sacred virtue: then it seems to find me, as it were, in a strange region of the universe that is not completely closed by the mud of the earth or completely balanced in the pureness of heaven and it seems to me that by the Grace of God I may be transported from this lower world to the higher one in an anagogical way.

Panofsky comments: "Here Suger gives us a vivid picture of that trance-like state which can be induced by gazing upon such shining objects as crystal balls or precious stone".[47] But also "the silence perpetually removed from every worldly tumult" of the Cistercian cells could induce such a trance-like state. We are dealing with two diverse but convergent psychological paths, for which the mystical climax is achieved on the one side by a more rigorous concentration (the Cistercians allowed a wooden cross as the only liturgical image) and on the other by such a crowding of sensations as to bring about in the beholder a sense of alienation. There are two ways to understand the life of the individual in society. The first is negative, aiming at isolation and introspection. The second is positive, based on the most complete participation and accessibility. Preaching, pilgrimages, the cult of reliquaries, authority, and royal prestige — all these aspects inevitably allowed the papacy to take the side of Abbot Suger. The popes well understood the social possibilities of the Orders, even when they were recalcitrant. Cimabue became an essential pawn in Rome's acceptance of the richness of Gothic imagery. The conversion of the papacy to Gothic imagery (according to Strzygowski, also the key to an understanding of Cimabue) must have already come about during the pontificate of Clement IV (1265-68), who was the protector of Roger Bacon, and who gave investiture to Charles of Anjou, nominating him a Roman Senator. His time was divided between his residences at Viterbo and Perugia. He is perhaps portrayed at the left of the throne in the Assisi apse. But for the history of art interest lies in the fact that, besides sharing the ideas of the French Court, Clement IV, who came from St. Gilles, had in his heart and before his eyes one of the major examples of Classicism. Clement IV continued his concern for the abbey even from a distance and had work restarted on its upper church. Here too is a double church, even though the lower one is cryptlike. In his

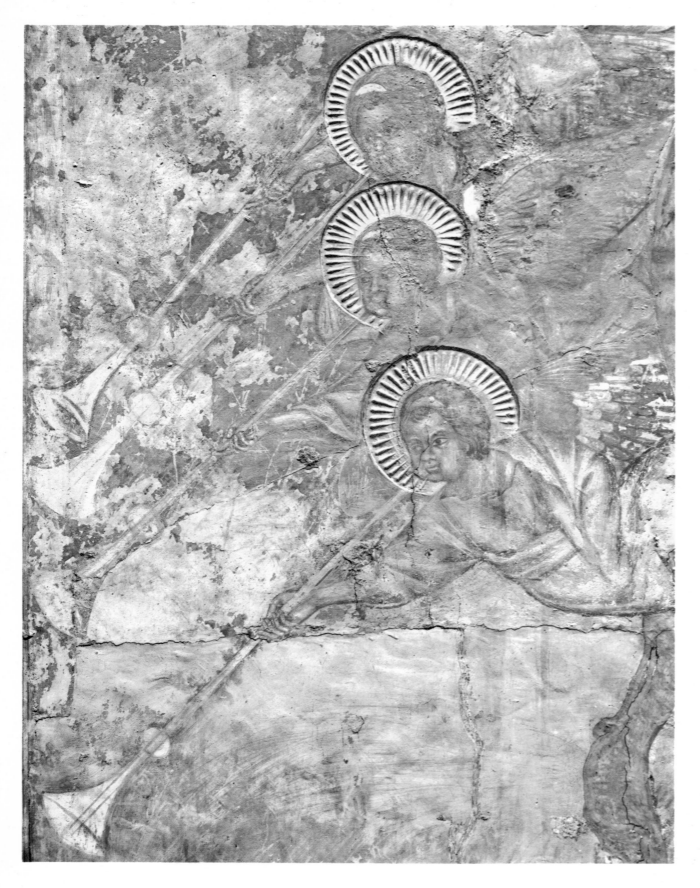

17 - CHRIST THE JUDGE (*detail, angels with trumpets*) - *Upper Church of San Francesco* - ASSISI

travels between his residences at Viterbo and Perugia, his pauses at Assisi where the Upper Church was nearing completion could have given the builders the best opportunity to hear his advice on how to transform the squalid interior into a sumptuous jewel box with galleries, triforia, and elegant vaulting.[49] In any case in 1266, presumably with papal assistance, money was found for the altars, behind one of which Cimabue was to paint his magnificent Crucifixion. It was not easy to convince the Franciscans of Assisi to abandon the severe strictness preached by St. Francis which St. Bonaventure continued to support. After his death in 1274 there was perhaps more indulgence towards art. But it was short-lived. In 1279 the general chapter held at Assisi affirmed again: "Since it is demonstrated that the taste for the exotic and the superfluous runs counter to poverty, we order that capricious decorations of sacred edifices, be it painting, basrelief, sculpture, windows, capitals, or other like elements, be strictly avoided". The allusion to bizarre decorations probably refers to the foliate pattern used in the apse vault, whose brilliant effect signaled the beginning of the pictorial decoration of the Upper Church. The resolution meant then the interruption of work already started or projected.[50]

The Patron of Cimabue

At this point a truly great patron intervened: Pope Nicholas III,[51] worthy of comparison to Abbot Suger whose ideas he approached as we see in a letter dated February, 1279 to the canons of St. Peter's, concerning the religious observances to be held in the Basilica, in which he deals with the obsolete, but compellingly expressed idea from the song of Solomon: "The Church Militant must appear like the new and holy Jerusalem descended from the sky, embellished by God like an adorned bride going toward her spouse". Assisi also had to transform itself into a heavenly apotheosis. Using as a lever the long standing familiarity that from childhood he had with his Franciscan confessors and the discussion he had had with members of the Order in regard to the Rule, Nicholas III, in a diplomatic but firm letter, declared the proscription of 1279 invalid. It is not true, he wrote, that the Franciscans must abstain from books, missals and breviaries. On the contrary, since their task was preaching, they would have to devote themselves to knowledge; and as "scientia requirit studium" and "exercitium veri studi communiter haberi non potest sine usu librorum", they must found a library. And to implement their charitable work it was good that they should receive offerings and recompense for their labor and that they should possess convents with suitable conveniences. In conclusion he wrote: "claret ex regula ad victum, vestitum, divinum cultum

et sapientiale studium necessariarum rerum usum fratribus esse concessum". Because of the direct dependence of the painters and architects of the Basilica of St. Francis on the Holy See, the administrator of the Order's wealth, this reference to liturgical necessities, to books and to missals, served also as an impregnable defense in the justification of the pictorial decoration as the "Bible of the poor", mirror of edification, pilgrimage attraction, etc. That Cimabue's presence in Assisi, and the financial basis of the undertaking were due to Nicholas III, is attested by the irrefutable documentary evidence of the crossing (directly above where the high altar used to be) with the four Evangelists, who sanction the universal mission of the Order. The four great Evangelists bear inscriptions and significant topographical emblems referring to Italy, Greece, Palestine and Asia [Pls. 8-11]. This implies the proposal of not only the renovation of religious life in Italy and, by extension, of Europe, but also a direct intervention to heal the Eastern schism, to reconquer Palestine, and to bring Christianity to Asia. This is the program of 1278, when Franciscan representatives were dispatched to those parts of the world. The names of the missionaries are known: Gerardo da Prato, Antonio da Parma, Giovanni di Sant'Agata, Andrea da Firenze and Matteo di Arezzo.[52] Their mission was notably successful, and on their return in 1289 may have resulted in the introduction of slight exotic elements in painting, if one would call the almond shaped eyes of Duccio and the Sienese artists an orientalizing motif.

The angles of the crossing vault of the Upper Church, moreover, commemorate another very important political event of the same year, 1278. That is the new political constitution which liberated Rome from the foreign subjugation of Charles of Anjou and renewed the splendor of the Senate by giving it a wide authority. At the same time Charles of Anjou renounced the imperial vicariate of Tuscany and withdrew his troops from Romagna and Bologna. In Rome political and religious power were again joined: "The magnificent exploits of the *alma* city sound again, and events demonstrate that the same Rome excels over all for the immensity of her titles, and is called *caput orbis*. Here the Omnipotent God Himself willed that His church be founded and that it be designated by the name Roman; and here the Prince of the Apostles established the seat of the Vicar of Christ".[53] These principles run all through the Renaissance and explain the origin of Classicism. No one before Cimabue, Strzygowski observed, drew the ancient monuments with greater exactness, documentary rigor and veracity, although in a necessarily artificial context. No longer do such works speak only to fantasy, but to reason. For Cimabue the rebirth of Imperial Rome was a reality not a utopia or a myth[Pl. 9]. Rome, in the angle fresco dedicated to Italy, is dominated, as C. Brandi has recognized,[54] by the Capitol, the monument that more than any other, attests

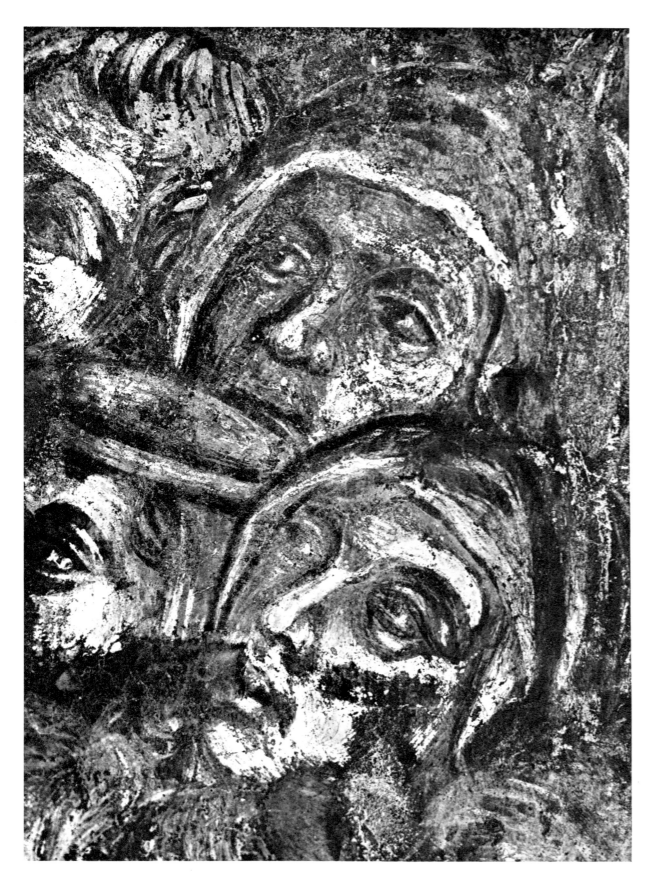

18 - CHRIST THE JUDGE (*detail, two women*) - *Upper Church of San Francesco* - ASSISI

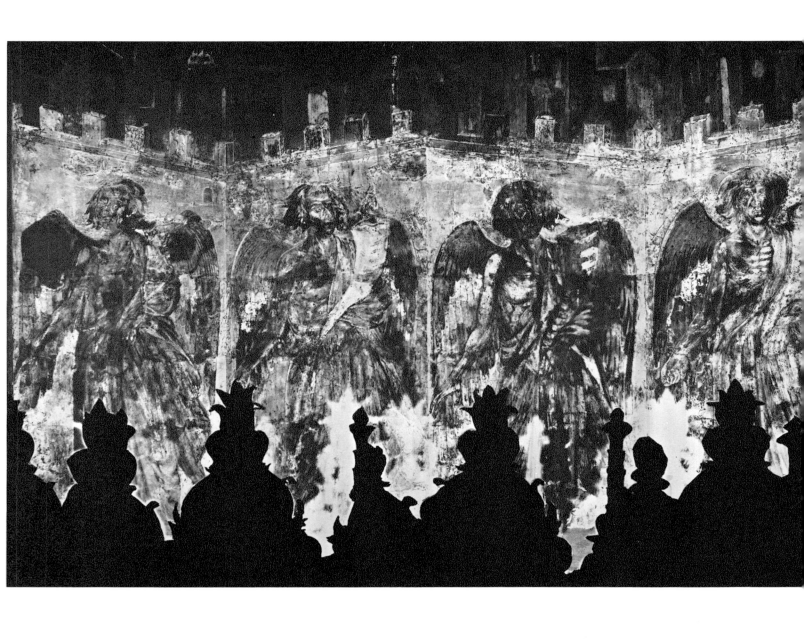

19 - THE ANGELS OF THE FOUR WINDS *(detail) - Upper Church of San Francesco* - ASSISI

to the city's political dignity and which had appeared in the foreground of earlier plans of the city. But this famous depiction of the Eternal City is also a homage to the Orsini, the family of the Pope. The crest of that house, still partly visible, under the roofs, appears on the battlements of the Capitol signifying the heights of power the Orsini had achieved in 1279-80 when Matteo Rosso II (Orsini) and Gentile Orsini followed one another as senators, and at the same time, to make a pair as was the law, the Pope himself succeeded to the senatorial seat of Charles of Anjou.[55] The homage to the Orsini is explained further by the fact that in 1279 Matteo Rosso II was named Cardinal Protector of the Franciscan Order. He remained in this post until his death in 1305 and was thus able to follow the development of one of the major artistic flowerings in the West — from Cimabue to Giotto. As was necessary, given the customs of the period, political reasons determined the choice of the buildings to be represented in the angles devoted to Rome and Italy: the Capitol, the governing center of the city, which the same Matteo Rosso may have had restored and, if so, would have had affixed his family coat of arms during the very period in which Cimabue painted his representation;[56] St. Peter's, the seat of the papacy, which Nicholas III restored and where he erected a splendid chapel and the papal palaces;[57] Castel Sant'Angelo, which he also restored and assigned to his family in 1277;[58] the Torre delle Milizie, which belonged to an allied family, the Annibaldi. The basilica at the top might be St. John of the Lateran, which with the Sancta Sanctorum, was also renovated by Nicholas III.[59] The inclusion of the Pantheon and the Meta Romuli was meant probably as a symbol of the monumental and archaeological tradition of the city, although more complete documentary evidence might show that they too were part of the moral and material patrimony of the Orsini.

The references cited above, that is, the double presence in the Capitol of the two senators of the Orsini family, suffice to date with certainty the Assisi vault painting around the summer of 1279. This date gives us the first firm point in Cimabue's artistic chronology. One could speculate on an earlier date for the beginning of the work, it is true, but it is characteristic of the artistic patronage of Nicholas III in contrast to his predecessor, Gregory X who was indifferent to architectural and decorative undertakings. Nicholas III was a powerful promoter of Italian Gothic. He was the founder of the Dominican churches of Santa Maria sopra Minerva in Rome and Santa Maria Novella in Florence with their elegant, fully developed, ogival style. He enlarged the Vatican Palace, transforming it into a sacred citadel — the gardens which he arranged presumably had a paradisiacal symbolism — and in St. Peter's, besides instituting splendid liturgical ceremonies which were to serve as models for others, he founded a chapel dedicated to St. Nicholas and decorated it with precious

silver ornaments: a cross, two candelabra, a censer, a chalice, etc. He embellished the Sancta Sanctorum in a style very similar to that finally used in the Upper Church of Assisi. As a kind of defense of his patronage he declared that it was "not for the ends of glory but as an example"[60], a statement placing him between the cultivated, predominantly hedonistic type of patronage of an Abbot Suger, and the political-religious patronage of the future Nicholas V, the successor to the pontifical throne most akin to him. In painting, besides the decorations of the Sancta Sanctorum, now, unfortunately, almost illegible, Cimabue's patron is linked to the grandiose fresco cycle of St. Paul's Outside the Walls by Cavallini, which no longer survives. This is a creditable record for a reign of about three years. There are perhaps other examples still unknown, since as yet no specific study has been devoted to this great personage.

The Towns on the Ceilings

With at least a clearer understanding of the cultural context in which Cimabue now found himself, we are better prepared to go up the scaffold for a close-up examination of the frescoes of the presbytery of the Upper Church. We left the Master with a concreteness of style and rigor of methodology, but in an environment where the opportunity for the expression of his ideas was limited both iconographically and stylistically. Now we find him with hundreds of square meters to paint, certainly with the pressure of a time limit, and in all probability, with the help and counsel of a theologian with a scholastic education and taste, but with a freer and more flexible spirit. More than the immensity of the blank walls, still probably damp from recent construction, it was the vastness of the themes and the necessity of differentiating them stylistically that must have been Cimabue's greater concern. It was a personal impellent, as he seems to have been the first painter to set forth the problem of diverse artistic levels which were adapted, as the grammarians and commentators of Cicero's *Orator* taught, to diverse themes. The number of experiences in which he had by now been involved must certainly have hastened him along: the proportional and compositive rationalism advocated by the Dominicans; the revival, still uncertain as to doctrine but intensely felt, of the Antique, and by this we mean every form from Hellenism to Carolingian; the new psychological and moral dimension imposed by the Apocalyptic climate surrounding devotion with a passionate agitation; and the Gothic and Franciscan desire for a love-filled, almost erotic approach to divinity. The Assisi cycle is, in a measure, a compendium

34

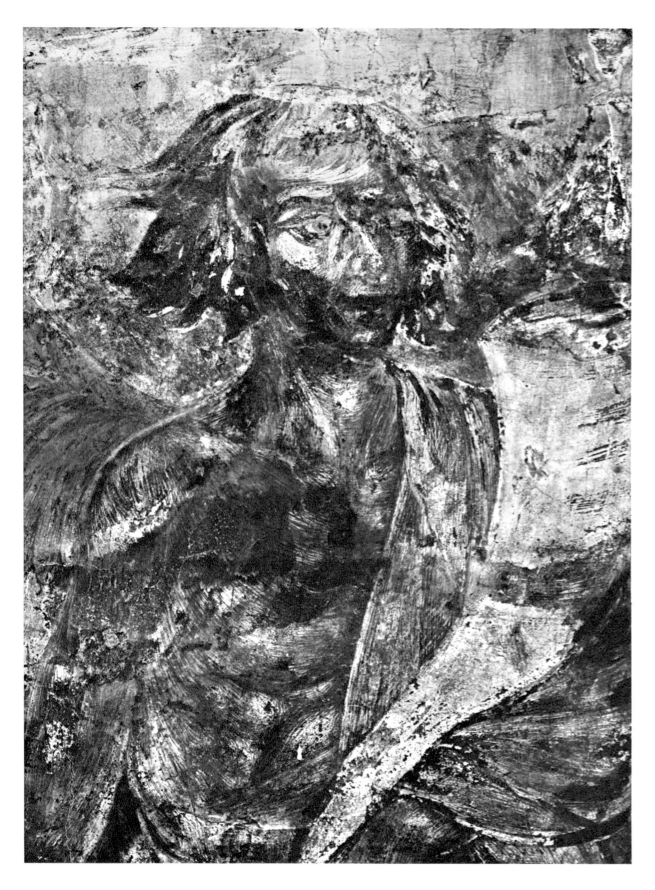

20 - THE ANGELS OF THE FOUR WINDS (*detail, an angel*) - *Upper Church of San Francesco* - ASSISI

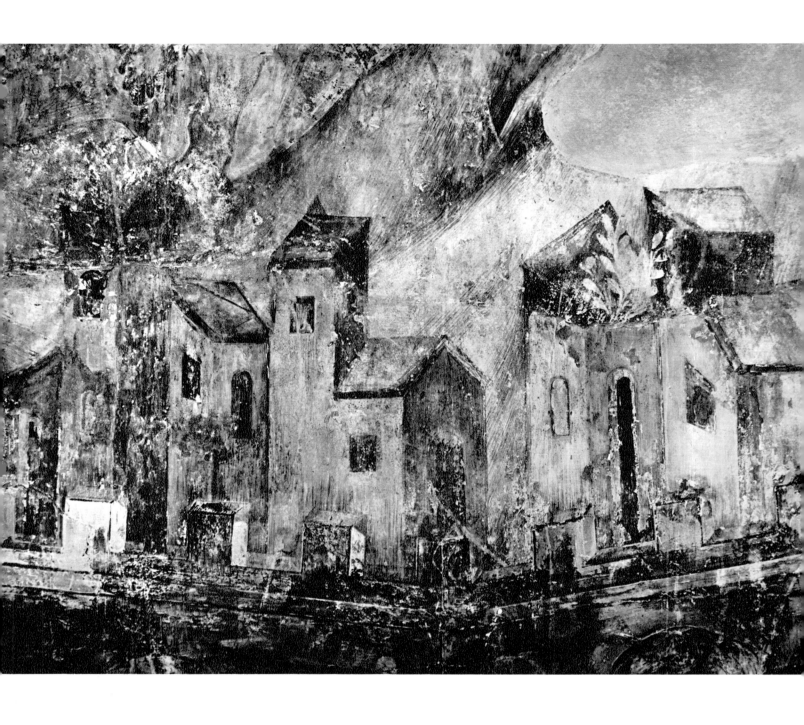

21 - THE ANGELS OF THE FOUR WINDS (*detail, the walled city*) - *Upper Church of San Francesco* - ASSISI

of all these alternatives. Its complexity still awes all those who have to interpret it. Cimabue had to devise styles, iconographies, characterizations and emotions frenetically, almost in a visionary paroxysm.

It is difficult to add anything further to what Strzygowski wrote in 1887 on the ceiling painting. After a meticulous description of the architectural types and elements that appear in the frescoes, and which had in part already been correctly identified, he compared them to earlier cartographical representation of Rome, all of a symbolical character — in one of 1119 the Tiber passes under the Capitol as if it were a bridge — or with only schematic indications of monuments leaning over fictitious streets (before 1205). "If we can define these in a few words as 'geometric, false, legendary', then the scenes of Cimabue are properly judged as 'in perspective, faithful and clear'. A more radical contrast cannot be imagined".[62] Moreover, in the Assisi frescoes some buildings are reproduced with such strong realism and with such minute fidelity, that they must necessarily have been based on a study of the original and constitute real documents [Pl. 9]. Castel Sant'Angelo still preserves its noble facing adorned with garlands. Well characterized is the cruder basement of rustic masonry of the crowning medieval tower. All the distinctive elements of the Pantheon are analyzed. On its architrave we see in capital letters the first epigraph of modern painting. The fact that the basilicas are only generic types is almost certainly due to the desire to make them synthetical and ideal types. Descriptive realism is accompanied by a general accentuation of spatial concreteness. It is in this sense that the passage from cartographical schematism to the panoramic bird's eye view indicates a general shift in the "vision of the world". Strzygowski considers Cimabue to be the creator of modern cartography and believed that he acted in this capacity in Rome for Charles of Anjou, an idea which given the revolutionary results of Assisi is not absurd. However, it would be an exaggeration to think that Rome was depicted in the angle as seen from Monte Mario with the Porta del Popolo below. It is quite true that the buildings although arranged according to a hierarchy of political importance present reciprocal characteristics of altimetric disposition, being placed one beside the other in accordance with a hierarchy of dimension. They fill, or rather crowd, a stable solid space. No longer the divine Jerusalem from heaven! The city seems truly the work of an individual made at an historic moment with extreme consciousness and objectivity. Subsequent examples of cartography up to the Late Quattrocento retain this form, but demonstrate the difficulty of maintaining Cimabue's great volumetric objectivity, as the sense of space cannot be transmitted by imitation, especially when, as in the case of Cimabue, it was intuitive and thus not supported by suitable technical means, e.g., by a systematic perspective. It also shows

35

the impossibility, after Cimabue, of returning to a totally schematic cartographic conception of the city of Rome. The great Master saw the other world capitals, as well, in three dimensions. They too are surrounded by strongly geometrized walls. The front elevation, densely built up, is constructed in a succession of planes in order to give an idea of a hilly topography. These scenes naturally lack the realism which characterizes the familiar Roman buildings with their plastic and decorative detail. This inevitably generic quality is compensated by a clearer stereometry of the masses and volumes. There is also an evident attempt to endow each region with a typical motif. In the Greek city, the central plan basilica with its high cupola and encircling colonnade surmounted by triangular tympana, is almost as convincing as a travel recollection, even though we know that it is made up of plausible rather than historically correct elements. For Palestine [Pl. 10], Cimabue evidently wished to invoke an impression of the famous sanctuaries of Jerusalem and an Arab city, but with a very vague knowledge. He was constrained to make use of conventions, introducing a great loggia, as was often done in mosaic representations of Palestine, and a U-shaped building with balconies, also in common use, which we see almost identically reproduced some decades later in a mosaic of a Palestinian subject of Kariye Cami in Istanbul.[63] Asia [Pl. 11] was rather more difficult to characterize. The pierced lunette superimposed on the arched entrance to the city is not Cimabue's invention, as this device had already been used in the portico of St. Peter's. Cimabue was unable to find help even in schematic conventions, as he was dealing with such a remote region. But as a philologist he knew that books could supply the answer. The tetrastyle building, next to the tower that dominates the city, is certainly based on a reading of Vitruvius. In chapter II of the third volume, following the section on proportions (which the artist had already found useful in Arezzo for deriving the proportional canon of the human body and which Ristoro had also used), we find a technical examination of various systems of constructing a temple facade: columns too thick and close together impede the ceremonial ascent of a procession entering the cella two abreast. An intercolumniation spaced too far apart risks breaking the architrave. The ideal type is the eustyle, which harmonizes the two extremes elegantly and beautifully and is superior both from the aesthetic and from a structural viewpoint. However, Vitruvius comments, "we have no example in Rome, but in Teos in Asia, there is one dedicated to Bacchus". This is why we find a Greek temple painted at the apex of an Asiatic city. Cimabue, the first figurative artist whose knowledge of Vitruvius can be demonstrated, reduced the columns to four for greater compositional simplicity, but the proportions remain as Vitruvius outlined them. The diameter of the columns is the module with the intercolumniation, except the center one which is three modules, being two and a half

times the diameter of the column, the height of which seems to be the eight and a half times the module in the manner prescribed. The cella is also drawn according to the antique canon.

The Evangelists

An attention to reality worthy of an archaeologist, a capacity for philological research and for literary integration, an intense interest in volumes in which the masses dominate the voids completely, so that the forms seem to be filled from within, and finally, an exceptional interest in architecture, are the characteristics of these ideal views of the capitals of the world. The commitment they demanded is shown — almost as in a psychological test — by the fact that they take up more space than would have been necessary to balance the figures of the Evangelists and to fill the area left vacant in the angles. Perhaps the colors, at least as we are able to evaluate them from what remains, apart from the inversion of lights and darks and the blues changed to green, as well as the almost complete loss of the gold background, did not provide in their musical modulation the necessary plastic congruence. It was Giotto who discovered in his Assisi fresco cycle that a harsh color scheme, dry and with pure contrasts, crystallizes and isolates, as in tarsia, houses, churches and cities. However, Giotto could not match the learning of Cimabue which was used even in the scene of Rome, where his task would seem to have been to invoke rather than to describe, to compose an apotheosis rather than a chronicle. After a study of these scenes of the four cities one is not surprised at the enormous heavy solidity of the Evangelists, with their large feet resting on the platforms of their chairs and their laborious meditation on their books (Vitruvius was also difficult to understand!). Their strained attention to reading and writing seems to receive rather exiguous aid from the heavenly inspiration transmitted by the very elegant Sienese-like angels. These angels are the work of a quite active assistant [Pl. 8]. The desks of the Evangelists are arranged with the necessary tools: inkwell, scissors, and stylus, depicted with such a great, almost Flemish, sense of detail that they seem like work benches. There are certainly many precedents for this in the Byzantine art of the tenth and eleventh centuries or in Ottonian and Carolingian art. Cimabue does not break with the forms, but monumentalizes and transforms them. The book, used as an attribute, now becomes a central motif. In spite of all the precedents, the Evangelists, by their interior gravity, end by allying themselves with the ancient philosophers, rising above the uncertainty and mysticism of the Medieval.

Cimabue's rationalism is equally disenchanted in confrontation with the bewilderment of the myths. A rationalizing attitude emerges through the planned iconographic organization of the whole cycle. The purpose of the great bands of putti framed in foliated forms was, as in the Baptistery in Florence, decorative enrichment towering over altars and choir. Here again Vitruvius was able to stimulate his fantasy in his descriptions of decorations in painting or stucco of those half-figures which emerge from stele volutes with human heads, which artists of the Late Quattrocento were to call grotesques [Fig. 9].[64] Yet as Wolfgang Schöne has demonstrated in a long analysis,[65] they also have the function of clearly distinguishing the weight-carrying architectural elements from other areas and leaving to these latter areas a pictorial function, the importance of which was increased by the framing provided by the fasciae. In a certain sense Cimabue's architectonic predilection again prevails. The tectonic structure, according to Schöne, not only bears the painting, but creates the syntax and makes for the efficacy of the representation.[66] The fusion of painting and architecture [Fig. 10], is happily attained although this decorative system looks more archaic and nearer to the Romanesque tradition than to the advanced Gothic of the vaults and the windows. It repudiates the oblique line of the ogival arches to demonstrate — more than sufficiently — its fidelity to the circle and to horizontal and vertical lines. This same Romanesque flavor is evident in the geometric systemization used in the organization of the themes. The decorations seem to underline, not the external rhythm of the architecture, but its heavy innermost structure, just what was most loved by Romanesque taste.

The series of almost identical angels in the soffits of the larger arches, above the broad ledge that runs around the whole church, have a powerful constant rhythm, serving almost as motionless caryatids of heaven. The ribs of the vaulting have smaller scale motifs which are strongly developed, but always on the surface. The architectonic sensibility reaches its culmination in the refinement of the left side of the apse, where we find three orders of superimposed galleries of which only the central one is real. From a wide trefoil arch we pass to the elegant group of three triforia, then to a third arched gallery, lower in height, from which the angels appear. The overall effect, with the choir of angels and the once vivid color, is conceived in a clearly illusionistic manner. The need for a downward sloping perspective is satisfied by the progressive reduction of the horizontal framing which was always efficacious for Cimabue, causing him to press the images and scenes toward the bottom [Fig. 10]. For the explanation of this systemization, which reduces to a static and stable order every

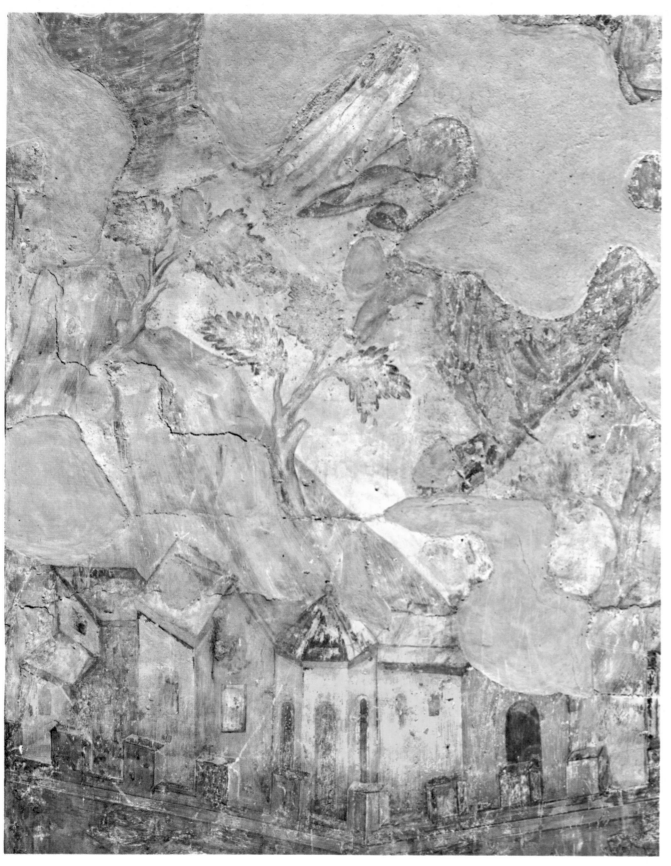

22 - THE ANGELS OF THE FOUR WINDS (*detail, the walled city and the messenger angel*)
Upper Church of San Francesco - ASSISI

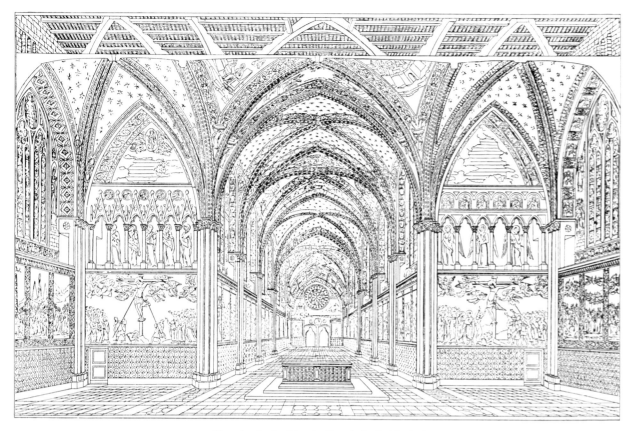

Drawing by L. Martinelli and G. B. Mariani

caprice of originality, one must turn inevitably to Scholasticism, whose influence, according to Panofsky,[67] permeated Gothic architecture which is based on a rigorous analytic distinction, and on the syntactic recomposition of the individual forms. St. Bonaventure seems to be particularly near Cimabue in his curious oscillation between a total instinctive adhesion to naturalism (defined almost passionately as "concupiscentia curiositatis") and a violent, ruthless, rational control. Because of the liturgical function of the frescoes St. Bonaventure's writings, which were strictly devotional in character, must have been one of the iconographic and stylistic sources of inspiration.

The three altars dedicated to the Madonna, St. Michael and St. Peter are expressions of the devotional practices of St. Francis. Although each theme defines an attitude of intense and differentiated devotion, the distribution of the subjects is mechanical and obligatory. Cimabue tried to give some plausibility to the different scenes, placing, for example, the episode of St. Michael casting the demons into hell above, and the earthly scenes below.[68] In fact, the symmetry remains the most striking feature of the system, marked by the repetition of the two great Crucifixions at the ends of the transept arms, and the carrying

out of the themes of the Apocalypse, the life of the Virgin, and of the Apostles in closed cycles which begin along the sides of the apse walls, forcing us, in one instance, to read from left to right, contrary to the normal practice. The most unsuccessful element of the Cimabuesque decorations at Assisi is the insistent repetition, inspired presumably by the symbolism of St. Bonaventure, of identical gestures and attributes of the angels in the soffits and the galleries [Figs. 13, 14]. This repetition is perhaps a reflection of the principle of "aequalitas numerosa" which held, using music as a point of departure, that equal moments are "mathematically, metaphysically and aesthetically" superior to those that are differentiated. It demonstrates the conviction that all things aspire to unity inasmuch as all reach toward divinity, striving to be as equal to themselves as possible and rigorously maintaining their own place and order in the universal order. The universe, in other words, is made up of repeated series — homogeneous and beautiful — in juxtaposed rows [Fig. 11]. Since the angels reflect divine wisdom in exact and equal measure in accordance with their particular hierarchical rank, the differentiation of their beauty would have to be minimal, based as it was on the precise symmetry of their parts.

Cimabue, who at Arezzo had already demonstrated his enthusiasm for the principles of proportion and repetition, reacted to Franciscan influences with a still more pronounced investigation of order, reason, and clarity. He makes the narrative coincide with symmetry within the cycles as well. For example, in the scenes from the Apocalypse, we find city scenes alternating with celestial visions and in the Marian cycle we find two coronations contraposed. But Cimabue's temperament was certainly not that of a mystic, and his disposition of the celestial and the terrestrial elements contain too little religious allusiveness. They interest us for the emergence of unexpected and extraordinary impulsiveness or when, as, for example, in the three famous angels in the arcade to the left of the apse — although the work of an assistant — [Pl. 7] he succeeds in imbueing physical dignity with a monumental heroic value through the use of the "aequalitas numerosa", in keeping with St. Bonaventure's concepts, but with the impact of a cosmic symbol, giving them a lofty dominance which lifts them far above us both physically and spiritually.

The Apocalypse

Still more pronounced is his tendency to translate the divine into the rational, even though it entails a lowering of the emotional level in the Apocalyptic scenes which begin to the left of the apse and continue up to the Crucifixion. Yet the Apocalyptic Visions of St. John must

have had a very real and terrifying meaning in the decades before and after 1260, the predestined year according to the prophecies of Joachim of Floris for the end of the world. They must have been especially meaningful for the Franciscans who held that the universal diffusion of the doctrine of Jesus through the work of the preachers would signal both the decisive triumph of Christianity and the end of historical vicissitudes. The hagiographical legend of St. Francis was interpreted apocalyptically.[69] On the other hand, the cycle which Cimabue painted has all the characteristics of the official interpretation. In coeval manuscripts of Apocalyptic scenes of the same period[70] we find, for example, the first two episodes placed side by side as in the Assisi fresco: the Vision of St. John on the Island of Patmos which is represented either with a surrounding sea filled with monsters and fish or by rivers of clear water; and the Fall of Babylon, whose ruins are traversed by demons and ostriches [Pls. 12-13]. This last animal "which had feathers, but could not fly because of its great size", became, according to the words of St. Anthony of Padua, the symbol of hypocrites "who aggravated by love and by the weight of earthly things, mask themselves in the feathers of a false religiosity".[71] The words of the Saint seem to be an explicit attack against the willing-

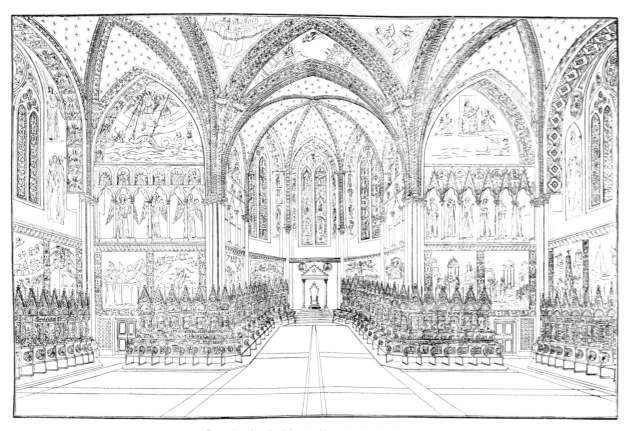

Drawing by L. Martinelli and G. B. Mariani

41

ness of the Franciscans to accept pomp and power in the name of an emotive individualism, without fear of the inevitable hypocrisy which binds all relations with society and with law. In the scene representing the Infant Christ on the Throne, an unusual iconographic treatment, but one which accords with the pathos of the Franciscan exegesis,[72] Cimabue was inspired almost textually by a dramatic Ottonian illumination, accentuating even more the verticalism of the composition. The Apocalyptic theme and the pictorial means at Cimabue's command could have given this cycle a visionary grandeur as powerful as that of the nearby Crucifixion, and as equally filled with "a tempest of dramatic life". But instead he developed the subject with the most unexpected sobriety, with a cold and rigorous monumentality. He used enframements and architectonic backgrounds almost, it would seem, to contain the vehemence of the figures, and their burning passions, figures such as the terrible Angels of the Four Winds with their flying hair, whose sudden spurt is arrested as if in a tremendous hour of expectancy [Pl. 20].

One should add that in the Cimabue narrative earthly scenes prevail substantially over heavenly and esoteric ones. Unfortunately, for a considered judgment we lack a knowledge of the upper parts; however we have photographic records of the lunette representing St. Michael, accompanied by two angels, fighting the demons. In this painting the expressive details (which remind us of the frescoes of Civate, a masterpiece of dramatic Romanesque) are contained within an extremely symmetrical and static scheme. Moreover, even in the beginning, the scenes in the lower register had the rôle of protagonist. Between the divine wrath, expressed by the cosmic battle in heaven, and the earthly passions the three mournful angels act as mediators immersed in a philosophic inwardness. Below, all the scenes of catastrophe, such as the Fall of Babylon and the Four Angels of the Apocalypse [Pl. 19], are literally enclosed by an insuperable wall of symmetry and rules which serves to clearly distinguish chaos from order, and to frustrate anyone looking toward the melancholy of the ruins of Babylon or toward the variousness of Nature.

The antisymbolism, that is the power of reducing the terror of the ultimate catastrophe (considered imminent by the mystics but evidently not by Cimabue) to knowledge, to synthesis, to dialogue even though the climate is full of tension, is explicit in other motifs that photography has finally brought to light. Thus in the predominant benevolence of the face of Christ the Judge [Pl. 16], the eyes, given the asymmetry of the pupils, are sharp and piercing, although certainly without anger. This painting seems strangely related to the later Last Judgment by Cavallini in Santa Cecilia, which also seems more like a sitting of the Curial

23 - THE ANGELS OF THE FOUR WINDS (*detail, a tree*) - *Upper Church of San Francesco* - ASSISI

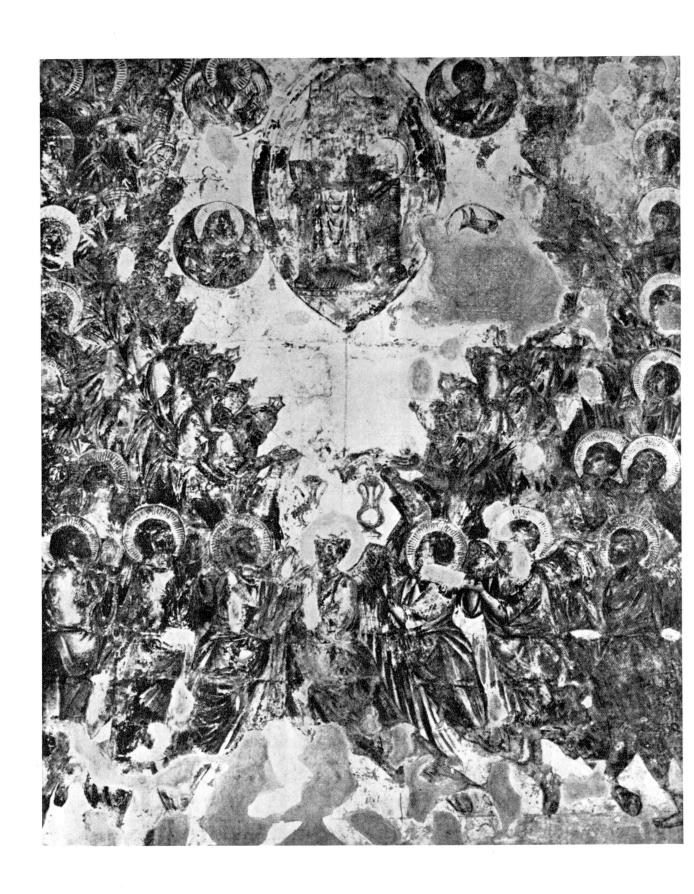

24 - THE ADORATION OF THE THRONE - *Upper Church of San Francesco* - ASSISI

Court than an eschatological climax. The judged ones follow the events with moving atten-tion, but seem to have already, in various ways, experienced catharsis. Their weeping is perhaps for our misfortunes, for those who are still waiting judgment [Pls. 14, 18].

The Life of the Virgin

Cimabue demonstrates in this reduction of excitement and agitation (which is resoundingly contradicted in the adjacent Crucifixion whose ends, however, are devotional and not expos-itory) not only an internal consistency, but also a coherence to the rationalism that is tradi-tionally attributed to the Florentines, as well as an extraordinary innovatory power. The emotional excitement is rechannelled into reasonable dimensions, upholding the conviction that the term "virtus" coincides with the "mediocritas". His stoic restraint urges him to substitute whenever possible, prosaic concreteness, even at the cost of destroying a millennary

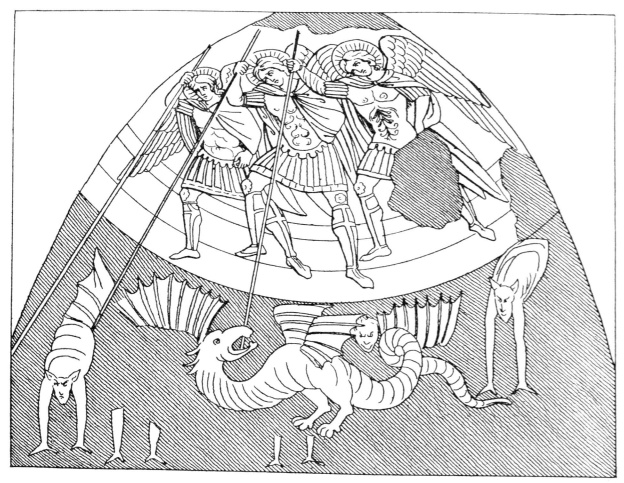

Drawing by W. Y. Ottley

symbolic tradition. To explain this attitude it is sufficient to open one of St. Bonaventure's most famous texts, *Itinerarium mentis in Deum*,[73] where in the first chapter, while conceding that spiritual elevation cannot be accomplished without the aid of superior virtue or the mediation of prayer, he affirms that the universe functions as a ladder for reaching God, and that it is more appropriate to initiate the ascent by the "vestige that is corporal, temporal and outside of us". The example, there inserted, of the six rungs by which one ascends to Solomon's throne, introduces us as well to the second fresco cycle in the apse: scenes from the Life of the Virgin which conclude with the monumental Christ and the Virgin Enthroned where, in a relevant manner, other ideas of St. Bonaventure are translated into visual terms [Pl. 40]. In St. Bonaventure's text the sentient experience, the first rung of the mystical ladder, is described in clearly corporal terms: "In the first mode", he asserts, "the contemplative who ponders on things in themselves, is aware of the weight, the number, the measure... and perceives in them mode, species, order as well as substance, virtue and function. From this, as from a vestige, can arise an understanding of the power, wisdom and immense bounty of the Creator". Also the correspondence of subtler successive qualities, such as those that are purely spiritual, is made by the analysis of physical properties which serve as a dialectical contrast. Returning to Cimabue, it is evident that he limits the operative possibilities and ends of his art to the first rung of physicality (where, at times, the subsequent modes are reflected) rather than dissolving naturalism in the hope of rendering it allusive and symbolic.

The insistence on the first sentient mode of the process, the mode which, for St. Bonaventure, was not only the initial phase, but the constant point of departure, corresponds to the painter's desire, in the scenes dedicated to the Dormition and Assumption of the Virgin, to construct a material bridge — tangible and manifest — between the human and the divine by setting the scenes in an architectonic and structural framework which would render them concrete and measurable. Thus the contiguous scenes of the Last Hours of the Virgin and the Dormition [Pl. 40] are enclosed by a Cosmatesque trilobate arch. The photographs taken before the choir stalls were put back in place make it clear that the bed was placed on a great platform seen from an oblique angle, anticipating an expedient dear to the hearts of the grandiloquent Renaissance artists. The Assumption also has its earthly counterpart in the huge sarcophagus seen in perspective (although the lines of the vanishing area converge toward the spectator), constituting a valid model up to Raphael and others. The steps of the throne come down almost to the eye level of the spectator while their size progressively increases as they come toward the bottom. Divinity seems to descend upon us almost as if its very exis-

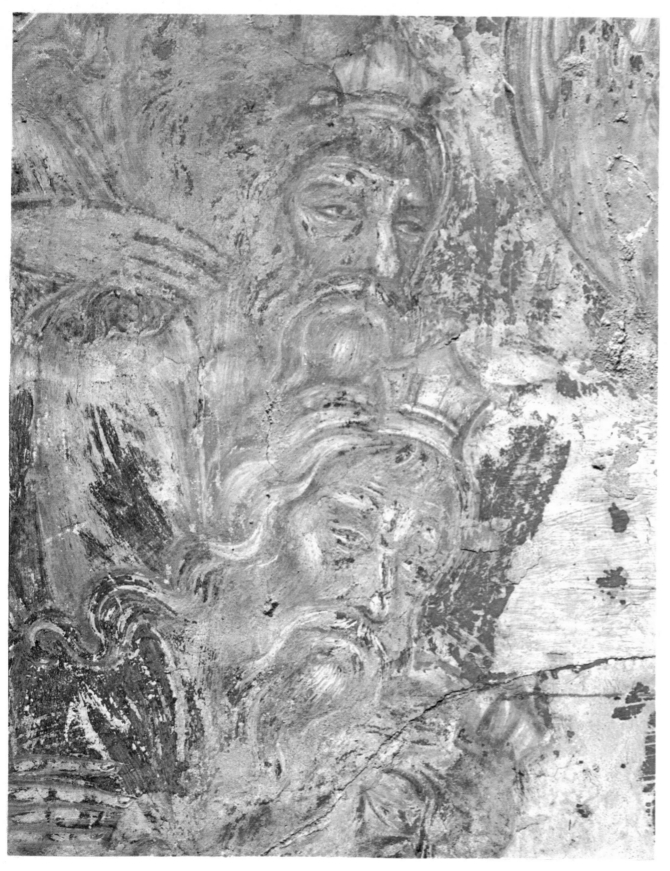

25 - THE ADORATION OF THE THRONE (*detail, the elders*) - *Upper Church of San Francesco* - ASSISI

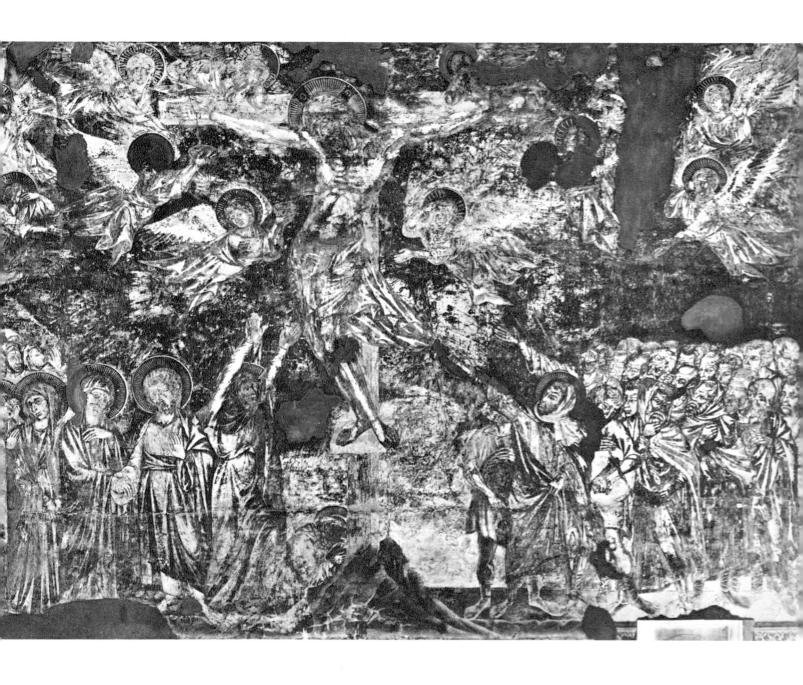

26 - THE GREAT CRUCIFIXION - *Upper Church of San Francesco* - ASSISI

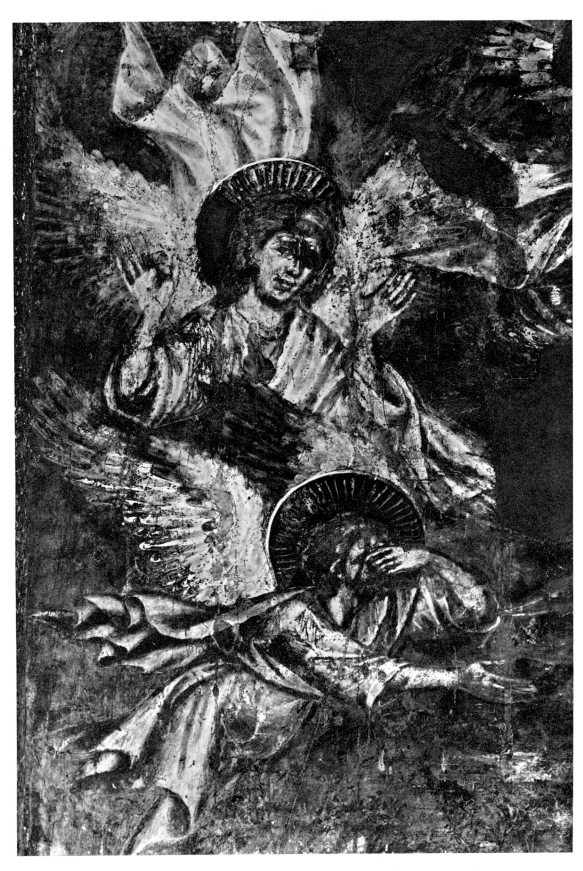

27 - THE GREAT CRUCIFIXION (*detail, the angels around the cross*)
Upper Church of San Francesco - ASSISI

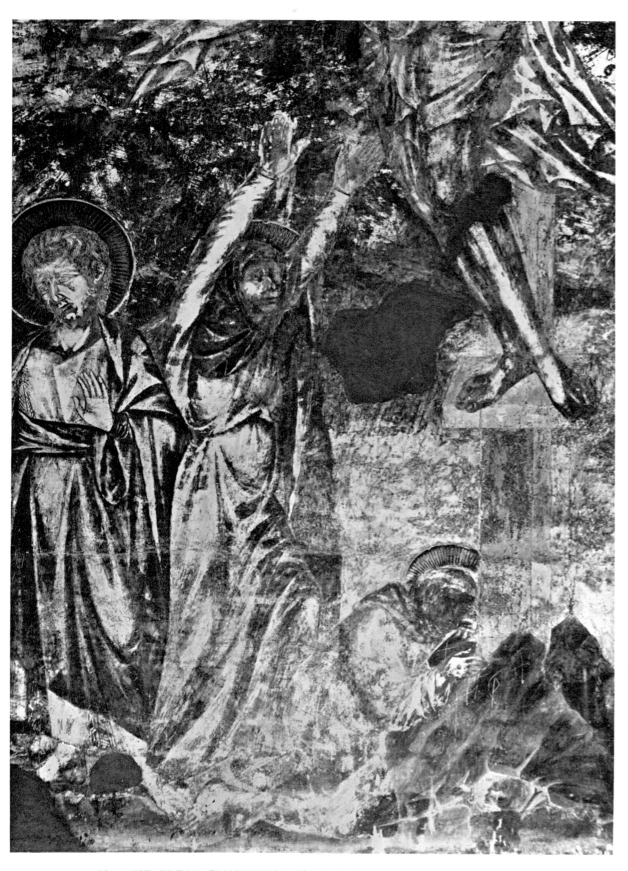

28 - THE GREAT CRUCIFIXION (*detail, the lamentation at the foot of the cross*)
Upper Church of San Francesco - ASSISI

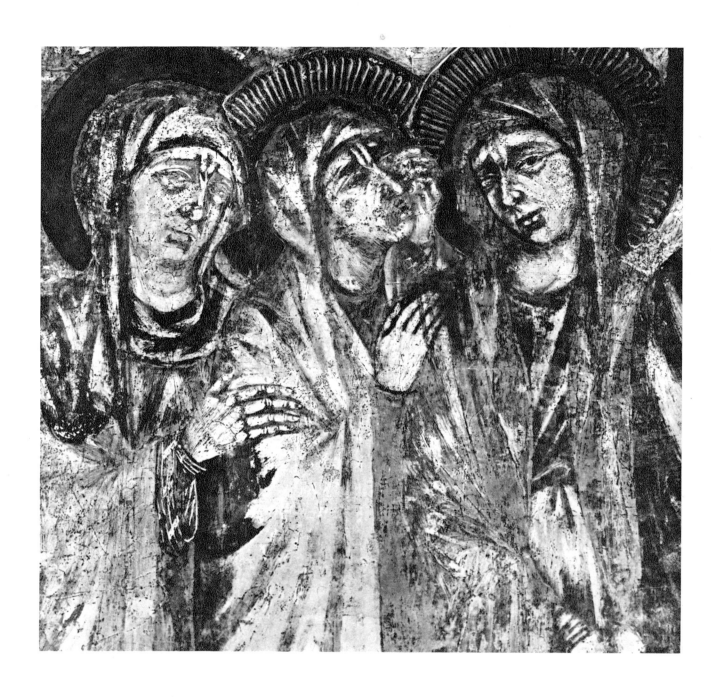

29 - THE GREAT CRUCIFIXION (*detail, the three Maries*) - *Upper Church of San Francesco* - ASSISI

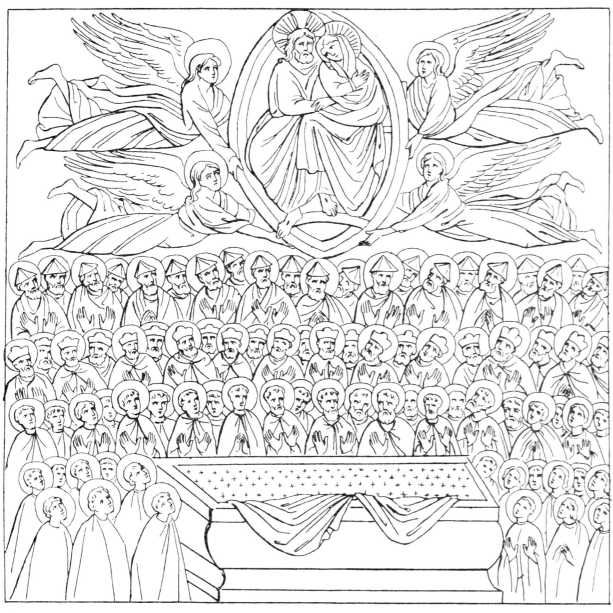

Drawing by W. Y. Ottley

tence depended on the continuity of a relationship with the earth. The sweetness and the idealization of Christ and the Virgin, the gentle gestures of the apostles, the prodigious portraits of the Franciscan fathers who crowd about to implore the help of the Virgin all serve to create a spiritual intimacy that demands a loving response from the spectator [Pls. 41-43]. The importance of these frescoes in the history of perspective has already been indicated by White[74] and Gioseffi,[75] although Cimabue's sense of space and volumes was still an intuitive one, resulting in a preponderance of masses over voids. Some of the research into illusionism,

however, is pushed even further. Simulated architectonic frames which delimit the upper scene produce optical effects of great originality and were later used by Giotto. Perspective for Cimabue was calculated on the revolving gaze of the spectator which moves from the center outward. He did not obey exclusive autonomous principles. The same is true of his realistic and clearly architectonic study of Roman buildings: he stops when he is satisfied that a certain level of verisimilitude has been reached. The insistence on constructing a bridge between the human and the divine, aims at balancing and stabilizing the relationship between appearance and reason, but it does not lead to a rigidly objective and universal rule.

The Histories of St. Peter

Confirmatory evidence appears in the first two scenes of the right transept arm dedicated to St. Peter. There the isolation of the figures, their somber, architectonic placement, the scale and balance with which they are constructed (when it is unnecessary to give dramatic emphasis to their emotions) anticipate all the better qualities of Giotto and the Renaissance: sense of volume, conciseness, gravity, action in being rather than in the process of development, and an emotional richness precisely because the conclusion is kept hidden. The intervention of assistants, one of whom seems to have been Manfredino da Pistoia [Fig. 16], and the degeneration of the color surfaces demand great effort from today's spectator. It is, however, sufficient to compare the little that remains of these scenes with the very mediocre painting of similar subjects in San Pietro in Grado near Pisa,[76] to recognize how completely Cimabue renewed the language, the tone, and the function of narrative painting of his time. His work rendered puerile all the frescoes of central Italy, with their small phantom-like figures which are full of naturalistic detail, but deprived of any true heroic or moral background. St. Peter extends and crosses his hands. An infinite power results from this gesture — a power that never before had been represented or conceived of in painting. And, perhaps, there was no necessity for the gesture, as he is seen as a demigod [Pl.46].

The Great Crucifixion

Despite the brilliance of the decorative schemes, the remarkable modernity of the three fresco cycles' plasticity, volume, perspective, and sense of drama, Cimabue's crowning masterpiece is the great Crucifixion of the left transept [Pls. 26-38]. Archaic in respect to stylistic research conducted in other places, following an imposed iconography, schematic

46

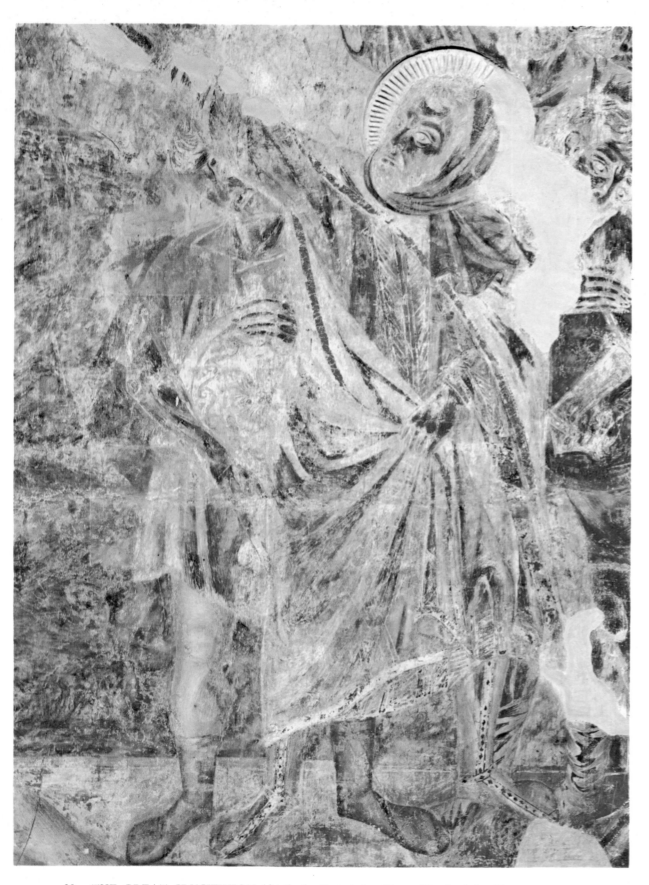

30 - THE GREAT CRUCIFIXION (*detail, the Centurion*) - *Upper Church of San Francesco* - ASSISI

in its style, it is yet extraordinarily communicative, fraught with a passion that the other frescoes, with all their fine qualities, do not possess. It could be maintained, moreover, that it is a conservative work, revealing a convulsive emotional climate as anachronistic as the politico-doctrinal program of Dante. This climate is connected with the most unjust blindness in coping with the extraordinary new rationalism which made possible a tremendous social and economic development of the cities. At the very moment the Crucifixion was painted, it had already been superseded by history, giving it the value of a posthumous moral witness. The Cimabue of the future is in the vault and apse walls and only that side of his art will be influential. Duccio was the first to follow the path he opened. In 1287-88 in the round stained glass window of the Siena Cathedral he employed, in an almost literal rendering, the Assisi Coronation. The execution of the Assisi Coronation was, however, left by Cimabue to an assistant with proto-Sienese characteristics [Pl. 44 and Fig. 15].

Our allegations of anachronism and traditionalism against Cimabue's Crucifixion correspond, of course, to the severe judgment imposed with their style by the painters of the early Trecento on their immediate predecessors. But one would have to demonstrate that in devotional painting, especially of a Christological nature, so large a stylistic innovation was possible. As far as we know Cimabue's career gives us the just reply. When confronted with the Christological theme, as we have seen in Arezzo and will see again in the Santa Croce Crucifix in Florence, the Master intentionally worked in an archaic traditional manner, inserting his innovations clandestinely and limiting them to theologically irrelevant details, such as the loincloth. Since his purpose was to excite emotion, he uses traditional schemes to suggest; he stylizes to be expressive. In the great Assisi scene two magnificent figures at the extreme right show clearly that Cimabue was more than equal to the task of painting the scene in a much more realistic way. Instead the two figures, half hidden by a column, are an exception, an episode existing by itself, so much that it leads us to think that one may be a self portrait,[77] the other the portrait, perhaps, of a venerated theologian and iconographic adviser of the fresco cycle. In order to express his intimate religious devotion Cimabue had need of cadence, rhythm, repetition of geometric motifs, and artificial construction. In a similar manner the great Bonaventura Berlinghieri, in the Pescia altarpiece of 1235, had transformed St. Francis, of whom he must have retained a vivid memory, into a rigid oneiric idol. In Berlinghieri's altarpiece the scenes of the legends were painted against a background of regal abstract monuments. Gesticulation was calculated so that every emotion would appear sublimated and otherworldly. History and popular legend were superimposed by a visual scheme that was intentionally hard and exotic. Also the re-elaboration that Coppo

made of the Giuntesque motif changes the feeling of kinship present in Giunta's image to a mysterious and inaccessible totemism.

Some details as well, apparently free of any model, upon closer observation turn out to be completely dependent in the most rigorous way upon the Scripture, or rather, upon the commentaries on the Scripture. Gillet, one of the most acute analysts of this artistic moment, writes in the following way about this Crucifixion, demonstrating how dangerous it is to interpret it only from a purely visual point of view: "It is the triumph of the author of the *Meditations* (St. Bonaventure). What the Evangelists sum up in a brief outline, he stresses; he analyzes it, splits it up in a series of successive pictures which the painters have only to carry out in images. He notes each detail, each gesture, puts it in a setting, indicates the placement of the accessories.... The author knows a host of things which Mark and Matthew are unaware of. He knows that the Cross was made of thick and heavy wood. He knows that it is fifteen feet high so that, when she was lifted up, the Virgin despaired of being able to reach up to the feet of her son". Now, the very monumental size of the structure of the Cross, the elevation of the image of Christ, which thus becomes untouchable, and the tremendous isolation produced between God and humanity, notwithstanding the reciprocal search for correlation, seem at first to be extraordinary pictorial inventions. To understand Cimabue it is necessary to progress from a distant vision of his work to one which again draws near, but which keeps in mind how the details are placed in the whole according to strict planning.

The Rediscovery of Tragedy

After he had observed the pattern of religious stylization and had interpreted the sacred history with the help of theologians, Cimabue introduces us to an indescribable number of innovations. He personalizes every square inch of the surface which on a close examination discloses a deeply felt and unique testimony. At this point the initial judgment of archaism, too obvious stylization, etc. is reversed. Indeed Cimabue's power of composition destroys all the old rules of behavior. The painter is placed on an advanced level in the rediscovery of Antique tragedy, whose protagonists, in a like manner, even while acknowledging the inevitability of fate and transcendency, rebel. Cimabue anticipates a mode of discourse so clearly and violently that it imposes itself on the style, a calligraphy so immediate as to create by itself the climate of an event and to explain it almost without the need of images. It is lamentable that the great figure of Christ is now only an illegible shadow. The loss,

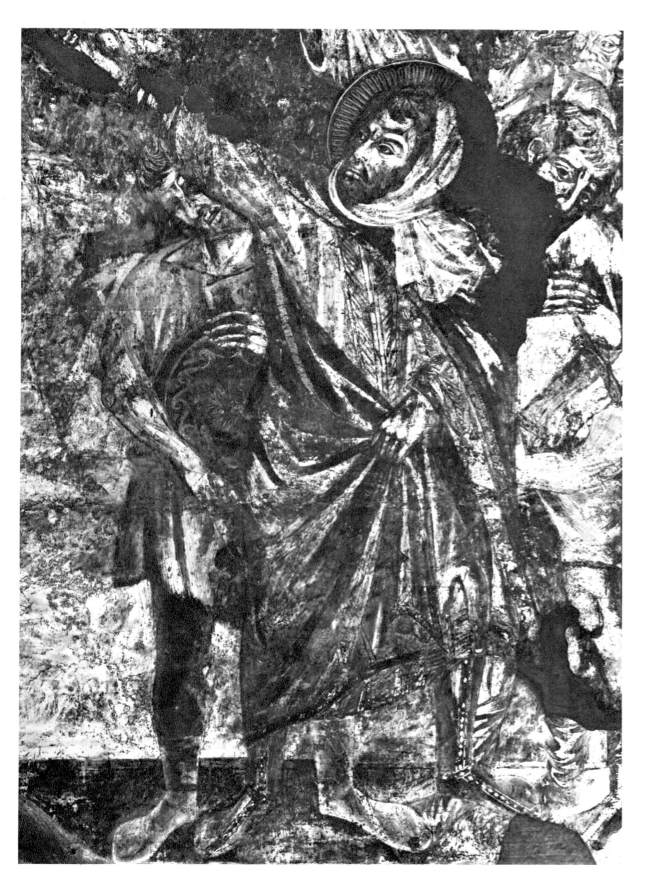

31 - **THE GREAT CRUCIFIXION** (*detail, the Centurion*) - *Upper Church of San Francesco* - ASSISI

32 - THE GREAT CRUCIFIXION (*detail, feet of onlookers*) - *Upper Church of San Francesco* - ASSISI

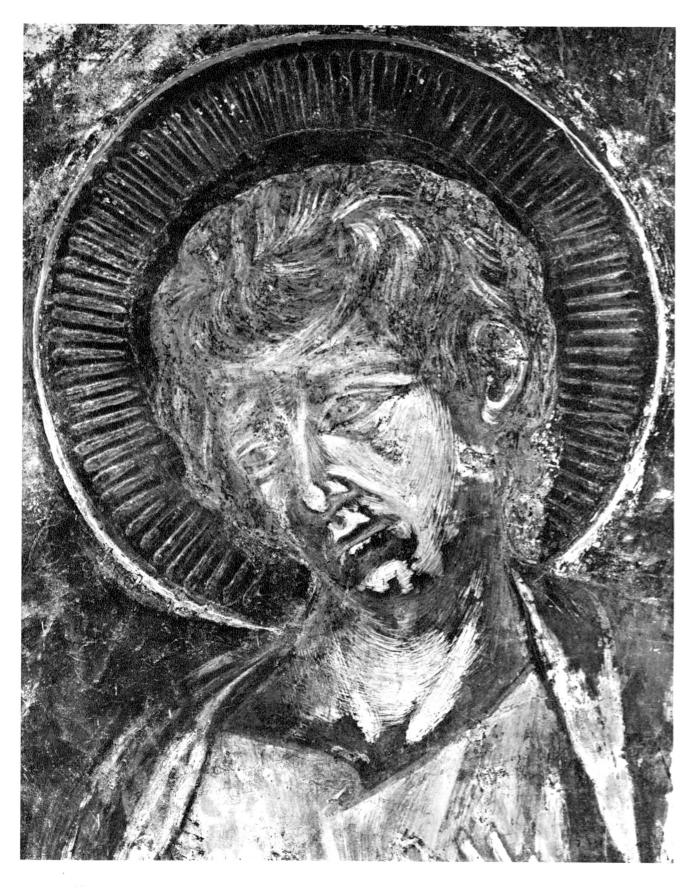

33 - THE GREAT CRUCIFIXION (*detail, the face of St. John*) - *Upper Church of San Francesco* - ASSISI

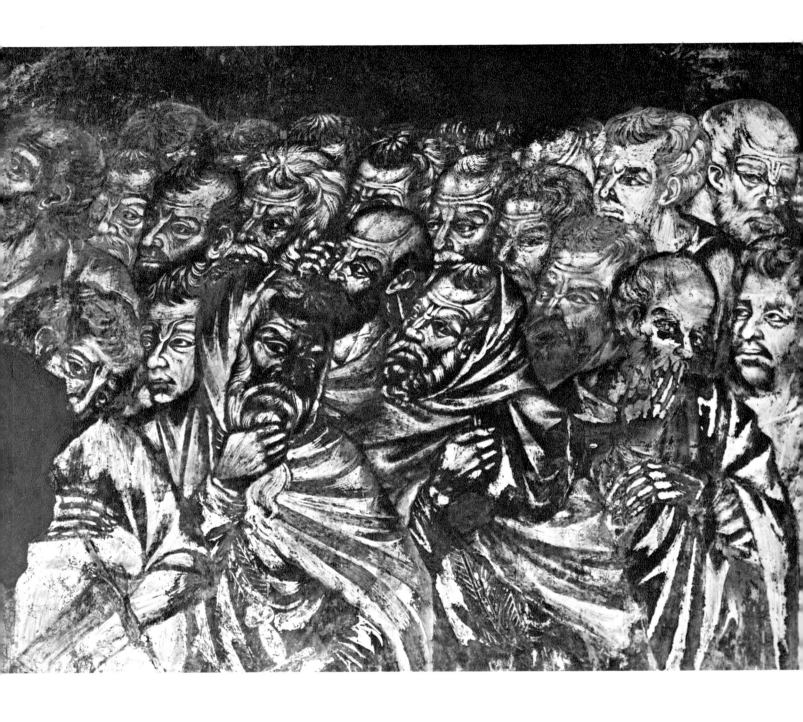

34 - THE GREAT CRUCIFIXION (*detail, Hebrews*) - *Upper Church of San Francesco* - ASSISI

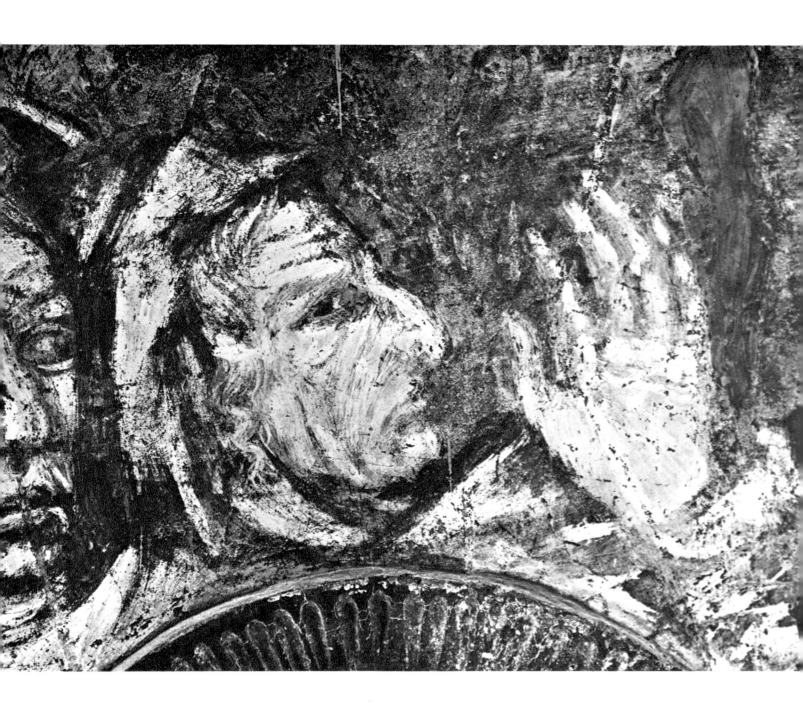

35 - THE GREAT CRUCIFIXION (*detail, an onlooker*) - *Upper Church of San Francesco* - ASSISI

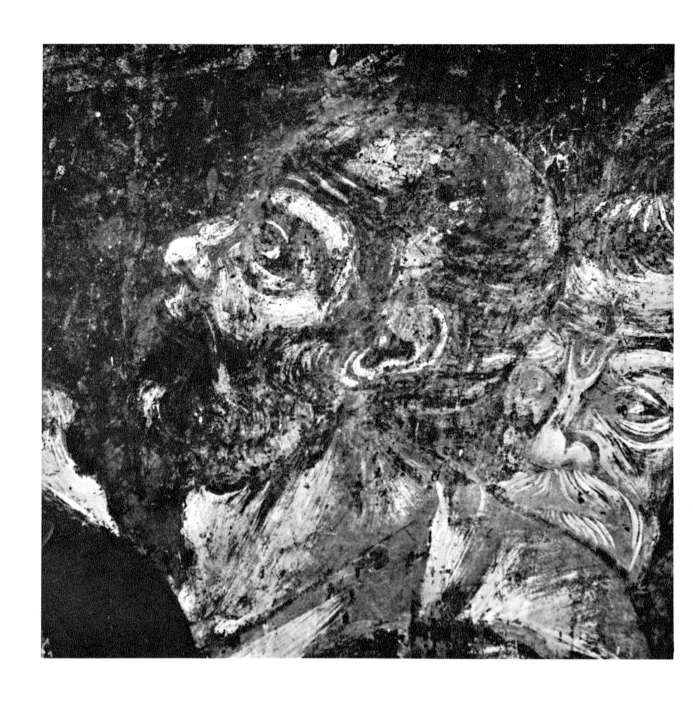

36 - THE GREAT CRUCIFIXION (*detail, an onlooker*) - *Upper Church of San Francesco* - ASSISI

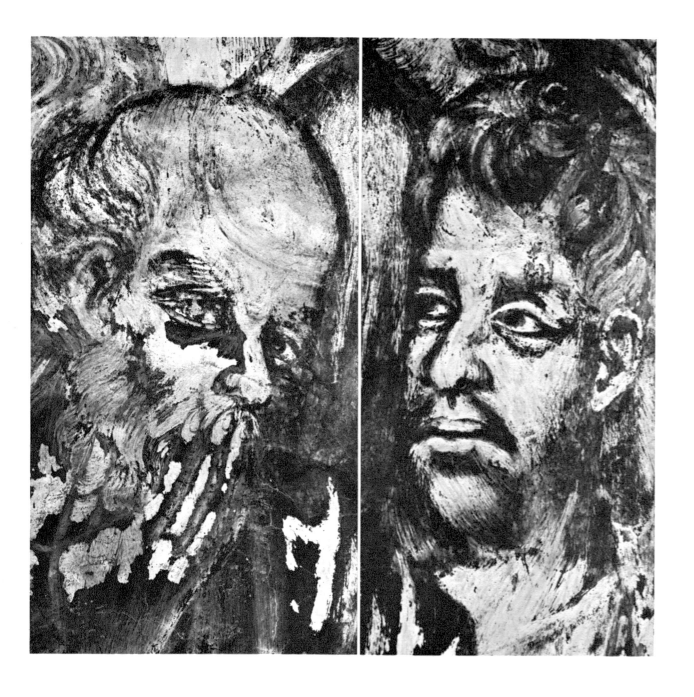

37 - THE GREAT CRUCIFIXION (*details, portrait of an elderly prelate and possible self-portrait of Cimabue*)
Upper Church of San Francesco - ASSISI

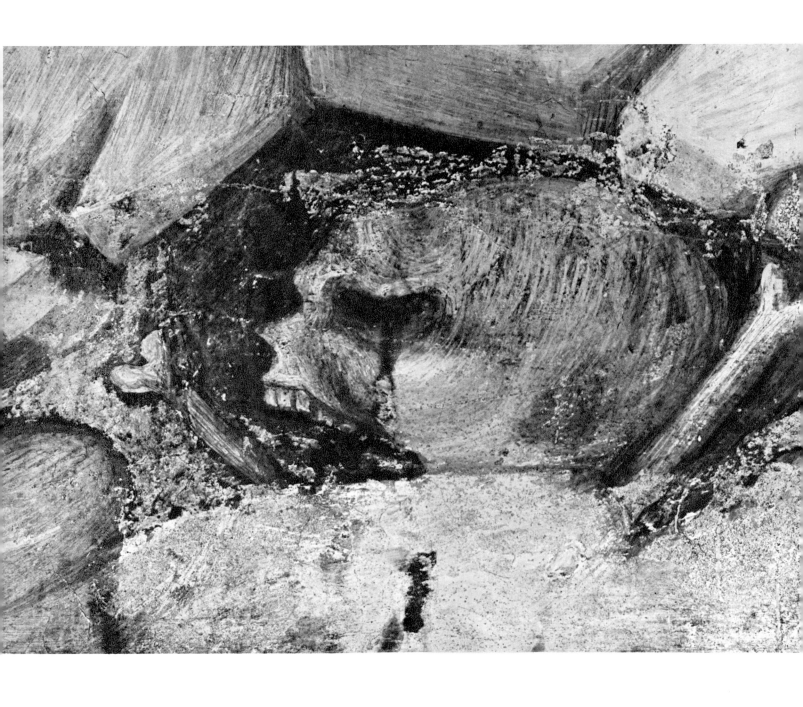

38 - THE GREAT CRUCIFIXION (*detail, the skull below the cross*) - *Upper Church of San Francesco* - ASSISI

however, is not crucial. The passion of the people witnessing the Crucifixion, almost re-construct His presence by means of the contraposition. Their participation reveals more of the event than the Cross alone could have done. This, then, is Cimabue's innovation: an implicit drama accompanies and exalts that which is explicit, justifies and determines it. In this discussion the illustrations speak for themselves; however, it may be helpful to point out how the energy of the truly metaphysical gesticulation springs, almost always, from a stylization of not merely a part of the body, but of the whole figure. The Magdalen is typical in this respect. Her outstretched arms are parallel and symmetrical; their position is main-tained as if by a supernatural petrification of the oblique line which, rising from the knees, cuts across the body to the shoulders. The accusing arm of Nicodemus flys out like a lance from the sheathing folds of his mantle, while on either side of him two heads peer out in opposite directions as if to emphasize other more timid alternatives. Here it is also possible to see how the difficult technique of fresco painting serves Cimabue as a stimulus, not as a re-straint; the bent line, so expressive of the pose of Nicodemus, corresponds to the separation in the plaster of two different work periods. The presence of such geometric schemes is evident from the use that Villar de Honnecourt made of them about fifty years earlier.[78] Ci-mabue externalized them. Some of his heads, for example, are not developed from the oval, but are inscribed within it with a rigor that renders them implacable and indissolvable by that light which scores and traces them. His geometric commitment is seen in the eyes, and in the tension of their gaze as, for example, in the pupils of the harshly characterized old man who ends the series of heads on the right, in the arabesques of the angels who create a mys-tic rose about the cross, in the repetition of similar episodes in a perfectly balanced, if asymmetric, manner on either side of the composition.

In Cimabue the design reinforces the emotion. As always the Medieval theorists had consid-ered this problem. To straight lines, above all, was attributed a more immediate and pow-erful expressive capacity.[79] Cimabue had also at his disposition the millennary dispute concerning characteristics connected with the static and the dynamic. Once Cassiodorus, Isidore and others declared that rhetoric must include all that enters into human judgment and consciousness including the two opposed but essential modes of persuasion, the apodictic and the emotional, "in quo motus est animi et vis quaedam et impetus mentis, ut sunt tra-goediae", they were accepted as operative, through conscious choice, in the arts. These two modes, which naturally find expression in a variety of relationships, are accompanied by two diverse types of gesticulation. The apodictic mode is conveyed by an immutable

gravity, which is manifested by a "moderata projectio" of the arms, with the shoulder neither raised nor lowered, with the feet only slightly separated — in short, with small movements of the body, without agitation or contortion. The gesticulation of this mode remains allusive, one of the indications that Byzantine art, because of its symbolic function, is apodictic and not emotional. The second type corresponds to the Iastian mode which is vehement, enthusiastic, exalting and stimulating. It invites participation in a manner both arcane and profound. It accepts any distortion as long as it is expressive.[80] Such a contrast could be developed between the polarities of Classicism and Romanticism or Expressionism. It is clear that Cimabue's Crucifixion, because of its Iastian gesticulation, belongs to the second mode, as do those great masterpieces of provincial Byzantium, the Purpureo Codex of Rossano and the frescoes of Castel Seprio, as well as the School of Rheims miniatures, Ottonian art generally, and the sculpture of Moissac, Autun, Vézelay, etc. However, the treatment could be a generical affinity rather than a specific connection of style.

The Drama of the Crucifixion

Every work of art should be examined with a concentration on its element of greatest importance and originality. In the case of the Crucifixion, this lies without doubt in the gesticulation of the figures in the foreground, for whom the masses, the angels and the fluttering drapery provide a perfect setting. Even at first sight one can see the enormous change from Byzantine gesticulation which, although it has the solemnity, and the dignity of an imperial court, is unable to escape from the ritualistic sphere.

This impression, however, can be developed on a more concrete philological plane. We have, in fact, a liturgical drama from Cividale, presumably contemporary, which not only has musical notations, but also, most unusually, indications of the movements to be made during the recitation. These gestures are for the most part apodictic: the protagonists most often indicate Christ with the right hand, or they point in turn. These movements of designation grow directly out of suggestions in the text. There is no organic narrative crescendo or effective reciprocal dialogue. In reading the text it seems that the movements of the individuals follow closely one after the other. But in listening to a recording of the chant one notices that the action is, instead, extremely static. The continual repetition of similar gestures, separated by enormous pauses, creates an atmosphere of the sacred and mysterious.

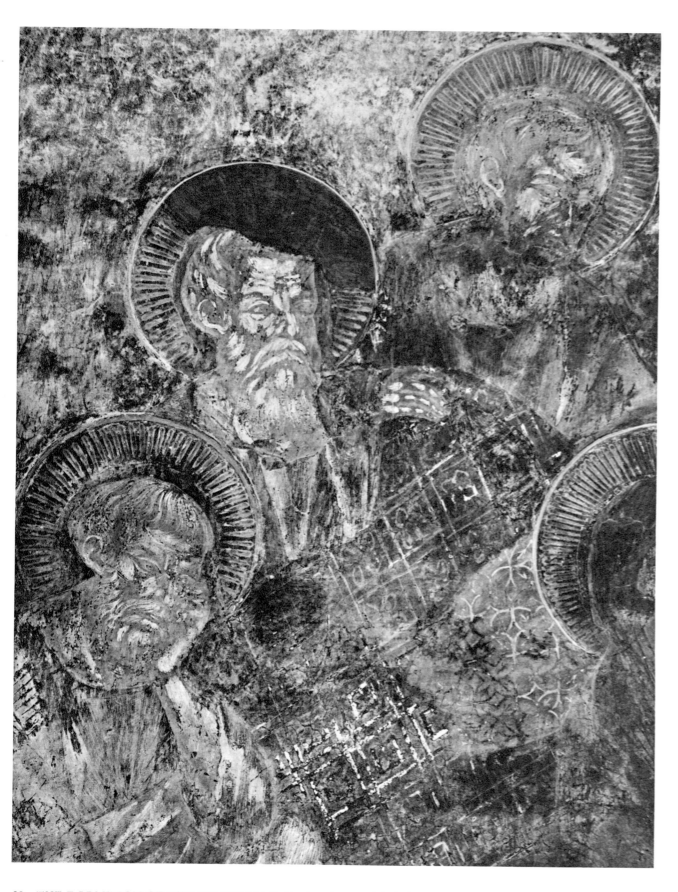

39 - THE DORMITION OF THE VIRGIN (*detail, the Apostles around the bed of Mary*) - *Upper Church of San Francesco* - ASSISI

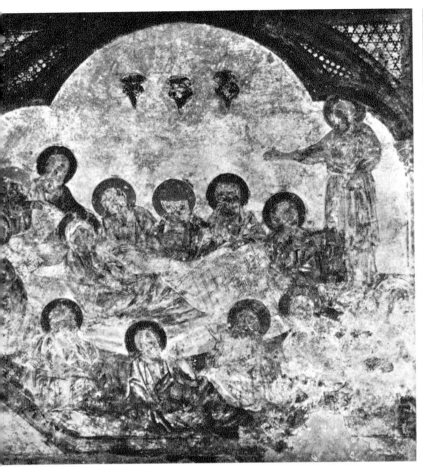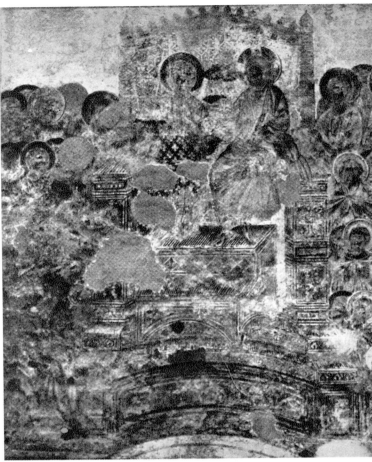

40 - THE DORMITION OF THE VIRGIN AND CHRIST AND THE VIRGIN ENTHRONED
Upper Church of San Francesco - ASSISI

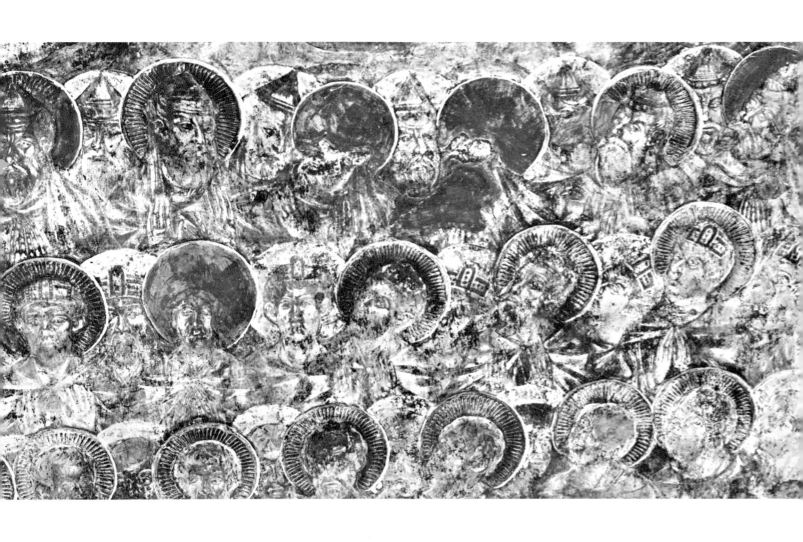

41 - THE ASSUMPTION OF THE VIRGIN *(detail, attendants)* - *Upper Church of San Francesco* - ASSISI

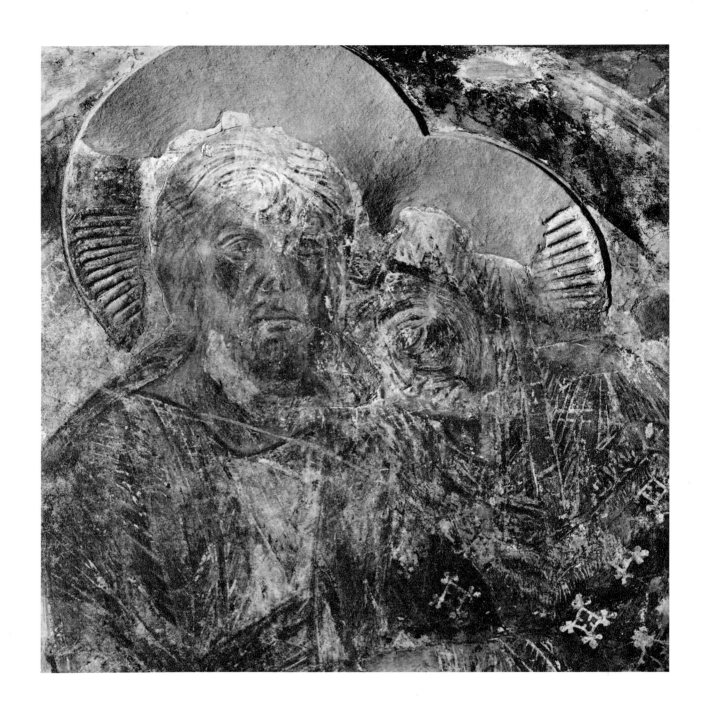

42 - THE ASSUMPTION OF THE VIRGIN (*detail, Christ and the Virgin*) - *Upper Church of San Francesco* - ASSISI

In the very beginning of the drama St. Mary Magdalene displays an immense burden of passion (the directions for the gestures are given in italics):

> *Hic vertat se ad homines cum brachiis extensis*
> O fratres
> *Hic ad mulieres*
> et sorores
> ubi est spes mea?
> *Hic percutiat pectus*
> Ubi consolacio mea?
> *Hic manus elevet*
> Ubi tota salus?
> *Hic, inclinato capite, sternat se ad pedes Christi*
> O magister mi?*

There is a suggestive reciprocity also between the gestures and the words spoken that approaches realism. For instance in the lines where the sins of the Magdalen are "forgiven" the author indicates that the Virgin Mary *relaxet manus deorsum*, and in the chanted allusion to their own tears and the tears of others the following instruction is given: *Hic tergat suas lacrimas*. There is considerable variety in the gestures: the participants move forward toward the audience; open their arms and let them fall; arise with arms extended and greet one another; beat their breasts and embrace; bow and prostrate themselves before the cross. It is clear, however, that the embrace (such as: *hic amplectetur Magdalenam ad collum cum duobus brachiis*), the beating of the breast, the show of emotion in the long scenic pauses formed by the slow melopea, do not represent anything different from the age-old gestures of the liturgy of the Mass. Even the more tragic moments where one might imagine a greater violence or a harsher rigidity of the body (such as occur in Venetian frescoes of the same date) are but anguished interludes in a schematic and allusive context. Their intense fascination derives from their absorption into a conceptualized and unnatural rhythm.

At a popular level the same thing must have occurred in mourning over the dead to which the pictorial representations of the Crucifixion with Mary swooning, and the Deposition especially, are clearly connected, even though figuratively they could derive very little from it. Gestures, melopea, rhythmics, are, in their manner, equally ritualistic. They are terrifying because they are archaic and obscure, beyond earthly passions, meant not to express but to substitute a catharsis for them.

* *Here she turns to the men with arms outstretched* — O brothers — *Here to the women* — and sisters — where is my hope? — *Here she beats her breast* — Where is my consolation? — *Here she elevates her hand* — Where is all salvation? — *Here bending her head, prostrates herself at the feet of Christ* — O my Master?

Cimabue, too, accepted the formula of the liturgical gesticulations for his Crucifixion. But he does not have pauses of silence between them. He crowds, blends, and, at the same time, with a reciprocal rhythm, shows the anguish of the people on earth, of the angels, and of Christ Himself, whose loincloth is fluttering wildly. The archaisms, the harsh lines, the rhythmic pattern, the abstract individualizations, the antinaturalism — all these are indispensable to the artist whose aims are visionary. A different moral dimension separates the assembled indistinct attendants and the venerable old man who is almost as if posed for a portrait [Pls. 34, 37]. Although one is entranced by this detail, the tone of the composition is established by the riotous and indistinct mass. Analogously, the style used by Cimabue for the Passion remains medieval, even though there are passages that may properly be considered modern.

The multiform world of Franciscan culture, because it had not hardened into a system, permitted radically new psychological solutions. The *Canticle of the Creatures* even with its strict ritualism, teems with direct and moving affirmations. One could compare the emotionalism of the Cimabue of the Crucifixion to Duns Scotus, who, besides being an almost exact contemporary (1265-1308), considered the will superior to the intellect, and attributed primacy to faith over knowledge, even in its most highly individual expression. Herschel Baker, in a rapid survey of the philosophical image of man, states in this regard: "... it was, of course, a conscious reaction to Thomistic rationalism, but it was more: it was the definitive Scholastic statement of a concept profoundly counter to the whole movement of Scholasticism, that is, the synthesis of reason and faith. And, in a more secular form and more secular terminology, it was to be one of the battle cries of the Renaissance. In the self-determinism of Machiavelli's prince, in the voluntarism of Calvin's terrifying God, in the autonomous individualism of Marlowe's Faustus, even in the 'will of the majority' of democratic theorists, Thomistic rationalism was to be repeatedly challenged".[81] The greatness of Assisi culture was that, alongside the solemn liturgical scheme, it permitted within the Order outcroppings of individualism, an individualism as intense as that of the most anarchical of the *poverelli*.

Cimabue and Jacopone

Cimabue clearly does not depart from the most orthodox devotion. The often noted parallelism with Jacopone (a parallel that chronologically also is difficult to sustain, since Jacopone did not enter the Franciscan Order until 1278 and then not in Assisi) is explained principally as an affinity of temperament and taste, as Salmi has pointed out.[82] It is, however,

quite true that the burning, the "self-consuming" frenzied ardor of the poet finds its figurative parallel in the serpentine lines of the image of the Magdalen with her uplifted arms, and in the crowding of the spectators of the Crucifixion which, to quote A. Monteverdi, is like the poem *Amor di Caritate* where "a wave which is born, grows, thrashes about, becomes calm, starts again, pressing, pulling up to the moment of the final explosion".

But Cimabue's characters differ from those of Jacopone both in degree and in kind. His dramatic intensity is not confused by a hectic blending of mysticism which is often repetitive, contemplative, and inert, even when the most exacerbated agonies are evoked. Cimabue's characters have a warlike aggressiveness. The Roman centurion and St. Mary Magdalene "are not striking attitudes" and they are not weeping; this is left to St. Francis, who lies prostrate at the foot of the cross by Adam's skull. With their feet, alternating with those of their companions, solidly planted on the ground their grief is spontaneously transformed into energetic action, be it imprecation, shouting, tears or revolt. Evidently in this period before the study of archaeology, the passions of antiquity were being revived. The artists, like the poets, already reveal in their work the resumption of the Platonic motif of heroic fury, the mania inspired by the Muses which legitimizes every original and audacious act of imagination. The heroes of the Assisi Crucifixion are distinguished from the tamed figures of Byzantium by the violent and unpredictable manner of their reactions. Their behavior makes us recall certain exceptional passages in historical chronicles but, more importantly, a passage from Seneca.[83] In his *De Ira* wrath is defined as: "most hideous and frenzied of all the passions, while the other emotions have in them some element of peace and calm this one is wholly violent and has its being in an onrush of resentment, raging with a most inhuman lust for weapons, blood and punishment, giving no thought to itself if only it can hurt another, hurling itself upon the very point of the dagger, and eager for revenge though it may drag down the avenger along with it". This sublime definition is followed, it is true, by a condemnation of wrath. This "temporary madness" is without dignity, unmindful of social ties, obstinately set in its purpose. But for Cimabue on the threshold, as we are today, of a new world morality, this passage, if he read it, would have certainly confirmed his conviction that revolt, no matter how blind, is better than any form of resignation in situations where reason is of no avail. His heroes have, as the heroes in the Seneca moral, "a fierce menacing face, a wrinkled forehead, a dark expression, a hurried step, restless hands, altered color, and frequent sighs. His eyes blaze and sparkle, his teeth are clenched, his joints crack from writhing... the whole body agitated, hurling violent angry threats".
Behind every great masterpiece which survives for centuries and millennia, with its power

to influence still alive, lies the grandeur of a moral background. Behind, or rather, within Cimabue's Crucifixion, if I am not mistaken, is the first image in Italian history of humanity in revolt: in revolt, it is true, in the name of God; for in those days politics, history, and the economy, were conducted in the name of a God, here announced, not as Judge, but as an Avenger of human agony, who is to be awaited now on earth, and not in that more imaginary than proximate moment of the Apocalypse.

The Religious Comedy

If then the Crucifixion is the tragedy, the Madonna and Child Enthroned with Angels and St. Francis [Pls. 47-48] which perhaps, originally, also included the figure of St. Anthony on the left, is the comedy. There is no irreverence in this designation. Comedy for the Medieval period was, in fact, the world of enduring and tranquil love. Although the *Sacra Rappresentazione*, even in its most tender and domestic moments, takes place on a superhuman plane, Cimabue captures completely, and visualizes in a superb manner, that other typical aspect of Franciscanism, more enduring and more deeply felt as a popular devotion: the affectionate love of the faithful for the Madonna and the Christ Child. This aspect is more closely connected with European culture. The Florentine painter, once again adjusting his style to the subject, and freeing himself, under the pressure of courteous chivalry, from his rationalism, forgets the spatial framework and the well-known stylizations which he used in the Upper Church where the Marian dogma is exalted, in order to translate into softer colors and lines the sweet casuistry of Gothic beauty, giving the icon which was destined for an altar a tranquil and delicate tone oscillating between legend and daily life. (It is the type of genre that he had touched upon lightly in the upper scenes of the Life of the Virgin, scenes very narrative in character but which are now, unhappily, almost completely illegible). Here also Cimabue goes far beyond his predecessors, probably even in the delicacy of his colors which 19th century repainting (hopefully not permanently) has obliterated. Aware that he must turn more to intuition and emotion than to reasoning Cimabue availed himself of a subtle rhetoric, the same as that which centuries earlier had been counseled by the Pseudo-Dionysius. A rhetoric that speaks in terms that are the same as those of the lauds and of Sienese painting of the thirteenth and fourteenth century: the irrational but very real fascination of color, of light, and above all of beauty — symbols immediately intelligible and capable of firing, illuminating and attracting, like an irresistible magnet, the faithful to God.[84] On this plane Cimabue, for the first time, encounters the Gothic without the mediating aid

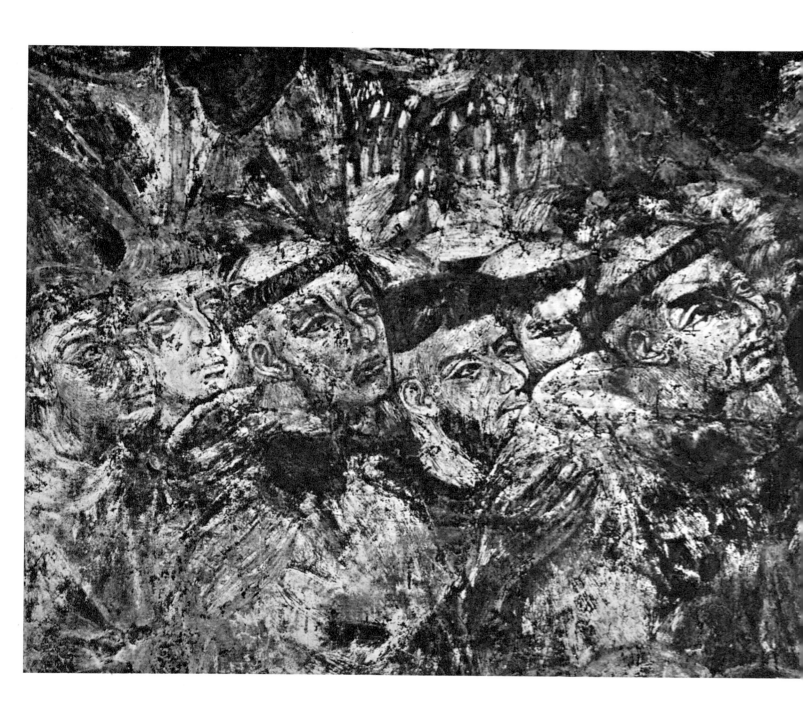

43 - CHRIST AND THE VIRGIN ENTHRONED (*detail, praying Franciscans*) - *Upper Church of San Francesco* - ASSISI

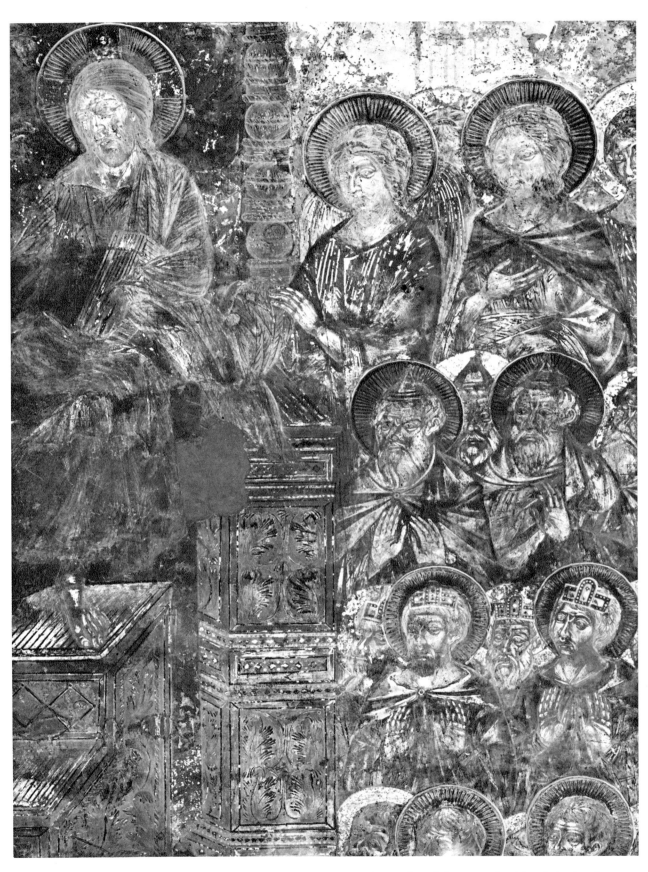

44 - CHRIST AND THE VIRGIN ENTHRONED (*detail, Angels and Saints at the right of the throne*)
Upper Church of San Francesco - ASSISI

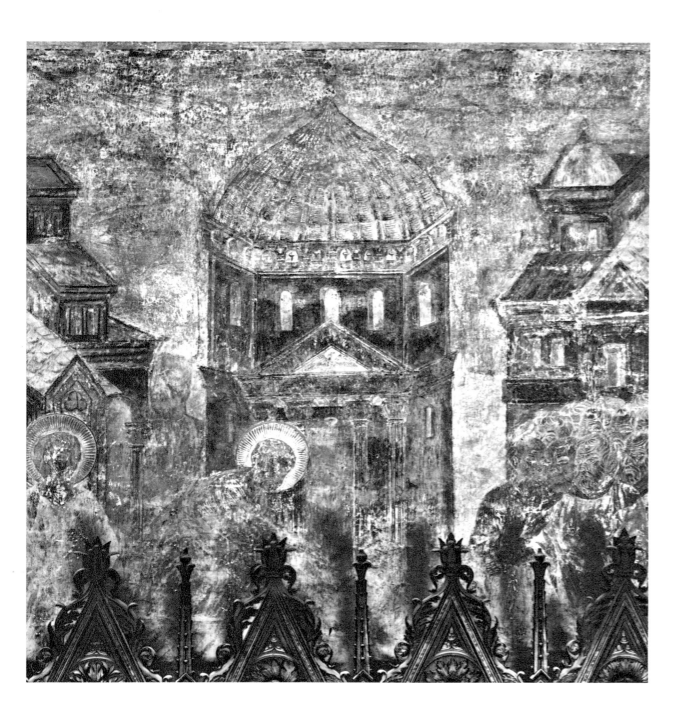

45 - ST. PETER HEALING THE LAME - *Upper Church of San Francesco* - ASSISI

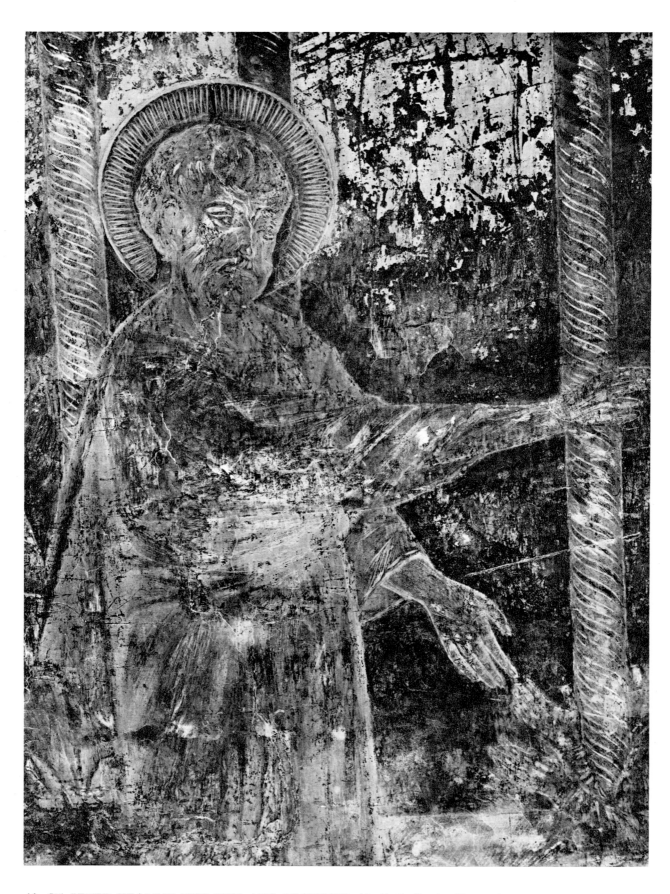

46 - ST. PETER HEALING THE SICK AND POSSESSED (*detail, St. Peter*) - *Upper Church of San Francesco* - ASSISI

of sculpture — Gothic that is if we accept Dvorák's idea[85] that its essential component is the representation of a spiritual affective contact between the single figures. Intense relationships are interwoven between the Madonna, Jesus, St. Francis and the onlooker. While the Infant Jesus inclines toward the Virgin with a gesture that could not be more appropriate and well-planned, she, together with the four angels that form her court, and St. Francis with his sorrowful stigmata, gaze out at us with thoughtful eyes as if to declare that we are guilty of the future suffering of her Son. The Madonna is only a little larger than life size. Her dress is extremely simple — an allusion to poverty. What distinguishes her is the nobility of her expression. St. Francis, although the same height as the angels, has a larger body. The whole scene, contrary to Duccio's future aerial quality, takes place on a platform solidly anchored to the earth on which the angels stand instead of hovering in the air. This creates a sense of stability as well as anguish. In accordance with Franciscan theology Cimabue, in the Upper Church, declares to the celebrant and to the faithful that the drama of the Crucifixion does not belong to the past, but is repeated each day. And in the Lower Church the Madonna's tragedy, caused as well by human beings, is equally perennial, but more tangible as it unfolds on a human plane. It is difficult to bear the intensity, the severity, and reproachfulness of her gaze, or to support without anguish the ill-concealed disquietude of the angels. The St. Francis is a masterpiece of portraiture, even if it is only a fantasy of the painter who was too young to have known him. What matters is that he is a well constructed personality, visually in keeping with his mission. An abyss separates this painting from the Byzantinizing interpretations which stylized the Saint to the point that he becomes an exotic primordial entity. But we must not be deceived. Cimabue does not present us with a true likeness. A comparison with the Franciscan faces taken from life at the Madonna's feet in the Upper Church, or the portrait of the young man at the extreme right of the Crucifixion, suffice to demonstrate the infinitely greater freedom of their design and the spontaneity of their characterizations. Nevertheless, we must recognize that the leap from the natural to the mystic and legendary plane was, in regard to the image of St. Francis, rather more limited. The Order's gravest crisis, at least at Assisi, was settled. The trumpets of the Apocalypse had ceased to sound. The monastic organization developed, more than ever before, its program of social action. And the saint in Cimabue's fresco walks the earth with naked feet, holding, though not displaying it as a transcendent symbol, in his pierced hands the small but sure book of truth.

THE FLORENTINE WORKS

Cimabue left Assisi sometime after 1283. His departure might have been unforeseen as the cycle dedicated to St. Peter was continued by another painter. The execution of the whole complex, moreover, seems quite hurried: the decorative parts reveal the participation of a number of assistants as, for instance, in the series of angels. The Coronation group is the work of a master very close to the style that will become Sienese. These figures are more fragile, more elongated, with an elegance that is sophisticated and immaterial. But in spite of the number of assistants and the hurried execution, the Assisi choir still emerges as a historical document of the first importance. The psychological intensity that characterizes it is far in advance of any achievement of Roman or Florentine painting, not only of the time, but also of the period immediately following. The dimensions of the Assisi complex transcend the scope of the great Pisan sculpture, in whose evolution Cimabue's stylistic position would fall between the calm Gothicism of Nicola Pisano and the agitated Gothicism of Giovanni. But Cimabue's superiority is, above all, in his capacity to differentiate his style to accord with the various themes of the cycles. His interpretation is complex and personal, with a commitment to the most advanced iconography. He takes advantage of all the cultural tools that the East and West could put at his disposal. Cimabue was a great theorist as well as a practician. He knew the sources and made use of them with circumspection; he was able to calculate both optical and psychological effects. When he had achieved the highest level of plasticity and perspective effects, that is, after he had subjected the sacred thematic idiom to the dictates of reason, he had the courage, when necessary, to express those sentiments which cannot be subjected to reason, and go beyond, while still recognizing which lines — the very rapid straight line, for example — which schematic method would be most suitable, as well as the appropriate literary and rhetorical tools to employ. He met with the treatise writers and philosophers. He was an archaeologist, a naturalist, a topographer, an historian, and, in his heart, a visionary.

But very little indeed of this cultural complexity is evident in the Florentine works executed after Assisi, which according to the documents relative to the churches for which they

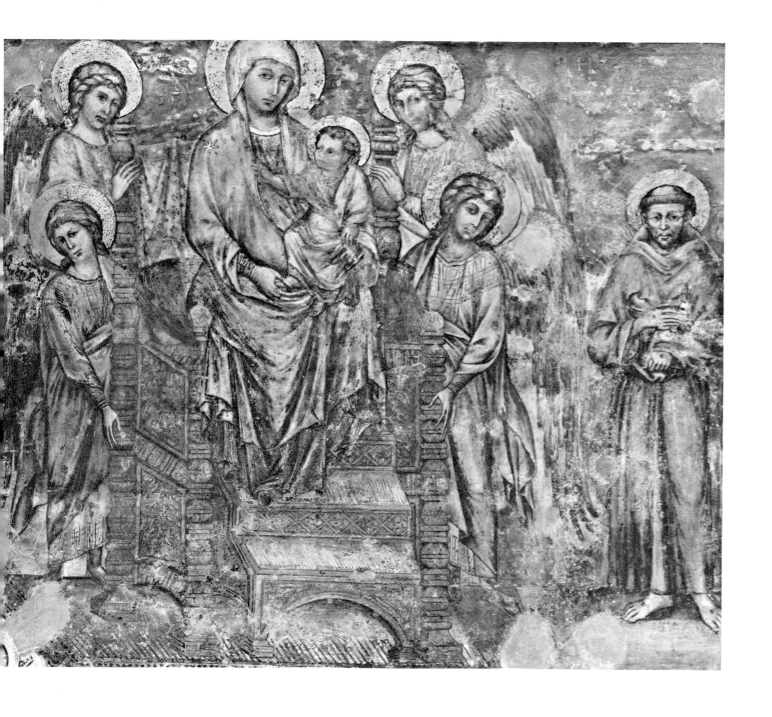

47 - MADONNA AND CHILD ENTHRONED WITH FOUR ANGELS AND ST. FRANCIS - *Lower Church of San Francesco* - ASSISI

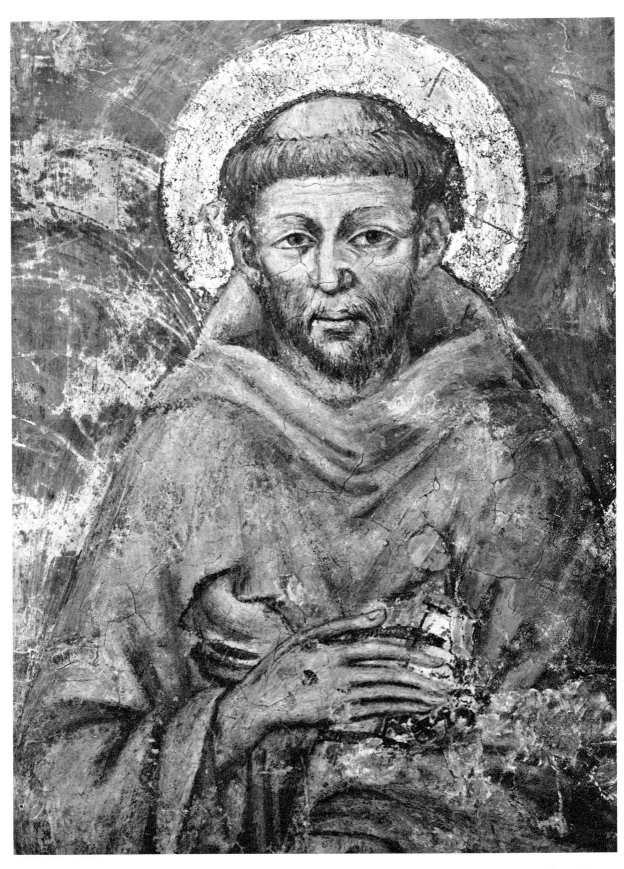

48 - MADONNA AND CHILD ENTHRONED WITH FOUR ANGELS AND ST. FRANCIS (*detail, St. Francis*)
Lower Church of San Francesco - ASSISI

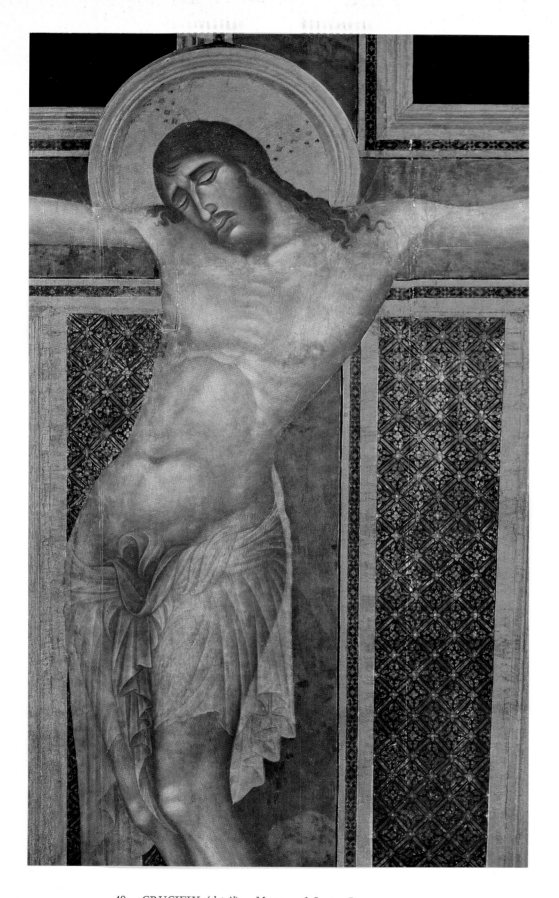

49 - CRUCIFIX (detail) - *Museum of Santa Croce* - FLORENCE

49 (*a*) - CRUCIFIX (*detail; after the flood of November 4, 1966*) - *Museum of Santa Croce* - FLORENCE

During the terrible flood of the River Arno on November 4, 1966, the waters invaded Santa Croce where the Cimabue Crucifix was exhibited. Mixed with naphtha, oil, and mud, the waters attained a height of more than eleven feet and in their violence substantially erased the surface of the painting, bringing about one of the heaviest losses in decades to the world of art.

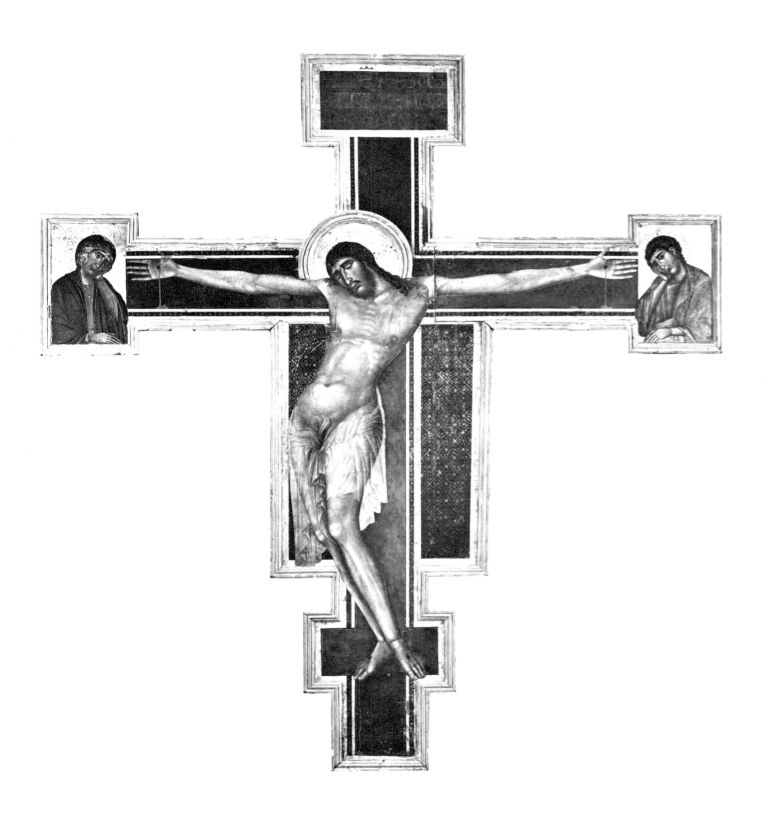

50 - CRUCIFIX - *Museum of Santa Croce* - FLORENCE

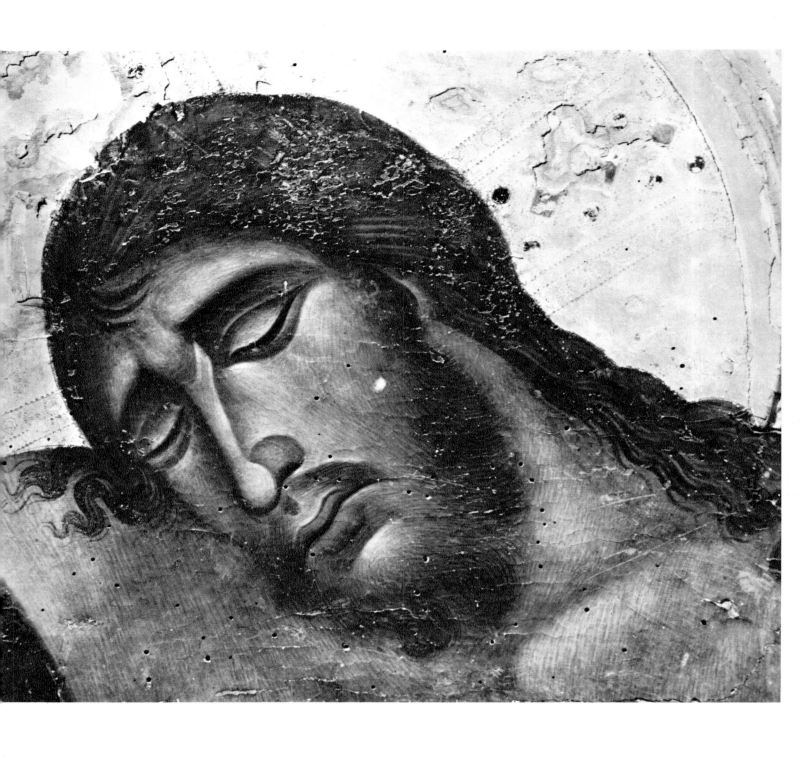

51 - CRUCIFIX (*detail, Christ's face*) - *Museum of Santa Croce* - FLORENCE

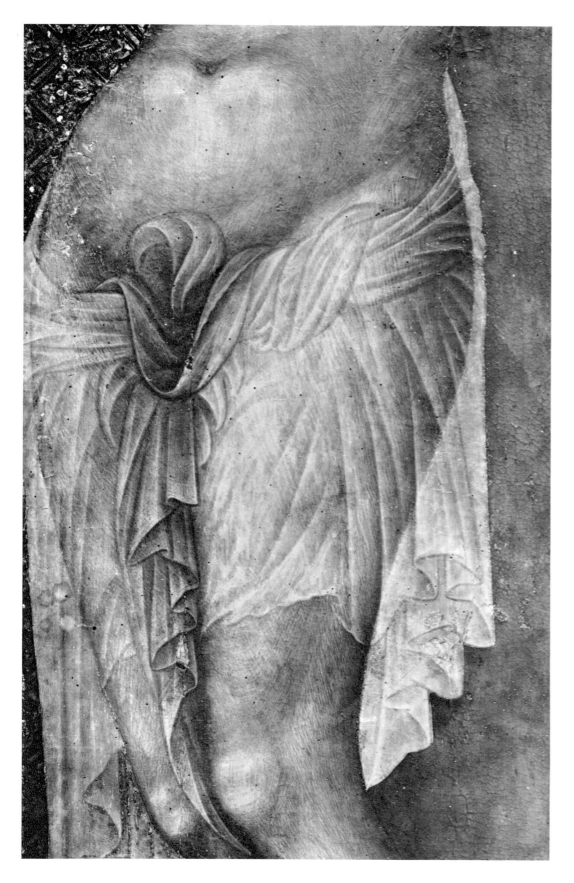

52 - CRUCIFIX (*detail, loincloth*) - *Museum of Santa Croce* - FLORENCE

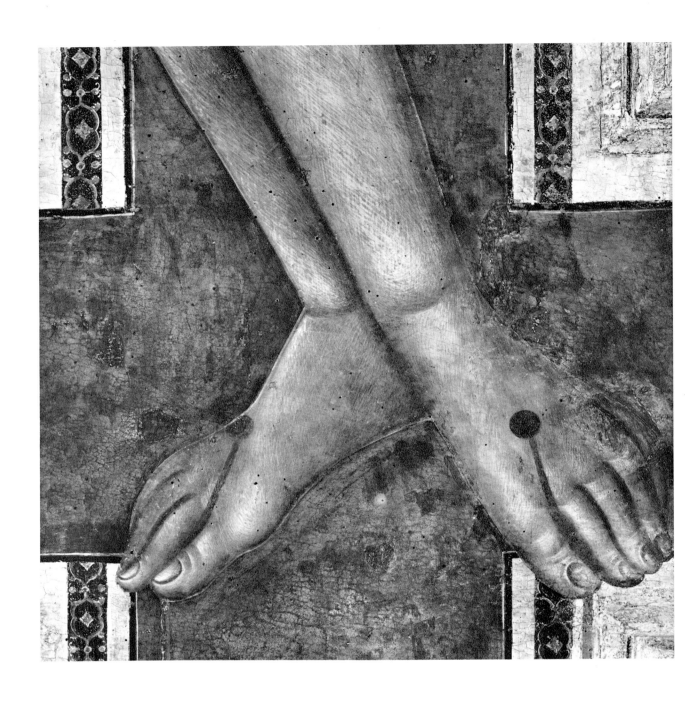

53 - CRUCIFIX (*detail, the nails*) - *Museum of Santa Croce* - FLORENCE

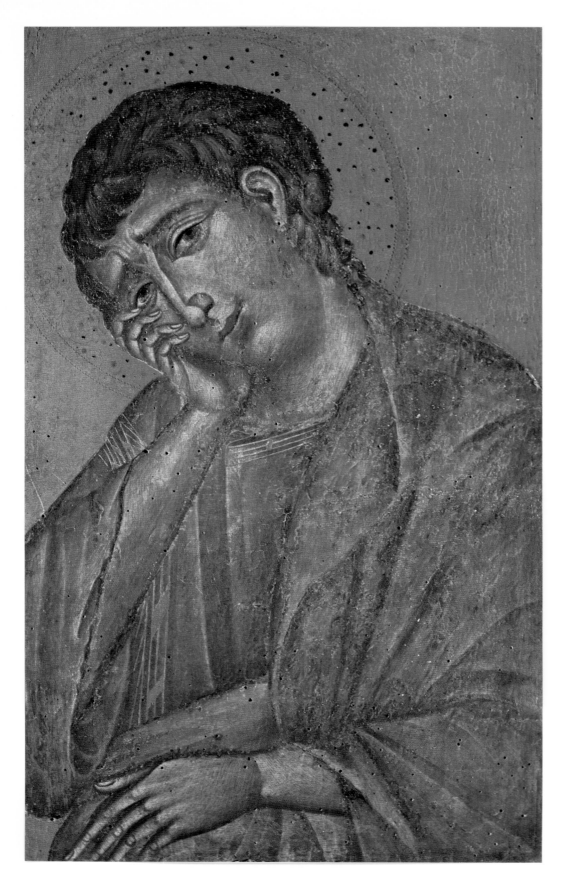

54 - CRUCIFIX *(detail, St. John)* - *Museum of Santa Croce* - FLORENCE

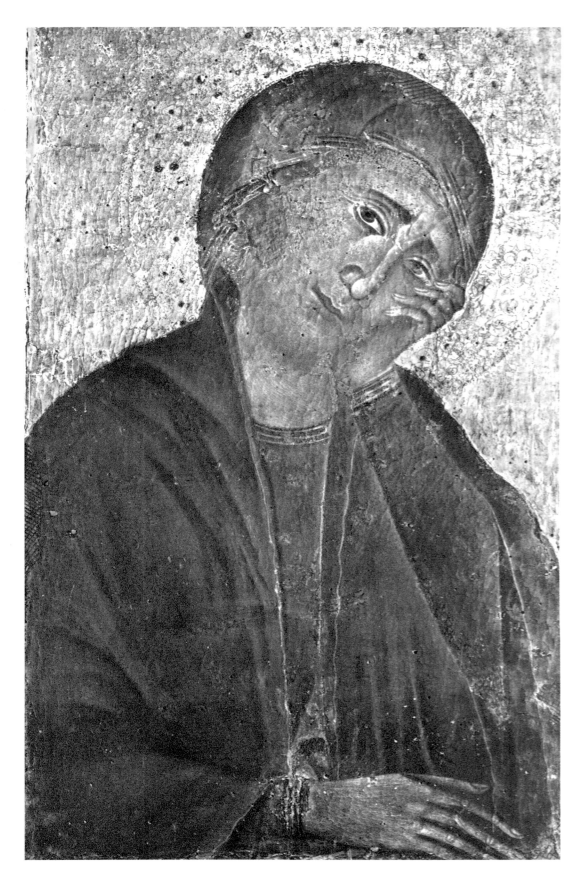

55 - CRUCIFIX (*detail, Mary*) - *Museum of Santa Croce* - FLORENCE

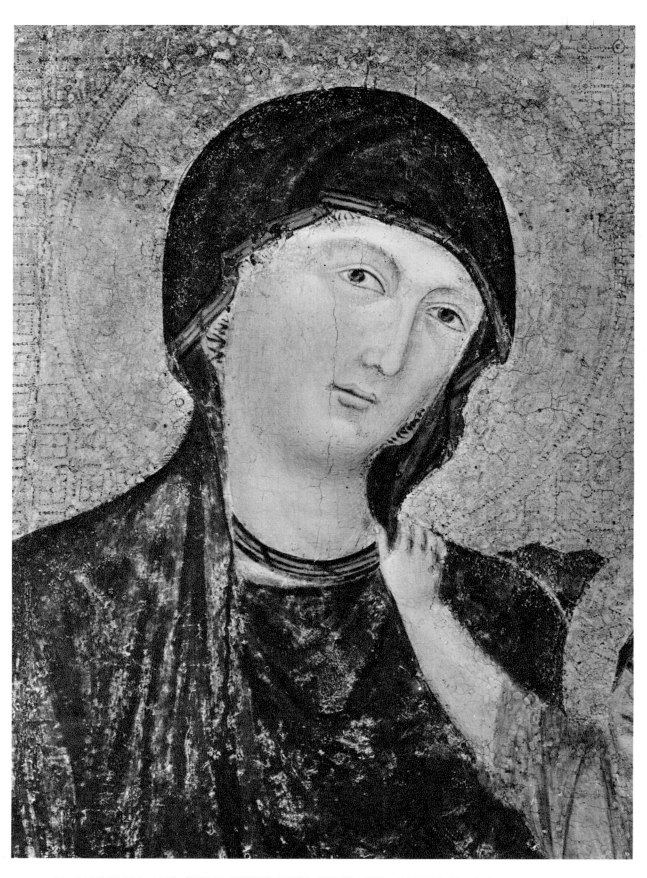

56 - MADONNA AND CHILD ENTHRONED WITH TWO ANGELS (*detail, the face of the Madonna*)
Santa Maria dei Servi - BOLOGNA

were intended, followed one after the other. This is proof of an extraordinary activity, the maximum part of which was entirely by his own hand, so much so that the possible presence of assistants is irrelevant. Nevertheless his stylistic sharpness and his innovatory capacity lessen. The Santa Croce Cross faithfully reproduces the scheme and the stylistic foundation of the Arezzo work. In the same way the large Santa Trinita altarpiece, now in the Uffizi, is so removed from the prevailing style that it defeats any plausible chronological attribution. The cross as well as the altarpiece, although definitely later, represent a more archaic phase than the Assisi frescoes. The reasons for this détente must have been external. Intellectually Florence was poorer than either Rome or Assisi and did not have their links to the papacy. Ideas arrived in Florence late and by second hand. In the field of religion conservative and archaizing tendencies can be shown to have existed in the Orders which were still the principal patrons. Cimabue seems to have yielded to these tendencies.

The Crucifix of Santa Croce

Fortunately we have a secure *ante quem* for the Santa Croce Crucifix [Pls. 49-55] in the Deodato Orlandi cross dated 1288 in the Lucca Pinacoteca which is an exact copy of Cimabue's work, even to the decoration of the apron panels. The divulgation, by means of copies, of the most celebrated icons was a normal process. The Crucifix in the Carmine was, for instance, copied with notable iconographic fidelity from the Crucifix by Giotto for Santa Maria Novella. The Cimabue copy in Lucca provides us with a chronological key that a stylistic investigation alone might never have uncovered, since, as was noted previously, the scheme and in part the style of the Santa Croce cross faithfully repeats his Arezzo Crucifix. The construction of the church of Santa Croce[86] was started in 1295 when the first stone was solemnly laid. The project had already been conceived in 1285 when considerable financial help was obtained. Such a project is more understandable when placed in the context of the general expansion of the churches of the Mendicant Orders in Florence and elsewhere which came about as the result of the new ecclesiastical rights they had been granted. Since Cimabue's cross was destined for the high altar of the new church, 1285 very likely could be the year when it was commissioned. Its measurements presuppose its placement in an edifice of vast size, as both Santa Croce and Santa Maria Novella were to be. It is also logical that soon after his arrival in Florence from Assisi Cimabue would receive an important commission from the Order that he had served so brilliantly. The delay from the initial planning of the church to the placing of the first stone could allow a complete change in

the scheme — the date of c. 1285, for example, raises difficulties in proposing the name of Arnolfo as the architect — and may be bound to an internal dispute in the Order concerning the question of poverty. Pietro Olivi and Ubertino da Casale who were, beginning in 1285 and 1287, the center of the most active conventual opposition because of their teaching activity, lived in the Santa Croce monastery until the end of the century. One of the major reasons for these disputes was the construction of the new churches and convents. The enormous expense of building Santa Croce, for instance, would have become, under the impact of repeated polemics, a popular scandal. A devout little monk dreamed that he saw Frate Giovenale, the organizer of the works, in hell with two hammers that beat him over the head until Judgment Day. The construction of the church came about by an act of force similar to that which compelled the Franciscans to accept the pictorial decoration in Assisi. But in Santa Croce the consequences are still to be seen: following St. Bonaventure's proscription the vaults were eliminated, structural simplicity was carried to an extreme. The changes in the plans were perhaps more drastic than now appears. A rather important iconographic detail may nevertheless indicate that the commission for Cimabue's Cross was not derived from the Franciscan Spirituals: Christ is nailed to the Cross by four nails and not three as the rigorists[87] seem to have maintained as correct. A little later the three nail iconography was widely diffused. Cimabue, although on the side of the rich and enterprising conventuals, seems perplexed and afraid to depart from the iconography to which he, along with Coppo, the Master of St. Francis, and other followers of the Giuntesque prototype had helped to make traditional and obligatory. Inert, it yields a work with no innovation on the devotional and liturgical plane. If Giotto was in his workshop he must have clenched his hands in rage, envisioning so many other alternatives.

But as is often the case in compromises, the Cross presents a number of small innovations. They are recognizable only after an attentive examination, even though the cross, now that it is in the museum of Santa Croce, is easy to see. For such an examination we must again run through a fairly complex set of calculations and reflections. In the Santa Croce Cross the proportions are less rigorous than those of Arezzo, but perhaps also more subtle and ductile. This is a sign of a new era, although the dramatic writhing of the Assisi Christ, of which there is no trace at Santa Croce, may be regretted. In comparison with the Arezzo Cross the great S curve of the body is more pronounced. The right hip, in fact, touches the edge of the right apron, leaving not even the slightest vertical strip that earlier had contained and hardened the convulsed image. A greater sense of tension is present also since the arms are stretched straight out, rather than bent, suggesting the weight they

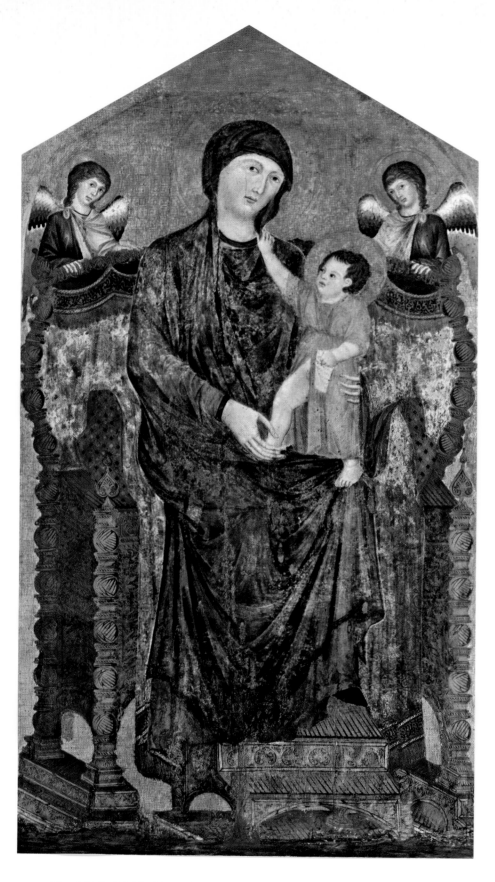

57 - MADONNA AND CHILD ENTHRONED WITH TWO ANGELS
Santa Maria dei Servi - BOLOGNA

support. The figure is thus thrust up higher and is less inert. Below the image the mouldings of the Cross are shifted slightly downward and the feet now rest on the edge of the frame. The general plan is very like that of the Arezzo Cross, but it would be useful to re-examine the construction, even though it may be repetitive. Christ stands out from the blue background that creates a cross within a cross. The fields are calculated with a ruler even though the edges are later put in by hand. The resultant optical effect is very geometric. The horizontal extension of the arms that reach out to the images of St. John and the Virgin, opposes the tendency toward verticality, here accentuated, and thus creates a dynamic equilibrium. When the Crucifix was raised up on the altar in the church this equilibrium was more effective because of the angle from which it was seen. The equilibrium is maintained by means of subtle calculations. For example, the superscription on the blue background above Christ's head has been slightly enlarged filling the borders. This enlargement by itself suffices to carry the gaze upwards. The words of the inscription, blazing out in red outlined with gold, together with the halo with its red bosses and its rather projecting moulding, determine the optical center, concentrating the eye at the intersection of the arms of the Cross, on the head whose hair and brown beard constitute a dark chromatic polarity as well.

The Colors of the Cross

Today the Cross is very dirty and has lost its original clear chromatic scale which must have been violent even though confined to low cold tones. Christ's body is based entirely on livid yellows and greens, with brown shadows, counterpointed and opposed by the various shades of bright colors: in the border, the Virgin's dress visible under her mantle of reddish violet, the trim of the veil about her head, and the violet of St. John's mantle standing out in relief against his green undergarment. The extraordinary plasticity which is concomitant to the monochromatic reduction, cannot be praised too highly. The very way it is painted has a plastic function: the interweaving of strokes, diversely and antithetically oriented often creates a sculptural vividness by the accentuation and interruptions of light. This illusionistic skill, through the use of chiaroscuro alone, culminates, perhaps because liturgical preoccupations were no longer in play, in the lower part of the body where the light falls on the stomach, the knees, the tibia, underlining almost naturalistically the points of major relief of the human body. The very light loincloth, which does not conceal the body, but allows the outlines of the thighs to show through in an almost atmospheric way giving as never before the illusion of a volume with tangible contours existing in space. Certainly Giotto's great Crucifix

for Santa Maria Novella, which is almost coeval, carries the investigation of solidity still further. He discovered the human condition in a more dramatic way and renewed the iconography of the Crucifixion by leading it into the realm of naturalism. But in 1285, the year when Cimabue presumably received his commission from the Franciscans, his cross must have seemed scandalously modern in Florence. The plastic results we admire in the lower part of the image were due perhaps to external suggestions during the course of his work. While the lower part of the body in comparison to the Arezzo work demonstrates a definite advance, the upper part is constructed in a rigid and immutable scheme that not only conforms more closely to the Arezzo model, but, in spite of the lights that insistently and repeatedly play about the musculature of the thin arms, has less plastic value. The geometry instead of being expressed in turned volumes becomes an investigation of elegant stylization. For example, the hands are so flattened as to appear to be cut from cardboard. Notwithstanding its uncertainty the work reveals a dramatic contraposition between new and old. Cimabue now only paid lip service to the geometrical rules, making it useless to attempt to reconstruct the cross' proportional canons, so ductile and evasive have they become. The *homo quadratus* is no more, and since the center falls at the groin it is necessary to presume that when erect the head would touch the upper part of the halo. He accepts naturalism only collaterally and continued to repel it in a liturgical context. He did not realize that a decisive choice between the sinking Medieval and the dawning Renaissance was by now necessary, even urgent.

The Madonna dei Servi

We have seen how the iconographic deference to the Christological theme for Cimabue culminates in the archaic anachronism of Florence. In contrast Cimabue displays a great deal more freedom in his treatment of Marian themes. Obviously the cultural context was different. The first was dogma; the second a devotion that was already deeply ingrained in the hearts of the Orders. It was a devotion in which various alternatives were offered by religious and social groups which in turn could be reflected in art. The Madonnas executed by Cimabue after his return to Florence have such strong stylistic diversity that at first glance they lead one to hope that here at least the Master would again fully reveal his inventive capacity. But very soon one realizes that they have more or less the same character as the architecture in which they are housed. Because of this we begin to suspect that the artist — certainly not because of old age — adapted himself too automatically to his patron's wishes.

And his patrons clearly were not among the most advanced. The Dominicans, who had no fear of accepting and favoring contrasting tendencies, were not among them. For their churches the Dominicans sought younger artists such as Duccio and Giotto — artists in style highly diverse, but both in step with Gothic Europe. There are traces of compromise and a lowering of the qualitative level as well in Cimabue's Madonna altarpieces after he left Assisi.

Unobjectionable, although slightly backward looking and, significantly, of little reduced dimensions is Cimabue's Madonna dei Servi altarpiece of Bologna [Pls. 56-59]. It must have already been over the altar in August, 1287. Today its color is still splendid, well suited to the color of the Lombard Gothic brick. Notwithstanding the elongated shape of the panel its space is exceptionally ample. The placement of the Madonna is so secure that the image has monumentality without any trace of rhetoric. The treatment of the subject was dictated by the need to follow the Servite iconography, although Cimabue did insert motifs he had used for his celebrated composition for the Lower Church of Assisi. The enthroned Madonna, like the one in Assisi, humbly caresses the Christ Child's foot while gazing out in a melancholy way. The throne has become more delicate though it is still very high; the angels on either side, who seem to be the work of an assistant very close to Cimabue in spirit as well as style, are now smaller. They hover in the air, lightly leaning on the spiraled back of the throne that is curved in at the sides exactly as it is in the Madonna that Coppo di Marcovaldo painted for the Mother Church of the Servites in Siena twenty-five years earlier as payment for release from prison.

Coppo arrived at an extraordinary simplification of the subject with a vertiginous descent of the divine to the human level. But after the frescoes of Assisi the Sienese were no longer content with Coppo's interpretation and very quickly had the face repainted by a pupil of Duccio. Faced with the necessity of respecting the Servite iconography Cimabue, instead of going forward in the modern style, ended by including, along with the tender emotionalism of the Assisi work, something of the severity and hardness of the traditional interpretation. While at Assisi the angels serve as an enclosure and have almost the same stature as the Madonna, in the Bolognese painting she, the Queen of Heaven, is regally set apart in her complete dominance over the angels. Her gestures, as well as those of the Infant Jesus, are more rigid and controlled. The painting is constructed on the basis of firm equilibrium and juxtapositions of masses, while at Assisi the prevalence of curved lines anticipates the airy and pathetic inconsistency of Duccio.

Fortunately the controlled stylization is accompanied by a happy and spontaneous plasticism, a

solemn balancing of masses and a wide range of splendid colors. Here, given the irredeemable losses of Assisi, we have the first true revelation of Cimabue as a colorist, capable of efficaciously rendering the traditional chromatic range and, as we would expect, removing from it every symbolical echo. The Christ Child's violet robe acts as a valid mediation between the Madonna's red tunic and blue mantle. They are also linked in a unity, which is at the same time affective and structural, by the double contact of the outstretched hand and foot.

One feels a slight sense of foreign plastic-volumetric influence. This is the period when perhaps Giotto separated himself from Cimabue (if Cimabue was his teacher as well-founded tradition would have). Apart from individual differences in details a close relationship unites this altarpiece to a problematic work of the young Giotto: the Madonna di San Giorgio alla Costa, in which the serene and lyric conciliation which Cimabue sought to attain between man and the earth comes under sharp attack. The colors are drier and more closed, the reiteration of the lines and the poses are pushed to extremes that approach sculpture with, perhaps, the intention of forcing the devotional theme back to the inaccessible level of the sacred. Many words are not necessary at this point to recall how Giotto, in reaction against Cimabue, allied himself with the Florentine modeling tradition, rejecting the influence of French Gothic. Duccio, although also hostile to Cimabue, but for opposed reasons, pushed this courtesy-Gothic to its limits, destroying plasticism in following the new style by sweetening the angels, saints and Madonnas. The Madonna dei Servi of Bologna curiously finds itself half way between these opposing tendencies. It accepts a little of both worlds and indicates the maximum point that Cimabue felt he could go in accepting the new style. The temptation arises to imagine that one or the other of Cimabue's great followers, Duccio or Giotto, assisted in the Bologna work.[89] But Duccio as well as Giotto had at this juncture already received taxing commissions from the Dominicans and, perhaps for some time, had been working independently.

Cimabue and Duccio

This same temptation — to suspect Giotto's participation — returns even more strongly when viewing the X-ray of the nearly coeval (c. 1286-88) panel that Folco Portinari, who seems to have been the father of Dante's Beatrice, commissioned for the Ospedale di Santa Maria Nuova. H. Hager, on the basis of iconographic deductions, has recently identified it[90] [Figs. 5-7]. The Madonna's face with its clearly marked eyebrows and nose, with its roundness that is analogous to the very volumetric face of the Christ Child carries us very near to

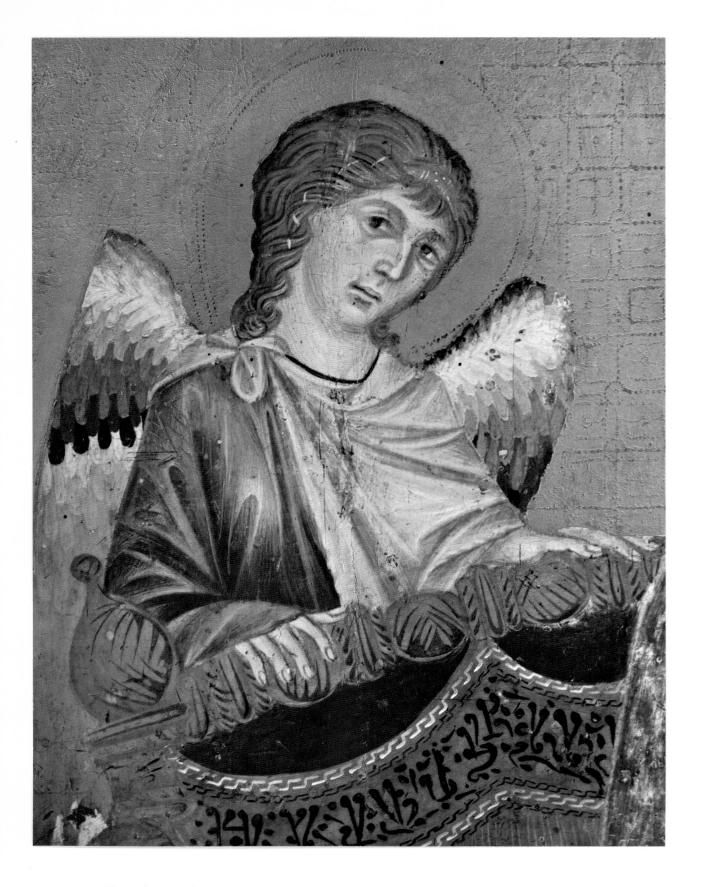

58 - MADONNA AND CHILD ENTHRONED WITH TWO ANGELS (*detail, an angel*)
Santa Maria dei Servi - BOLOGNA

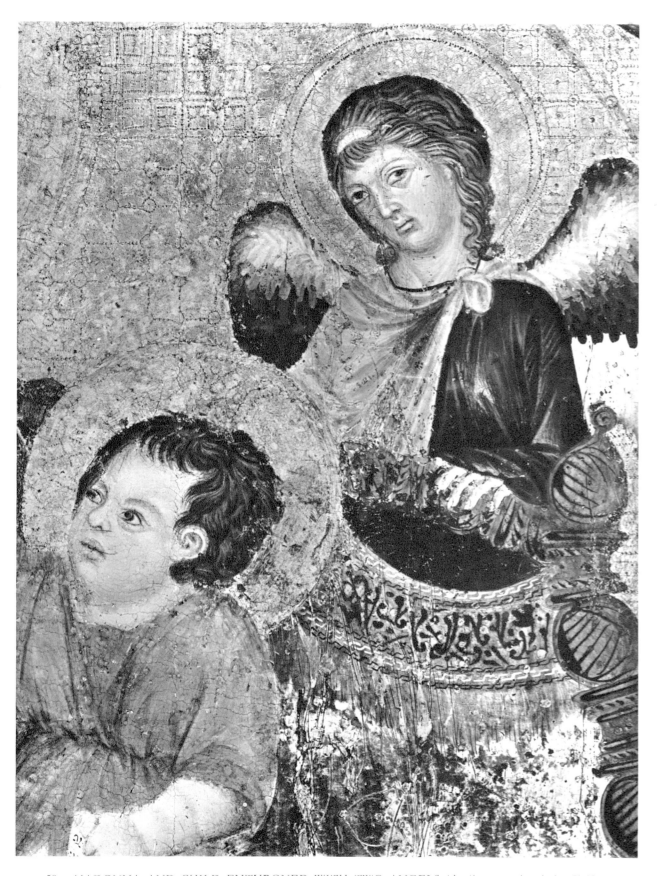

59 - MADONNA AND CHILD ENTHRONED WITH TWO ANGELS (*detail, an angel and the Child*)
Santa Maria dei Servi - BOLOGNA

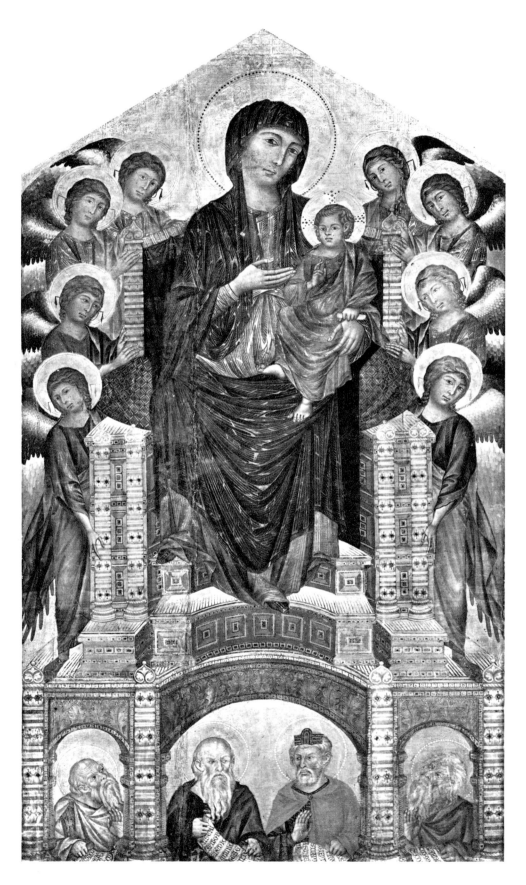

60 - MADONNA AND CHILD ENTHRONED WITH ANGELS AND PROPHETS - *Uffizi* - FLORENCE

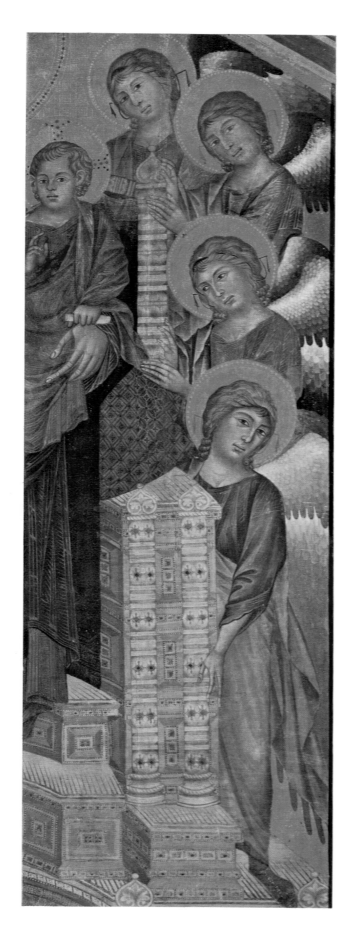

61 - MADONNA AND CHILD ENTHRONED
WITH ANGELS AND PROPHETS (*detail*)
Uffizi - FLORENCE

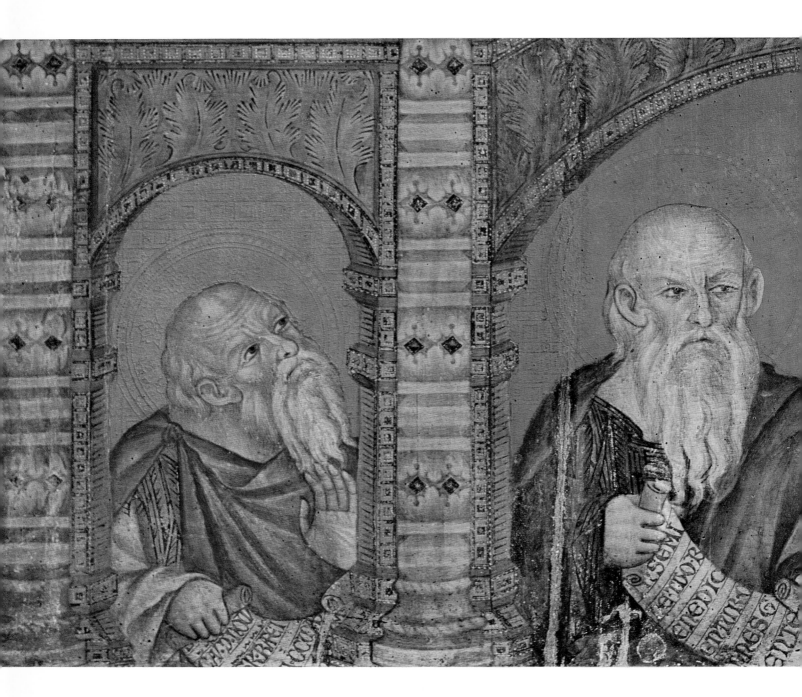

- MADONNA AND CHILD ENTHRONED WITH ANGELS AND PROPHETS (*detail, the Prophets*) - *Uffizi* - FLORENCE

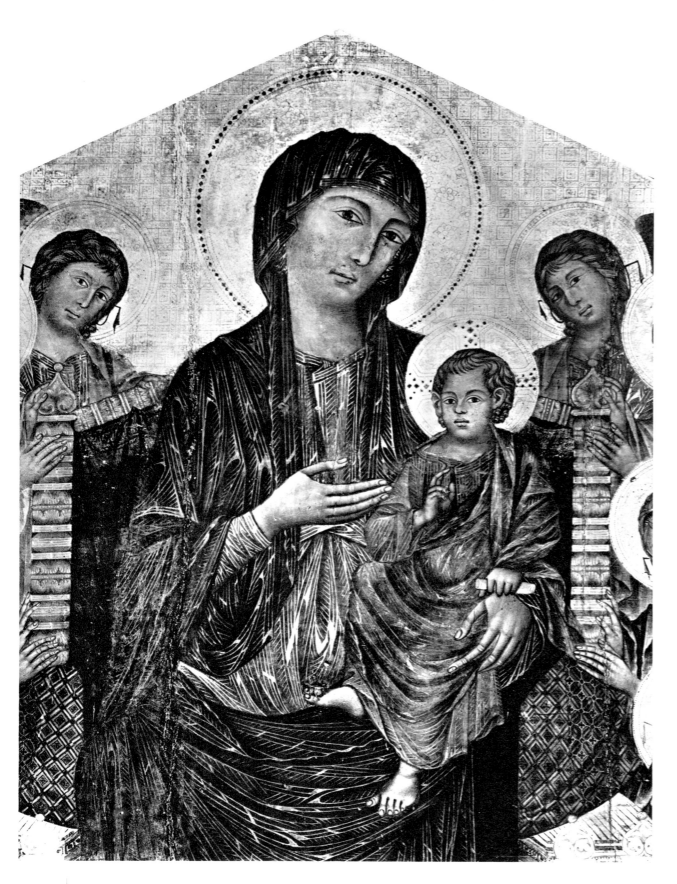

64 - MADONNA AND CHILD ENTHRONED WITH ANGELS AND PROPHETS (*detail*) - *Uffizi* - FLORENCE

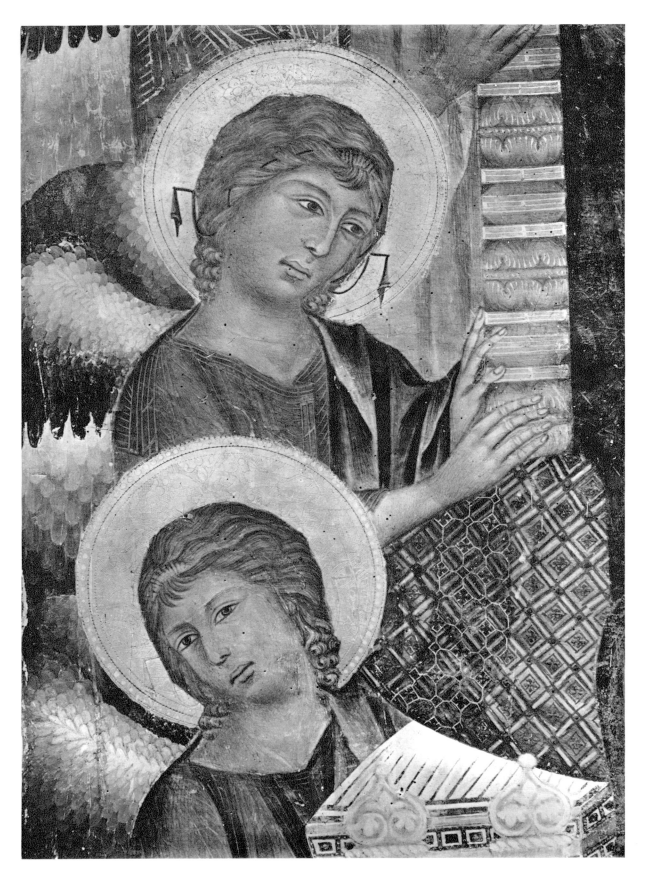

65 - MADONNA AND CHILD ENTHRONED WITH ANGELS AND PROPHETS (*detail, two angels*) - *Uffizi* - FLORENCE

the first scenes of the Life of St. Francis at Assisi by Giotto. Without indulging in too much fantasy one could imagine, like a scene in a novel, a fiery dispute between the pupil who denounces his master's plastic timidity and Cimabue, the master, holding that Giotto, the pupil, was anachronistic in elaborating his neo-Romanesque style in the face of the many Gothic influences. Certainly, the years from 1285 to 1290 heralded a radical change — Cimabue is rendered obsolete by the modern artists.

Perhaps Cimabue's decisive defeat in the eyes of the Florentine public was the solemn inauguration of Duccio's altarpiece for Santa Maria Novella, which was accompanied by a popular festival that is legendary. The transfiguration and emotive unification of the sacred image is realized to the fullest extent. Every detail contributes to the effect. The old hieratic and coldly dialectical relationship between prophets, angels, Madonna and Christ is broken. There is now a complete integration between the transcendency of the sacred image, richly decorated and iridescent in color in her phantom-like throne that seems to float in air as if it were a weightless nimbus. The process of humanization in the painting comes from the image of the Virgin who, although reigning over tiny angels, is realized by lines so undulating and by color modulations of so hedonistic a musicality as to awaken the most intimate emotive response in the beholder. In other words, it is the rationalistic inconsistency of this fine painting which gives it a value that is both mystical and naturalistic (or better, visceral). It is impossible to stabilize by means of the existing documentation whether Duccio's Rucellai Madonna or Cimabue's Madonna for Santa Trinita [Pls. 60-66][91] came first in the Florentine stylistic evolution that took place during the years 1280-90. Even though the large, freestanding, gable-shaped altarpiece derives from Sienese prototypes as Hager has demonstrated, the Santa Trinita Madonna does not show actual influences from Duccio. However, the altarpiece painted for the church of San Francesco at Pisa and now in the Louvre whose dating cannot be before 1295-1300 is closely dependent on Duccio's Rucellai Madonna both in its positioning and in the simplification of the relationship between the angels and the Virgin. Since this work, although substantially executed by an assistant of Cimabue, expresses so strongly Duccio's influence, it leads one to suppose that during the period Cimabue worked for Santa Trinita he was unaffected by Duccio's style because he was unaware of it. Moreover, workshop secrets were so jealously kept that knowledge of them meant one was a true initiate. The year 1285 is besides only a *terminus post quem* for the Duccio work. There is no indication that the great altarpiece, whose documentation does not specify the date of consignment, was executed by Duccio with any degree of rapidity. We know in fact that subsequently he made two trips to Siena: on 8 October 1285 and again in January of

1286. In the winter of 1287-88 Duccio delivered the design for the circular windows of the Siena Cathedral. Nor, given the large dimensions of the Florentine altarpiece, is it possible to think that it could have been executed outside the city or even outside the convent itself. Duccio had to spend the summers traveling from one city to another. But which were the effective working months of the year? And perhaps only after 1289 could the almond-shaped stylization of the eyes, if they were influenced by the oriental objects that presumably were brought to Florence by members of the famous Apostolic Mission of 1278, have appeared.[92]

Moreover, from what we can gather from the documents, Cimabue seems to have been prompt in executing his works. The terms of his contracts were very strict: a few weeks of work for the figure of St. John the Evangelist for the Pisa Cathedral; a year for the complex altarpiece for Santa Chiara. With Duccio, instead, we have many documents telling of fines for debts. He seems to have had the authentic bohemian temperament and, just as his best works demonstrate, he was by nature more instinctive and irregular than ordered and calculating. Cimabue, although starting later on the Santa Trinita altarpiece could have been able to make up the time differential and exhibit his work publicly before knowing of the extraordinary innovation of his genial adversary.

The Altar of Santa Trinita

The stylistic gap separating Cimabue and Duccio can be measured by the timid Gothic of Cimabue's Santa Trinita altarpiece[93] compared with the mature and ostentatious Gothic of Duccio's altarpiece for Santa Maria Novella which is a clear homage to France. But it is well known that architecture reflects the cultural position immediately. The commission for the Cimabue altarpiece seems to have come from Valentino II, a learned authoritarian man, who strongly defended the majesty of the Church against any claim of the layman. Cimabue's Madonna on the religious plane obeys an equally closed form of devotion. Doctrinal preoccupations, such as producing historical proof for the mystery of the Incarnation, are apparent in the figures of the prophets who are placed, congruously for the era as well as for their dignity, beneath the sacred image. The symmetry of the elements is absolute. It would be ingenuous to consider this symmetry, which is clearly seen in the plates, a consequence of the expeditious use of identical models. This repetition is accompanied by an equally strict execution of details: the perfectly geometrical and round pupils; the persistent use of the narrow hooked up band in the angels' hair (a device Duccio used as an alter-

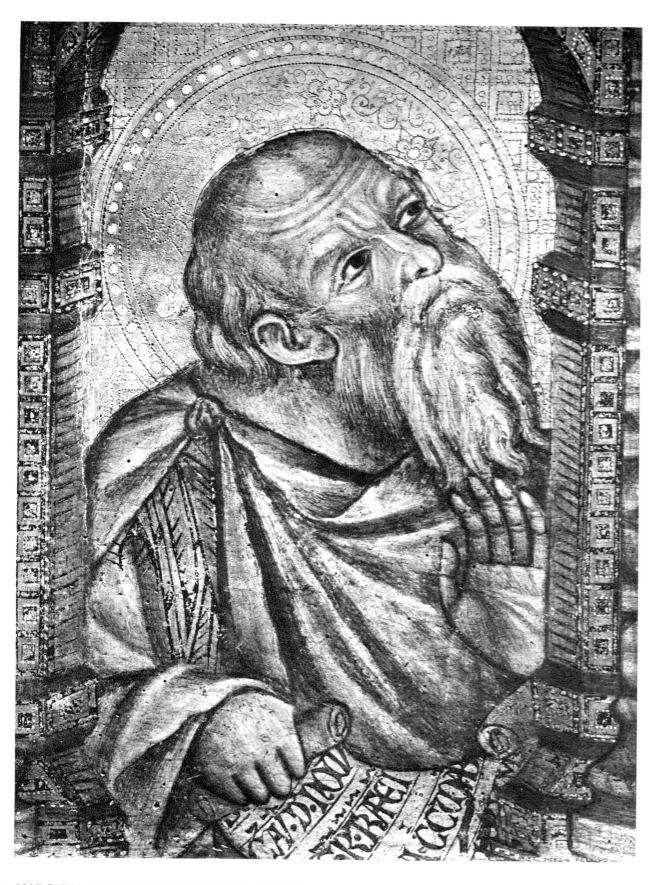

66 - MADONNA AND CHILD ENTHRONED WITH ANGELS AND PROPHETS (*detail, a Prophet*) - *Uffizi* - FLORENCE

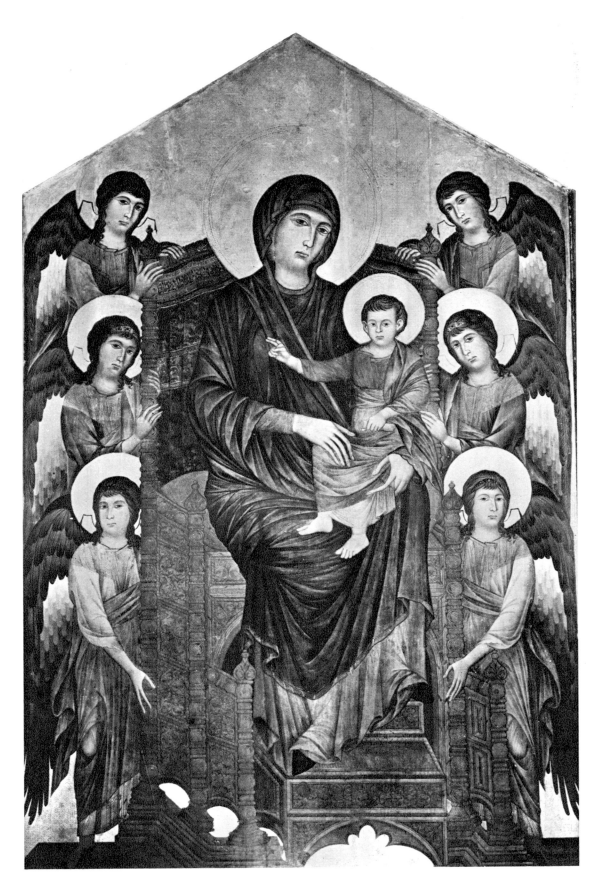

67 - MADONNA AND CHILD ENTHRONED WITH ANGELS - *Louvre* - PARIS

nate); and the repetition of the colors of the angels' robes on either side of the throne. When the conventions of a style are so clear it is impossible not to consider it intentional, especially when we have passages from literature that give it aesthetic validity. The commentary by Bauduin of Canterbury on the *Song of Songs* is, for example, pertinent.[94] It must, however, be remembered that this praise of symmetry is not an original trope: "Parilitas autem dimensionis secundum aequalitatem, similitudinem, compositionem et modificatam et commensuratam congruentiam partium non minima pars pulchritudinis est". "Non enim conveniunt oculi dissimiles aut inaequales, facies dispares, labia discrepantia — nec universo quaevis pars pulchre congruit quae a reliquae partis congruentia sua deformitate vel enormitate recedit" ("The symmetry of dimension, based on equality, likeness, composition and harmony proportional and commensurate in all its parts, constitutes a not irrelevant part of beauty". "In fact it is unsuitable to have diverse and unequal eyes, dissimilar features, ill-matching lips and if one part because of its deformity or largeness does not harmonize gracefully with the others, unity vanishes from the whole"). Yet, as is known, this principle of symmetry lasted little more than a century after which the canon of the treatise writers turned to the opposed principle of variety in gestures and expressions. Naturally there are also more spontaneous qualities in the Santa Trinita altarpiece. A great innovation in respect to earlier Florentine representations of the Madonna,[95] as all scholars have recognized, is the solemn architectonic elaboration of the throne. It is not only in perspective but plastically exalted and decorated with a geometric repertory that unites graceful recollections of Cosmatesque work with typical regional Romanesque motifs such as the stripes, the fasciae, the lozenge forms, etc. The iconography of the throne had enthralled Cimabue at Assisi. In his Madonna Enthroned with St. Francis the mystical sense of divinity is rendered within such architectonic realism that it conveys the certainty and power of the mediation of the Virgin between the human and divine. But now confronted with the Gothic aesthetic of transference, Cimabue's flight of stairs, where the distance is always measurable in terms of space, seems prosaic, almost pagan. The ascent to the Virgin's throne is reminiscent of the physically difficult ascent to the summit of the tallest Mesopotamian ziggurat. Still, if we think that the subsequent problem of the Florentines will be that of turning from the inconsistency of the Gothic with its lack of space to a perspective architectonic solidity, then Cimabue seems singularly anticipatory since for him structure gains possession of the sacred values of sublimity and magniloquence. Structure is so supreme that the Maestà theme is given over to the elaboration of the throne, and the divine image along with the other stereotypes seem only adjuncts to it. In his way Cimabue adored the throne exactly as they

did in Byzantium — the difference being that for the Byzantines the throne was a symbol and as such could raise itself to heaven — while for Cimabue it is earthly with its center of gravity toward the bottom instead of the top. Giotto will add still more weight, making it of marble instead of wood.

Though the Santa Trinita altarpiece is unfortunately very soiled, its sensitive and sophisticated chromatic details can still be appreciated. The gilt decoration and the ornamental designs are extremely rich; the faces obey the stipulations for the Late Medieval concept of beauty.[96] The Madonna's face, inspired by an ancient Byzantine-manner icon, is softened by a moving smile, by the curving soft brush strokes of the flesh, by the small mouth. Her eyes are elegantly stylized, though the pupils are round as in nature. The prophets are so domesticated as to completely erase the memory of those of Assisi who were so very expressive. These softening elements are, like the decorative overlay of the throne, applied in a rather external way on forms that are constructed according to strict plastic and geometric principles. In contrast Duccio's oval pupils are the emblem of an almost total accord between form and ornamentation, and cannot be thought of as successive additions.

To better understand the problem we turn again to Scholasticism and in particular to a passage from St. Bonaventure wherein the origin of beauty is considered to be twofold, inasmuch as an image besides possessing beauty by reason of its purpose may also assume an autonomous and subsequent beauty "quando bene protracta est", that is when it is well executed. There seems to be in St. Bonaventure's use of the verb an almost involuntary implication of effort and diligence in the execution of the image. At this point it is important to restate that from about 1260 — Coppo di Marcovaldo, an exemplar also in this respect, must be included — there was superimposed on the representative and semantic function of the image a series of provisos or, one might better say, a series of ornamental arabesques that ended by completely monopolizing the attention of the spectator. In other words the initial function of decoration was modified and transformed into a high and autonomous expressive function. It is the case of the famous almond eyes, certainly an exoticism, which by themselves suffice to individualize Duccio's work. Beauty innate in the execution rather than just the iconography has indeed an extraordinary evocative power on the observer, who from a detail is able to reconstruct the whole and understand the subject. We should consider whether these artistic investigations did not also have a remarkable evocative value for the faithful by clearly characterizing for them the icon of a church or an Order in respect to the others. In the art of the second half of the Dugento there is, for example, an analogous aesthetic component in a Cavallini or an Arnolfo in their archaeological or Antique allusions

or in the repetitious elaboration of the equal geometric folds of a Coppo di Marcovaldo or, in more banal cases, in the richness of the garments. Unquestionably the idea of the "protracta" beauty corresponds to the artist's awareness of his actual powers. He gained freedom, although commercial competition was, perhaps, his own justification. These were the years when the artist organized his activities commercially in order to assure himself of steady independent work.

The rhythmic cadences in Cimabue are now so apparent that the semantic aspect is reduced to a secondary position. The decorative stylizations are so conspicuous in the great Santa Trinita altarpiece and have such a quality of additions that the effect in comparison to the natural emotion of his earlier Madonnas is archaistic. While for Duccio decorative stylizations served to perfect the idealization of his images, for Cimabue, oriented always more intensely toward naturalism, they seem like incongruous tinselling. Their use is too systematic even if the goal is to emphasize the hieraticism of the image.

PISA

The works executed after Cimabue's return to Florence constitute in my opinion a curious hiatus. They reflect restlessness and uncertainty, an incapacity to adapt to the figurative world of the younger generation, coupled with a measure of readiness to engage in new experiments. Because of this the paintings, except the magnificent Madonna dei Servi of Bologna, are either incongruous and inconsistent or, at the least, introduce little that is new. While the ideas contained in the Assisi frescoes which had an innovatory value in Florence were continued and elaborated by his assistants and younger artists, the Santa Croce Crucifix' influence was confined to poor imitators, and the Madonna of Santa Trinita remained an isolated phenomenon. Moreover, Cimabue, in spite of his feverish work, lost contact with the most advanced Order: the doors of the Dominican church of Santa Maria Novella were closed to him. Neither did the directors of the Duomo workshop call upon him to take part, at least not in a determinative or recognizable way, in the work on the Baptistry mosaics. His transfer to Pisa about 1295 (?)[97] like his earlier trip to Bologna, though not signifying pressing economic difficulties, seems to indicate that appreciation of his work in Florence was not great enough to insure regular commissions. His pupils, Giotto above all, by taking from him acclaim, commissions and money also forced him to leave his native city. The Franciscans, though racked by internal disputes, alone remained faithful (but also here he was pursued by Giotto...). It was through Franciscan mediation that Cimabue was called to Pisa to paint the huge altarpiece now in the Louvre. It comes from the great church of St. Francis from where it was removed in 1811 to be exhibited in Paris in 1814.

Saint Francis' Altarpiece

Few of Cimabue's works are as much discussed today as this altarpiece and few are more difficult to judge adequately. Some Italian critics, following Longhi, consider that it is an early work and date it even before Duccio's Rucellai Madonna commissioned in 1285. Others, among them the present writer, believe it is later than Duccio's and consider it,

together with the mosaic for the Pisa Cathedral, one of the last works by Cimabue, viewing it as a proof of the master's difficulty to find new ways, or rather, to assert his stylistic independence from the painters of the new generation. Unfortunately there are no documents — at least as far as we know today — to enable us to date this altarpiece with absolute certainty, nor is what is known of the history of the church for which it was painted of any help on this point.

However, such a huge altarpiece (height 4.24 m., width 2.76 m.) can but belong, as H. Hager has pointed out, to the end period of the fashion for such painted altarpieces, it cannot be an early instance of the genre. Besides, it stands to reason that it could only have been commissioned to an experienced painter already enjoying a wide reputation. Now, it is only at the beginning of the 1300 that we find Cimabue entrusted with a work of remarkable importance, at Pisa, when the mosaics for the apse of the Cathedral were commissioned to him for which he received a relatively generous payment, giving a further indication of his position of prestige in the city. In the same circumstance we find him closely connected with a confraternity of artists whose headquarters served probably as the official residence for some of them. It would seem that, perhaps, there already existed a type of guild, headed by foreigners, which enabled artists to work on the site, and at the same time served cultural and assistance purposes, similar to those that the Opera del Duomo provided for architects and decorators.

Moreover, whatever the opinion one may have about the Louvre altarpiece, it would be difficult to deny that it is the result of a cooperation between one master and several helpers. The association of Cimabue with one or more assistants is documented both by the existing orders of payment made out for the Pisa mosaics and, as regards style, by the fact that it can be detected in all Cimabue's later works: in the Pala dei Servi as well as in the Santa Croce Crucifix where all the minor figures are clearly the work of another painter. In the Louvre altarpiece it was not possible, in view of the structure of the painting, to distribute the work so mechanically.

Yet, so long as a thorough cleaning and restoration of this altarpiece has not been carried out, it is difficult to pass a well grounded judgment on the differences of hands. Practically, only the heads (but not the hair), the hands and the dresses of the angels, the faces of the Madonna and of the Child are, as we see it today, intact, but they are put out of harmony with the gold background, cleaned to perfection from under a solid overpainting of chrome yellow paint which, however, when applied in the last century, had been harmonized, not without skill, with the rest of the picture.

The ensuing disharmonies are particularly damaging to the effects of a perspective, up to a point even aerial, which undoubtedly constituted the greatest novelty of this piece: if we try to visualize the colors of the angel's wings as much lighter, they recede at once to another plane; if the throne is brought back to its original lightness and brilliancy — now all its gilt ornaments are deeply darkened, almost like in a photographic inversion of light and shade — we would have a very effective aureole of light round the Madonna and Child. Moreover if we create a mental picture of the piece placed on an altar, a fairly high one, standing on a presbytery raised on a few steps, its spatial effect, its almost perspective effect, will appear to be very noticeable, and to represent a remarkable progress on the hesitating experiment of the slanting placement of the throne attempted in the Pala dei Servi at Bologna. Also the direction of the angels' glances focuses the attention to the center of the picture.

Along this way neither Duccio nor the strictly bidimensional and popular Maestro di San Martino, who might have been one of Cimabue's assistants in this very altarpiece, can keep pace with the master. In the unspoiled portions, also at the bottom of the altarpiece that is at the end of the work, the pictorial technique of crossed brush strokes appears to be the same that was used in the Santa Croce crucifix. The stiffness of the folds of the drapery, which can already be noticed in the Santa Trinita Altarpiece, is here stressed, not only because of a possible influence of the Gothic style (represented in Pisa by Giovanni Pisano and to which homage is being paid here in the trilobate arch of the steps of the throne) but, above all, to create a rich decorative texture, to replace the traditional gold-streaked ornamentation, which would have been altogether unsuitable for a Madonna that was to be represented in modest attire, almost as a goddess of poverty. Today I would no longer speak of archaism, of an outmoded pictorial style but rather of a new research in style, different from the work done in Florence. The Franciscan strictness, which had for a long time its bulwark in Pisa, may be the real cause of the change. The work of the assistants accounts for a certain hardness of line, but the altarpiece having been conceived to be seen from a distance required clear-cut contours of all the images. In fact this work, thanks to the skilful disposition of all its elements, the subtlety of its volumetric research, the greater simplification, the longer proportions and above all, thanks to the visual unification of its theme represents a real progress in comparison to the more hieratic and, if one wishes, more Romanesque, St. Trinita altarpiece. The negative aspects of the Louvre painting indicate that Cimabue at the age of around fifty to sixty was no longer able to maintain or reconstruct a large studio of personally instructed assistants capable of executing his ideas without

betraying them and of consequently widely diffusing them. This practical limitation weighed on his old age more than any theoretical hesitancy. His last known work indicates that adaptation to the Gothic style, that earlier had been so difficult, he was now able to resolve more happily.

The Mosaic for the Cathedral

The accentuated balance of the figures, the trend toward unity which are only presentiments in the Louvre altarpiece are wonderfully brought to fruition in the St. John the Evangelist [Pl. 68], a mosaic for the apse of the Pisa Cathedral. This commission, among others, demonstrates the notably high degree of esteem enjoyed by the Florentine Master who was invited to the most famous workshop in Tuscany for the specific purpose of decorating the apsidal vault. One would expect that here, within sight of Giovanni Pisano's pulpit, Cimabue's image now would be substantially Gothic, and that the archaizing and rigorism present in the Louvre altarpiece would lessen. Cimabue does not disappoint us. Moreover, since the colors of the tesserae have not changed, we discover how elegant and flexible his palette must have been.

On the gold ground, which in the white-blue atmosphere of the church assumes a gray-green tonality, the figure of the Evangelist, instead of triumphing in majesty with the livid plasticism of the Crucifixions, has the inconsistency of a tenuous apparition. Very delicate chromatic relationships, not unworthy of Duccio at his best, pass from the gray-rose of the skin and the blue of the robe to the violet-blue of the mantle. The hair, that in the Crucifixions and in the important isolated figures in the frescoes was strongly marked by areas of unified color and constituted a dramatic expedient, is in the St. John almost blended into the still more delicate passages of the skin tones. The mosaic technique which can often be a betrayal, is here so successful that it permits one to intuit and discover, as if it were a panel painting, Cimabue's late style of painting. We saw how the rapid and direct brushwork of the Santa Croce Christ threw volumes back into relief by means of the light springing from an exact stereometry rather than through the actual representation of volumes. Here at Pisa the mosaic underlines a color treatment even more free and compendiary. Cimabue does not subdivide colors into their pure components but, more than ever, identifies them by light. In the middle range of tonalities that make up the whole image, the large homogeneous areas of the hands and face are almost phosphorescent. The touches of light separate gradually from the rose-gray background to accompany the natural reliefs of the body, but very quickly forget

this function and take the shape of vibrating, luminous, autonomous forms. This chromatic poetry is so subtle that it becomes noticeable only after a long and attentive study. It contrasts particularly with the sharp brilliant tints of the Madonna in the center of the apse. Subtlety, the dissolution of plastic volumes, or at least of a plastic illusion, a lyrical tone without dramatic contrasts are the unexpected characteristics of this great Pisan masterpiece. Cimabue, however, did not abandon his great ability to structure form. The St. John maintains, indeed, a strict co-ordination of a type more inward than apparent. The image with its careful drapery forms an ideal kinship with the Antique world: the Evangelist has the tranquil nobility of an ancient philosopher, although the elongation of his proportions places him on another, more modern plane of spirituality. On a secondary level functional lines of purely pictorial value are present, creating efficacious directional and proportional contrasts within the figure — here Coppo di Marcovaldo again comes to mind.

The figure's modulation is static and verticalizing, the folds of the mantle, largely restored, fall with plumbline exactitude. The head is inclined but not enough to disturb the figure's equilibrium as the forward movement is completely compensated by the mass of his hair. The Evangelist's act of adoration of the Madonna is very evident. To this end Cimabue availed himself of the contrasting and compositive expedients of which he was an insuperable master. Thus the right shoulder of the Evangelist is highlighted and the asymmetry of the neckline of the robe, with its wide gold band that meets the mantle as it slips from the shoulder, is accentuated. The right eye (from the spectator's point of view) is asymmetrical, placed higher than the left eye and appears to be half closed. Attention is thus focused on the left eye whose gaze is directed toward the *Majestas*. The greater brilliance of the blue in respect to the violet reinforces the submissive attitude of St. John to the central figure.

With a structural scheme of such sobriety and calmness it would seem completely unjustified to speak of Gothic taste, of gracious idealization. And yet, notwithstanding the abyss separating the Evangelist from the vehement expressiveness of Giovanni Pisano's pulpit several yards away, one must recognize that Cimabue's work is equally modern exactly because of its delicacy and spirituality. There, where they are not limited by fasciae or shadowed areas, the lineaments of the face are traced with very light red lines. These facial lines, in contrast to the dark zones that are almost always geometrized and hardened by the mantle folds, have the elegance of authentic arabesques. By their discontinuity they give the impression of a spontaneous design drawn at the last moment. In fact we know from documents that Cimabue with the aid of an assistant laid the tesserae himself.

We have stressed the chromatic dissolution, the dominant gray tonality and the lack of plastic

aggressiveness in the image. However, it would be erroneous to deduce from these characteristics that Cimabue's most grandiose quality, the continuing attempt to assimilate the metaphysical into reality, fails at Pisa. At Pisa the process is pursued with serenity in the spontaneous integration of the sacred into the human, passing beyond polemic. This peaceful integration may perhaps be symbolized by the tranquil manner in which the Evangelist holds in his large hands the book, emblem of the universality of the world. Naturalness and knowledge joined.

CONCLUSION

After Cimabue's Gothic development in Pisa, an evolution that must have culminated in the Santa Caterina polypytch, the framework of which was similar to the type Simone Martini would use, the artist, according to Vasari, was called to Florence to collaborate with Arnolfo in the building of the cathedral. There he was buried. Vasari writes that his tombstone was inscribed:

> Credidit ut Cimabos picturae castra tenere,
> Sic tenuit vivens, nunc tenet astra poli.

Unfortunately, these words are a translation of Dante's famous lines. In any case caution is required in assessing Vasari's account, as it was written much later and may perhaps be a literary invention. No document refers to Cimabue as an architect.[98] There is support for this position, it is true, in the very able stereometry displayed in the buildings painted with perspective maps in the Upper Church of Assisi, as well as in his insistent use of measuring instruments, not only in his decorations but also in the construction of his figures; in the unusual richness of his architectonic enframements; and in his ability to distinguish in the layout of the frescoes, the functional elements of the church architecture from those that were not weight bearing, reserving to the latter the narrative schemes. He reveals a strong inclination toward architecture — an inclination that will be peculiar to all Renaissance art in Tuscany. The Cimabue legend again indicates the existence of a real problem whose effective limits may be better understood in the future.

A return to the lines from Dante is perhaps the best way to conclude this study. At the outset we learned from these verses to appreciate Cimabue's quality as an innovator, and from them other aspects of his contrasted heredity may be understood. Without question Dante grasped the passage from one artistic world to another, and attributed this change to the coming of a new generation and to the increasing complexity — progression, if one likes — of cultural life. Cimabue created a style that, in Italy from 1272 to about 1285, belonged to the advance guard. After 1285 he had to reconcile his ideas to those of others. It is not true, however, that when Dante wrote his famous lines about 1310,[99] Cimabue had already been obscured and passed over. His greatness must have continued to astonish his contem-

poraries if Sacchetti, in referring to a discussion of painters that might have taken place about 1350 in the monastery of San Miniato overlooking Florence, states someone placed Cimabue, if not above Giotto, then certainly above his followers. This is high praise, coming seventy years after the acme of Cimabue's glory.

Times, however, had greatly changed and Cimabue's influence must have already appeared seriously limited. We find this confirmed when we consider the geographical range of his activity. Giunta travelled between the convents of Bologna and Assisi, perhaps to Rome, and in the area of his native Assisi. Coppo, with a more varied patronage, left works in Florence, Pistoia, Siena, Orvieto and San Gimignano. Cimabue, despite his high prestige and renown, found his fame confined to an only slightly larger area: Assisi, Rome, Florence, Pisa, and, when a young man, Arezzo. But Giotto's sphere of patronage stretched from Florence to Rome, from Assisi to Rimini, from Padua to Milan, from Bologna to Naples, and almost to Avignon. Giotto's followers had even larger spheres of activity, who modified the pictorial style of all Italy and a large part of Europe as well, while Cimabue's identifiable followers at most penetrated only to Genoa. Given the losses and the dearth of documents these indications certainly remain approximate, but they do point out in an almost visible way the triumph of the new generation. During Cimabue's lifetime the cultural and civic panorama was extraordinarily enlarged. In painting, part of this amplification must be credited to him. However, he was overcome by the movement that he himself had started. Thus it seems one must interpret, across the span of centuries, Dante's melancholy words.

Because of the dispersion, in a large measure definitive, of the documentary evidence, as well as the inadequacy of the specific research now at our disposal for this general survey, only a small part of the stylistic itinerary and cultural mutations of Cimabue have been dealt with in the preceeding pages. For these reasons we grasp his greatness largely through intuition after we have removed the barriers erected by anachronistic tastes and aesthetic training and the annoyance caused by the poor preservation and the chromatic degeneration of his work. Then we can directly dispute with his ideas, face again the problems he confront-ed, and distinguish the innovatory elements from those in general use, mentally reconstruct the genesis of his masterworks, and comprehend the practical and conceptual forces of the cultural context that fostered them. But even then Cimabue remains a difficult artist, closed and disdainful, full of inaccessible originality. If after attempting a colloquium with Cimabue one turns back to Dugento painting, the great forward movement that was accomplished, thanks to him, becomes very clear in respect to the various local traditions which he opposed with a proud commitment to syncretism. In comparison to Florentine painting, the vault

mosaics in the Florence Baptistry, for example, whose colors are almost undiminished by time, Cimabue stands out for the superior conceptualism that allows him to construct forms that are at the same time severe, powerful, and sublime even in comparison to the Florentine style that later triumphed. It is this gift that Giotto will inherit and which will contribute to giving to the pictorial image a definition and firmness equal to that of sculpture. Plasticism, rationality, constructive power, the insertion of tragic passion into a system, and a highly optimistic, positive almost materialistic concept of the world — all these are characteristics which emerge with Cimabue and distinguish his art from that preceding it, including the work of Coppo di Marcovaldo who by now is a part of the past. Confronted with the Roman tradition, with a truly prophetic innovatory power he breaks the equilibrium of the tired classicizing of the painting of history that had continued in Rome throughout the Dugento. He breaks it so decisively that his most authentic inheritors appear to be Andrea del Castagno and Donatello. In so doing he filled his art with the vehemence and rebellion of his own impulsive feelings, rediscovering the problematic of the sublime. We deal here with a concept that finds a parallel in Jacopone da Todi and consequently with Franciscan mysticism: "In my opinion", writes Auerbach,[100] "the first sublime style of Medieval Europe arose in that moment when the single event fills itself with life", and with a similar outlook exalted "the free release and dramatic cries of sorrow, fear and invocation which Jacopone expresses by vocatives, accumulated exhortations and pursuing questions" praising the "fiery abandon to feeling" the "lack of timidity in giving public vent to his emotions", that is to say, those characteristics we find in the Assisi Crucifixion. Yet, in my opinion, the only possible comparison with Cimabue must be sought in poetry of a much higher order — in Dante and in Mussato if we stay within Medieval Italy, in Seneca if we wish to place Cimabue in a sufficiently vast humanistic tradition. The Magdalen, who with upflung arms inveighs against Christ's assassination, is by all rights the heir of a classical heroine — Andromache of the Troades. Jacopone's Donna del Paradiso, in spite of the intense emotive rhythms of the narrative, dissolves her protest in a lament:

> O figlio, occhi jocundi, Io comenso el corrotto;
> figlio, co' non respundi? figlio, mio deporto
> Figlio, perché t'escundi figlio chi me t'ha morto?
> dal petto o' se' lattato? figlio mio delicato!*
>

*O Son, joyous eyes, — Son, why do you not answer? — Son, why do you hide from — the breast that nourished you?...I begin the lamentation; — Son, my joy — Son, who has made you dead to me? — Son, my gentle one!

76

There is no escape from the drama written by the prophets. Religious catharsis in a certain sense precedes the event. In Cimabue's painting the drama is anything but resolved, or, at least, its fatal conclusion is certainly not peaceful. We have mentioned Seneca's Andromache: the tragedy of Troy had also been prophesied, and for all the hour of death and lamentation had arrived. Andromache, however, does not renounce her right to protest. And while the crowd abandons itself to terror she cries out in rebellion:

> You have profaned the temples
> of the Gods
> But I, even though woman,
> Will resist
> with my unarmed hands
> against yours cruel and armed.
> Strength, wrath will give me strength
>
> I will rush among you,
> I will fall to the tomb
> That I have so strongly defended
>
> Me, me, destroy me first
> Kill me with the sword.

Pictorial precedents exist, for example, in Ottonian culture and, if one wishes, in the Eastern Provinces. There is an Assumption in the Lower Church of San Clemente dating from the period of the papacy of Leo IV (847-55) where, though ritualized, the gesture of stupefication has an immediate emotive effect on the spectator. And in the Crucifixion in the crypt of the abbey of San Vincenzo in Volturno we find the same violent emotion in the Virgin and St. John. For this re-evaluation of pathos we should also recall the movements of the flagellants. Although they did not give rise to an efficacious and original style in art, they presumably imply the recovery by the cultivated middle class — the movement was operative also on that level — of an emotionalism that paid no heed to any concept of decorum or rule whether stoic, classic or literary. Kerényi[101] has observed that the cult of the cross, the Holy Week processions which still take place in central Italy, has a close seasonal coincidence with the bloody celebrations "with tree and rush, with blood and joy" of Attis, the lover of Cybele. And like the flagellants of the Dugento, "Cybele's priests lacerated their shoulders and arms with knives and their backs with knotted whips. The sounds of flutes, cymbols, raganelle and drums accompanied the frenzied dance in which they sacrificed blood, their own blood... mutilators of themselves, the devil's prey in the eyes of the Christian...". And the tree sprinkled with blood is by their pledge more than a symbol of resurrection and survival. To this archaic

pathos Cimabue certainly gave the most complete and coherent image. And precisely because he felt it himself, he becomes one with the greatest visionaries in the history of art, for whom the mystery, that is the irrational, the myth and, if we wish, the archaic, flowered and exploded into consciousness, marking the outermost limits of bookish awareness. Rationalism and irrationalism are present together as never before in a single work of art. There is in the Crucifixion with its dark and tragic tone the realization that action or revolt has at least a determining value, constituting both the history and the image.

Unfortunately Cimabue's Gothic moment or better, the "courtesy-Gothic" moment, is less tangible. He accepted the mythology, the literary rhetoric, the chromatic iridescence of the new moral climate, but did not remove from his work the structure of real values: solid, measurable, architectonic. The Gothic moment, moreover, had already appeared in the scenes of the life of the Virgin in Assisi. In fact, Cimabue's happiest Gothic realization is the Madonna with St. Francis in the Lower Church, where finally an affective relationship, communicative and affinitive, is established between the figures. But the expressive intensity which characterizes the figures convinces us that the Gothic Arcadia, almost more rational than devout, would have been an uncertain victory, not a peaceful adjustment in a world freed of all problems and on the contrary just for the age in which he lived. Cimabue could adjust partially to a new civilization in which the eschatological values reflected in the Assisi cycles became a far away memory: a new civilization in which facility became the touchstone in the arts, a dissolving of rigorous demands in a peaceful adjustment of the individual to the world and its vicissitudes. Cimabue's journey is the reverse of that travelled by the great Renaissance masters such as Titian or Michelangelo, who, in the beginning, were integrated in a literary and relatively optimistic civilization and who with successive experiences moved toward isolation and inner turmoil. But until that time, everyone had to take into account the enormous range of stylistic and human problems that Cimabue was the first to infuse into painting to such a degree that, in the light of history, he emerges not as a precursor but the nucleus, the compendium of almost all Italian art.

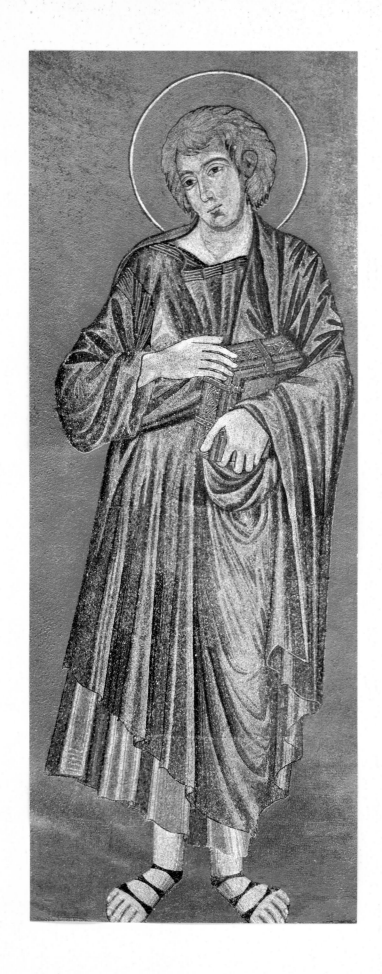

68 - ST. JOHN THE EVANGELIST
(detail of apsidal mosaic) - Cathedral - PISA

NOTES

1) The fundamental bibliography of Cimabue, which I have referred to constantly, is composed of a very few books: JOSEF STRZYGOWSKI, *Cimabue und Rom-Funde und Forschungen zur Kunstgeschichte und zur Topographie der Stadt Rom*, Vienna, 1888, some of Strzygowski's theses are re-explored in this book; ERNST BENKARD, *Das literarische Porträt des Giovanni Cimabue*, Munich, 1917 — this valuable collection and study of the Cimabue source material remains an indispensable tool (even though PAATZ in *Die Kirchen von Florenz* has reconsidered most of the documents, which have also, in part, been re-examined by P. MURRAY in *An Index of Attributions made in Tuscan Sources before Vasari*, Florence, 1959, pp. 49-51, the major part of this source material is reproduced in the Documents appendix of this book); ALFRED NICHOLSON, *Cimabue, A Critical Study* in the series Princeton Monographs in Art and Archaeology, Princeton, 1932, has the most complete illustration of the Assisi cycle, including the upper scenes; ROBERTO SALVINI, *Cimabue*, Rome, 1946, together with his article " Postilla a Cimabue " in *Rivista d'Arte*, XXVI, 1950, pp. 43-60 and his entry " Cimabue " in the *Enciclopedia Universale dell'Arte*, III, Rome-Venice, 1958, col. 470-75, Pls. 249-56. For the art of Cimabue's period, excepting Assisi studies which I will cite separately, the catalogue of the 1937 Giottesque exhibition in Florence, *Pittura Italiana del Duecento e Trecento* by GIULIA SINIBALDI and GIULIA BRUNETTI, Florence, 1943, and E. H. GARRISON's index *Italian Romanesque Panel Painting*, Florence, 1949 (with subsequent amplifications), are essential. On the interpretative plane cf. the questionable " Giudizio sul Duecento " by R. LONGHI in *Proporzioni*, II, 1948, pp. 5-55; R. OERTEL's excellent volume *Frühzeit der italienischen Malerei*, Stuttgart, 1966; C. L. RAGGHIANTI's well illustrated *Pittura del Dugento a Firenze*, Florence, 1955, makes important attributive contributions; F. BOLOGNA, *La pittura italiana delle origini*, Rome-Dresden, 1962, although closely following LONGHI, is broader and more balanced with a generally positive attitude toward Italian Medieval painting. See now in the popular series *I maestri del colore* Number 113, " Cimabue " by F. BOLOGNA (Milan, 1966) in which two of the photographs made exclusively for the present volume are reproduced without permission or reference to the source. The bibliography does not cite the present work just as the other monographs on the Master by Nicholson and Salvini, which oppose certain of Longhi's opinions, are uncited. The very mediocre " portrait " of St. Francis in Santa Maria degli Angeli is reproduced in color. See the Catalogue of the Works for further observations.

2) STRZYGOWSKI published the Roman document. The Pisan documents have been published and discussed by CIAMPI, A. DA MORRONA, G. FONTANA, L. TANFANI-CENTOFANTI, I. B. SUPINO. Cf. Documents appendix.

3) R. LONGHI (" Giudizio sul Duecento ", *Proporzioni*, II, 1948, pp. 16-18, 46, Pls. 22-30): Madonna and Child between Sts. John and Peter, Contini-Bonacossi Collection, Florence; St. Francis, S. Maria degli Angeli, Assisi, reproduced in color by F. BOLOGNA in *La pittura italiana delle origini*, Rome-Dresden, 1962, Pl. 73; Nativity, Last Supper, The Betrayal of Christ, Last Judgement, Longhi Collection, Florence; Kress Collection, New York; Private Collection, Milan; Madonna Enthroned between Sts. Francis and Dominic, Contini-Bonacossi Collection, Florence; Flagellation, Frick Collection, New York, attributed to Cimabue by R. LONGHI in *Art News*, Feb., 1951 — others attribute it to Duccio or an anonymous Sienese; earlier frescoes of the Cappella dei Velluti in Santa Croce by C. L. RAGGHIANTI in *Pittura del Dugento a Firenze*, Florence, 1955, pp. 112, 126-27. I have not noted completely inconsistent attributions such as, for example, that proposed by G. B. SALERNO in *Atti e Memorie della Società Tiburtina*, Tivoli, 1954, pp. 159-63 of a fresco at Tivoli. For the presence of Cimabue's hand in the Florentine Baptistry cf. list of attributed works. Opposition has been voiced by E. B. GARRISON, among others, to arbitrary attributions which threaten to again confuse Cimabue's unified stylistic profile in " The Rôle of Criticism in the Historiography of Painting " in *College Art Journal*, 2, 1959-61, pp. 110-120, where on page 114 we read: " in Prof. Longhi's portentous judgment upon the Ducento, we find an evaluation of the Florentine Cimabue, based upon works some two thirds of which are not by him — a few not even Florentine — and an evaluation of a Pisano, his so-called ' Maestro della Madonna di S. Martino ' who is, I here repeat, none other than Raniero di Ugolino, based upon four works, two of which — one half — are not by him, all four of which are erroneously dated, and among which one of his production may be sought in vain ".

4) HELLMUT HAGER, *Die Anfänge des Altarbildes in der Toscana*, Veröffentlichung der Biblioteca Hertziana (Max Planck-Institut in Rom), Munich, 1962.

5) J. WHITE, *The Birth and Rebirth of Pictorial Space*, London, 1957.

6) For the history of aesthetics it is sufficient to cite EDGAR DE BRUYNE, *Études d'Esthétique Médiévale*, Brugge, 1946, and R. ASSUNTO, *La critica d'arte nel pensiero medioevale*, Milan, 1961, with bibliography; and for the history of figurative art, E. PANOFSKY, *Renaissance and Renascences in Western Art*, Stockholm, 1960, which includes a full bibliography arranged according to subject.

7) I wish to thank my friends Carlo Battisti and Tullio de Mauro to whom I turned for information and who, together with W. Belardi, excluded the possibility that the name might be of a toponymical origin.

8) I have referred to E. H. GOMBRICH's extensive and stimulating essay " The Renaissance Concept of Artistic Progress and its Consequences " in *Actes du XVIIe Congrès International d'Histoire de l'Art*, Amsterdam, 23-31 July, 1952 (The Hague, 1955), pp. 291-307.

9) E. DE BRUYNE, *op. cit.*, Vol. II, pp. 406-20. Concerning the prestige that architects had acquired cf. also the brief but documented study by J. GIMPEL, *I costruttori di cattedrali*, Milan, 1961.

10) For Cristoforo Landino, cf. O. MORISANI in *The Burlington Magazine*, 1953, 95, pp. 267-70 and P. MURRAY, ibid., pp. 931-32. CARLO VOLPE in *Paragone* 173 (May, 1964) ironically denies that Landino made use of Plinian meanings and references. However, Landino was responsible for the first revised edition of Pliny in 1469 and for the first Italian translation in 1470.

11) I have used the edition and translation edited by SILVIO FERRI, Rome, 1946 (L.XXXV, 67), pp. 152-53.

12) Cf. R. ASSUNTO, *op. cit.*, pp. 259-84, " Concetto dell'arte e ideali estetici in Dante ".

13) For the Dante-Giotto relationship cf. E. Battisti *Giotto*, Geneva, 1960, pp. 21-25; F. Rossi, " La data della cappella del Podestà " in *Giotto e il suo Mugello*, Florence, 1937. Style affinities have been individuated contrarily by M. Gosebruch, " Vom Auftragen der Figuren in Dantes Dichtung und Giottos Malerei ", in *Festschrift Kurt Badt zum siebzigsten Geburtstage*, Berlin, 1961, pp. 32-65. For Cavalcanti cf. P. Bigongiari's magnificent study in *Secoli vari*, " Libera Cattedra di Storia della Civiltà Fiorentina ", Florence, 1958. For the parallelism between poets and painters in Dante see A. W. Byvanck " Dante e Cimabue " in *Dante Alighieri 1321-1921, Omaggio dell'Olanda*, pp. 68-78. My observations on the significance of the association made between poets and artists by Dante are developed from those of M. Dvořák in his 1913 review of the article by F. Rintelen " Dante über Cimabue ".

14) E. de Bruyne, *op. cit.*, III, pp. 121-52.

15) F. Bologna, *La pittura italiana delle origini*, Rome-Dresden, 1962, pp. 108-9.

16) R. Longhi, " Giudizio sul Duecento ", where on p. 9 we read, " There is another observation, this time 'thematic', that cannot be left unsaid, above all in order to tear down the claim, advanced more and more frequently from all quarters, that in the realm of the figurative arts that frozen textual Byzantinism was inspired by the Franciscan spirit. Let us be quite clear — there is not here an instance of the customary exigency, so dear to cultural historians, of art reflecting in its manner, and straightaway, the new religious currents, in this case the Franciscan moral renewal. We must take cognizance of the fact that although the Dugento Sienese, Lucchese and Florentine artists certainly used Franciscan themes so filled with hitherto unknown spirituality, this great new experience was ground out indifferently by the Byzantine mill, if it is acknowledged that for fifty years, from Bonaventura Berlinghieri to the Maestro di Pisa to the Maestro of Santa Croce (Florentine with Lucchese influences) St. Francis was portrayed — not even like a Benedictine — but like a surly embittered Basilian. This same indifference is reflected in the St. John the Baptist in the aforementioned Sienese altar frontal, who is shown seated on the throne almost in the guise of a Tsar of the Bulgars. If these are pictures painted by Italians then it would have to be said that a good many of our countrymen were 'Balkanized' to a high degree. If they are the work of immigrants the verdict remains the same : an alien and forced graft on the body of Italian art ".
In regard to the last sentence it is worthwhile to recall Garrison's ironic comment that in 1938-39, the date when Longhi's study was written, was the period in which Italy was dominated not only by Benedetto Croce's aesthetics, but also by the racial myth. There is to my knowledge no integrated study of the relationship between the religious world of the East and that of Italy in the 13th century that would be useful for a parallel interpretation of the art of the period. However, in the political-military sphere we recall the establishment of the Latin Empire of Constantinople from 1204 to 1254, and the fall of Constantinople in 1261. During this period there were continuous attempts to heal the schism of 1054. The repercussions of these events were felt in Venice (Tommaso Morosini, moreover, was the patriarch of Constantinople) and must have indirectly influenced the whole course of the Italian stylistic development.
The popes who reigned during the last decades of the Dugento, when Byzantine influence was most direct and evident, all engaged in attempts to bridge the rift with the Greek Church. Alexander IV (1254-61) approached the Eastern Emperor; Clement IV (1265-68) asked the Dominicans for messengers to send to Greece; Gregory

X (1271-77) arranged the Council of Lyons and arrived at a provisional union between the two churches. Numerous Byzantine icons arrived in Rome and other Italian cities as a result of these efforts. See now W. F. Volbach, " Byzanz und sein Einfluss auf Deutschland und Italien ", in *Byzantine Art-European Art*, *Lectures given on the occasion of the 9th Exhibition of the Council of Europe*, p. 106-107, " In Constantinopel war die Kunst, vor allem in der paläologischen Periode, noch stärker als in früheren Epochen zur Nachahmung der Antike zurückgekehrt. Die westlichen Künstler benutzen diese antikisierenden Werke — vor allem in der Malerei, wo die klassischen Vorbilder fehlten — wie wirkliche antike Vorbilder ".

17) In fact in 1327, along with his closest collaborators, he was the first painter to become a member of the Guild of Physicians and Apothecaries, which only from that date accepted artists as members. Cf. R. Graves Mather, " Nuove informazioni relative alle matricole di Giotto, ecc. nell'Arte dei medici e speziali " in *L'Arte*, January, 1936, pp. 50-64.

18) R. Assunto, *La critica d'arte nel pensiero medioevale, op. cit.*, pp. 217-31.

19) There is no direct documentation for the Arezzo Crucifixion. For the various attributions see the Catalogue of the Works in the appendix. The cross appears to have been associated with the church of San Domenico *ab antiquo*. The history of the church is unclear and there appears to be little likelihood of clarification, given the great gaps in the Aretine archives. One can only draw inferences.
The monastery's history should be helpful. The Dominicans came to Arezzo in 1238, following a bull by Gregory IX. However, the convent was not founded until 1242 with twelve monks and a master, in imitation of the Apostles. In 1262 the confraternity of S. Maria della Misericordia was established in San Domenico, probably for the singing of lauds in which only laymen took part. A chapel or the small church of monastic origin would have been sufficient for their needs. If we knew the date of the enlargement of the church we might also indirectly date the Crucifixion as well. Since the Dominicans were dependent on Rome it is possible that the decision to enlarge the church came from the Holy See. To build a church of the size we see today, capable of accommodating 800 to 1000 people at religious functions, depends on a general desire on the part of the Order as a whole for expansion, not on local initiative alone. The local clergy everywhere were violently opposed to any diminution of their prerogatives, as witnessed by the reaction to the papal bull of 1259 which gave the Orders the right to erect churches and public oratories with provisions for tombs, liberty to preach, and dispensation from taxation. One of the popes under whom the Dominican prerogatives were reinforced was Clement IV (1265-68) who delivered 96 bulls in their favor, and had St. Dominic's body placed in the famous Bolognese tomb. Also Gregory X, who died in Arezzo, was close to the Minor Orders. The date of 1275 advanced by Vasari, who attributed the church to Nicola Pisano, is not acceptable. This date was probably derived from the inscription of 1274 on the bell made by Giovanni Pisano's foundry for the church of S. Agostino.
Florentine elements, such as the apsidal window, which is similar to that of S. Maria Novella in Florence, make one think of a Florentine connection which might also explain the calling of a Florentine like Cimabue. The problem would also be clarified if we knew the name of the commissioner of the work. Unfortunately, I was unable to find any lists of the priors of the Dominican convent in Arezzo. The question of whether the cross might have been an offering by a private individ-

ual is also unresolved. Vasari speaks of the patronage of the Tarlati family who, however, came to the fore-front later. The Bishop of Volterra, Ranieri degli Ubertini, who died 1300 or 1301, was buried in San Domenico but in a tomb dated about 1330-40. The bishopric of Guglielmo Ubertini coincides with the Dominican victory in Arezzo, but this does not necessarily mean that he was a direct patron, especially of Cimabue's cross. Cf. M. SALMI, *San Domenico e San Francesco di Arezzo*, Rome, 1951.

In 1272 Cimabue was in contact with the Dominicans and Franciscans in Rome. Presumably he had already worked for the two Orders. Stylistically the Arezzo Crucifixion appears prior to a Roman visit. The execution of the cross would seem to fall between c. 1265-1272. A. PARRONCHI in *Studi su la dolce prospettiva*, (Milan, 1961) pp. 100-101 gives a fine analysis of the effect of the internal spatial quality of the church of San Domenico that Cimabue's altarpiece utilizes. He attributes the building to Nicola Pisano (which does not seem to me to be sufficiently proved) and describes it as follows: " In studying the architectural details one perceives, moreover, that, firstly, the terminal walls of the lateral chapels of the apse are sustained on slightly oblique axes toward the end; secondly, the windows of the single nave are placed at equal intervals, but the first three at increasing distances, and from the third window to the sixth they are at progressively closer distances ... Thus the effect one receives from the end of the church is of being before a much longer space that in actuality it is. Such accentuated depth augments the single object of importance that the interior presupposes, that is to say, Cimabue's Crucifix, which now hangs in its original position over the high altar, the value of which is all the more since it is the first painting of the second half of the Ducento in which Christ's figures stands out with plastic clarity from the background of the cross ".

20) Cf. HELLMUT HAGER, *Die Anfänge des Altarbildes in der Toscana*, Munich, 1962.

21) These resolutions are to be found in *Acta Capitulorum Generalium ordinis Praedicatorum*, edited by FR. B. MARIA REICHERT, Rome, from 1898. Research in this area has been carried out by Signa. Elena Cacciagli who has prepared a systematic list of all prescriptions relating to figurative art.

22) HUMBERT DE ROMANS' violent attack against illuminated manuscripts is a prime example: " Iterum pulchritudo. Hoc est puerile quid: quia pueri delectantur in litteris floridis et varie depictis et hujusmodi pulchritudinem preferentibus. Hujusmodi puerilitatem multi senes retinent. Seneca: Plerumque non puericia, sed, quot gravius est, puerilitas remanet in nobis. Contra hujusmodi pulchritudinem dicit iterum Jeronimus: Permittant michi meisque non tam pulchros habere codices, quam emendatos " (*Expositio Regulae Beati Augustini*, Toulouse Municipal Library, ms. 417 (I, 302) folio 141-142a. Cited by C. DOUAIS, *Essai sur l'organisation des études dans l'ordre des Frères Prêcheurs*, Paris-Toulouse, 1884. Humbert de Romans died in Rome in 1277. The origin of these ideas is found in the famous dispute between St. Bernard and Abbot Suger: cf. E. PANOFSKY, *Abbot Suger on the Abbey Church of St. Denis*, Princeton, 1946.

23) There is no modern study devoted to the architecture of the Mendicant Orders. Cf. L. GILLET, *Histoire artistique des ordres mendiants*, Paris, 1939; K. BIEBRACH, *Die holzgedekten Franziskaner und Dominikanerkirchen in Umbria und Toscana*, Berlin, 1908, touches on the essential point of the prohibition against vaults, but considers it only in a philological way. See, however, R. WAGNER-RIEGER, *Die italienische Baukunst zu Beginn der Gotik*, 2 Vol., Graz-Köln, 1956-57; the entry " Gotico "

by A. M. ROMANINI, under " Italia, architettura ", in Vol. VI of the *Enciclopedia Universale dell'Arte*, col. 378-87, and by the same scholar the book on Italian Gothic architecture. That, at least for the major works, it was a question of planning from above is confirmed by the recurrence of the names of the same architects, Sisto and Ristoro, for the building of the churches in Florence, Rome, etc.

24) E. CARLI, *Pittura medievale Pisana*, Milan, 1958, p. 32. The theological justification of this attitude has been given by L. H. GRONDIJS, *L'iconographie byzantine du Crucifié sur la croix*, in " Bibliotecha Byzantina Bruxellensis ", I, 1947, 2nd ed. (" L'Evangile franciscain et l'image franciscaine du Crucifixe "), referring to ST. BONAVENTURE, *Opera*, ed. Peltier, Parisiis, 1868, XIV, p. 174:

> Suo corpori tunc nudo
> Non remansit pulchritudo
> Decor omnis aufugit
>
> Membra sua sunt distenta
> Propter aspera tormenta
> Et illata vulnera
>
> Inter magnos cruciatus
> Est in cruce lacrymatus
> Et emisit spiritus.

GRONDIJS refers also to ISAIAH, 53, 2-4: " He hath no form nor comeliness; and when we shall see him, there is no beauty that we should desire him. He is despised and rejected of men; a man of sorrows, and acquainted with grief; and we hid as it were our faces from him; he was despised, and we esteemed him not. Surely he hath borne our griefs, and carried our sorrows: yet we did esteem him stricken, smitten of God, and afflicted ".

25) MARIE VELTE, " Les recherches anatomiques dans la sculpture française des années 1210-1235 ", *Actes du XIXe Congrès International d'Histoire de l'Art*, Paris, 1958, pp. 134-38.

26) The most valuable contributions to the iconography of the Flagellants as related to the depiction of the Flagellation of Christ are those by M. MEISS, " The Case of the Frick Flagellation " in *Journal of the Walters Art Gallery*, 1956, pp. 43-63 and MEYER SHAPIRO'S " On an Italian Painting of the Flagellation of Christ in the Frick Collection ", in *Scritti di Storia dell'Arte in onore di Lionello Venturi*, Rome, 1956, I, pp. 29-53.

27) F. ANTAL's analysis in *Florentine Painting etc.* would have to be perfected by arranging the works by the Orders for which they were intended (Franciscan, Dominican, etc.), studying any of their possible patrons, their themes and how they were carried out, their distribution by topography, and the level of production of the various regions during each decade; then parallelly bringing together the religious prescriptions, identifying literary evidence (for example, the writings of the mystics), and the works that gave birth to a particular religious emotion.

28) The " Planctus Mariae " is known from a 14th century manuscript of Cividale that includes a terzetto of the Stabat Mater. It is reproduced, among other places, in VINCENZO DE BARTHOLOMAEIS' *Origini della poesia drammatica italiana*, Turin, 1952 (2nd ed.), with the relative stage directions which are unique in the Medieval theatre in the West. The passage here quoted, taken practically word for word from St. Bonaventure's Comment to St. Luke and based on the Lamentations of Jeremiah 1:12, is a good example of how theological influence can encourage graftings of extraordinary modernity. The same verses are carved in the gold ornament of the panel of the extremely famous Pietà of Avignon.

The hypothesis has recently been advanced that from the musical point of view some of the parts must be much earlier — the 8th century in fact. Cf. the conference by Padre PELLEGRINO ERNETTI at the 'Istituto di Lettere, Musica e Teatro of the Fondazione Cini' in Venice, 3 March 1962. This hypothesis, however, is certainly not valid for the text which is largely dependent on St. Bonaventure's writings. There are at least two recordings available, those by the firms Carish and Fonit.

29) A good recent bibliography exists for Coppo di Marcovaldo: COOR-ACHENBACH, "A Visual Basis for the Documents relating to Coppo di Marcovaldo and his Son Salerno", in *Art Bulletin*, 1946, December, pp. 237-47; COOR-ACHENBACH, "Coppo di Marcovaldo, his Art in Relation to the Art of his Time", in *Marsyas*, V, 1947-49, pp. 1-21. C. BRANDI, "Il restauro della Madonna di Coppo di Marcovaldo nella Chiesa dei Servi di Siena", in *Bollettino d'Arte*, 1950, pp. 160-70; C. L. RAGGHIANTI, *Pitture del Dugento a Firenze*, pp. 47-78 in which certain of the Florentine Baptistry mosaics are attributed to Coppo. See also the very long catalogue entry 57 in the *Catalogo della Mostra Giottesca*, pp. 185-91. The chronology of the S. Gimignano Crucifixion is still uncertain. I would now be inclined to date it circa 1270. Since San Gimignano was a military stronghold it is more than probable that Coppo's Crucifix had been sent there from Siena. This at least is the opinion Enzo Carli has expressed orally as well as in the book on San Gimignano which he wrote in collaboration with G. Cecchini.

30) The most searching study of the proportionate modules remains that by E. PANOFSKY, "Die Entwicklung der Proportionslehre als Abbild der Stilentwicklung", in *Monatshefte für Kunstwissenschaft*, XIV, 1921, pp. 188-219; translated in *Meaning in the Visual Arts*, Garden City, N. Y. 1955, pp. 55-107. Attempts to extend this investigation into the painting of the Dugento and Trecento are found in the entry *Proporzioni* in the *Enciclopedia Universale dell'Arte*, XI, col. 81-84. General but useful is JOSEPHA WEITZMANN FIEDLER's *Die Aktdarstellung in der Malerei vom Ausgang der Antike bis zum Ende des romanischen Stils*, Strassburg, 1934, pp. 55-82.

31) There is a rather large bibliography on the *homo quadratus* which has been summarized by U. ECO in "Sviluppo dell'estetica medievale", in *Momenti e problemi di Storia dell'Estetica*, Milan, 1959, and in particular on p. 143: "The number becomes ... a number that is pivotal and determinative, full of serial determinations. The cardinal points, the principal winds, phases of the moon and of the seasons, the *Platonic* tetrahedron of fire, the letters in the name Adam — all are four. And four will be, as Vitruvius instructed, the number of man, since the breadth of a man with outstretched arms corresponds to his height, thus forming the breadth and height of an ideal square; and four will be the number of moral perfection, so that the tetragon will be called the man morally fortified".
It was in its mystical sense that it was understood by Hildegard of Bingen (see the reconstruction of her schema in M. DAVY, *Essai sur la Symbolique Romane*, Paris, 1955, p. 111), and in a classicizing way by VINCENT OF BEAUVAIS, *Speculum Naturale*, XXVIII, 2 (cf. DE BRUYNE, *op. cit.*, I, p. 247): "Vitruvius in libro III de Architectura: corpus hominis ita natura composuit ut os capitis a mento ad summam frontem et radices imas capilli esset decimae partis. Item manus palma ab articulo ad extremum medium digitum tantumdem. Impius autem oris altitudinis tertia pars ab imo mento ad imas nares. Nasus ab imis naribus ad finem medium superciliorum tantumdem. Ab eorum autem fine ad imas radices capillorum ubi frons efficitur, item tertiae partis. Reliqua quoque membra suas habent commensurationes ac proportiones

quibus etiam antiqui pictores ac statuarii nobiles usi, magnas laudes sunt assecuti. Corporis autem centrum naturaliter est umbilicus. Namque si homo collocatus fuerit supinus manibus ac pedibus pansis circinique centrum in ejus umbilico collocatum circumagendo rotundationem utrorumque manuum ac pedum digiti linea tangentur. Item quadrata designatio in eo invenitur. Nam si a pedibus imis ad summum caput mensuraveris eamdemque mensuram ad manus pansas retuleris, invenietur eadem latitudo uti et altitudo". This passage is almost certainly the source that Fra Ristoro of Arezzo used; furthermore, in Florence, especially, the *homo quadratus* tradition for devotional images was very much alive. On the Porta di San Tommaso, as we know from an engraving, there existed a crucifixion that was clearly quadrate, as are also the crosses of S. Giovanni Gualberto and of Trebbio.
The manner in which the Vitruvian codex was known in the zone comprising Florence, Arezzo and Rome still remains to be clarified. According to L. A. CIAPPONI, "Il *De Architettura* di Vitruvio nel primo umanesimo" in *Italia medioevale e umanistica*, III, 1960, the diffusion of the text began only with Petrarch. Nevertheless, Vitruvian ideas had been utilized for some time by architects and sculptors who because of their profession were nomads. The Vitruvian canon for the human body was in particular noted by Villard de Honnecourt, as V. MORTET has already cited in "La mesure de la figure humaine et le canon des proportions d'après les dessins de Villard de Honnecourt, d'Albert Durer et de Léonard", in *Mélanges Châtellin*, Paris, 1910, pp. 367 ff. See the critical edition by HANS R. HAHNLOSER, Vienna, 1935, pp. 95-96, 101 (for the tri-partition of the face); and pp. 240-41 for the proportions in general. For the history of the Vitruvian manuscripts, cf. E. DE BRUYNE, *op. cit.*, I, 246-47.
In the number on Cimabue in the series *I Maestri del Colore* F. Bologna observes in regard to my attempt to establish the proportional canon of the San Domenico altarpiece, in the first page of his five page text that " on the contrary, by measuring it properly the Arezzo Christ appears constructed according to the ancient canon of nine heads, indeed, exactly in accordance with the prescriptions of the celebrated Byzantine manuscript of Mount Athos that Cimabue also followed in the Santa Croce Cross and then at Assisi. Moreover, these prescriptions were current in Tuscany at the end of the Trecento when we find them codified in Cennino Cennini's treatise ". Except for the fact, that is, that the " celebrated manuscript " of Mount Athos is precisely datable at the beginning of the eighteenth century and therefore could not have been used as a model by Cimabue and by Giotto's followers. I have reference to a canon equivalent to the length of a face or countenance (such as the one which Ristoro d'Arezzo expounds) and not a canon equivalent to the length of a whole head. Bologna's two-fold confusion — clearly he is unaware of these questions — does not vitiate the argument that a canon of nine heads is possible in the Medieval Period. In the case of the San Domenico Crucifix a module of seven and one-half heads is by computation the maximum.

32) This information comes from L. PREMUDA's study, *Storia dell'iconografia anatomica*, Milan, 1957, pp. 32-38 and Pls. XVIII-XX. But above all compare GEORGE SARTON, *The Appreciation of Ancient and Medieval Science during the Renaissance*, 1450-1600, (Philadelphia, 1953), Lecture I, Medicine: CHARLES SINGER, *A Short History of Anatomy and Physiology from the Greeks to Harvey* (New York, 1957).

33) VINCENT OF BEAUVAIS, *Speculum Naturale*, XXVIII, c. 4.

34) RISTORO OF AREZZO, Libro VIII, capitolo XX of the *Composizione del Mondo colle sue cagioni*. Cited from

the edition by E. Narducci, Rome, 1850. For Ristoro and his relative bibliography see the outline by G. Bertoni, " Il Duecento " in *Storia Letteraria d'Italia*, Vallardi. I have used the 1954 edition. Schlosser has also commented on Ristoro in *La Letteratura Artistica*; and above all Walter Paatz, " Die Bedeutung des Humanismus für die toskanische Kunst des Trecento — Ein Versuch ", in " Ursprünge und Anfänge der Renaissance ", *Kunstkronik*, VII, 1954, May, pp. 114-16, with a discussion pp. 117-19; and by Panofsky, *Renaissance and Renascences, op. cit.*, pp. 72, 73, 188, 210.

35) L. Venturi, *La Peinture Italienne, I, Les Créateurs de la Renaissance*, Skira, 1950, p. 32.

36) *The Image of Man, A Study of the Idea of Human Dignity in Classical Antiquity, The Middle Ages, and the Renaissance*, Harvard University Press, reprinted by Harper Torchbooks, see in particular pp. 194-200.

37) 2.67 meters \times 3.36 meters.

38) Ristoro, *op. cit.*, chap. IV, Book VIII. A precedent and rather similar instance, in its descriptive character, is the short poem by Teodulfo describing a silver bowl with scenes of the labors of Hercules. It has been published by, among others, J. Adhémar, *Influences antiques dans l'art du moyen âge français. Recherches sur les sources et les thèmes d'inspiration*, London, 1939, pp. 308-9.

39) E. Panofsky, *Renaissance and Renascences*, p. 63, note 5.

40) Cf. the reproduction in *Enciclopedia Universale dell'Arte*, VI, Pl. 378.

41) However, as we can see in the illustrations of the *Psychomachia* of Prudenzio, mss. 22, Biblioteque du Palais des Arts, Lyons, this had already occurred during the High Romanesque period.

42) Antique vases were especially found during the foundation work on S. Francesco.

43) Hélène Wieruszowki, " Arezzo as a Center of Learning and Letters in the Thirteenth Century ", *Traditio*, IX, 1953, pp. 321-91. In 1215 the famous jurist, Goffredo di Benevento, established facilities for medical and law students for the university which was already functioning, but the organization of which was in an embryonic state. The development of the university was connected with the fortunes of the Ghibelline party, as Arezzo was one of the few Ghibelline cities with a university for general studies. It lost importance in 1260; the peace of 1261 gave place to a further expansion. The seat was in the Abbey of Santa Fiora and S. Pier Piccoli. Concerning the culture of Arezzo which is of interest although it only explains the history of Cimabue's patrons or the admirers of his work see also Roberto Weiss, " Geri d'Arezzo " in *Il Primo Secolo dell'Umanesimo* (Rome, 1949) pp. 43-66.

44) Josef Strzygowski, *Cimabue und Rom. Funde und Forschungen zur Kunstgeschichte und zur Topographie der Stadt Rom*, Vienna, 1888, particularly pp. 157-67.

45) The document is republished by E. Sindona, *Pietro Cavallini*, Milan, 1958, p. 37, note 7.

46) The relationship between Abbot Suger and the French Court, on the stylistic plane, has been further underlined by R. Assunto in *La Critica d'Arte nel Pensiero Medioevale*, Milan, 1961, pp. 109-114 with relative bibliography.

47) Erwin Panofsky, *Abbot Suger on the Abbey Church of St.-Denis and its art Treasures*, Princeton N. Y., 1946.

48) The relations signalled here with France, which merit a deeper study than that now done by Augusta Monferrini (in *Commentary*, XVI, 1-2, 1966 pp. 3-33), are reconfirmed by the exceptional resemblances in the architectural decoration of the Presbytery of Assisi, and, we should add, in the Chapel of the Sancta Sanctorum and in the Sainte Chapelle of Paris and the Kings Gallery of the Cathedral of Rheims. Unfortunately I do not know of an adequate modern bibliography concerning this pope. My information is derived from general historical studies and from *Clement IV* by Nicolas Geremia, Nimes, 1910. The hypothesis that his portrait appears to the left of the throne in the Upper Church of Assisi was suggested to me by the portrait reproduced by N. Geremia, *op. cit.* On the work of Saint-Gilles, which was taken up again in 1261 through the action of the architect Martin de Lonay, I find nothing specific in R. Hamann, *Die Abteikirche von St.-Gilles und ihre künstlerische Nachfolge*, Berlin, 1955. The overall scheme had, moreover, already been defined before 1116.

49) There is no need of retracing the building history of the Basilica of San Francesco (in this regard cf. B. Kleinschmidt, *Die Basilika San Francesco in Assisi*, Berlin, 1915-26; I. B. Supino, *La Basilica di S. Francesco di Assisi*, Bologna, 1924. E. Hertlein, *Die Basilika San Francesco in Assisi. Gestalt, Bedeutung, Herkunst*, Florence 1964). Nevertheless, the reconstructions that have so far been attempted are open to question, in my opinion, by their failure to consider two essential matters: the internal disputes in the Orders and the accompanying prescriptions on sacred art; their precarious and often interrupted financial structure, a state related to the differing attitudes of the popes towards the Minor Orders. The first factor must have been the determinant one, forcing at least two changes in the original plan for the Upper Church, which, as is known, was derived with great fidelity from the Cathedral of Angers (cf. W. Krönig, " Hallenkirchen in Mittelitalien ", in *Jahrbuch* of the Biblioteca Hertziana, 1938, p. 36). Ribbed vaulting must have therefore been envisaged. We find, however, that the roof is supported by turret shaped buttresses with low flying arches, which are constructed with such regularity that they must have been meant to be seen. The same solution was used in S. Chiara, the construction of which was begun in 1257 as Coletti has noted (*Gli affreschi della Basilica di Assisi*, Bergamo, 1949, pp. 75-78). The decision of 1260 prohibiting the Order from building churches with stone vaulting seems to me to bear in this direction. The decision coincides with the probable start of the roofing of Santa Chiara, and it might well have also been timely for the Upper Church, work on which was ordered continued by a papal brief issued by Innocent IV in 1253, wherein he declared that the church was not yet seemly or completed. His orders were that the Basilica be completed as a noble structure and that it be decorated with splendid works of art at all the most prominent points. The essential work must have been completed in 1266, when money obtained through offerings was assigned to the altars.
The prohibition against vaults was repeated on other occasions. Santa Croce in Florence ended with a trussed roof for that reason. St. Bonaventure was responsible for this rigidity. At the same time he prohibited in Franciscan buildings the construction of separate bell towers, stained glass windows, sculpted columns and ornate pictorial schemes — all to be found in great abundance at Assisi. It is hard to imagine that these decorations, although anticipated in the 1257 papal bull, could have been carried out in opposition to St. Bonaventure prior to his death in 1274. Moreover, the first document explicitly citing the Upper Church as usable is of 1278. Since, in general, frescoes were painted just as soon as possible after the completion of the construction, a dating of 1274-79 for the ribbed vaulting over the pres-

bytery would seem justifiable, as well as for the galleries than run along all the walls. The elemental structure that was a result of the simplification and impoverishment of the original plan, was enriched in the interior by decorative architectural additions and screens. Giotto's frescoes were probably painted on a series of screens covering the open niches of the original project if, indeed, the Angers model was followed in this aspect also.

50) Analogous troubles, but caused by the rivalry of the Eremitani, engulfed Giotto in Padua twenty-five years later. He was forced to cut short his fresco cycle in the Scrovegni Chapel, which was planned to extend into the apse and transept (cf. E. BATTISTI, *Giotto*, Geneva, 1960, pp. 78-87). Certainly today it is repugnant to hear the Giotto paintings, as well as the still more religious ones by Cimabue, defined as "strange and superfluous things" made "for pomp and vainglory" — so much so that Roberto Salvini in rejecting my interpretation takes these words to mean magnificent ceremonies (and in a church that, moreover, was not even consecrated!) — yet all the history of civilization shows us that the relegation of figurative art to "sin and vanity" is not only recurrent, but almost preponderant. One need only go two hundred years beyond Giotto to see works of art not only condemned by the clergy, but furiously destroyed by the people.
A critical edition of Giotto's poem against poverty which, perhaps, was instigated by this event along with a study of its historical significance has been made finally by Peter Hirschfeld: "Chancon giotti pintori de florentia, Die Kanzone des Malers Giotto über die Armut" in *Beiträge zur Heimatforschung in Schleswig-Holstein, Hamburg und Lübeck*, Band 34, 1965, pp. 31-42 — there is a very large bibliography on the question. A very useful discussion of the whole problem which, however does not dwell on the architectural and figurative consequences is M. D. Lambert, *Franciscan Poverty*: *The Doctrine of the absolute poverty of Christ and the Apostles in the Franciscan Order*, 1210-1324 (London, 1961).

51) Concerning Nicholas III (1277-1280) and the arts there exists but a brief chapter (pp. 48-56) in H. SCHRÖDER, *Die kunstfördernde Tätigkeit der Päpste im 13. Jahrhundert. Inaugural Dissertation*. Faced with this dearth of specific studies one can only turn to biographies and chronological registers of the documents: A. DEMSKI, *Papst Nikolaus III*, Münster in W., 1903; J. GAY, *Les registres de Nicolas III*, Paris, 1898-1916 in the series Bibliothèque des Écoles Françaises d'Athènes et de Rome; a fifth volume has been published by SUZANNE VITTE, Paris, 1938. See also the bibliography on the individual monuments.

52) *Annales Minorum etc.*, edited by L. WADDING, Quaracchi, 1931. I cite from the 3rd edition. The program as we learn from paragraph VII and VIII of the resolution was as follows: "Rogantes Altissimum, quod errantibus, ut in viam possint redire justitiae, veritatis suae lumen ostendat, ut cognoscant veram lucem, quae Christus est, illa respuant, quae huic inimica sunt nomini, et ea quae sunt apta sectentur". Cf. also P. C. ENBEL, *Die während des 14. Jahrhunderts im Missionsgebiet der Dominikaner und Franziskaner errichteten Bisthümer. Festschrift zum elfhundertjährigen Jubiläum des deutschen Campo Santo in Rome*, herausgegeben von Dr. Stephan Ehses, Freiburg in B., 1897. The city showing Judea is interpreted by F. Bologna (1965) as the symbol of the "evangelized world" which is completely contrary to the historical situation.

53) FRIEDRICK BOCH, "Il Registrum super senatoria Urbis di papa Nicolò III", in *Bollettino dell'Istituto Storico Italiano per il Medio Evo e Archivio Muratoriano*, No. 66, Rome, 1954.

54) C. BRANDI, *Duccio*, Florence, 1951, p. 129. There is a long discussion from page 127 to 134 on the possible identification of the monuments of the "Italy" anglein Assisi, and on the dating of the works in San Francesco.

55) The senatorial mandate of Charles of Anjou ended 16 September 1278 and was not renewed. Cf. *Archivio della Società Romana di Storia Patria*, LXXI, 1948, pp. 123-24. The even height in the fresco of the Capitol and the Church is a sign of parity of powers.

56) The fragmentary inscription has been published by CARLO PIETRANGELI, "Iscrizioni inedite o poco note dei Palazzi Capitolini", in *Archivio della Società Romana di Storia Patria*, 1948, Vol. II, pp. 123-24, 131. Prof. Pietrangeli, whom I sincerely thank, communicated to me that the Orsini arms, identical in form to those of Assisi, still exist on the roof of the Capitol.

57) He bought land on which he constructed the *viridarium novum* or *pomarium*, surrounded by walls and towers — the entrance was from Porta Viridaria. On 12 June 1279 he dedicated a chapel to St. Nicholas, decorated with a silver cross, two candelabra and other liturgical furnishings in gilded silver. He also had placed in St. Peter's and in St. Paul's all the portraits of the popes up to his time. He restored the Borgo passageway and had dwellings constructed for pilgrims.

58) SAVIO, "Simeotto Orsini e gli Orsini di Castel S. Angelo" in *Bollettino della Società Umbra di Storia Patria*, I, 1895, No. 3; and M. BORGATTI, *Castel Sant'Angelo*, Rome, 1911, pp. IX-XI.

59) For the Sancta Sanctorum, whose internal architecture represents the closest example to that of Assisi though it appears richer and more refined (Fig. 8) cf. HARTMANN GRISAR, *Die römische Kapelle Sancta Sanctorum und ihr Schatz*, Freiburg, 1908 and A. CEMPANARI and T. AMODEI, *La Scala Santa*, Rome, 1963 (*Le chiese di Roma illustrate*, 72). Notwithstanding the fact that the complex is almost inaccessible and in any case too repainted to allow a definitive judgment, F. Bologna (1965) determines that it was executed soon after 1278 by the Assisi workmen, directed by Torriti, who had returned from Rome.

60) The continuity of Nicholas III's program can be illustrated by the Cappella Major which he founded and which later was turned into the Sistine Chapel; the probable relationship with Durandus de Mende might throw light on the liturgical ideas promoted by the Rome Court. In Rationale, I, chapter 2, we read the following concerning painting: "Pictura plus videtur movere animum quam scriptura. Per picturam quidem res gesta ante oculos ponitur quasi in praesenti geri videatur, sed per scripturam res gesta quasi per auditum, qui minus animum movet, ad memoriam revocatur. Hinc etiam est quod in ecclesia non tantam reverentiam exhibemus quantam imaginibus et picturis". Regarding this passage E. DE BRUYNE, *op. cit.*, writes: "Il est difficile de suggérer avec plus de force la nécessité pour le peintre de tendre au réalisme intuitif et émouvant et de rendre superflu le titulus".

61) Cf. J. WHITE, "Cavallini and the Lost Frescoes in S. Paolo", in *Journal of the Warburg and Courtauld Institutes*, 1956, XIX, pp. 84-95. The frescoes were commissioned by Gian Gaetano Orsini who was represented in them as the donor before he became pope. White writes on the dramatic consequences of the destruction of most of the Roman fresco cycles, p. 84, regarding the relationships between the Roman culture and that of Tuscany during this period: "Apart from the fact that the origins of many of the Tuscan works consequently remain obscure, it is often difficult to be sure whether a particular, seemingly coherent pattern of development, such as that to be seen upon the walls of

S. Francesco at Assisi, from Cimabue's frescoes in the choir to the Legend of St. Francis in the nave, is an isolated phenomenon, deceptive in its orderliness, or whether it represents a sequence of events which is of general significance ".

62) J. Strzygowski, *Cimabue und Rom*, cited, pp. 84-130 ("Cimabue's Ansicht von Rom in Assisi": "Cimabue, der Schöpfer des römischen Stadtplanes "), and particularly p. 105. It is clear from the photographic reproduction that Cimabue, for the first time in painting, has also taken up again the classical capitals, reproducing with absolute fidelity the dedicatory inscription on the Pantheon, but as far as I can see changing the object of the elogy to Augustus. For the plans of Rome see, besides the valuable chapters of Strzygowski, the monumental three volume work, *Piante di Roma*, edited by A. P. Frutaz, Istituto di Studi Romani, Rome, 1962, Vol. II, pp. 114-15, Pl. 141, with erroneous identifications owing to the slight knowledge of the modern bibliography on Cimabue. Nicholson notes (p. 35, note 5) the analogies, pointed out to him by M. A. Friend, running between the Evangelists, associated with sections of the Antique world, and Byzantine illustrations of the prologues to the Vulgate.

63) There is a reproduction of it in D. Talbot Rice, *Arte di Bisanzio*, Florence-Munich, 1959, Pl. 184.

64) A direct influence of ancient motifs is affirmed by W. Paeseler, " Der Rückgriff der spätrömischen Dugento Malerei auf die Christliche Spätantike ", *Beiträge zur Kunst des Mittelalters*, Berlin, 1950, pp. 157-74; H. Wentzel, " Antike-Imitationen des 12. und 13. Jahrhunderts in Italien ", *Zeitschrift für Kunstwissenschaft*, IX, 1955, pp. 29-72 (especially important for the Atlantes motifs which, however, in mosaic and painting would seem to have been transmitted by way of the sculptured candelabra of Southern Italy). Paeseler publishes a very important fresco from S. Maria Maggiore in Tivoli with loggias on brackets painted in perspective. They are very similar to Cimabue's simulated compartments at Assisi, though even less rigid and more decorative. Analogous perspective-decorative investigations were undertaken in Venice: cf. M. Muraro, " Antichi affreschi veneziani ", in *Le Meraviglie del Passato*, Florence, 1954, p. 661, and R. Pallucchini, *Storia della Pittura Veneziana. Il Trecento*, Venice, 1965, with reproductions of frescoes of the third quarter of the 13th century, with niches and engravements in perspective that are found in San Zan Degolà in Venice. For the illusionistic value of architectonic framing in Assisi cf. Sven Sandström, " Levels of Unreality ", *Figura*, Uppsala, 1963, p. 22.

65) " Studien zür Oberkirche von Assisi ", in *Festschrift Kurt Bauch*, 1957, pp. 50 ff.

66) Ibid., p. 88.

67) E. Panofsky, *Gothic Architecture and Scholasticism*, Latrobe, Pa., 1951.

68) E. Borsook, *The Mural Painters of Tuscany from Cimabue to Andrea del Sarto*, London, 1960.

69) Peter Murray, " Notes on Some Early Giotto Sources ", *Journal of the Warburg and Courtauld Institutes*, XVI, 1953, pp. 58-80; F. D. Klingender, " St. Francis and the Birds of the Apocalypse ", *ibid.*, XV, 1953, pp. 13-23; R. Freyhan, " Joachim and the English Apocalypse ", in *Journal of the Warburg and Courtauld Institutes*, XVIII, 1955, n. 3-4, pp. 211-44. For the whole problem relative to the relations of the Franciscans at the time of Giotto and the arts, cf. the first chapter of E. Battisti, *Rinascimento e Barocco*, Turin, 1960, pp. 3-49; and idem., *Giotto*, pp. 39-58. The present work is a direct continuation of these studies. Cf. also footnote 82.

Earlier, Gillet in *Histoire artistique des ordres mendiants* pp. 76-77 observed how Giotto represented an antithetical position at the initial Franciscan movement and citing the " Canzone contro la povertà " comments: " Quel manque de sympatie pur ce qu'il y a de plus profond dans le christianisme franciscain. Quelle inintelligence de la doctrine d'affranchissement qu'est le tendre évangile de Notre-Dame — la Pauvreté ".

70) Cf. R. Freyhan, *op. cit.* The codices to which I have referred are Ms. R 16z f. 20v Trinity College, and Ms. Lat. 10474 f. 38 of the Bibliotèque National of Paris.

71) " Struthio, quae pennas habet, sed propter corporis magnitudinem volare non potest, hypocritam significat, qui, terrenorum amore et onere agravatus, sub penna falsae religionis se mentitur ". Cf. *Expositio Mystica in libros Job*, XXXIX.

72) F. Van der Meer, *Maiestas Domini*, *Théophanies de l'Apocalypse dans l'art chrétien*. Vatican City, 1938, p. 169: " Par un hasard curieux, l'Enfant monte même sur le trône de l'Apocalypse ". While at Assisi He takes the place of the book of seven seals, in the churches of the XIV century the Lamb is substituted. I was unable to ascertain from the bibliography I consulted and from the coeval texts I read where this association was first advanced. The particular devotion of St. Francis and St. Anthony of Padua toward the Infant Jesus is well known.

73) Cited from the translation by Augusto Hermet, Lanciano, 1933.

74) John White, *The Birth and Rebirth of Pictorial Space*, London, 1957, pp. 23 ff.

75) Decio Gioseffi, " Perspectiva Artificialis. Per la storia della prospettiva. Spigolature e Appunti ", in *Quaderni dell'Istituto di Storia dell'Arte Antica e Moderna dell'Università di Trieste*, n. 7, 1957, p. 61: see also F. Alessio, " Per uno studio sull'ottica del Trecento ", in *Studi Medievali*, 1961, pp. 444-504, with bibliography. Graziella Federici Vescovini's *Studi sulla prospettiva medievale* (Turin, 1965).

76) The relationship is however purely generic. The probability exists that both the Assisi scenes and those of S. Pietro in Grado are derived from a Roman prototype, specifically the scene from the atrium of Old St. Peter's that is reproduced in the Barberini Latin Codex 2733 Grimaldi; but one must add that the only scenes with an actual iconographic correspondence are the last three in the Assisi cycle, which are by another artist, perhaps — or perhaps not — a follower of Cimabue. Indeed, the Roman influence, the whole effect of which has been precisely specified by J. Garber, *Wirkungen der Frühchristlichen Gemäldezyklen der alten Peters-und Pauls-Basiliken in Rom*, Berlin, 1918, seems to indicate a change of program and the exclusion for some time of Tuscan artists from the Assisi projects. Cf. A. Nicholson, " The Roman School at Assisi ", in *Art Bulletin*, XII, 1930, pp. 270-300. The influence of certain details of the atrium scenes in Old St. Peter's (the date and authorship of which are uncertain) can be noted here and there in Cimabue. The placement in the foreground of the Virgin's sepulchre, the plastic monumental quality of the figures, especially in the scenes of St. Peter; certain furnishings such as the hanging lights which are inspired by the Discovery of the Bodies of St. Peter and St. Paul; certain architectonic details, such as the perforated grill on the gateway to the city, show a deep knowledge of the cycle, and reveal the great effect that the figurative art of Rome had on Cimabue. Prudence dictates, in the absence of a systematic modern study devoted to the Roman Dugento, that the discussion be closed provisionally at this point. However, the frescoes of S. Pietro in Grado must be excluded as docu-

85

ment for the Roman paintings. Various essential details are different (cf. Maria Floriani Squarciapino, " L'obelisco di San Pietro a Roma e una pittura di San Pietro in Grado ", in *Studi Romani*, March-April, 1962, pp. 167-70). Concerning Orlandi, the Pisan painter then active, and his dependency on Cimabue cf. E. B. Garrison, " Toward a New History of Early Lucchese Painting " in *Art Bulletin*, XXXIII, 1951, I, pp. 11-31.
For the hanging lamps which actually existed, cf. C. Cecchelli, *La Vita di Roma nel Medio Evo*, Rome, 1951-52, p. 159 (the lamps were recovered during the excavations of 1902 in S. Saba and were formerly at the Collegio Germanico).

77) The position of the head and the side-long gaze, as my friend Guglielmo Capogrossi pointed out to me, gives rise to this supposition. The portrait of Cimabue given by Vasari is probably based on local legendary attribution (similar to that which sees Cimabue's portrait in the Spanish Chapel). Guglielmo Capogrossi, author of studies on the Zuccari and as such well-known to all scholars specializing in Mannerism, is not to be confused, as Volpe has done, with Capogrossi the painter, who, however, is a most sensitive observer as well as being one of Italy's greatest artists.

78) Comparisons can be made to the figures reproduced by E. Panofsky in his previously cited study on human proportions (in *Meaning in the Visual Arts*, N. Y. 1955).

79) Grosseteste, *De Lineis*, ed. Baur, p. 60 ff.

80) I have referred to Cassiodorus, who was still read during the Middle Ages, for the modi. For a general exposition of the ideas cf. de Bruyne, *op. cit.*, I, pp. 43-73.

81) Herschel Baker, *The Image of Man*, etc., Harper Torchbook, 1961, pp. 199-200.

82) I have substantially based my interpretation of Jacopone on the *Atti del Convegno* held in Todi 13-15 October 1957 and published, *ibid.*, in 1960. Other than M. Salmi, *Cimabue e Jacopone*, pp. 57-72, which is an abridged monograph of the artist I have consulted Angelo Monteverdi, *Jacopone Poeta*, pp. 49-50 and Arsenio Frugoni, *Jacopone Francescano*, p. 85 ff.
I am pleased to find that Ferdinando Bologna in *La pittura Italiana delle origini*, pp. 180-89, feels, as I, that there are more differences between likenesses between Jacopone and Cimabue. He writes: " [Cimabue's] scene not only has the most purely expressive and liturgical feeling that one could image to support the mimic part of the sacred drama, but is based on compositional imperatives, on an ordering of space, on an extremely controlled and rich formal problematic that, because of a more stable mental makeup and a crystal clarity of outlook, goes beyond the culture of Jacopone ".
Regarding the diverse and successive relations between the arts and Franciscan mysticism the study by P. Francastel is the most complete, " Réflexions nouvelles sur un vieux procès — L'art Italien et le Rôle Personnel de Saint François " in *Annales*, XI, October-December, 1956, No. 4, pp. 481-89; and Galienne Francastel, *Histoire de la Peinture Italienne*, I, Paris, 1955.

83) I have used the translation of the *Dialoghi* edited by Augusta Mattioli for the *Biblioteca Universale Rizzoli*, II, Milan, 1958, p. 127-28. Analogous gestures of violent release are found in certain Sienese paintings which may have a Cimabue dependency. Cf., J. Stubblebine, " An Altarpiece by Guido da Siena ", in *Art Bulletin*, September, 1959, pp. 260 ff.
But in this regard it is useful to cite the following page from the essay by Ferruccio Ulivi, which clarifies Cimabue's reluctance to accept the Dionysian aesthetic and stresses the need to reach precise determinations without either falling prey to easy inductions or remaining on well-trodden ground: " With the coming of St.

Francis there was born a serene, glad, trustful optimism, founded on the disappearance of fear and on the lessening of the distance between man and the celestial sphere. There was an increasing popularity of devotions directed toward the human personality of Christ, who by His Incarnation and by the feverish yearning to share the sorrows of His passion became " our Brother ". This prevalence of the spirit of love in the interpretation of God's redeeming power emerged as the dominant motif of the relationship between the loving soul of the faithful and the Creator, confirming those motifs which Weise has already put forward. But if it is not open to question that such feelings were in the end to bring about a leavening and refinement in an artificially imaginative way, it is likewise true that these same themes appeared in a most concrete and moderate manner in the Saint's personality. Also his moment of *stile douce* — of potential *mignardise* in the interpretation of events and life — was moderated. Far from yielding (as happened in other religious spirits and in part in his own hagiological literature) to tones of ecstasy or oversimplified brilliance or transcendental mysticism, he knew how to attain an extraordinary level of human inspiration ". According to Ulivi these characteristics distinguish the Giottesque tradition (and we may add the Cimabuesque) from the Sienese Gothic. Cited by Ferruccio Ulivi, " Il setimento francescano delle cose e San Bonaventura ", in *Lettere Italiane*, January-March, 1962, pp. 1-32, and in particular pp. 30-31 (note 93). For this side of Franciscan devotion see: *Relazioni al X Congresso Internazionale di Scienze Storiche*, concerning the " Storia del Medioevo ", Florence, 1955, III Vol., dedicated to popular religious movements and heresies. Offner has written a splendid description of the unusual dramatic character of this fresco. I quote from the verbatim record of the lecture given at the Metropolitan Museum of Art in New York on October 15, 1924: " This type of rendering is the supreme expression of the subject in Italy — it rises to tragic terror and is accomplished by the expression of intense emotion and by giving his characters the highest possible psychic character. Notice the arms of the Magdalen and the heads of the Pharisees. There is a Hebraic quality about this Crucifixion, and the spirit is of the Old Testament. It is distinctly an unchristian type of representation yet the Christ is of great beauty and refinement ". Additional references of the interest for the tragedy are in the writings of St. Bonaventure from which the particular iconography for this masterpiece was drawn and are given in the preface of this English edition.

84) Obviously we are paraphrasing the splendid pages written by St. Bonaventure concerning the joy of the faithful in the contemplation of images of the Madonna reigning with Christ in the palace of the Holy Trinity. The best comments on these concepts are in two studies published by the Franciscan Institute of New York: Robert P. Prentice, *The Psychology of Love according to St. Bonaventure*, 1951; Emma Jane Marie Spargo, *The Category of Aesthetic in the Philosophy of Saint Bonaventure*, 1953; and Emma Thérèse Healy, *Woman according to Saint Bonaventure* (Erie, Pa., 1956).

85) *Idealismus und Naturalismus in der Gotischen Skulptur und Malerei*, Munich-Berlin, 1918.

86) We have no complete study devoted to Santa Croce; the material gathered by W. Paatz, *Werden und Wesen der Trecento-Architektur in Toskana*, Burg b. M., 1937, pp. 56-80, is only indicative. Antal in particular has stressed the consequences on art as a result of the poverty issue: an issue that seems to have been transferred from Rome and Assisi to Florence during the rebuilding of the Franciscan churches. In 1285 Fra Arrigo de' Cerchi left 2000 gold florins for the projected church; two other legacies were received in 1292 — one of which had the attached condition that it be used in the

enlargement or reconstruction of the church. Cimabue's Cross indirectly confirms the project in as much as we know from the previously mentioned research of HAGER that it is connected with the altar, and thus constitutes an indispensable part of the liturgical furniture, especially in the case of a church dedicated to the Cross. The painting must have been already completed or very advanced as it was copied in 1288. Thus, we may then assume that an elaborated plan for the church existed in 1285. Moreover, we note that there is an exact mathematical proportion between the width of the Cross and the sanctuary of about 1:2.5, it would be worthwile to have this point further clarified. The same proportional canon is probably valid for the height of the triumphal arch. If this observation is correct, one could deduce that the church projected in 1285 had, more or less, the sanctuary dimensions we find today. We are also able to signal Fra Filippo di Perugia as the actual promoter of the undertaking. He came there in 1279. He was a friend of St. Bonaventure, but was loyal to Nicholas III. It is possible that originally Santa Croce was envisaged like S. Maria Novella, which was begun in 1279, with ribbed vaulting and a bell tower. Its final form was, however, quite different, demonstrating that social conditioning was an influence in typology and architectonic style. And not this alone as the prevalence of strict ideas in Santa Croce gave conservative and Late Romanesque intonations to Franciscan culture for some decades. Modern ideas, on the contrary, triumphed at S. Maria Novella, due almost certainly to Remigio del Chiaro Girolami, who was closely bound on one side to French culture (so closely that he was able to ask Charles of Anjou for financial aid in the church's construction) and on the other side through his powerful brother to the *Arte della lana*.

CARLO VOLPE in *Paragone*, No. 173, p. 71 ascribes to me the date of 1295 for Cimabue's Santa Croce Crucifix. Upon examination I counted at least three occasions where I stated that in my opinion — an opinion shared by many others — that the aforesaid Crucifix was executed between c. 1285-1288 and so reported in the Chronology of Cimabue. I do not understand why Volpe considers the history of the construction of the church valueless for the resolution of the dating problem. On St. Croce church see the series of lectures (22 February-31 March 1964) by Carlo Pellegrini, Roberto Salvini, Yves Renouard, Raoul Manselli, Ugo Procacci, Federico Melis, Mario Salmi (Libera cattedra di Storia della civiltà fiorentina).

87) The diffusion of the three nail iconography—following the ideas of S. Bonaventura (*Meditationes*, LXXVIII was also used by the Dominicans, who toward the end of the Dugento and the beginning of the Trecento, had analogous spiritual tendencies — might give us a fairly exact picture of the religious situation during these years of violent polemic. The relationship between the spiritual movement and pictorial archaism has already been pointed out by ANTAL. It is confirmed by the presence in the late Trecento of imitators of the type of cross elaborated in 1260-70, (examples at Milan in S. Eustorgio; and Genoa, cf. P. TORRITI, " Il Maestro di S. Maria di Castello ", *Quaderni della Soprintendenza alle Gallerie ed Opere d'Arte della Liguria*, No. 5, Genoa, 1956; and among the Sienese manner artists). On the subject of three nail iconography cf., FÉDÉGAND CALLAEY, *L'idéalisme Franciscain Spirituel du XIV siècle*, Louvain, 1911 (Ubertino da Casale seems to have further emphasized the conception of three nails), and the relative, unfortunately only slightly documented, study of L. H. GRONDIJS, *L'iconographie byzantine du crucifié mort sur la croix*, 2nd ed., 1947, " Bibliotheca Byzantina Bruxellensis ", I.

88) The history of the Bologna altarpiece is as follows: the Servites established themselves in Bologna 1260-61 at the walls south of Via Emilia. In 1267 St. Filippo

Benizzi, a Florentine, defended the rights of the friars who under pain of excommunication had neither a church nor oratory. In 1268 he obtained from the Bishop of Bologna the privilege of hearing confessions and was allowed to have a portable altar. In 1275 the Servites, favored by the citizen government, moved into the convent near S. Petronio. There is evidence of their continued presence there in 1289 and 1291. On 13 February 1287 the convent came under the protection of the Holy See with permission to celebrate the divine offices even during the period of prohibition. On 22 August 1287 the Blessed Andrea Balducci of Borgo San Sepolcro, who succeeded St. Filippo Benizzi as prior in 1285 and who presumably gave Cimabue the commission to paint the altarpiece implored " humbly and devotedly that for the love of Christ and of His Mother the Glorious Virgin and for the honor of the community and people of Bologna, with whose help the domicile of the friars was begun and through the grace of God and the bounty of the city will be completed, to be so kind as to visit personally their domicile on the Feast of the Glorious Virgin, which will there be solemnly commemorated and to impart some assistance to them so that these friars may be obligated to always pray for the honor and well being of the city ". This quotation refers to the partial consecration of the yet uncompleted church in connection with the solemn establishment of a Marian feastday. The stylistic closeness of the Servite Madonna to the one Cimabue painted for the Ospedale di S. Maria Nuova in Florence (1286-88) leads one seriously to consider that the image honored was the one which today is still conserved in the Order's 14th-century basilica. Otherwise, for further building activity, one would have to move to the years 1291-99. Cf. F. MONTANARI, " La Chiesa di S. Maria dei Servi in Bologna ", extract from the *Bollettino della Diocesi di Bologna*, VI, 1915, I, p. 29 ff; II, p. 65 ff; FRANCESCO FILIPPINI, " La Madonna di Cimabue nella Chiesa dei Servi ", in *Bologna*, XV, 1937, No. 6, pp. 29-32; PAOLO FERRONATO-GABRIELE ROCCA, *Santa Maria dei Servi in Bologna*, Genoa, 1958; H. HAGER, *Die Anfänge des Altarbildes in der Toscana*, Munich, 1962, p. 143, demonstrates, how the work, in spite of its reduced dimensions, was proper for an altar.

Carlo Volpe who incidentally lives in Bologna charges me with having used " a very modest historiography, which, in fact, is practically unknown to the specialists ", and of not making an adequate critique of the sources. The object, however, of this note, which in large measure is verified by Bolognese archival documents regarding the church of S. Maria dei Servi, is the confirmation of the possibility of the church's consecration (which could not have taken place without an altarpiece) precisely in 1287, the year cited in the document.

Through the Madonna prototype by Coppo di Marcovaldo at Siena the iconography of the Madonna dei Servi might go back to the Madonnas on the bejeweled cushioned thrones attested in Rome as early as the eighth century.

89) In *Giotto*, Geneva, 1960, I pointed out the relationship between Duccio and the Bolognese altarpiece. The fact that the iconographic theme was of Sienese origin — as well as the typology of the altarpiece — as HAGER has clearly shown, explains certain agreements better than a direct Cimabue-Duccio collaboration which F. BOLOGNA now conjectures, (" Ciò che resta di un capolavoro giovanile di Duccio " in *Paragone*, 125, May 1960 — the actual date of issue was, however, much later) and in *La Pittura Italiana delle Origini*, Rome-Dresden, 1962, pp. 128-29: " In my opinion this great painting must have been thought out and drawn by Cimabue himself, when the grand manner of the early transept frescoes had already begun to be softened. A softening along with the transposition of forms in a chromatic sweetness that up to then had not appeared in his work are certainly the signs of the same intervention that

during this period also appears in the ' Angel ' of the Assisi window and in the ' Madonna ' in Turin: the intervention, that is, of the youthful Duccio ". The problem of the contact with Siena seems to me certainly to be placed too early — F. Bologna was not familiar with the Bolognese documents and thus associates works that are chronologically separated such as the Assisi frescoes and the Servite altarpiece. Rather such an influence is to be studied in *Christ and the Virgin Enthroned* of the Assisi cycle (Fig. 15), and almost certainly we see the Sienese Master's hand in the angel in the angle devoted to St. Luke (Pl. 8 in color). It should be borne in mind, moreover, that that scene was Duccio's inspiration for the window of the Siena Cathedral.

90) H. HAGER, *Die Anfänge des Altarbildes*, pp. 139-141, Figs. 203-6. The panel which is completely repainted is in the dependency of the Convento delle Oblate Ospitaliere at Careggi near Florence. Although the identification of the painting is one of the most important of recent years there is no plan to remove the repainting and reveal the original Dugento brushwork (verbal communication to Dr. Hager by Prof. Ugo Procacci). The 1286-88 dating of the panel furnishes the second firm point for Cimabue's Florentine activity which was concentrated in the span of a few years.

91) Unfortunately, there are no chronological clues for the S. Trinita Altarpiece either in the history of the building or in the history of the Order. The commission seems to have come about, in this instance also, as a consequence of Cimabue's work in Assisi, but not so much because of a connection between the Vallombrosan Order and the Franciscans as that Valentino II degli Abati (Abbot General from 1277 to 1298) was a counsellor to Nicholas III and was his delegate to the Florentines. For the church's history see: W. PAATZ, " Die gotische Kirche S. Trinita in Florenz ", *Miscellanea Goldschmidt*, Berlin, 1935, pp. 113-18; R. BALDACCINI, " Santa Trinita nel periodo romanico ", in *Rivista d'Arte*, XXVI, 1950, pp. 23-72; and idem, " Santa Trinita nel periodo gotico ", *ibid.*, XXVII, 1951-52, pp. 57-91; H. SAALMAN, " The Church of Santa Trinita in Florence ", in *Marsyas*, X, 1961, p. 71. The only firm point is that the church was usable in 1289 as an assembly was held there at that time.
On the architectural history of Santa Trinita F. OSWALD's did a lecture at the Kunsthistorisches Institut di Firenze, the 13, VI, 1962. PARRONCHI in *Studi sulla dolce prospettiva*, p. 101-104 attributes the plan of Santa Trinita to Nicola Pisano.

92) Cf. G. SOULIER, *Les influences orientales dans la peinture toscane*, Paris, 1924, p. 148. The difference between Cimabue and Duccio in the shape of the pupils of the eyes might, however, also derive from Duccio's knowledge of Vitello's manuscript on Optics where in book IV, p. 148 we read, " Figura etiam facit pulcritudinem; unde artificiata bene figurata videntur pulchra, magis autem opera naturae: unde oculi hominis cum sint figurae amygdalaris oblangae, videntur pulchri, rotundi vero oculi videntur penitus deformes ". Naturally it is possible that around 1285 in Viterbo, that is to say in the immediate vicinity of Rome, Vitello in this observation had oriental paintings in mind. Cf. *Opticae Thesaurus Alhazeni Arabis libri septem, i...item Vitellionis Thuringopoloni libri X*, etc., (Basileae, 1572), pp. 35-36.

93) RENZO BALDACCINI (*Op. cit.*, II, p. 90) writes: " his physiognomy reflects, through his marked acceptance of flat forms, a certain hesitancy in the reception of Gothic verticalism. A vivid Romanesque recollection, that will remain throughout the whole Florentine Trecento, prevails in the arrangement. A tone of austerity that reflects the component of the Florentine spirit of the time characterizes it: severe and composed, sober and plainly

clothed. His forms are simple, still uncertain, but based always on the Florentine tradition. We already see in him the ' vernacular ' poetry, the lyric accent of his lines mirrors the content of that genuine popular current and is decisively separated from the rational abstractions of French Gothic ". With slight changes, the description seems an analysis of Cimabue's altarpiece.

94) Cited by EDGAR DE BRUYNE, *Études d'Estéthique Médiévale*, III, Bruges, 1946, pp. 50-51.

95) Cf. JAMES H. STUBBLEBINE, " The Development of the Throne in Dugento Tuscan Painting ", *Marsyas*, 1954-57, pp. 25-39. A splendid analysis of this throne from the spatial point of view has been made by Miriam Schild Bunim, *Space in Medieval Painting and the Forerunners of Perspective*, New York, 1940. The powerful construction of the Cimabuesque throne has also interested modern artists connected with Cubism and the study of visual proportions, cf. LUCIEN SCHWOB, *Réalité de l'Art* with a preface by J. Villon, Lausanne, 1954, pp. 130-32. In an oral communication Prof. Salvini notes the ascending effect of the image and recalls that it was meant to be seen from below. Nevertheless, it is inexact to state that the perspective is from below; in fact the perspective lines converge regularly, even though by groups, toward focuses which are found at about two-thirds and one-half the height of the altarpiece.

96) Fundamental in this area is G. WEISE, *Die geistige Welt der Gotik und ihre Bedeutung für Italien*, Halle a S., 1939, partially translated into Italian under the title *L'Italia e il mondo gotico*, Florence, 1956.

97) For the Pisan works cf. the Documents Appendix.

98) There are no indications of any architectural activity on Cimabue's part (although the possibility is indirectly given credence by the successive appointment of a painter close to him — that is Giotto — to S. Maria del Fiore). The coeval architectonic culture shared with Cimabue analogous preoccupations with proportions, syntax, coherence and, one might add, perspective. However, this concomitance was probably due to an analogous prevalence of rationalism and perhaps of scholasticism. H. HAHN, *Die frühe Kirchenbaukunst der Zisterzienser*, Berlin, 1957, pp. 316-17, attempts to demonstrate the profound influence through the medium of S. Maria Novella of proportional ideas that in their original formulation go back to St. Bernard. A very rigorous canon of 2:3.5 was applied to the decorative marble panelling of the base of S. Maria del Fiore according to the original elevation by Arnolfo (cf. M. WEINBERGER, " The First Façade of the Cathedral of Florence ", *Journal of the Warburg and Courtauld Institutes*, IV, 1940-41, pp. 67 ff.). WALTER PAATZ, *Werden und Wesen der Trecento-Architektur in Toskana*, Burg b. M., 1937, believes Cimabue was connected with the Badia in Florence (which he dates 1280-90) as it is free of Gothic stylizations. Nevertheless, at the beginning of 1300 the work on S. Maria del Fiore slowed down, perhaps also because of financial difficulty and general politics. Cf., P. METZ, " Die Florentiner Domfassade des Arnolfo di Cambio ", *Jahrbuch der preuszischen Kunstsammlungen*, LIX, 1938, pp. 121-60.

99) I referred to the study of H. BERI for this date: " The Original Plan of the Divine Comedy " in *Journal of the Warburg and Courtauld Institute*, 1955, pp. 189-210, which takes up the thesis of G. FERRETTI (*Saggi Danteschi*, 1950, pp. 3-25) that the first seven cantos were started in 1301-02 and Canto VIII of the *Inferno* not less than five years later.

100) E. AUERBACH, *Mimesis, Il realismo nella letteratura occidentale*, Italian trans., Turin, 1956, chapter VII.

101) CARLO KERÉNYI, *Miti e Misteri*, Italian trans., Turin, 1950, chapter " Arbor intrat ", pp. 365-75.

CHRONOLOGY OF CIMABUE

(*Documented dates are in italics*)

1250 c. Born in Florence, the son of a certain Pepo (= Giuseppe), baptisimal name Benvenuto (= Cenno).

(?) The Crucifix for San Domenico at Arezzo, undocumented, attributed to Cimabue by Toesca; the attribution has been unanimously accepted by the critics and confirmed by its similarity to the Santa Croce Crucifix at Florence.

1272 Appears as a witness in a notably important juridical action in Rome, concerning the passage of the nuns of St. Damian to the Augustinian rule through the express order of Pope Gregory X, with the aim of avoiding disputes and polemics among the Franciscans.

1279-83 c. The frescoes of the Basilica of St. Francis at Assisi.

1285-88 c. Crucifix for Santa Croce at Florence.

1287 Madonna dei Servi altarpiece for S. Maria dei Servi at Bologna, perhaps executed in Bologna.

1286-88 c. Madonna and Child Enthroned with two Angels for the Ospedale di Santa Maria Nuova at Florence.

(?) Santa Trinita altarpiece at Florence.

Before 1301 Altarpiece for the Chiesa di San Francesco at Assisi, now in the Louvre.

1301- February, 1302 St. John the Evangelist, apsidal mosaic in the Pisa Cathedral.

1301-2 Altarpiece for the Ospedale di Santa Chiara of the Franciscan Order at Pisa. Executed in collaboration with Johannes detto Nuchulus. The work is lost or not executed.

February or March 1302 Death of Cimabue.

19 March, 1302 A document speaks of "heredes Cenni pictoris" as adjoining a house near Fiesole. This is proof that Cimabue himself left real estate to his heirs.

4 July, 1302 Two cloths which belonged to Cimabue are conveyed to the new Camerlengo of the Confraternita dei Battuti, where presumably Cimabue had formal residence in order to be able to work in the city and still keep his Florentine citizenship.

DOCUMENTS

ROME
1272, 18 June, Archives of Santa Maria Maggiore
Parchment A. 45.

In nomine domini. anno ejusdem millesimo CC LXXII
Indictione XV die VIII mensis Iunii intrantis. Pontifi-
catus domini Gregorii papæ decimi. Anno primo.

In presentia mei Guidonis ballonis Parmensis Notarii
et testium subscriptorum ad hec specialiter vocatorum
et rogatorum: Reverendus pater frater Thomas misera-
tione divina sacrosancte Ierosolymitane Ecclesie patriar-
cha asserens oraculo vive vocis sibi a domino papæ com-
missum ad instanciam et in presentia Reverendi patris
domini Ottoboni sancti Adriani diaconi cardinalis ut de
dominabus quondam ordinis sancti Damiani — que sunt
apud ecclesiam sancti Andree de fractis prope sanctam
Mariam majorem de Urbe, in qua ipse domine de Ro-
manie exilio venientes fuerunt dudum per dictum do-
minum Cardinalem misericorditer collocate — provide-
ret et ordinaret prout saluti animarum suarum melius
expedire videret, vel eas in illo habitu demittendo vel ad
aliam Religionem et professionem transferendo, ita quod
omnis controversia, turbatio et molestia —, que exor-
ta fuisset vel exoriri posset imposterum inter dictas do-
minas ex una parte et religiosos viros fratres Minores ex
altera, ex quacumque causa, occasione vel modo — de
cetero sopiretur, ita quod et dictis fratribus Minoribus
nullum ex eis scandalum generaretur, et dictarum domi-
narum saluti et quieti ac stabilitati illius loci providere-
tur:

habita diligenti deliberatione cum Reverendo patre
domino Opizone Dei gratia sacrosanctæ et Antiochene
sedis patriarcha divine pietatis intuitu disquisitis prius
ipsarum voluntatibus dominarum, provisis etiam et col-
latis cum predicto domino Opizone patriarcha Antio-
cheno omnibus que ad salutem dominarum illarum, ad
Religionis cultum, ac dicti loci stabilitatem et incremen-
tum possent imposterum pertinere et ut scandalo vel
calumgnie quorumcumque Monasteriorum de Urbe pre-
caveretur:

In nomine patris et filii et spiritus sancti absolvit dictas
dominas omnes et singulas ab omni vinculo professionis
regulæ sancti Damiani et transtulit eas ad professionem
et regulam beati Augustini et constitutiones dominarum
sancti Syxti de Urbe competentes eisdem secundum
quem et quas a dictis dominabus universis et singulis
professionem et obedientiam manualem vice et nomine
dicti domini pape recepit. Volens ac statuens de dicti
domini pape speciali mandato, ut dixit, ut eedem domine
sint sub obedientia patrocinio et protectione Reverendi
patris domini Ottoboni Cardinalis predicti a quo reci-
pient visitatores correctores et confessores, prout idem
dominus Cardinalis duxerit pro tempore ordinandum
quamdiu vixerit, ita tamen quod post mortem suam
semper simili modo habeant alium Cardinalem protecto-
rem et defensorem de speciali mandato domini pape cui
immediate subsunt sicut summo prelato Urbis et Orbis.
Habitum quoque earum griseum prius mutavit in album
ita quod tunicis et mantellis albis de cetero utantur re-
lictis eis capuccis griseis, et offitio divino Curie Romane
et clausura perpetua sicut prius, ita quod ab aliis personis
Religiosis essent discrete habitu vel professione et modo
vivendi.

Quam ordinationem institutionem et translationem et
habitus mutationem ipse domine universe et singule
libenter et prumptis animis susceperunt tam pro se,
quam pro succedentibus eis in eodem Monasterio sancti

Andree de fractis imperpetuum observandas et invio-
labiliter tenendas in honorem dei et beate virginis, beati
Andree, domini pape et Romane ecclesie cuius obedien-
tie se totaliter ut dictum est submiserunt.

In quorum omnium testimonium et munimen perpe-
tuum predictus dominus patriarcha Jerosolymitanus
instruendo presenti ad instanciam dominarum ipsarum
suum fecit sigillum apponi.

Actum Rome in domibus predictarum dominarum san-
cti Andree de fractis presentibus dicto domino patriarcha
Antiocheno, fratre Raynaldo episcopo Marsiceno, do-
mino Petro Paparano canonico ecclesie sancte Marie
Majoris de Urbe, fratre Gualtero de Augusta, de ordine
fratrum Predicatorum Gentile et Paulo Canonicis eccle-
sie sancti Martini in Montibus de Urbe, Presbitero Ar-
mano de sancto Petro de Clavaro, domino Jacobo
Iohannis Sassonis de Urbe, et Cimabove pictore de
Florencia, et aliis pluribus testibus vocatis ad ea specia-
liter et rogatis.

Et ego Guido predictus sacrosancte Romane ecclesie
auctoritate Notarius, etc.

The juridical action, published by Strzygowski, 1888,
pp. 158-60, was previously known to De Angelis,
Basilica S. Mariae majoris descriptio, etc., Rome, 1621,
p. 57 who refers to the passage of the nuns of St. Peter
Damian of the Franciscan Order to the Augustinian rule
by the express order of Pope Gregory X with the pur-
pose of avoiding every "controversia, turbatio et mo-
lestia" occurred or occurring within the Franciscan
Order. The reference to St. Peter Damian in the name
of the female Order leads one to think of a very rigoris-
tic attitude. In fact in the *Divine Comedy, Paradise*,
XXI, 121 ff., St. Peter Damian opposes ceremonial
splendor.
F. Bologna (1965) emphasizes, further corroborating
the importance of this document formerly almost ignor-
ed by Italian criticism, that "that date and that presence
acquire additional meaning if one takes into account
that the action occurred only three months after the
coronation of Gregory X, the pope who, after the
fall of the Svevi, was the first to restore importance
to the Roman See ".

PISA
1301, 30 August - 1302, 19 February
Magistri Magiestatis majoris.
From the book of Income and Expenditures of 1301,
p. 94. Archives of the Pisa Cathedral (Ciampi, Doc. 24).

Uguccio Grucci, et Jacobus Nucci positi, et constituti
a Comuni Civitatis pisane super fieri faciendo majesta-
tem super altare majoris ecclesie pisane etc.

From the book entitled "Introitus et exitus facti,
et habiti a Burgundio Tadi, Operario operae
Sanctae Mariae pis. majoris eccle. sub a. d. MCCCII
Ind. (X) IIII de mense madij inceptus", *ibid.*, (Ciampi,
Doc. 25).

Magister Franciscus pictor de S. Simone porte maris
cum famulo suo pro diebus V quibus in dicta opera
Magiestatis laborarunt ad rationem solidorum X pro
die. . . Victorius ejius filius pro se et Sandruccio famulo
suo etc. Lapus de Floren. etc. Michael pictor etc. Duc-
cius pictor etc. Tura pictor etc. Datus pictor etc. Bon-
turus pictor, etc. Puccinellus pictor, etc. filius magistri
Cioli, etc. Vannes Florentinus pictor, etc.

(Ciampi Doc. 26).

Magister Cimabue pictor Magiestatis pro se et famulo suo pro diebus quatuor quibus laborarunt in dicta Opera ad rationem solid. X pro die. . .libr. II
Cimabue pictor Magiestatis sua sponte fuit confessus se habuisse a D. Operario de summa libr. decem quas dictus Cimabue habere debebat de figura S. Johannis quas fecit juxta Magiestatem. . .libr. V sol. X [Actum Pisis in apotheca domus Gerardi Fazeli. . .XJ Kalendas martii MCCCIJ]
Johannes Orlandi coram me Ugolino notario recepit a D. Burgundio operario pro pretio librarum 76 olei linseminis ab eo, et operato. . .ad operam Magiestatis que fit in majori Ecclesia, lib. III sol. XVIIII den. pis.
Bacciameus filius Jovenchi mediolanensis . . . fuit confessus se habuisse a D. Operario libras quatuordecim et sold. tredecim den. pis. de pretio vitri laborati et colorati quem facere debuit juxta. . .et voluntatem magistri Cimabovis pictoris, quem vitrum dictus Bacciomeus vendere et dare debet suprad. operario ad rationem den. XXVIII pro qualibet libra pro operando ipsum ad illas figuras que noviter fiunt circa Magiestatem inceptam in majori Ecclesia S. Marie.

Johannes Orlandi sua sponte dixit se habuisse a d. Operario libras duas den. pis. pro pretio libre viginti novem trementine operate ad operam Magiestatis

Libras quinquaginta quatuor, et solidos decem et octo den. pisanorum minutorum pro pretio centinarum quatuor olei linseiminis ad operam Magiestatis, et aliarum figurarum que fiunt in majori Ecclesia, ad rationem denariorum XXVIII pro qualibet libra.
Upechinus pictor pro libris quadraginta tribus vernicis emptis ab eo ad operam Magiestatis.

From *Notizie inedite della sagrestia pistoiese*, etc., by Prof. Ciampi, Florence, 1810, pp. 143-44; the documents were republished by A. Da Morrona, *Pisa Illustrata*, etc., Vol. I, Leghorn, 1812, p. 249. According to Giorgio Trenta, *I musaici del duomo di Pisa e i loro autori*, Florence, 1896, pp. 80-88, payments referring to Cimabue were from 2 September 1301 at the rate of 10 *soldi* a day for himself and for his assistant up till 20 January 1302. A brief interruption, then until 19 February 1302 when the figure of St. John the Evangelist was specified as the work of Cimabue. Cf. above all L. Tanfani-Centofanti, *Notizie di artisti tratte dai documenti pisani*, Pisa 1897, pp. 114-19 where further information is given on the course of the works, on Cimabue's collaborators and on the quality of material used. See also pp. 121 and 186-89.

1301, 1 November, Ospedale of Santa Chiara at Pisa. Contracts of Ser Giovanni di Bonagiunta, No. 012, p. 29, Pisa State Archives.

Magister Cenni dictus Cimabu pictor condam Pepi de Florentia, de populo sancti Ambrosii et Iohannes dictus Nuchulus pictor qui moratur Pisis in Cappella sancti Nicoli et filius Apparecchiati de Luca, et quilibet eorum in solidum per solemnem stipulationem convenerunt et promiserunt fratri Henrico magistro dicti hospitalis pro dicto hospitali recipienti quod hinc ad unum annum proxime venturum eorum manibus propriis facient pingere et laborabunt tabulam unam (cum) colonnellis, tabernaculis et predula pictam storiis divine maestatis beate Marie Virginis, apostolorum, angelorum et aliis figuris et picturis de quibus videbitur et placuerit ipsi magistro vel alteri persone legiptime pro dicto hospitali, et unam crucem depicta (sic) de argento deaurato ponendam ad tabernaculum de medio dicte tabule. Que picture maestatis divine beate Marie Virginis et apostolorum et aliorum sanctorum fiende in colonnellis et predula dicte tabule et planis tabule fiant et fieri debeant de bono et de puro auro floreni, et alie picture fiende in dicta tabula a colonnellis sursum in tabernaculis et angelis pasis et scorniciatis fiant et fieri debeant per eos ut dictum est, de bono argento deaurato, ponendam

super altari majori Sancti Spiritus ecclesie sancte Clare dicti hospitalis in ea longitudine qua est dictum altare et in ea altitudine de qua videbitur ipsi magistro vel alteri persone pro dicto hospitali. Et quod ipsam tabulam, sic factam et pictam ut dictum est, omnibus eorum expensis ponet super dictum altare fixam et firmam ut ipsi magistro videbitur expedire pro infrascripto salario. Alioquin penam infrascripti pretii et totius dampni interesse et expensas que propterea predictum hospitale substineret et pateretur. Et omnes expensas etc. Obligando se in solidum et cuiusque eorum heredes et bona insolidum ei recipienti pro dicto hospitali et ipsi hospitali pro dictis omnibus obligando. Renuntiando benificio solidi et privilegio fori, etc. Quare predictus magister pro dicto hospitali et eius vice et nomine per solemnem stipulationem convenit et promisit suprascriptis magistro Cenni et Johanni dare et solvere vel dari et solvi facere eis etc. pro pretio et nomine certi pretii predicte tabule et eius laborerii libras centum quinque denariorum pisanorum ad infrascriptos terminos videlicet hinc ad unum mensem proxime venturum libras quadraginta denariorum pisanorum et residuum dicti pretii in fine dicti anni vel ante si dicta Tabula conpleta vel facta esset. Alioquin penam dupli dicti pretii. Et omnes expensas etc. Obligando se et bona etc. Renuntiando omni iuri etc. Et statuerunt inter se dicti contrahentes ex pacto quod quandocumque predicti magistri reciperent predictum pretium vel aliquam eius partem dabunt ipsi magistro vel alii persone legiptime pro dicto hospitali recipienti bonum et ydoneum fideiussorem de pecunia et de tabula predicta facienda ut dictum est. Actum Pisis in loco dicti hospitalis, presentibus Puccio filio Guidonis Henriconis notarii de cappella sancte Marie Majoris et Puccio vinario filio Coscii vinarii de Sancto Blasio in ponte testibus ad haec rogatis MCCCII indictione XV ipso die Kalendarum Novembris.

1301, 5 November, *ibid.*, p. 30

Magister Cenni dictus Cimabu pictor condam Pepi et Johannes dictus Nucchulus pictor filius Apparecchiati coram me etc. abuerunt et receperunt a fratre Henrico magistro dicti hospitalis dante et solvente pro dicto hospitali libras quadraginta denariorum pisanorum de summa et quantitate librarum centum quinque denariorum pisanorum quas predictus magister convenit et promisit dare et solvere eis pro pretio et nomine certi pretii unius tabule per cartam rogatam a me notario. De quibus se etc. Et inde cum etc. Et dictam cartam in dicta quantitate cassam et irritam vocaverunt. Actum Pisis in loco dicti hospitalis, presentibus Coscio condam Argomenti de cappella sancti Petri in curte veteri et Puccio condam Henrici de cappella Sancti Felicis testibus ad hec rogatis MCCCII indictione XV, nonis Novembris.

Published by G. Fontana, *Due documenti inediti riguardanti Cimabue*, Pisa, 1878 and by L. Tanfani-Centofanti, *Notizie di artisti tratte dai documenti pisani*, Pisa, 1897, pp. 119-21. Comparative check made in the archives.

FIESOLE
1302, 19 March

A document, quoted by R. Davidson, *Geschichte von Florenz. Die Frühzeit der Florentiner Kultur. III, Kirchliches und Geistiges Leben, Kunst, Öffentliches und Häusliches Dasein,* Berlin, 1927, note at page 227, speaks of "heredes Cienni pictoris" as adjoining a house "in populo canonice Fesulane in contrata de S. Mauritio".
This in proof of an estate patrimony outside Florence and of the death of the Master shortly before.

PISA
1302, 4 July. State Archives of Florence. Register of Chiaro d'Andrea, Notarial c. 462 c. 37 verso.

Marchus suprascriptus coram me etc. habuit et recepit a Balduccio (olim camerarius super dicte societatis) dante

suprascripto modo unum par guantorum de ferro Telleri baccellori, pro soldis octo den. pis. et unam serram Mannucci Arcarij pro denariis duodecim et tobaliam unam et tobaliolam unam Cimabue pictoris et unam sportam et duo tobaliole Landucci Fanelli de quibus se etc. Actum in suprascripto loco (in Apotheca Ecclesiæ Sancti Nicoli) et suprascripto die (MCCC III, Ind. XV, quarto nonas julii).

From SUPINO, *Arte Pisana*, Pisa, 1904, p. 251. Comparative check made in the archives. The document refers to a precedent act (folio 37a) of consignment on the part of Balduccio Boteghe, former *camerario* of the Society of the Piovuti, of monies to the new *Camerlengo* Marco di Riccomanno, pharmacist.

The Society of the Piovuti was, according to FRANCESCO BONAINI, *Memorie inedite intorno alla vita e ai dipinti di Francesco Traini*, Pisa, 1846 and according to SUPINO, *op. cit.*, a weapons company. However, at the beginning of the 14th century, they displayed a certain artistic patronage (on 16 June 1302 they paid for some body shields; in the same year the walls of the confraternity were frescoed by the same Vittorio who worked on the Maestà on the apsidal vault of the Cathedral). They also assembled a great number of painters, all called "della Cappella di S. Niccola".
In this Pisan document we do not find reference to the death of Cimabue: perhaps because this happened not in Pisa, but probably in Florence, where according to the doubtful testimony of Vasari, he had been called by the Opera del Duomo.

PRINCIPAL LITERARY SOURCES

1310 c. DANTE, *The Divine Comedy*, Purgatory, XI, 91 and following.

O vanagloria dell'umane posse,
Com' poco verde in su la cima dura,
Se non è giunta dall'etati grosse!

Credette Cimabue nella pittura
Tener lo campo; ed ora ha Giotto il grido,
Sí che la fama di colui oscura.

Cosí ha tolto l'uno all'altro Guido
La gloria della lingua; e forse è nato
Chi l'uno e l'altro caccerà di nido

1328-33. COMEDIA DI DANTE... COL COMMENTO DI JACOPO DELLA LANA, ed., Bologna, 1866-67; Vol. II, p. 130-31.

"Questi (Cimabue) fue al suo tempo sommo dipintore in del mondo, e cosí credette essere sempre nomato per lo migliore; e lo suo creder venne meno che in del tempo dello autore fue piue nomato un altro ch'ebbe nome Giotto, e di quello Cimabue non si dicea nulla".

1333-34. L'OTTIMO COMMENTO DELLA DIVINA COMMEDIA. TESTO INEDITO D'UN CONTEMPORANEO DI DANTE CITATO DAGLI ACCADEMICI DELLA CRUSCA, Pisa, 1828, II, p. 188.

"Qui narra per esemplo, e dice, che come Oderigi nel miniare, cosí Cimabue nel dipingere, credette essere nominato per lo miglior pittore del mondo, e 'l suo creder venne tosto meno, peroché sopravvenne Giotto, tale che a colui ha tolto la fama; e dicesi ora pure di lui. Fu Cimabue nella città di Firenze pintore nel tempo dello Autore, e molto nobile, de piú che uomo sapesse; e con questo fu sí arrogante, e sí sdegnoso, che se per alcuno gli fosse a sua opera posto alcuno difetto, o egli da sé l'avesse veduto (che, come accade alcuna volta, l'artefice pecca per difetto della materia in ch'adopera, o per mancamento che è nello strumento, con che lavora)

immantenente quella cosa disertava, fosse cara quanto si volesse".

Bibl. J. SCHLOSSER, *Zur Geschichte der Kunsthistoriographie; Die florentinische Künstleranekdote*, in "Präludien", p. 248 ff.

1340. PETRI ALLEGHERII SUPER DANTIS IPSIUS GENITORIS COMOEDIAM COMMENTARIUM, ed. V. Nannucci, Florence, 1846, p. 375.

Et maxime modicum durat haec nostra fama, scilicet vanagloria, si ætates subtiles sequantur, ut patet in Cimabove et Giotto pictoribus egregiis... Et hoc est quod vult dicere, si tempus non propagetur ab ætatibus grossis dicta fama modicum viridis dessicatur.

SACCHETTI, *Novella* 136.

Nella città di Firenze, che sempre di nuovi uomeni è stata doviziosa, furono già certi dipintori e altri maestri, li quali essendo a un luogo fuori della città, che si chiama San Miniato a Monte, per alcuna dipintura e lavorio, che alla chiesa si doveva fare; quando ebbono desinato con l'Abate, e ben pasciuti e bene avvinazzati, cominciorono a questionare; e fra l'altre questione mosse uno, ch'avea nome l'Orcagna, il quale fu capo maestro dell'oratorio nobile di Nostra Donna d'Orto San Michele: Quale fu il maggior maestro di dipignere, che altro, che sia stato da Giotto in fuori? Chi dicea che fu Cimabue, chi Stefano, chi Bernardo (Daddi), chi Buffalmacco, e chi uno e chi un altro. Taddeo Gaddi, che era nella Brigata, disse: " Per certo assai valenti dipintori sono stati, e che hanno dipinto per forma, ch'è impossibile a natura umana poterlo fare: ma quest'arte è venuta e viene mancando tutto dí".

1379. COMMENTUM MAGISTRI BENVENUTI DA IMOLA IN COMOEDIAM DANTIS, edition edited by Lod. Antonio Muratori, Antiqui Italici Medii Aevi, I, pp. 1185-86.

Sed spes ejus (Cimabovis) est delusa, quia non reperit in ætatibus grossis immo nec in subtilioribus.

XV century. COMMENTO ALLA DIVINA COMEDIA D'ANONIMO FIORENTINO, edition edited by Pietro Fanfani, II, p. 187.

Cimabue fu da Firenze, grande et famoso dipintore, tanto che al suo tempo in Italia non si trovava maggiore maestro di dipingere et molte opere si truovano ancora in Firenze et altrove; et uno palio fra gli altri notabile di maisterio in Santa Maria nuova in Firenze. Et ancora vivi suoi discendenti.

1405 c. FILIPPO VILLANI, *De origine civitatis Florentinae et eiusdem famosis civibus*.

" Inter quos primus Johannes, cui cognomento Cimabue nomen fuit, antiquatam picturam et a nature similitudine pictorum inscicia pueriliter discrepantem cepit ad nature similitudinem quasi lascivam et vagantem longius arte et ingenio revocare. Constat siquidem ante hunc Grecam Latinamque picturam per multa secula sub crasse imperitie ministerio iacuisse, ut plane ostendunt figure et ymagines que in tabulis atque parietibus cernuntur sanctorum ecclesias adornare. Post hunc strata iam in novibus via Giottus, non solum illustris fame decore antiquis pictoribus conparandus sed arte et ingenio preferendus, in pristinam dignitatem nomenque maximum pictura restituit ".

Bibl. J. SCHLOSSER, " Quellenbuch zur Kunstgeschichte des abendländischen Mittelalters " *Quellenschriften für Kunstgeschichte*, N. F., VII, Vienna, 1896, p. 370 ff. Idem, " Filippo Villanis Kapitel über die Kunst in Florenz ", in *Präludien*, Berlin, 1927, p. 261 ff.

E. Panofsky, " Renaissance and Renascences in Western Art ", *Figura* 10, Uppsala, 1960, p. 15.

1455. Lorenzo Ghiberti, *I Commentari*.

Second commentary, 2.

Cominciò l'arte della pittura a sormontare in Etruria. In una villa allato alla città di Firenze, la quale si chiamava Vespignano, nacque un fanciullo di mirabile ingegno, il quale si ritraeva dal naturale una pecora. In su passando Cimabue pittore per la strada a Bologna vide il fanciullo sedente in terra e disegnava in su una lastra una pecora. Prese grandissima ammirazione del fanciullo, essendo di picciola età fare tanto bene. Domandò, veggendo aver l'arte da natura, il fanciullo come egli aveva nome. Rispose e disse: — Per nome io son chiamato Giotto: il mio padre à nome Bondoni e sta in questa casa che è appresso — disse. Cimabue andò con Giotto al padre: aveva bellissima presenza: chiese al padre il fanciullo: il padre era poverissimo. Concedettegli il fanciullo e Cimabue menò seco Giotto e fu discepolo di Cimabue: tenea la maniera greca, in quella maniera ebbe in Etruria grandissima fama: fecesi Giotto grande nell'arte della pittura.

The narrative follows a mythic scheme: cf. E. Kris, O. Kurz, *Die Legende vom Künstler*, Vienna, 1934, pp. 33 ff. J. Schlosser, *Präludien, Vorträge und Aufsätze*, Berlin, 1927, pp. 248 ff.

Giotto would have had to enter Cimabue's workshop after 1272, the date of the painter's sojourn in Rome, or during one of Cimabue's possible trips back to Florence. During the period of the Master's work in Assisi, the young pupil would have been from 13 to 18 years of age. However, there is no proof that a direct master-pupil relationship existed and not merely a stylistic influence.

1474. Alamanno Rinuccini, *Lettera XXXII*. Ad illustrem principem Federicum Feretranum Urbini comitem. Alamanni Rinuccini in libros Phylostrati De Vita Apollonii Tyanei e græco in latinum conversos præfatio incipit.

Cogitanti mihi sæpenumero, generosissime princeps Federice, et ætatis nostræ viros cum veteribus conferenti, perabsurda videri solet eorum opinio, qui veterum quæque dicta factave pro maximis celebrantes, non digne satis ea laudari posse arbitrantur, nisi temporum suorum mores accusent, ingenia damnent, homines deprimant, infortunium denique suum deplorent, quod hoc sæculo nasci contigerit, in quo nulla probitas, nulla industria, nulla, ut ipsi putant, bonarum artium studia celebrantur. Cuius res causam plerique in naturam referentes, senescentis mundi vitio et iam ad interitum vergentis id ipsum putant evenire. Quæruntur enim et ætates hominum breviores et corpora imbecilliora et ingenia ad res præclaras hebetiora nunc a natura proferri, quam olim fuerint cum illi viguerunt, quos tantopere laudant et admirantur...

Mihi vero contra gloriari interdum libet, quod hac ætate nasci contigerit, quæ viros pæne innumerabile tulit, ita variis artium et disciplinarum generibus excellentes, ut putem etiam cum veteribus comparandos. Atque, ut ab inferioribus profecti ad maiorem tandem veniamus, sculpturæ picturæque artes, iam antea Cimaboi, Iocti, Taddeique Gaddi ingeniis illustratas, qui ætate nostra claruerunt pictores, eo magnitudinis bonitatisque perduxere, ut cum veteribus conferri merito possint. Nostræ autem ætati proximus Masaccius naturalium quarumque rerum similitudines ita pingendo expressit, ut non rerum imagines, sed res ipsas oculis cernere videamur. Quid vero Dominici Veneti picturis artificiosus? Quid Philippi monaci tabulis admirabilius? Quid Iohannis ex Prædicatorum ordine imaginibus ornatius? Qui omnes, varietate quadam inter se dissimiles, artis tamen excellentia, et bonitate simillimi putantur...

From *Lettere ed Orazioni*, edited by Vito R. Giustiniani, Florence, 1953, p. 107. Commented on by E. H. Gombrich, " The Renaissance Concept of Artistic Progress and its Consequences ", in *Actes du XVIIe Congrès International d'Histoire de l'Art*, Amsterdam, 23-31 July 1952 (The Hague, 1955), pp. 291-307.

1481. Comento di Christophoro Landino fiorentino sopra la Comedia di Dante Alighieri poeta fiorentino. Firenze Nicola di Lorenzo della mappa 1481/proemio ... fiorentini excellenti in pictura et sculptura.

Resta la pictura: la quale appresso gli antichi non fu mai in piccola stima. Scrivono gli egyptii la pittura essere loro invenzione: et d'Egypto essere venuta in Grecia. Ma de' greci alcuni dicono che è trovata in Sycione, alcuni in Coryntho. Erono le prime picture d'una sola linea, con la quale circundavano l'ombra dell'uomo. Di poi con un solo colore cominciorono a dipignere: onde tal pictura fu chiamata monocromata, idest d'un solo colore, perché monos significa solo, et croma colore. Né fu molto antica, perché secondo Plinio ne' suoi tempi delle guerre troiane non si trovavono ancora pictori. E primi in Grecia furono Serdice [*Aridices*] Corynthio et Thelophane [*Telephane*] Sycionio. Ma Parrasio Ephesio la ridusse in grande dignità. Seguitorono di poi molti da molti lodati, tra' quali il primo grado tiene Apelle, da tutti reputato etiam ne' futuri secoli insuperabile. Ma tale arte dopo la sua perfectione come molte altre nell'italica servitù quasi si spense: et erono le picture in quegli secoli non punto atteggiate et sanza affecto alcuno d'animo. Fu adunque el primo Joanni fiorentino cognominato Cimabue che ritrovò e liniamenti naturali et la vera proportione, la quale e greci chiamano Symetria; et le figure ne' superiori pictori morte fece vive et di vari gesti, et gran fama lasciò di sé: ma molto maggiore la lasciava, se non avessi avuto sì nobile successore, quale fu Giotto fiorentino coetaneo di Dante. Costui fu tanto perfecto et absoluto, che molto dipoi si sono affaticati gli altri che hanno voluto superarlo. E refertissima Italia delle sue picture, ma mirabile la nave di musaico a sancto Pietro di Roma de' dodici apostoli: ne' quali ciascuno ha gesti vivi et prompti et altutto sé differenti, et nientedimeno condecenti et proprii. Dalla disciplina di Giotto come da caval troiano uscirono mirabili pictori, tra' quali molto è lodata la venustà di Maso. Stephano da tutti è nominato Scimia della natura, tanto espresse qualunque cosa volle. Grandissima arte appare in Taddeo Gaddi. Fu Masaccio optimo imitatore di natura, di gran rilievo universale, buono componitore et puro sanza ornato, perché solo si decte all'imitatione del vero et al rilievo delle figure: fu certo buono et prospectivo quanto altro di quegli tempi, et di gran facilità nel fare, essendo ben giovane, che morì d'anni ventisei. Fu fra Philippo gratioso et ornato et artificioso sopra modo: valse molto nelle compositioni et varietà, nel colorire, nel rilievo, ne gli ornamenti d'ogni sorte, maxime imitati dal vero o finti. Andreino fu grande disegnatore et di gran rilievo: amatore delle difficultà dell'arte et di scorci, vivo et prompto molto et assai facile nel fare. Paolo Uccello buono componitore et vario, gran maestro d'animali et di paesi, artificioso negli scorci, perché intese bene di prospectiva. Fra Giovanni Angelico et vezoso et divoto et ornato molto con grandissima facilità. Pesello sopra gli altri valse negli animali. Seguitò Pesellino Gentile, et in compositione di cose piccole excellente. Philippo di ser Brunellesco architectore valse ancora assai nella pictura et sculptura: maxime intese bene prospectiva, et alcuni afferman lui esserne suto o ritrovatore o inventore: et nell'una arte et nell'altra ci sono cose excellenti facte da lui. Donato sculptore da essere connumerato fra gli antichi, mirabile in compositione et in varietà, prompto et con grande vivacità o nell'ordine o nel situare delle figure, le quali tutte ap-

paiono in moto. Fu grande imitatore degli antichi et di prospectiva intese assai. Desiderio grandissimo et dilicato et vezoso et di somma gratia: et che molto puliva le cose sue (et el quale molto ripuliva le cose): et se morte molto immatura non lo rapiva ne' primi anni sperava ogni dotto in quella arte che arebbe venuto ad somma perfectione. È notissimo Laurentio [di] Bartoluccio [*Ghiberti*] per le porte di bronzo del nostro baptisterio. Restono opere perfecte d'Antonio cognominato Rosso [*Rossellino*]. Et similmente di Bernardo suo fratello, architecto nobile.

COMMENT ON CANTO XI OF PURGATORY

Et provalo per exemplo di Cimabue el quale obtenne l'honore & el primo luogho nella pictura tanto che Giotto venne tal maestro che supero & vince Cimabue così forse verra in un altro tempo chi vincerà Giotto. Adunque non debba piglare alcuno vangloria delle proprie posse. Cimabue: costui essendo la pictura in obscurità la riduxe in buona fama. Giotto divenne magiore & più nobile maestro di Cimabue.

Bibl. J. Schlosser, *La letteratura artistica*, Cf. O. Morisani, " Art Historians and Art Critics, III; Christoforo Landino ", in *The Burlington Magazine*, XCV, 1953, p. 267 ff. P. Murray, *ibid.*, pp. 391-92.

1490. Piero di Lorenzo di Piero di Cosimo di Giovani di Bicci de Medici intese che noi avamo apud nos una tavoletta dipinta di mano di *Cimabue*, dipinta da ogni lato: dall'uno lato era una Disposizione di Croce colle Marie e altri sancti; da l'altro lato era Christo che metteva l'una mano in sul collo a Nostra Donna, e l'altra a Giovanni vangelista. E mandò acchiederla in compera, dove don Niccholo di Lionardo Biadi priore gliela donò personalmente al dì 20 di novembre 1490: presente don Paulo Coppini e frate Panutio e Ghalieno ricamatore. E mostrò averla molto grata, e molto si proferse in tutte le cose che per lui si poteva fare per la casa nostra no meno che gli suoi antichi. From the *Libro di ricordanze of the Monastero di San Benedetto*, p. 14. Cf. L. Pagliai in *Rivista d'Arte*, III, 1905, p. 153.

XVI century. Anonimo Magliabecchiano.
Florence, National Library, Cod. Magl. cl. XVII, 17.

Giovanni pittore, per cognome detto Cimabue, fu circha il 1300 e nelli sua tempi per le sue rare virtú era in gran veneratione. E esso fu, che ritrovò i lineamenti naturali e la vera proportione, da Greci chiamata simetria, et fece le fiure di varii gesti e teneva nell'opere sue la maniera Grega. Hebbe per compagno Gaddo Gaddo et per discepolo Giotto.
Et tra l'altre sue opere si vede in Firenze una Nostra Donna grande in tavola nella chiesa di Santa Maria Novella acanto alla Cappella de Rucellaj. E nel primo chiostro di frati di Santo Spirito fece certe historie non molto grandi.
In Pisa nella chiesa di San Francesco è di sua mano in tavola dipinto un san Francesco.
A 'Scesj nella chiesa di Santo Francesco dipinse, che dipoi da Giotto fu seguitata tale opera.
In Empoli nella pieve operò anchora.
Ed. Frey, Berlin, 1892, p. 49.

1490-1510. Il Libro di Antonio Billi, Ed. Frey, Berlin, 1892, p. 5.

Principal variants:
Cimabue nacque nel 1240. morì l'anno 1300.

In regard to the Rucellai Altarpiece: . . . oggi posta alto fra la cappella di Bardj et de Ruciellai. Andolla a vedere in borgo Allegri, mentre che la dipigneva, il re Carlo d'Angiò, et fu portata in chiesa a suono di trombe. Stava in casa in via del Cocomero.

1568. Giorgio Vasari, *Le vite dei più eccellenti pittori, scultori, e Architettori*, Florence, Giunti, 1568, pp. 82-88.

Vita di Cimabue, pittore fiorentino.

Erano per l'infinito Diluvio de' mali, ch' havevano cacciato al disotto, e affogata la misera Italia, non solamente rovinate quelle, che veramente fabriche chiamar si potevano; Ma, quello che importa piú, spento affatto tutto il numero degli artefici; Quando, come Dio volle, nacque nella città di Fiorenza l'anno MCCXL per dar i primi lumi all'Arte della pittura, Giovanni cognominato Cimabue della nobil famiglia in que' tempi de' Cimabui; costui crescendo, per esser giudicato dal padre, & da altri di bello, & acuto ingegno, fu mandato, acciò si esercitasse nelle lettere, in S. Maria Novella ad un maestro suo parente, che allora insegnava grammatica a' Novizij di quel convento: Ma Cimabue in cambio d'attendere alle lettere, consumava tutto il giorno, come quello che aciò si sentiva tirato dalla Natura, in dipingere in su' libri, & altri fogli, huomini, cavalli, casamenti & altre diverse fantasie; Alla quale inclinazione di Natura fu favorevole la fortuna; perché essendo chiamati in Firenze da chi allhora governava la città, alcuni pittori di Grecia, non per altro, che per rimettere in Firenze la pittura, piutosto perduta, che smarrita, cominciarono fra l'altre opere tolte à far nella città, la cappella de' Gondi, di cui hoggi le volte, e le facciate, sono poco meno che consumate dal tempo, come si può vedere in Santa Maria Novella, allato alla principale cappella, dove ell'è posta. Onde Cimabue, cominciato a dar' principio a quest'arte, che gli piaceva, fuggendosi spesso dalla scuola, stava tutto il giorno a vedere lavorare que' maestri; di Maniera, che giudicato dal padre, & da quei pittori in modo alto alla pittura, che si poteva di lui sperare, attendendo a quella professione, honorata riuscita; con non sua piccola sodisfattione fu da detto suo padre acconcio con esso loro; la dove di continuo esercitandosi l'aiutò in poco tempo talmente la Natura, che passò di gran lunga, sí nel disegno, come nel colore la maniera dei maestri, che gl'insegnavano, i quali non si curando passar piú innanti, havevano fatte quelle opre nel modo, che elle si veggono hoggi; cioè non nella buona maniera greca antica, ma in quella goffa moderna di que' tempi: & perché, sebene imitò que' Greci, aggiunse molta perfezzione all'arte, levandole gran parte della maniera loro goffa, honorò la sua patria col nome, & con l'opre che fece; di che fanno fede in Fiorenza le pitture, che egli lavorò, come il Dossale del'altare di S. Cecilia, & in S. Croce una tavola drentovi una nostra donna, la quale fu & è ancora appoggiata in uno pilastro a man destra intorno al coro. Doppo la quale fece in una tavoletta in campo d'oro un S. Francesco, e lo ritrasse, il che fu cosa nuova in que' tempi, di naturale, come seppe il meglio, & intorno ad esso tutte l'istorie della vita sua in venti quadretti pieni di figure picciole in campo d'oro. Havendo poi preso a fare, per i Monaci di Vall'Ombrosa, nella badia di Santa Trinita di Fiorenza una gran tavola, mostrò in quella opera, usandovi gran diligenza, per rispondere alla fama, che già era conceputa di lui, migliore inventione, & bel modo nell'attitudini d'una nostra Donna, che fece col figliuolo in braccio & con molti angeli intorno, che l'adoravano in campo d'oro, la qual tavola finita fu posta da que' monaci in sull'altar Maggiore di detta chiesa; donde essendo poi levata, per dar quel luogo alla tavola, che v'è oggi di Alessio Baldovinetti, fu posta in una capella minore della Navata sinistra di detta chiesa. Lavorando poi in fresco allo spedale del Porcellana, sul canto della via nuova, che va in borgo Ognisanti nella facciata dinanzi, che ha in mezo la porta principale, da un lato la Vergine Annunziata dal'Angelo, & dal'altro Giesú Christo con Cleofas, & Luca, figure grandi quanto il naturale, levò via quella vecchiaia, facendo in quest'opra i panni, & le vesti, & l'altre cose un poco più vive, & naturali, & piú morbide, che la maniera di que'

Greci, tutta piena di linee & di proffili, cosí nel musaico, come nelle pitture; la qual maniera scabrosa, & goffa & ordinaria havevano, non mediante lo studio, ma per una cotal usanza insegnato l'uno all'altro, per molti & molti anni, i pittori di que' tempi, senza pensar mai a migliorare il disegno, à bellezza di colorito, ò inventione alcuna che buona fusse. Essendo dopo quest'opra richiamato Cimabue dallo stesso guardiano, che gli haveva fatto [fare] l'opere di S. Croce, gli fece un Crocifisso grande in legno, che ancora hoggi si vede in chiesa, la quale opera fu cagione parendo al guardiano essere stato servito bene, che lo conducesse in S. Francesco di Pisa, loro convento, a fare in una tavola un S. Francesco, che fu da que' popoli tenuto cosa rarissima, conoscendosi in esso un certo ché, piú di bontà, & nell'aria della testa, e nelle pieghe de' panni, che nella maniera greca non era stata usata in sin'allora da chi haveva alcuna cosa lavorato, non pur' in Pisa, ma in tutta Italia. Havendo poi Cimabue, nella medesima chiesa fatto in una tavola grande, l'immagine di nostra Donna col figliuolo in collo, e con molti angeli intorno, pur in campo d'oro, ella fu dopo non molto tempo levata di dove ella era stata collocata la prima volta, per farvi l'altare di marmo, che vi è al presente; e posta dentro alla chiesa allato alla porta, a man manca. Per la quale opera fu molto lodato, & premiato dai Pisani. Nella medesima città di Pisa, fece a richiesta dell'Abbate allora di S. Paolo in Ripa d'Arno, in una tavoletta una S. Agnesa, & intorno a essa di figure piccole tutte le storie della vita di lei, la qual tavoletta è hoggi sopra l'altare delle vergini in detta chiesa. Per queste opere dunque, essendo assai chiaro per tutto il nome di Cimabue, egli fu condotto in Ascesi città dell'Umbria, dove in compagnia d'alcuni maestri greci dipinse nella chiesa di sotto di S. Francesco parte delle volte, & nelle facciate la vita di Giesú Christo, & quella di S. Francesco. Nelle quali pitture passò di gran lunga que' pittori greci: onde cresciutogli l'animo, cominciò da sé solo a dipingere a fresco la chiesa di sopra, e nella tribuna maggiore fece sopra il choro in quattro facciate alcune storie della nostra Donna, cioè la morte; quando è da Cristo portata l'anima di lei in cielo sopra un trono di nuvole, & quando in mezzo a un coro d'Angeli la corona, essendo da piè gran numero di santi & sante, oggi dal tempo, dalla polvere consumati. Nelle crociere poi delle volte di detta chiesa, che sono cinque, dipinse similmente molte storie. Nella prima sopra il coro fece i quattro evangelisti maggiori del vivo, e cosí bene, che ancor hoggi si conosce in loro assai del buono; e la freschezza de' colori nelle carni, mostrano, che la pittura cominciò a fare per le fatiche di Cimabue grande acquisto nel lavoro a fresco. La seconda crociera fece piena di stelle d'oro in campo d'azzurro oltramarino. Nella terza fece in alcuni tondi Giesú Christo, la Vergine sua madre, S. Giovanni Battista & S. Francesco, cioè in ogni tondo una di queste figure, & in ogni quarto della volta un tondo. E fra questa è la quinta crociera, dipinse la quarta di stelle d'oro, come disopra, in azzurro d'oltramarino. Nella quinta dipinse i quattro Dottori della Chiesa, & appresso a ciascuno di loro, una delle quattro prime religioni, opera certo faticosa, & condotta con diligenza infinita. Finite le volte lavorò pure in fresco le facciate di sopra della banda manca di tutta la chiesa, facendo verso l'altar maggiore fra le finestre & insino alla volta otto storie del testamento vecchio, cominciandosi dal principio del Genesi, e seguitando le cose piú notabili. Et nello spazio, che è intorno alle finestre insino a che le terminano in sul corridore, che gira intorno dentro al muro della Chiesa dipinse il rimanente del testamento vecchio in altre otto storie. E dirimpetto a questa opera in altre sedici storie, ribattendo quelle, dipinse i fatti di nostra Donna, e di Giesú Cristo. E nella facciata da piè sopra la porta principale, e intorno all'occhio della chiesa, fece l'ascendere di lei in cielo, et lo spirito santo, che discende sopra gl'Apostoli. La

qual opera veramente grandissima, & ricca & benissimo condotta, dovette per mio giudizio, fare in que' tempi stupire il mondo, essendo massimamente stata la pittura tanto tempo in tanta cecità; & a me, che l'anno 1563 la rividi parve bellissima, pensando come in tante tenebre potesse veder Cimabue tanto lume. Ma di tutte queste pitture (al che si deve haver considerazione) quelle delle volte, come meno dalla polvere, e dagli altri accidenti offese, si sono molto meglio che l'altre conservate. Finite queste opere, mise mano Giovanni a dipignere le facciate di sotto, cioè quelle che sono dalle finestre in giù, & vi fece alcune cose; ma essendo a Firenze da alcune sue bisogne chiamato, non seguitò altramente il lavoro; ma lo finí, come al suo luogo si dirà, Giotto, molti anni dopo. Tornato dunque Cimabue a Firenze, dipinse nel chiostro di S. Spirito, dove è dipinto alla greca da altri maestri, tutta la banda di verso la Chiesa, tre Archetti di sua mano, della vita di CHRISTO, & certo con molto disegno. Et nel medesimo tempo mandò alcune cose da sé lavorate in Firenze, a Empoli, le quali ancor hoggi sono nella pieve di quel castello tenute in gran venerazione. Fece poi per la Chiesa di Santa Maria Novella la Tavola di Nostra Donna, che è posta in alto fra la cappella de' Rucellai, e quella de' Bardi da Vernia; La qual opera fu di maggior grandezza, che figura, che fusse stata fatta insin' a quel tempo; ed alcuni Angeli, che le sono intorno, mostrano, ancor ch'egli havesse la maniera greca, che s'andò accostando in parte al lineamento, & modo della moderna. Onde fu quest'opera di tanta maraviglia ne' popoli di quell'età, per non si essere veduto insino allora meglio, che da casa di Cimabue fu con molta festa, & con le trombe alla chiesa portata con solennissima processione, & egli perciò molto premiato, & honorato. Dicesi, & in certi ricordi di vecchi pittori si legge, che mentre Cimabue la detta tavola dipingeva in certi orti appresso porta S. Pietro; che passò il re Carlo il vecchio d'Angiò per Firenze, e che fra le molte accoglienze fattegli dagli huomini di questa Città, e lo condussero a vedere la tavola di Cimabue. E che per non essere ancora stata veduta da nessuno, nel mostrarsi al Re vi concorsero tutti gli huomini, & tutte le Donne di Firenze, con grandissima festa e con la maggior calca del mondo. La onde per l'allegrezza che n'hebbero i vicini, chiamarono quel luogo Borgo Allegri, il quale col tempo messo fra le mura della città, ha poi sempre ritenuto il medesimo nome. In S. Francesco di Pisa, dove egli lavorò, come si è detto disopra, alcune altre cose, è di mano di Cimabue nel chiostro allato alla porta, che entra in chiesa in un cantone, una tavolina a tempera, nella quale è un Christo in croce con alcuni Angeli atorno, i quali piangendo pigliano con le mani certe parole che sono scritte intorno alla testa di Christo e le mandano all'orecchie d'una nostra Donna, che a man ritta, sta piangendo, e dall'altro lato a S. Giovanni Evangelista, che è tutto dolente a man sinistra: e sono le parole alla Vergine: MULIER ECCE FILIUS TUUS, e quelle a san Giovanni ECCE MATER TUA. E quelle che tiene in mano un'altr'angel'appartato: dicano: Ex illa hora accepit eam discipulus in suam. Nel che è da considerare, che Cimabue cominciò a dar lume, & aprire la via all'invenzione, ajutando l'arte con le parole per esprimere il suo concetto; 'l che certo fu cosa capricciosa, e nuova. Hora, perché, mediante queste opere s'haveva acquistato Cimabue con molto utile grandissimo nome, egli fu messo per Architetto in compagnia d'Arnolfo Lapi, huomo allora nell'architettura eccellente, alla fabrica di S. Maria del Fior in Fiorenza. Ma finalmente, essendo vivuto sessanta anni passò all'altra vita l'anno Milletrecento, avendo poco meno, che resuscitata la pittura. Lasciò molti discepoli, e fra gl'altri Giotto, che poi fu Ecc. pittore; il quale Giotto habitò dopo Cimabue nelle proprie case del suo Maestro nella via del Cocomero. Fu sotterrato Cimabue in S. Maria del Fiore, con questo epitaffio fattogli da uno de' Nini:

Credidit ut Cimabos picturæ castra tenere,
Sic tenuit; nunc tenet astra poli

Non lascerò di dire, che se alla gloria di Cimabue, non havesse contrastato la grandezza di Giotto suo discepolo, sarebbe stata la fama di lui maggiore, come ne dimostra Dante nella sua Comedia, dove alludendo nell'undecimo canto del purgatorio, alla stessa inscrizione della sepoltura, disse:

Credette Cimabue, nella pintura
Tener lo campo, & hora ha Giotto il grido,
Sí che la fama di colui oscura.

Nella dichiarazione de' quali versi un Comentatore di Dante, il quale scrisse nel tempo, che Giotto vivea; dieci o dodici anni dopo la morte d'esso Dante, cioè intorno agli anni di Christo Mille trecento trentaquattro, dice, parlando di Cimabue queste proprie parole precisamente: "Fu Cimabue di Firenze pintore nel tempo di l'autore, molto nobile di più che homo sapesse, & con questo fue si arogante, & sì disdegnoso, che si per alcuno li fusse a sua opera posto alcun fallo o difetto o elli da se l'avessi veduto: che come accade molte volte l'Artefice pecca per difetto della materia, in che adopra, o per mancamente ch'è nello strumento con che lavora, mantenente quell'opra disertava, fussi cara quanto volesse. Fu, et è Giotto in tra li dipintori il più sommo della medesima Città di Firenze, e le sue opere il testimoniano a Roma, a Napoli, a Vignone, a Firenze, a Padova. & in molte parti del mondo, &cc." Il quale comento è hoggi appresso il molto R. Don Vincenzio Borghini priore degl'Innocenti, huomo non solo per nobiltà, bontà, e dottrina chiarissimo, ma anco così amatore, & intendente di tutte le arti migliori, che ha meritato esser giudiziosamente eletto dal S. Duca Cosimo in suo luogotenente nella nostra Accademia del disegno. Ma per tornare a Cimabue, oscurò Giotto veramente la fama di lui, non altrimenti, che un lume grande faccia lo splendore d'un molto minore; perciochè, sebene fu Cimabue quasi prima cagione della rinovazione dell'arte della pittura, Giotto nondimeno suo creato, mosso da lodevole ambizion & aiutato dal Cielo e dalla Natura, fu quegli, che andando più alto col pensiero, aperse la porta della verità a coloro che l'hanno poi ridotta a quella perfezione, e grandezza, in che veggiamo al secolo nostro. Il quale avezzo ogni dì a vedere le maraviglie, i miracoli, e l'impossibilità degli artefici in quest'arte, è condotto, hoggimai a tale, che di cosa che facciano gli huomini, benché più divina che humana sia, punto non si maraviglia. È buon per coloro, che lodevolmente s'affaticano, se in cambio d'essere lodati, & ammirati, non ne riportassero biasimo, e molte volte vergogna. Il ritratto di Cimabue si vede di mano di Simon Sanese nel capitolo di S. Maria Novella fatto in profilo nella storia della fede, in una figura, che ha il viso magro, la barba piccola, rossetta, & apuntata con un capuccio, secondo l'uso di quei tempi, che lo fascia intorno e sotto la gola con bella maniera. Quello, che gli è allato, è l'istesso Simone maestro di quell'opera, che si ritrasse da sé con due specchi, per fare la testa in profilo, ribattendo l'uno nell'altro. E quel soldato coperto d'arme, che è fra loro, è secondo si dice, il Conte Guido Novello, Signore allora di Poppi. Restami à dire di Cimabue, che nel principio d'un nostro libro, dove ho messo insieme disegni di propria mano di tutti coloro, che da lui in quà, hanno disegnato, si vede di sua mano alcune cose piccole, fatte a modo di minio; nelle quali, come ch'oggi forse paino anzi goffe, che altrimenti, si vede quanto per sua opera acquistasse di bontà il disegno.

COMPARATIVE PLATES[*]

* The page numbers of the text where the work is cited are given at the end of each caption.

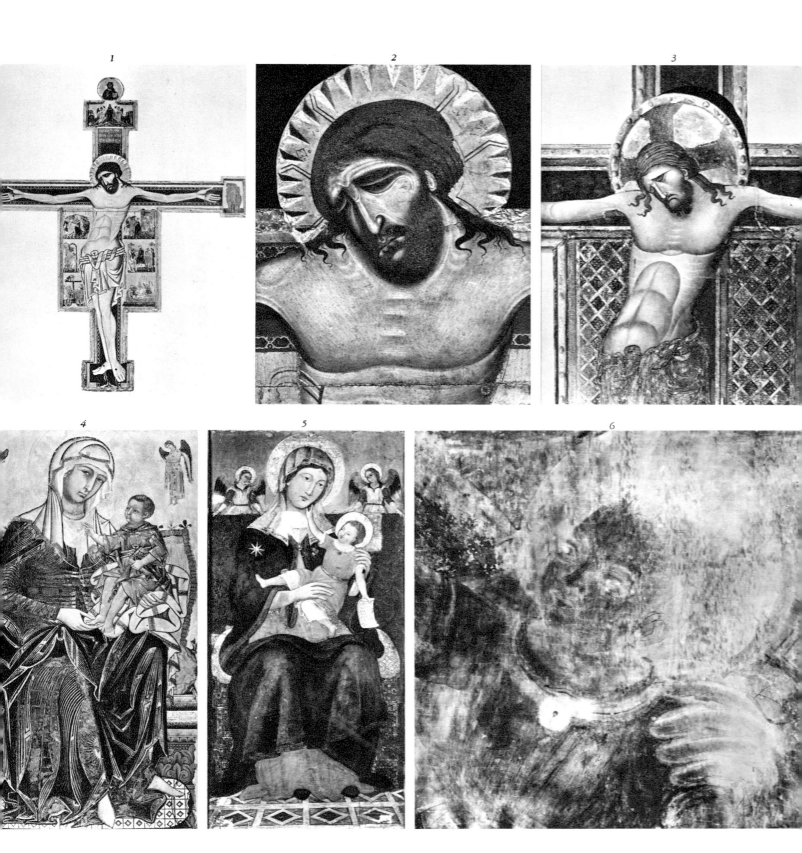

Fig. 1) Coppo di Marcovaldo - *Crucifix* - Museum, San Gimignano (pp. 18-23). – Fig. 2) Coppo di Marcovaldo - *Crucifix* (detail, *Christ's face*) - Museum, San Gimignano (pp. 18-23). – Fig. 3) Giunta Pisano - *Crucifix* - Church of San Domenico, Bologna (pp. 15-23). – Fig. 4) Coppo di Marcovaldo - *Madonna dei Servi* - Church of San Martino ai Servi, Orvieto (p. 61). – Fig. 5) Cimabue - *Madonna and Child with Angels* (repainted) - Convento delle Oblate Ospitaliere, Careggi - (from Sta. Maria Nuova in Florence) (pp. 62-64). – Fig. 6) Cimabue - *Madonna and Child with Angels* (detail, *Infant Jesus*) - (X-ray) - Convento delle Oblate Ospitaliere, Careggi - (from Sta. Maria Nuova in Florence) (pp. 62-64).

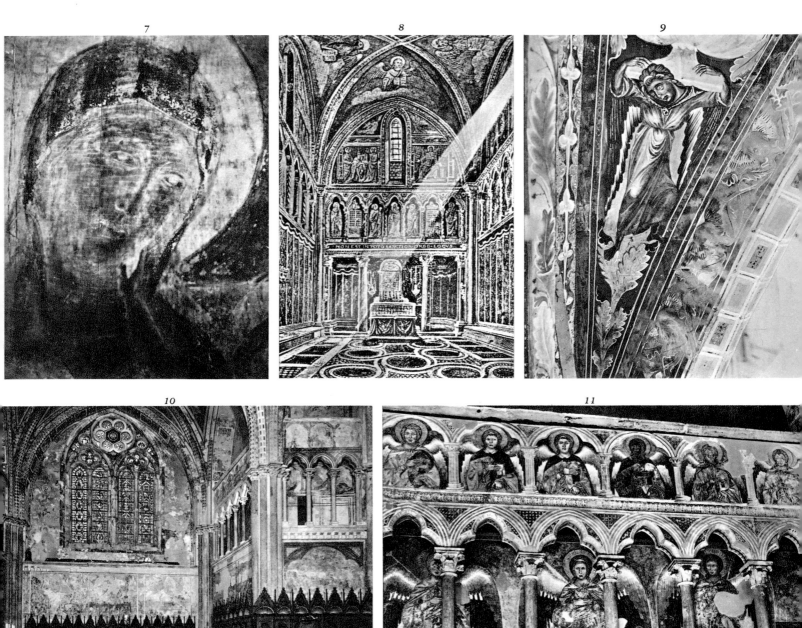

Fig. 7) CIMABUE - *Madonna and Child with Angels (detail, the Madonna)* - (X-ray) - Convento delle Oblate Ospitaliere, Careggi - (from Sta. Maria Nuova in Florence) (pp. 62-64). – Fig. 8) *Sancta Sanctorum Chapel* (decorated under Nicholas III) -Rome (p. 59). – Fig. 9) *A Telamon* - (Presbytery vault) - Upper Church of San Francesco, Assisi (pp. 33, 84). – Fig. 10) *View of the transept with the Apocalyptic scenes* - Upper Church of San Francesco, Assisi (pp. 33, 46). – Fig. 11) *Angelic Hierarchy* - Upper Church of San Francesco, Assisi (p. 33). – Fig. 12) *Christ Blessing* - medallion from the top of the Cru-

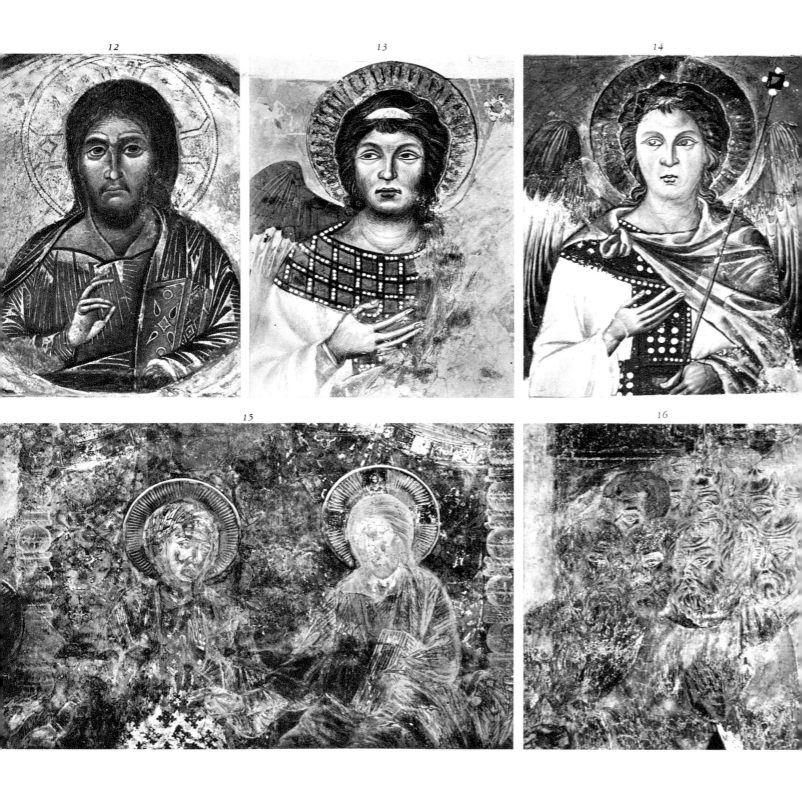

12 · 13 · 14 · 15 · 16

cifix - Church of San Domenico, Arezzo (p. 101). – Fig. 13) *Angel* - from soffit of left window - Upper Church of San Francesco, Assisi (p. 38). – Fig. 14) *Angel* - from soffit of left window - Upper Church of San Francesco, Assisi (p. 38). – Fig. 15) *Christ and the Virgin Enthroned* (*detail*) - Upper Church of San Francesco, Assisi (p. 105). – Fig. 16) *St. Peter Healing the Lame* (*detail, figures of attendants*) - Upper Church of San Francesco, Assisi (p. 105).

Fig. 17) *The Fall of Simon Magus* (*detail, St. Peter*) - Upper Church of San Francesco, Assisi (p. 105). – Fig. 18) *The Fall of Simon Magus* (*detail, Nero and the counsellors*) - Upper Church of San Francesco, Assisi (p. 105). – Fig. 19) *The Fall of Simon Magus* - (copy by Grimaldi from the frescoes in the porch of St. Peter's - Cod. Barberini Latino 2733, folio 135) (p. 106). – Fig. 20) *The Crucifixion* (*detail, the face of Christ*) - Upper Church of San Francesco, Assisi (pp. 105-106). – Fig. 21) *The Crucifixion* (*detail, two angels*) - Upper Church of San Francesco, Assisi (p. 106). – Fig. 22) *Crucifixion of St.*

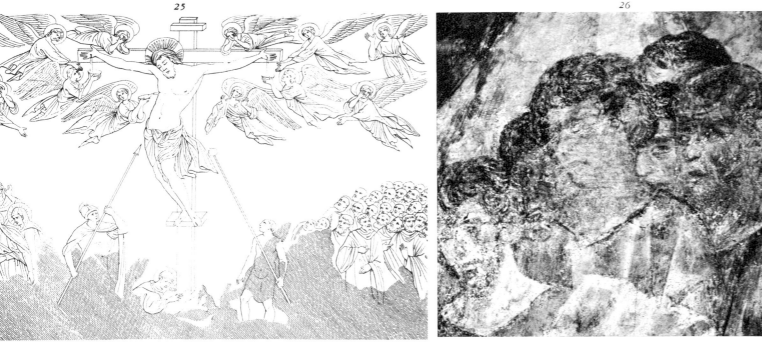

22

23

24

25

26

Peter (*detail, the crowd*) - Upper Church of San Francesco, Assisi (pp. 105-106). – Fig. 23) *Crucifixion of St. Peter* (*detail, three soldiers*) - Upper Church of San Francesco, Assisi (p. 83). – Fig. 24) *Crucifixion of St. Peter* (copy by Grimaldi from the frescoes in the porch of St. Peter's - Cod. Barberini Latino 2733, folio 135) (pp. 105-106). – Fig. 25) *The Crucifixion* - Engraving by G. Carattoni (p. 85). – Fig. 26) *Decapitation of St. Paul* (*detail, the soldiers*) - Upper Church of San Francesco, Assisi (p. 106).

Fig. 27) ATTRIB. TO CIMABUE - *The Naming of John the Baptist (detail)* - Baptistry, Florence (p. 111). – Fig. 28) ATTRIB. TO CIMABUE - *Flagellation of Christ* - Frick Coll., New York (pp. 111-112). – Fig. 29) ATTRIB. TO CIMABUE - *Last Judgment* - Private Collection, Milan (pp. 79, 112). – Fig. 30) ATTRIB. TO CIMABUE - *Seizure of Christ* - Kress Coll., Portland Art Museum, Portland, Oregon (pp. 79, 112). – Fig. 31) ATTRIB. TO CIMABUE - *The Nativity* - Longhi Coll., Florence (pp. 79, 112). – Fig. 32) DUCCIO DA BUONINSEGNA - *Rucellai Altarpiece* - Uffizi, Florence (pp. 63-64, 111). – Fig. 33) ATTRIB.

32 33 36

34 35

TO CIMABUE - *Madonna and Child between SS. Francis and Dominic* - Contini-Bonacossi Coll., Florence (p. 113). – Fig. 34) ATTRIB. TO CIMABUE - *Gualino Madonna* - Pinacoteca Sabauda, Turin (pp. 112-113). – Fig. 35) ATTRIB. TO CIMABUE - *Madonna and Child between SS. Peter and Paul* - National Gallery of Art (Kress Coll.), Washington (p. 112). – Fig. 36) AT-TRIB. TO CIMABUE - *St. Francis* - Sta. Maria degli Angeli, Assisi (p. 112).

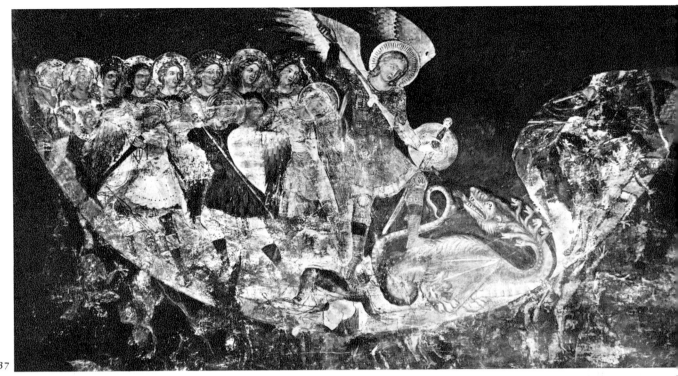

37

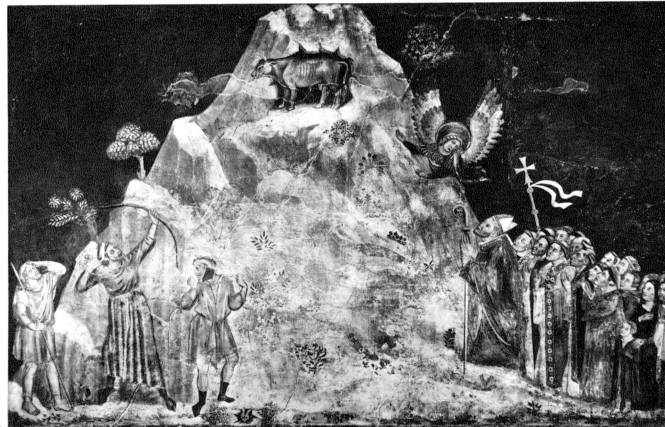

38

Fig. 37) ATTRIB. TO CIMABUE - *Victory of the Archangel St. Michael* - Santa Croce (Cappella Velluti), Florence (pp. 103, 111). – Fig. 38) ATTRIB. TO CIMABUE - *Apparition of the Throne on Monte Gargano* - Santa Croce (Cappella Velluti), Florence (p. 111).

Crucifix.

(Pls. 1-6).

Arezzo, S. Domenico.

Panel, 3.36 × 2.67 m.

Part of the chest has been repainted in the area of the horizontal joining of the cross. The painting was restored by Domenico Fiscali before the war. The head of Christ in the medallion (Fig. 12) is the work of an assistant. No documentation exists for the cross. P. TOESCA in the *Storia dell' Arte Italiana, Il Medioevo*, Turin, 1927, p. 1011, attributed it to Cimabue. Previously the cross had been attributed to various artists, including Coppo di Marcovaldo. Regarding this whole question see the thorough discussion in the *Catalogo della Mostra Giottesca*, entry 81, pp. 253-57. The dating of the cross in recent criticism has been considered by LONGHI in *Giudizio sul Duecento*, p. 45, who proposes the period of 1260-65. According to M. SALMI, *Jacopone e il suo tempo*, p. 61, it is the earliest work of Cimabue that is known, and certainly subsequent to 1272 when the artist, then about thirty years old, visited Rome. The cross can only be dated on stylistic grounds, as the various phases of the construction of the church are uncertain (according to Vasari it was enlarged to its present form in 1275). Cf. M. SALMI, *San Domenico e San Francesco di Arezzo*, Rome, 1955; and by the same author, "La Chiesa di S. Domenico d'Arezzo" in *La Rassegna Nazionale*, Florence, 1914; P. CHIARONI, *Chiesa di San Domenico* in FERRUCCIO BIGI, *Arte sacra nella Diocesi aretina*, Arezzo, 1934, p. 44. I would date it between c. 1265-1272. Note 19 of this book also deals with this question.

The Crucifix was exhibited in Florence in 1947 (*Catalogo della Mostra di opere d'arte trasportate a Firenze durante la guerra*, Florence, 1947, p. 26) and in Arezzo in 1950 (*Onoranze a Guido d'Arezzo. Mostra d'Arte Sacra della Diocesi e della Provincia dal sec. XI al XVIII*, Arezzo, 1950, entry no. 23).

For the iconography of the Crucifix cf. EVELYN SANDBERG-VAVALÀ, *La croce dipinta italiana e l'iconografia della passione*, Verona, 1929; L. H. GRONDIJS, *L' iconographie byzantine du Crucifié mort sur la croix*, 2nd ed., 1947 (Bibliotheca Byzantina Bruxellensis, I); PAUL THOBY, *Le Crucifixe dès Origines au Concile de Trente*, Nantes, 1951; L.H. GRONDIJS, *Autour de l'iconographie byzantine du Crucifié mort sur la croix*, Leyden, 1960 (cf. this text, pp. 13-24).

Frescoes of the Upper Church of San Francesco at Assisi.

(Pls. 7-46).

It is a vast complex including the geometric decorations, foliated patterns, and "grotesques", as well as the Four Evangelists painted on the vault of crossing on a gold ground (cf., for further documentation: R. SALVINI, *Cimabue*, Rome, 1946, Pls. 16-19; L. COLETTI, *Gli affreschi della Basilica di Assisi*, Bergamo, 1949; P. TOESCA, "Gli Affreschi del Vecchio e del Nuovo Testamento nella Chiesa Superiore del Santuario di Assisi", *Artis Monumenta Photographice Edita*, IV). The decorations proceed with series of angels, prophets, etc., in the soffits and window embrasures and above and below the galleries (for illustrations, although unfortunately incomplete, see TOESCA and COLETTI, and the collection of the Gabinetto Fotografico Nazionale; Cimabue's pupils must have continued to work in the vaults of the IV and III abutments, although under different direction; cf. TOESCA, *op. cit.*, Vol. I, 1, Figs. 16-20, 32, etc.). However the decorations change substantially in character, assuming deliberately Gothic and ornamental forms in the right transept where the gallery is surmounted by pinnacles between which are shields with figures of angels. Since the scenes below of the Apostolic cycle show that Cimabue here broke off his work, his sudden departure from Assisi may be presumed. The difficulty of finding a substitute to finish the Master's work is also indicated as the Apostolic cycle was not completed by the same artist who decorated the upper part of the transept. The three cycles — Apocalyptic, Marian and Apostolic — which unfold for the most part in the lower registers, have their beginnings below the vaulting where, unfortunately, the degeneration of the plaster is so advanced that the subject matter is indecipherable. In the bottom sections the color is largely lost or diminished in the areas where the white to black chemical inversion of the white lead is not present. A complete chemical analysis of the plaster surface was performed by the Istituto Centrale del Restauro at the time when the three large angels under the gallery in the left transept were cut away and transferred to canvas. (Cf. M. FEZZI, " Premure dell'Istituto Centrale del Restauro per gli affreschi della Basilica di San Francesco ", in *Atti dell'Accademia Properziana del Subasio*, Assisi, 1 April 1954, pp. 71-74.) A public report on the work is yet to appear. C. BRANDI in " I maestri della pittura italiana " (*Epoca*, 25 November 1956) concerning Ci-

* The page numbers of the text where the work is treated more fully are given at the end of each entry.

mabue wrote that " the analysis of the plaster surface revealed a scarcity of lime and a large quantity of chloride and organic matter ". A lively controversy, with the participation of P. SCARPELLINI and G. URBANI, arose over the detachment of the angels (*Il Mondo*, 1955, No. 45, 48, 49). For G. URBANI cf. also " Restoration of Frescoes in Rome and Assisi ", *The Connoisseur*, 1955, p. 155-60. Also see R. OERTEL, *Die Frühzeit der Italienischen Malerei*, Stuttgart, 1966 (pp. 56, 224) and this text, p. 104.

Concerning the much discussed problem of the dating of the Assisi frescoes we refer back to our text, limiting ourselves to cite here culminating research points: C. BRANDI, *Duccio*, Florence, 1951, pp. 127-34; C. GNUDI, *Giotto*, Milan, 1958, pp. 235-37. According to BOLOGNA (1965) the work at Assisi had been initiated as early as the Spring of 1278, that is to say before the senatorial nominations of Nicolas III and another member of the Orsini family. The scaffolding being still in place, just the four armorial bearings were added in September. Bologna is thus saying that he considers the study of the symbolic meaning of the buildings in the angles erroneous and useless. At any rate having to prove Duccio's presence in Assisi he is forced to anticipate the start of the work (which, among other things, was not stated to have been initiated precisely on the central vault; in fact it was probably started on the left transept vault) in order to allow an interruption as early as 1279. He states: " To concede the suspension of the work at Assisi is at any rate indispensable in order to take into account that precisely at the mid-point of the work in Assisi in respect to style Cimabue painted the great Maesta for the Vallombrosan Fathers of Santa Trinita ... The work in Assisi had to be reinitiated very quickly and Cimabue returned there with the group of pupils that he himself had trained during the previous years in the transept and to whom he entrusted the execution of the nave. Among them, certainly, was the Sienese, Duccio di Buoninsegna, who contributed a great deal, collaborating directly with the Master to sweeten this " awesome style ". The fresco of the Madonna with Angels and St. Francis in the Lower Basilica came from this sweetening and, above all, the beautiful Madonna dei Servi in Bologna which in order to be the probable result of a deepened collaboration between Cimabue who drew it up and Duccio who gave it its incomparable sweetness of coloring, must be dated before 1285 when Duccio had already gone to Florence to paint the Madonna for the Compagnia dei Laudesi ". This last date is inexact inasmuch as in 1285 Duccio had only the commission for the altarpiece. H. Hager has demonstrated in an exhaustive manner that the Santa Trinita altarpiece type could not be anterior to the Duccio commission. Furthermore, Duccio's collaboration is negated by authoritative specialists such as E. Carli.

AUGUSTA MONFERRINI, in the *Apocalypse of Cimabue*, Commentaries XVI, I-II (1966) discusses the general iconographical scheme of Cimabue and offers new contributions and hypotheses. (I am quoting from the unnumbered proofs). Monferrini relates the Fall of Babylon as an allusion to the Roman church, to the spiritual currents to which Cimabue would have belonged, with emphasis on the revelations of St. John the Evangelist, the association of Saint Francis to the angel of the Seventh Seal of the Apocalypse, and so forth. Nevertheless, Monferrini believes that the scene in which S. John of Patmos is recognized should be considered not the first, but the last of the series. Her article suggests numerous particulars surrounding the iconography of the individual scenes, and some of the observations will be related in the succeeding notes. According to Monferrini, there can be seen two (or at the most three) devil-bears adored by prone figures, and the bird is not a swan, but a wading-bird. The devil-bears allude to the Orsini family and to Nicholas III, obviously in a polemical sense, as a symbol of simony. From this she suggests a connection with Pietro Olivi, who was at Assisi under the General of the Order Girolamo d'Ascoli (circa 1274-8) and whose writings were condemned only in 1283.

As for the dating of the frescos, Augusta Monferrini, who considers them (as has been said) related to spiritual movements rather than to an act imposed by Rome, holds they were done between August of 1280 and 1283 " in the period in which Rome, the Pope being absent, was under senatorial and civil power of the French (and thus the most precise explanation of the portrayal of the Campidoglio upon which are visible, in small, the Orsini coat-of-arms which should, then, be understood to refer to Senator Gentile Orsini, supporter of the French) and under the rule of the Annibaldi (and here, in fact, that the tower of the Annibaldi stands out in an extraordinary relief in the representation of the city of Rome, side by side, with the Campidoglio.) " The sole objection that I can now make, is that the position of the " Spiritual " seems decidedly contrary to every form of ornament. By contrast, the sumptuous decoration of the transept of Assisi reveals itself — independent of the motifs which are self-justifying by their didactic character— as a sign of a proud court culture. The history of the Assisi Basilica is given along with a bibliography by B. KLEINSCHMIDT, *Die Basilica S. Francesco in Assisi*, Berlin, 1915-26; and by COLETTI, *op. cit.* There are drawings which are notably helpful: those by Ottley, executed in the early part of the 19th century, published by SÉROUX D'AGINCOURT in *Storia dell'Arte*, VI, Mantua, 1841, Fls. CII and CX, and by OTTLEY in *The Italian School of Design*, London, 1823; by Rambaux (in color), *Graphische Sammlung di Düsseldorf*, studied by BEYE in 1957, a copy is in the photographic archives of the Kunsthistorisches Institut in Florence; by L. Carpinelli and G. B. Mariani, two general drawings

of the transept, published by KLEINSCHMIDT, which are, however, unacceptable in the details and show a very careless reading of the scenes (cf. this text pp. 38, 40).

Principal photographic sources: Anderson 26896-7, 26904-7; Millet C 811-13; Archivio E. 10050-73, 10361-3, E. 10372 (the most important and valuable); Alinari 5250, 15346; Sansoni 8018 (cf. this text pp. 27-55).

THE FOUR EVANGELISTS
(Pls. 8-11).

In the central crossing vault above the altar the Four Evangelists are represented together with the four parts of the world: Rome, Greece, Judea and Asia. The Evangelists are assisted by angels. For the meaning and a short stylistic analysis of these angels cf. the text pp. 32-37.

Carlo Volpe in the review cited and F. Bologna in Number 113, " Cimabue ", of the series *Maestri di colore* deny that the angels are by an assistant and state that the frescoes are completely autograph. Bologna gives a good color reproduction of two angels. For other photographic details one must go to Nicholson and Salvini, *op. cit*. I do not know of a specialized study of the iconography of these Four Evangelists.

Photographic sources for the vault of the Basilica of San Francesco: Hautes Etudes C. 811-4; Anderson 26896-26907, 15344-46; Archivio E. 10050-66, 10070-74, 10361-72; Benvenuti 464, 663; Sansoni 1926, 8016-18; Alinari 10364-68.

SCENES FROM THE APOCALYPSE (upper section).
(Pl. 7).

The Apocalyptic cycle begins in the upper part of the left transept in two facing lunettes above the arcade and the gallery. The lunette fresco above the Crucifixion is completely gone. Fragments remain of the " Triumph of St. Michael ". Cimabuesque passages are clearly present in the Archangel who is accompanied by two other angels (cf. the photograph, of unknown provenance, published by NICHOLSON, Fig. 6). Fortunately the composition is reproduced in several graphic sources: a water-color by Ramboux now at Düsseldorf (which I am familiar with thanks to a photograph lent to me by Prof. Beye); the engraving from a drawing by Ottley, published in *Storia dell'Arte* by d'AGINCOURT, cf. the present text p. 48; and a general view of the transept by L. Carpinelli and G. B. Mariani. These drawings are all from the first half of the nineteenth century. The most reliable of them seems to be the engraving in d'Agincourt, in which the enormous lacunae that already existed then are clearly indicated. Nevertheless, the Ramboux reconstruction seems justifiable; the double line of demons are bent over so their hands are touching the ground in the lower part. The dragon in the center is supported by the demons. There is a certain relationship, in the pre-

sence of the three angels at least, with Northern miniatures; cf. MONTAGNE RHODES JAMES, *The Apocalypse in Latin*, Oxford, 1927. Comparisons with Civate concern the dramatic tone rather than the style; Beye has noted that this lunette was copied by a Cimabue follower in the Velluti Chapel in Santa Croce at Florence (Fig. 37), cf. this text, pp. 38-43).

APOCALYPTIC CYCLE (lower section).
(Pls. 12-25).

Consisting of five scenes beginning from the left of the apse.

The singular very rationalized interpretation of the Last Judgement must, it now seems to me, be put in close relationship with the *Breviloquium* of St. Bonaventure, VII, 1 and 2 where it is stated that Christ the Judge " appearing to the just in his loving-kindness "; and, as is emphasized in the introduction, " in order to manifest the loftiness of power, the rectitude of truth, and the plenitude of goodness, there must necessarily follow a universal judgement bringing about a just distribution of rewards, an open declaration of merits, and a irrevocable passing of sentences: so that the plenitude of supreme goodness may appear in the distribution of rewards to the just, the rectitude of truth in the open declaration of merits and the loftiness of might and power in the irrevocable passing of sentences ".

I. *St. John on Patmos* (Rev. I, 9-11). The scene which is still legible in the old photographs by Carloforti, which NICHOLSON, among others, reproduces, Fig. 7, shows St. John listening to the angel who has flown down behind him. The angel reveals to him the imminent fall of Babylon. The island is seen from above between flowing sea waters containing fish and realistically rendered monsters. We can approximately reconstruct the original appearance of the fresco from the painting of the Magdalen at the Port of Marseilles in the Magdalen Chapel in the Lower Church of Assisi and the overall scheme from the panel attributed to Ambrogio Lorenzetti in the Städel Institute in Frankfort (also published in *Paragone*, 13, 1951, Fig. 20). The Lorenzetti derivation, however, lacks the vigorous and solid positioning of the figures which is monumental in effect.

II. *The Fall of Babylon* (Rev., 18). The juxtaposition of the two scenes may be justified in the reading of *The Revelations of St. John* by Babylon's legendary position on the sea as the goal of pilots, navigators, and sailors. The destruction of the city is represented in progress: the inhabitants are fleeing from its opened gates. Roaming through the streets, stylized rather like the shaggy bear who later appears in *St. Peter Healing the Possessed*, is a demon. An ostrich, the " unclean and abominable bird ", (cf. footnote 71) is also in the street. The scene is in a very ruined

state; the figures, evidently painted on dry plaster, are almost completely gone. BEYE, in his aforementioned dissertation, has recognized in the upper left part " den in fünf konzentrischen Viertelkreisen angegebenen Himmel, sowie den in Text erwähnten Engel, auf dessen Geheiss sich der Fall vollzieht ". The two Apocalyptic scenes appear side by side in English manuscripts. Cf. note 70, Pls. 12-13.

III. *Christ the Judge.* This culminating scene of the cycle represents the Resurrection of the Dead and the Last Judgement. The space is divided horizontally into three parts: Christ the Judge surrounded by seven angels with trumpets (Rev., 8, 2); the tabernacle of heavenly Jerusalem carried to the earth by an angel; the ranks of the resurrected, probably divided between the saved (at our left) and the damned (at our right). The fresco has a remarkable resemblance to the later one by Cavallini in Santa Cecilia. The scene, moreover, allows numerous comparisons, although shadowy, with analogous iconographical representations in Central Italy (cf. Pls. 14-18).

IV. *The Angels of the Four Winds* (Rev., VII, 1-3) This is one of the episodes in which Cimabue's creative process and his philologically scrupulous interpretation of the Biblical text may more easily be traced. The four corners of the earth are schematized like a crenellated wall curtain; the rustic landscape, the trees, the hills are seen — since the angels hold the winds in their horns — in a state of immobility. The sea, also motionless, was probably portrayed at the right (cf. Pls. 19-23).

V. *The Infant Christ on the Throne* (*The Seven Seals*) (Rev., IV, 2-11; V, 1). The iconography is traditional. The substitution of the Infant Jesus for the figure of Christ the Judge is perhaps due not only to the Franciscan devotion to the Christ Child, but also the desire to avoid too precise a symmetry between the third and fifth scene (cf. Pls. 24-25).

GREAT CRUCIFIXION.
(Pls. 26-38).

Occupies the whole wall of the transept arm, formerly behind an altar now done away with; it faces the choir. Cf. the drawing illustrated on p. 39, the Crucifixion appears on the right.
L. TINTORI and M. MEISS, *The Painting of the Life of St. Francis in Assisi*, etc. (New York, 1962) point out the presence of the trace of a scaffold stage at the bottom of the Crucifixion, " passing just above the knees of the standing figures and above the head of the kneeling St. Francis " (pls. 26-28). They also have a careful study of the causes of the damage: " The rest was executed a secco, and to this technique must be ascribed part of the cause of the ruinous state of the frescoes. The deterioration was promoted by moisture, constantly sweeping through the stone, and through

an unusually thin coat of rough plaster or arriccio. White lead, furthermore, was used extensively, and it has turned black. Where the intonaco was spread directly on a large stone in a small rectangle immediately over the door in the lower right hand corner of the Crucifixion the white lead has not darkened (Pl. 32) blues and greens without lead are, however, not well preserved in this rectangle, so that the causes of deterioration in Cimabue's cycle are evidently complex. The colors are exchanged in parts of the vaults and of the angels in the arcades above the scenes, perhaps because the areas are smaller and proportionately more was painted while the intonaco was damp. There is also a precious specimen of Cimabue's finished surface in the apostle seated last at the right in the Death of the Virgin. It is a small patch of soft, luminous gray drapery, and because it is rather square in shape it may well have been painted on a *freshly laid* patch of plaster that filled a hole left by a beam of the scaffold or some other object " (pp. 8-9).
During the photographic campaign I tried to identify the days of work, which, given the complexity of the composition, are very irregular, but I am not at all sure of my observations which could only be conclusively defined by another study of the frescoes taking into account M. Meiss' very extensive series of investigations, something that for me is now impossible. (Cf. this text pp. 46-54).

MARIAN CYCLE (upper part).

The Scenes from the Life of the Virgin are all in the apsidal area. The first scenes unfold in the vast lunettes contained between the vaults and the gallery (cf. the Brogi photographs 24318 and 24319, reproduced in NICHOLSON, figs. 15, 16). The frescoes are in a disastrous state, besides vast lacunae there is much repainting which prevents us from making out their compositional character. Above, at our left is the Annunciation to Joachim and below, the Delivery of the Staffs; to the right the Birth of the Virgin and below, the Marriage of the Virgin. For certain details, sometimes naturalistic (like Joachim's flock), for the development of the narrative, for the perspective of the interiors, this part of the cycle of which no old graphic reproduction exists, could have constituted an aspect of extreme interest of the Master's poetic imagination. In its present state it is difficult to even ascertain its autograph quality.

MARIAN CYCLE (lower part).
(Pls. 39-44, fig. 15).

There are four scenes in the apse on either side of the papal throne.

I. *The Last Hours of the Virgin.* The scene illustrates and unites three extracts from the *Golden Legend* of JACOBUS DE VARAGINE, relative to the Assumption of the Virgin. We see Mary lying on her deathbed

surrounded by the Apostles who have been miraculously transported to her side. St. John announces to the Apostles the imminent death of the Mother of the Redeemer lying in their midst " surrounded by lights and burning oil lamps ". The opportunity to represent an interior, even though schematic, prompted the framing of the scene by a triforium, making it almost appear as if the scene were seen through a real window (Pls. 39-40).

According to PETER BEYE, *Cimabue und die Dugento-malerei*, an Inaugural-Dissertation for the University of Freiburg im Breisgau, 1957, St. Peter is the protagonist in the *Golden Legend* episode here illustrated.

It is now my impression that the Assisi cycle is directly based on the Apocryphal Dormition of the Virgin. The three oil lamps are linked to the Madonna's three day struggle with death.

II. *The Dormition of the Virgin.* The scene is closely united compositionally to the preceeding one and repeats its framing and its compositional scheme. It is illustrated in NICHOLSON, *op. cit.*, fig. 18. Christ is at the center. He receives in his arms the soul of the Virgin while around in four rows are represented, according to NICHOLSON, p. 14, the patriarchs, the confessors, and martyrs. BEYE, *op. cit.*, confirms this reading on the basis of the symbolic peculiarities and the haloes.

III. *The Assumption of the Virgin.* Above the rows of patriarchs, martyrs and confessors, in an aureole held up by four angels, Jesus welcomes with a moving embrace His Mother, who in the successive scene will appear on his right. For the iconography of the Assumption in general cf. E. STAEDEL, *Ikonographie der Himmelfahrt Mariens*, Strassburg, 1935 and, above all. A. WENGER, *L'Assomption de la Vierge dans la Tradition Byzantine du VIeme au Xeme siècle*, Paris, 1955. Cf. Pls. 41-42 and the drawing by Ottley on p. 45).

IV. *Christ and the Virgin Enthroned.* The scene is usual in the Roman mosaic tradition, but it, nevertheless, shows an explicit accentuation of the Virgin's role as an intermediary. In fact on the side with the Virgin in the lower part of the fresco there is a group of Franciscans praying. Cf. for the entire scene NICHOLSON, *op. cit.*, fig. 20. The theme became so typical of Franciscan devotion that its quick diffusion was assured, appearing almost immediately in Siena. Cf., E. CARLI, *Vetrata Duccesca*, Florence-Milan, 1946.

There are patriarchs and apostles around the throne.

Only the portraits of the Franciscans seem to be autograph; the throne group is by a Sienese-manner artist, perhaps the same who painted the messenger angels in the angles; the lower rows of attendants at the right are, given their forced expressionism, perhaps the work of another assistant. Cf., for the

iconography, E. T. DE WALD, " Observations on Duccio's Maestà ", in *Miscellanea Friend*, Princeton, 1954, pp. 362-386 (Pls. 43-44, fig. 15) and G. COOR, " The Earliest Italian Representation of the Coronation of the Virgin ", in *The Burlington Magazine*, XCIX, 1957, pp. 328-330 (cf. this text pp. 43-46).

APOSTOLIC CYCLE.
(Pls. 45-46, fig. 16).
Consists of five scenes in the right transept beginning at the right of the tribune.

I. *SS. Peter and John Healing the Lame (The Acts*, III, 1-10). St. Peter is accompanied by St. John; the attendants on the right are by an assistant, perhaps Manfredino da Pistoia. The architectural background seems also to have been executed by an assistant. The architecture is extremely rich in keeping with the Biblical temple setting. (Pl. 45, fig. 16).

II. *St. Peter Healing the Sick and the Possessed. (The Acts*, V, 12-17). The buildings represent Solomon's porch, elegantly stylized after the Cosmatesque manner. It is clear, as is demonstrated also by its state of preservation (the colors have not inverted), that another master intervened in the last rows of attendants in the upper right. In the scene St. Peter also attends to the sick who have been transported to the square in their sickbeds, (Pl. 46). At this point another painter appears, characterized most clearly by his obsequious imitation, as the GRIMALDI drawings demonstrate (*cod. Barberini Lat.* 2733), of the fresco prototypes in the porch of Old St. Peter's. His stylistic peculiarities are made up of a greater naturalism — the countenances are individually realized — in spite of this the execution is summary, he does not have the capacity of constructing by means of the movements of the masses, there is a lack of plasticism and the employment of elementary and general compositive schemes (triangles, oblique lines, etc.). In spite of the strong Roman influence reasons are not lacking for placing this master quite close to the circle of Cimabue followers around 1285-90. The Crucifixion as a whole, notwithstanding its details, is strongly Tuscan, the Christ also has a relationship to the one by the Master of St. Francis. Nevertheless, the Roman component is dominant. The work closest to it is the group of *Three Angels and Abraham* in the upper part of the nave (L. COLETTI, *Assisi*, Pl. 36; F. BOLOGNA, *op. cit.*, Pl. 82).

ROMAN MASTER OF THE CLOSE OF THE CENTURY.

III. *Fall of Simon Magus.* Possibly after Cimabue's architectural drawings. Derived from the fresco of Old St. Peter's (Grimaldi, folio 135) (figs. 17-19).

IV. *The Martyrdom of St. Peter.* Idem., from the fresco of Old St. Peter's, reproduced in Grimaldi, 137 r. (figs. 22-24).

V. *The Beheading of St. Paul.* The scene is now almost illegible, but shows strong variation in respect to the Grimaldi copies (folio 138) (fig. 26).

VI. *Crucifixion.* (figs. 20-21, 25).
[p. 46].

Madonna and Child enthroned with Four Angels and St. Francis.
(Pls. 47-48).
Assisi, Basilica of St. Francis, Lower Church.

The fresco, originally behind an altar, clearly has had a section cut away from the left side, thus removing the image of a saint which balanced that of St. Francis on the right. Moreover, if viewed under strong illumination it appears to have been completely gone over in a nineteenth century restoration even though CAVALCASELLE (Vol. I, p. 364, note 1 in *Storia della Pittura in Italia*, Florence, 1886) praised the circumspection of the restorer, Botti. In its present state the fresco, except in certain details, is almost beyond assessing (cf. the angel reproduced by R. SALVINI, *Cimabue*, 1946, Pl. 46). The camera in this and in other instances is more penetrating than the naked eye.

There is no documentation before the 16th century. The traditional attribution of the fresco to Cimabue appears, however, continuous in the various local sources.

A certain narrowing of the dating problem as far as an *ante quem* is concerned may come from the destruction of the left side. The painting is now framed in an inadequate mounting, belonging to the 14th century decorations of this side of the transept, that covers part of the upper section. It is possible, in fact, that the destruction of the figure of the saint, the pendant to St. Francis — presumably it was St. Anthony — came through an order of Boniface VIII. This pope in 1296 wished to suppress the Saint's image in the apsidal vault of St. John in Lateran, and seems to have been dissuaded from the project only when the workers charged with its destruction fell from the scaffolding through divine intervention: legend reported by L. WADDING, *Annales Minorum seu Trium Ordinum*, etc., V, 3rd ed., Quaracchi, 1931, pp. 395-396 (351). A close dating of the work through stylistic inductions is based, on the one hand, on the similar characteristics it shares with Christ and the Virgin

Enthroned in the Upper Church and, on the other hand, on the Santa Trinita altarpiece and on the later Madonnas. Now with the increased knowledge of the dating of these works and with the beginning of the Assisi work clarified about 1279, the *termine ante quem* — if one does not presume Cimabue's return to Assisi for the express purpose of painting only this fresco — remains fixed before 1285 circa, the epoch in which Cimabue left Assisi and received the commission for the Santa Croce Crucifixion and for the Madonna of Santa Maria Nuova. The Madonna dei Servi in Bologna particularly seems almost an intentional replica, though slightly more severe and archaistic, of the gentle Assisi fresco. For the attributive bibliography cf. L. COLETTI, *Gli affreschi della Basilica di Assisi*, Bergamo, 1949, p. 90. Recently SALVINI in *Enciclopedia Universale dell'Arte*, III, col. 473 on the basis of a late dating of the Santa Croce Crucifix, assigns it to 1295 circa, a date which the possible demolition of the figure of St. Anthony by Boniface VIII, might contradict. For the very interesting iconography, cf. C. H. WEIGELT, " Über die mütterliche Madonna in der italienischen Malerei des 13. Jahrhunderts, in *Art Studies*, 1928, p. 195; E. SANDBERG-VAVALÀ, *L'iconografia della Madonna col Bambino nelle pitture italiane del Dugento*, Siena, 1934; R. JACQUES, " Die Ikonographie der Madonna in Trono in der Malerei des Dugento ", in *Mitteilungen des Kunsthistorisches Institute in Florenz*, II, V, 1937; V. LAZAREFF, " Studies in the Iconography of the Virgin ", in *Art Bulletin*, XX, 1938, pp. 61-72; J. H. STUBBLEBINE, " The Development of the Throne in Dugento Tuscan Painting ", in *Marsyas*, 1954-57, pp. 25-39; D. C. SHORR, *The Christ Child in Devotional Images in Italy during the XIV Century*, New York, 1954, pp. 58-60, (cf. this text pp. 54-55).

Crucifix.

(Pls. 49-55).

Florence, Santa Croce, Museo dell'Opera, formerly in the church [see *note*, p. 113].

Panel, 4.48 × 3.90 m.

In spite of the presence of several lacunae, the work has no restorations that hinder its reading. The upper medallion of Christ Blessing is missing. The cross was attributed to Cimabue by ALBERTINI (1510, ed. 1909, p. 16), and by VASARI. There is a *termine ante quem* in the cross painted by Deodato Orlandi in 1288. Deodato remained faithful to the type, repeating it again in 1301, leading one to suppose that he was not so much an imitator from a distance but a direct participant in Cimabue's studio. Concerning Deodato see, E. B. GARRISON, " Toward a New History of Early Lucchese Painting ", *Art Bulletin*, XXXIII, 1951, No. 1, pp. 11-31. As is often the case in these works the lateral figures of Mary and St. John have a noticeably lower quality which suggests an assistant who was closely supervised by Cimabue.

The dating has been debated in spite of the presence of a reliable *ante quem*. Among the critics who hold it to be an early work we find R. LONGHI, " Giudizio sul Duecento ", p. 45, who believes it immediately prior to the cross by Salerno and Coppo in Pistoia of 1274. Actually Cimabue's Crucifixion is connected with the new church of Santa Croce, cf. our text and footnote 86.

C. L. RAGGHIANTI, on the other hand, in *Pittura del Dugento a Firenze*, p. 122, places it after Assisi and before the Santa Trinita altarpiece; R. SALVINI in *Enciclopedia Universale dell'Arte*, III, col. 473 also puts it after Assisi; while F. BOLOGNA, *Pittura delle Origini*, p. 101, follows Longhi word for word. Even in 1965 he repeats without offering proof that the Crucifix was imitated as early as 1274 by Coppo and Salerno in Pistoia and states, " this bears out its early dating and is the reason why it must be considered basic to understanding the profound change of vision effected by Cimabue even before the journey to Rome ".

For earlier criticism, cf. the excellent entry in the *Catalogo della Mostra Giottesca*, No. 83, pp. 267-271 and the *Catalogo degli Uffizi*, by L. MARCUCCI. For the iconography, cf. the relative bibliography under the Arezzo Cross [pp. 62-65]. (Cf. this text, pp. 57-60).

Madonna and Child enthroned with Two Angels.

(Pls. 56-59).

Bologna, Santa Maria dei Servi.

Panel, 2.18 × 1.18 m.

It comes from the Order's oldest church in Borgo San Petronio. It was restored before 1937 by Enrico Podio, Cf. L. BECHERUCCI in *Bollettino d'Arte*, 1937, p. 9. There are, nevertheless, many abrasions, the color is largely lost and the dimensions of the bottom and the sides have been reduced slightly.

After its restoration critical opinion has become more favorable in accepting it as an autograph work. Cf. the very thorough note dealing with critical opinion up until 1937 in the *Catalogo della Mostra Giottesca*, pp. 273-275. Among the more interesting opinions proposed successively we cite: R. SALVINI, who did not reproduce it in his 1944 monograph and who continues to believe it a workshop piece (*Rivista d'Arte*, 1950, and in *E.U.A.*, *op. cit.*); R. LONGHI, " Giudizio sul Duecento ", p. 47, " even if it is not completely by the Master, the archaic angel type together with the plastic mass of the central figure is a good pretext for confirming the precedence, before Assisi, of a Roman ' plastic period'; C. L. RAGGHIANTI, *Pittura del Dugento a Firenze*, p. 126 (before 1301); F. BOLOGNA, " Ciò che resta di un capolavoro giovanile di Duccio ", in *Paragone*, 1960, No. 125, pp. 12-13, and *Pittura delle Origini*, p. 110, " Contemporary with the last works in the transept, with the collaboration of the youthful Duccio ". After reading this book Salvini accepted the date for Bologna proposed here.

107

We note, in case of possible discussion regarding the date (which, however, the history of the church, as we have put forth in the text and in footnote 88 seems to have adequately resolved) that the two angels are certainly the work of an assistant, closely supervised by Cimabue. The Madonna di Mosciano (*Catalogo della Mostra Giottesca*, entry 92, pp. 291-93) may perhaps also be the work of this assistant and is as well closely connected to the Acton Madonna, *ibid.*, entry 93, pp. 294-95. In this regard we note that L. CUPPINI in *Commentari*, 1952, I, p. 13, proposed the identification of the Master of the Acton Madonna with Corso di Buono, painter of Cimabuesque frescoes at Montelupo in 1284 (cf. this text pp. 60-62).

Madonna and Child with Angels.
(Figs. 5-7).
Careggi, near Florence, Convento delle Oblate Ospitaliere.
Panel, 1.51 × 0.715 m.

The panel was completely repainted in the 15th century. There has also been later repainting. The Gabinetto dei Restauri of Florence has made an X-ray of the painting (Soprintendenza photograph numbers 104002 and 104003).

It comes from the Convento delle Oblate Ospitaliere of Via S. Egidio in Florence. It is certainly the small altarpiece that Folco Portinari commissioned for the high altar of the hospital of S. Maria Nuova, founded by him in 1285 and consecrated in 1288.

Numerous citations mention the altarpiece. Several modern historians have erroneously identified the Portinari panel with the altarpiece of S. Maria Novella (Thode, Wackernagel, Frey) which was later recognized as a work by Duccio rather than Cimabue. The Mother General of the Suore Ospitaliere of S. Maria Nuova confirmed its Florentine provenance to Garrison. In the *Commento alla Divina Commedia d'Anonimo Fiorentino*, dating from the early 15th century, published by PIETRO FANFANI (Bologna, 1866, Vol. II, p. 187) we read that of the " many works that are still in Florence and elsewhere ", there is " an altarpiece in S. Maria Nuova that among the others is notable for its workmanship ". In this regard cf. the thorough exposition and bibliography of E. BENKARD, *Das literarische Porträt des Giovanni Cimabue*, Munich, 1927, pp. 37-38. Independently, RICHA in *Notizie delle Chiese Fiorentine*, Florence, 1754-1761, III, pp. 175-78 and 188-89, writes of a " Madonna in S. Maria Nuova ", commissioned by Folco Portinari between 1286 and 23 June 1288. The hospital was consecrated in 1288 and the altarpiece would have to be in place in the chapel in the middle of the dormitory within sight of the patients on either side, as the system was in Quattrocento wards and is still observed almost unchanged today in S. Spirito in Rome. Cf., W. PAATZ, *Die Kirchen*, etc., IV, p. 29.

A. Parronchi in *Paragone*, 179, Nov. 1964, pp. 42-48 where interesting information regarding the hospital is reported, construes that Cimabue's painting was meant to decorate the Portinari tomb and maintains that it had the cuspidate form of the other Maestàs. It is lost but is reproduced in a drawing of the Sepoltuario Baldovinetti in the Fondo Moreniano of the Biblioteca Ricciardiana in Florence. It seems to me that the painting here reproduced is of the late Trecento.

The altarpiece was attributed to the ninth century by GARRISON on the basis of X-ray photographs. Very recently it was identified and stylistically connected to the S. Trinita altarpiece by H. HAGER, *Die Anfänge des Altarbildes in der Toscana*, Munich, 1962, pp. 139-42. I wish to express my thanks to Dr. Hager for the long discussion I had with him relative to Cimabue's entire chronology in Tuscany as well as for information concerning the Portinari panel.

For the iconography of the Madonna type cf. the pertinent bibliography under the Madonna dei Servi [P. 67] (cf. this text pp. 62-64).

Madonna and Child enthroned with Angels and Prophets.
(Pls. 60-66).
Uffizi, Florence.
Panel, 3.85 × 2.23 m.

It comes from the church of S. Trinita. It was removed from the high altar in 1471 and a painting by Baldovinetti put in its place. Attributed to Cimabue by BILLI and subsequently by VASARI in the second edition of the *Vite*. The altarpiece was reproduced in an engraving as early as 1810 by F. and J. RIEPENHAUSEN in *Geschichte der Mahlerei in Italien*, Pl. 6. While in general no doubts have been expressed concerning its autograph quality it has been dated before and after Assisi, and has also been placed in relationship with the Pisa altarpiece now in the Louvre.

An exhaustive bibliography through 1937 is found in the *Mostra Giottesca* catalogue, pp. 259-65; for the bibliography after 1937 see the *Catalogo degli Uffizi, I dipinti toscani del secolo XIII*, edited by L. MARCUCCI. Only the most recent proposals for its dating will be noted here: R. LONGHI, " Giudizio sul Duecento ", p. 46 (contemporary with Assisi, 1280 c.); R. SALVINI in *Enciclopedia Universale dell'Arte*, III, col. 472 (probably about 1285, but before Assisi); M. SALMI, *Jacopone e il suo tempo*, p. 63 (after Arezzo, before Assisi which he dates in the ninth decade of the century). C. L. RAGGHIANTI, *Pittura del Dugento a Firenze*, p. 124 (about 1285, after Assisi, although before the Madonna and Child with St. Francis in the Lower Church); E. B. GARRISON, " Addenda ad Indicem ", V, in *Studies in the History of Medieval Italian Painting*, III, 1957-58, p. 273 (between 1285 and 1290); F. BOLOGNA, *La pittura delle origini*, p. 105, (1277-80, before Assisi); H.

HAGER, *Die Anfänge* etc., pp. 142-43 (a little after the Rucellai altarpiece, that is after 1285).

For the history of the church see footnote 91.

The four Prophets can be identified, on the basis of the writing on their scrolls, as Jeremiah (31:22), Abraham (*Genesis* 22:18), David (*Psalms*, 131:11) and Isaiah (VII:14). Their linking seems to underline the theme of the Immaculate Conception of the Virgin, even though I have not been able to find in some contemporary texts these four biblical citations so related. It is also difficult to pin down the phases of the relevant theological discussion, especially between the Franciscans and Domenicans. The Cimabue altar-piece seems, in any event, to reflect Franciscan sentiments, nothwithstanding that it was executed for a Benedictine order, and the literary source could be referable to the Sermons on B. Virgin Mary by San Bonaventura. Nevertheless, it is our impression that the peculiar organization of the whole must have a polemical signification, against the opposers of the thesis of the Immaculate Conception.

On these problems see: MIRELLA LEVI D'ANCONA, *The Iconography of the Immaculate Conception in the Middle Ages and Early Renaissance*, College Art Association, 1957.

Father Floriano, the archivist of Loreto Basilica, is studying the connection between the Duecento throne, upheld by angels, and the legend of the transport of the Holy House from Jerusalem to Loreto by angels in 1291. This reference secms more possible for the Duccio altar-piece. For the mysticism of the throne see, *passim*, GERSHOM G. SCHOLEM, *Major Trends in Jewish Mysticism*, New York, 1941.

Prof. Fernanda de Maffei suggested to me that the dislocation in the lower part, constituting a sort of autonomous *palliotto* of the four prophets, could derive from Syrian-Byzantine models, especially miniatures.

The frame in wood is not original, see MONIKA CAMMERER-GEORGE, *Die Rahmung der Toskanischen Altarbilder im Trecento*, Strasbourg, 1966, p. 32-33 (cf. this text pp. 64-67).

Madonna and Child enthroned with Angels. (Pl. 67).

Paris, Louvre.

Panel, 4.24 × 2.76 m.

Cited by BILLI and successively by VASARI as in S. Francesco at Pisa. It was taken from the high altar in the 16th century and first hung inside the church on the door and later hung on the door of the sacristy. It was taken down by order of Napoleon and carried to Paris in 1811. See M. L. BLUMER, " Catalogue des Peintures transportées d'Italie en France de 1796 à 1814 ", in *Bulletin de la Societé d'Histoire de l'Art Français*, 1936, p. 277. We have CARLO LASINIO's testimony regarding the consignment of the painting. The first description of the work in the Napoleonic Museum appears in *Notices des tableaux des écoles primitives* in 1814. The critical problems aroused by the altarpiece are of a two-fold nature; the authorship — however, the impression is that its quality is inferior to the Santa Trinita work — and the dating. R. Offner in his 1924 lecture judged the Cimabue of the Louvre as follows: " The composition has very little of the temperamental rhythmic upward movement seen in Cimabue's work. His characteristics are repeated in a weaker form, i. e. the execution of the drapery and the articulation of the hands. The line is dead and formal. It is lyric instead of dramatic and less free and vital than Cimabue ". The opinion of STRZYGOWSKI and AUBERT that it is a late work is opposed by, among others, LONGHI (*Giudizio sul Duecento*, pp. 15-16), and recently by BOLOGNA (*La pittura delle origini*, p. 105). Now (1965) he defines it as an " autograph masterpiece too often unfairly underrated by the critics, the most important testimony of the connections Cimabue had with Pisa and with the new sculptural art even before 1272 ". This is a typical error of an attributive method which considers the details and not the work as a whole, ignoring the fact that the great altarpiece, besides the similarly large dimensions, derives its composition and structure from the Rucellai Altarpiece, which was commissioned in 1285, with such fidelity that it seems a copy of it. LANGTON DOUGLAS' attribution of the Louvre painting to the Sienese school in a footnote in the English translation of the *Storia della Pittura Italiana* by CAVALCASELLE, London, 1903, is not then, at least iconographically, completely mistaken. Furthermore, while Cimabue's presence in Pisa in 1301-02 is documented, it is completely arbitrary to presume that he was active there before his voyage to Rome, and before his Assisi work. Equally arbitrary is the anticipation of the activity of the so-called Maestro di San Martino — actually Ranieri da Ugolino as both GARRISON (*College Art Journal*, 1951, No. 2, pp. 110-20) and L. CUPPINI (*Commentari*, 1952, No. 1, pp. 7-13) have demonstrated — turning the dependency relationship upside down. Cimabue's influence is, in Pisa, very limited. The local tradition in which he worked was not at a level to welcome his essential qualities: the volumetrical nature, the simplification and organization of the masses, the structural commitment. For the iconography cf. the bibliography relative to the Santa Trinita Altarpiece. In spite of the fact that the altarpiece is connected with the transformation and renovation of the Franciscan church, documents pertaining to the edifice do not furnish useful information for dating the Louvre work. We know that in 1300 the Gualandi family left a bequest of stone for the facade which, nevertheless, remained unfinished (the epigraph is published by DA MORRONE, III, pp. 48-49). S. Francesco also housed the Giottesque altarpiece, now in the Lou-

vre, representing *St. Francis Receiving the Stigmata*, erroneously cited as by Cimabue by Billi, Anonimo Magliabechiano and Gelli.

Exceptionally, another LONGHI pupil, G. PREVITALI in *Early Italian Painting* (New York, 1964), dates the Louvre altarpiece 1285.

The frame in wood is original. See MONIKA CAMMERER-GEORGE, *Die Rahmung der Toscanischen Altarbilder im Trecento*, Strasbourg, 1966, p. 32. The twenty-six small figures in shields as in Duccio's Altarpiece are largely repainted and mostly lost. For the bibliography, see L. MARCUCCI, *I Dipinti toscani del secolo XIII — Scuole Bizantine e Russe dal secolo XII al secolo XVIII*, in the series of the Catalogues of the Uffizi Museums, Rome, 1958. (cf. this text pp. 68-71).

St. John the Evangelist.
(Pl. 68).
Pisa, Cathedral.
Apse Mosaic.

It is located at the right of the Christ Enthroned by a certain Francesco di Simone di Porta a Mare, of Pisa, not otherwise known, who began the Majestas in the apse but was unable to finish it, stopping work July 8, 1301. He was helped by two assistants, Turretto and Vanne da Firenze. The Majestas was completed by September 1321 and we know that Domenico Ghirlandajo restored it in 1493. It is opposite to the Madonna executed, after a long interruption of the work, by Vincino da Pistoia. There is a wide crossing band in the lower part where the colors seem brighter. There may perhaps have been some restoration on this section, or the difference in color may be due to an efflorescence produced by the humidity. This area in any case does not show any substantial differences of a graphic or compositive character. The St. John the Evangelist is the only work by Cimabue that is securely documented and exactly dated and thus constitutes an obligatory point of reference for any attribution to the Master even though it represents his late style.

For the documents cf., pp. 91-92. The physical composition of the mosaic was analyzed in 1810, cf., *Lettera del Sig. Giuseppe Branchi professore di Chimica nell'imperiale Accademia di Pisa al professore Sebastiano Ciampi sopra gli ingredienti di vari musaici e di varie antiche pitture*. In the appendix of CIAMPI's *Notizie*, etc., pp. 20-24. Anthony wrote in 1935 (*History of Mosaics*, p. 205, fig. 230, Pl. 64) " Shows the work of several hands ... has suffered somewhat from restoration. Fortunately, one head, that of St. John, has escaped the hands of the restorer and as it is an unquestioned work by Cimabue, it is of the greatest importance as a clue to his style ". Cf. C. H. SHERRILL, *Mosaics in Italy*. London 1933, pp. 29-31. Our positive judgment in regard to the work's quality is in contrast to a long series of negative judgments initiated by RICHTER, *Lecture in the National Gallery*, London, 1898, " a most uninteresting figure " (noted by NICHOLSON, p. 55). In its favor we can advance, among others, the definition of " masterpiece " given by E. CARLI, *Pittura medievale Pisana*, Milan, 1958, and SALMI's acute comment (*Jacopone e il suo tempo*, 1958, p. 58) " it has its own concise plastic essence of Romanesque origin and through its vigorous, harsh, sure design medium great humanity ". [Pp. 71-73].

Photographic sources: Alinari 8861a; Anderson 28374; Brogi 19450.

LOST WORKS

Polyptych with the Maestà, Apostles, Angels and Other Figures.
Pisa, S. Chiara.

The work was commissioned 5 November 1301 (1302, according to Pisan reckoning), but was probably never executed, as it is not cited in any subsequent documents. Cimabue's collaborator, Giovanni, called Nuchulus di Lucca, is otherwise unknown. The church of S. Chiara was completely remodelled. In spite of this, HELMUT HAGER has succeeded in making a convincing graphic reconstruction of the polyptich (*Die Anfänge, op. cit.*, p. 113-14, fig. 164), as a Gothic structure, very like the polyptich of Meo da Siena, now in the Galleria Nazionale of Umbria at Perugia. The subjects represented would be the Madonna and Child between St. Peter, St. Paul, St. Francis and St. Chiara and on the top of the center gable a cross. The predella would contain scenes from the life of the Virgin.

ATTRIBUTED WORKS

We limit ourselves to listing the attributions that are either of recent date, or of significance, or closely connected with Cimabue's critical history.

Map of Rome for Charles of Anjou.

Attributed by JOSEF STRZYGOWSKI, *Cimabue und Rom*, etc., Vienna, 1888.

Painted Cross.

S. Jacopo di Ripoli, near Florence.

Cited by RICHA, *Notizie delle Chiese Fiorentine*, IV, pp. 306-307: " a Crucifixion painted by Cimabue and transported to the Monastery from the Pian di Ripoli in 1292 ". BENKARD, p. 197, held the attribution to be sound as it was founded on archival information. The cross, vulgarly repainted, is now in the Villa, formerly the property of the Grand Duchess Cristina of Lorena, (Chapel of the SS. Trinità) at La Quiete, near Florence. It is No. 517 in GARRISON's lists. Alinari photograph No. 46636. Concerning the transference of the cross cf. P. CO-STANZO BECCHI, " S. Jacopo a Ripoli " in *L'Illustratore Fiorentino*, 1908, pp. 97-106. The date 1292 is the year when the Dominicans left S. Jacopo a Ripoli and transferred to S. Maria Novella, and could also serve as a chronological reference for the consecration of the sanctuary and at least part of the nave of the great church. The quality of the painting is very low.

Madonna Enthroned with Angels.

(Rucellai Altarpiece).
(Fig. 32).
Florence, Uffizi.

It comes from the church of S. Maria Novella. The ancient attribution owing to an erroneous interpretation of the literary evidence referring to the small altarpiece for S. Maria Nuova, is pertinent to the still unresolved problem of the relationship between Cimabue and Duccio. The attribution of the Rucellai resolved (cf. the entry in *Catalogo della Mostra Giottesca*, pp. 107-13), the discussion was reopened in regard to the Frick Flagellation (cf. Attributed Works) and the question of Duccio's participation in the Assisi frescoes, on the basis of a suggestion by LONGHI, " Giudizio sul Duecento ", p. 37, later taken up by C. VOLPE, " Preistoria di Duccio " in *Paragone*, 149, 1954, pp. 4-20 and, above all, by F. BOLOGNA, " Ciò che resta di un capolavoro giovanile di Duccio ", *Paragone*, 125, pp. 3-13.

Frescoes in the Cappella Velluti.

(Figs. 37-38).
Florence, Santa Croce.

Assigned to Cimabue by H. THODE, *Franz von Assisi*, Berlin, 1904, p. 238; by A. VENTURI, *Storia*

dell'Arte Italiana, V, p. 217; and only the Miracolo del Gargano by C. L. RAGGHIANTI, *Pittura del Dugento a Firenze*, p. 126-27. Assigned to the school of Cimabue or an anonymous Trecento artist by M. G. ZIMMERMANN, *Giotto und die Kunst Italiens im Mittelalter*, Leipzig, 1899, p. 222, as also does NICHOLSON in *Cimabue*, p. 60.

Mosaics with scenes of the Selling of Joseph and the Naming of John the Baptist.

(Fig. 27).
Florence, Baptistry.

The possibility of a collaboration on the part of Cimabue was advanced by A. VENTURI (*Storia dell'Arte Italiana*, V. pp. 229 ff.); confirmed by TOESCA and, above all, by M. SALMI, " I mosaici del bel ' San Giovanni ' e la pittura del secolo XIII a Firenze ", *Dedalo*, XXVIII, 1930-31, pp. 543-70. Salmi has been widely followed, for example, by SALVINI, in *Enciclopedia Universale dell'Arte*, III, col. 472, and by LASAREFF in *Rivista d'Arte*, 1955, p. 61. Cimabue's participation in the mosaics have, on the other hand, been negated by NICHOLSON.
F. Bologna (1965) accepting in part my thesis, states that in the Baptistry mosaics Cimabue " participates now and then and only after 1285 ".
There is, actually, a tendency to consider the mosaics of the Baptistry to be rather late (cf. I. HUECK, *Das Program der Kuppelmosaiken in Florentiner Baptisterium*, a Dissertation presented to the University of Munich, knowledge of which I owe to Doctor Beye). A late date would make it more difficult to think of an intermittent collaboration, in a subordinate role under another master, which is the general opinion of those who uphold the attribution of these scenes to Cimabue. The Kunsthistorisches Institut at Florence has a very full documentation which, in part, has been published by ANTONY DE WITT, *I mosaici del Battistero di Firenze*, 5 Vol., Florence, 1954.

Flagellation.

(Fig. 28).
New York, Frick Collection.

Attributed by R. LONGHI to Cimabue in " Splendid Trinity for the Frick ", *Art News*, February, 1951, p. 22; to Duccio by M. MEISS in *Art Bulletin*, June, 1951, pp. 95-100, and E. CARLI, *Duccio*, Milan, 1951, Pl. 20; to the school of Cimabue by J. POPE HENNESSY, by B. BERENSON (*Letter to the Frick Library*) and E. SANDBERG-VAVALÀ, *Sienese Studies*, Florence, 1953; by C. BRANDI, *Duccio*, Florence, 1951, pp. 156, No. 34 and to an assistant of Duccio or a follower rather than Duccio himself by MEYER SHAPIRO, " On an Italian Painting of the Flagellation of Christ in the Frick Collection " in *Miscellanea Ven-*

turi, I, Rome, 1956, pp. 29-53. R. Longhi upheld his original attribution to Cimabue (" Prima Cimabue, poi Duccio ") in *Paragone*, 23, 1951, pp. 8-13. Millard Meiss maintained with new reasons his attribution to Duccio (" Scusi, ma sempre Duccio ") in *Paragone*, 27, 1952, pp. 63-64; (" Ancora una volta Duccio e Cimabue ") in *Rivista d'Arte*, XXX, 1955, pp. 107-113; (" The Case of the Frick Flagellation ") in the *Journal of the Walters Art Gallery*, 1956-57, pp. 43-63 where he responded to Meyer Shapiro as well, and published an infra-red photograph. American scholars in general consider the work Sienese. I feel that Cimabue's influence is relatively weak.

Madonna and Child with St. John the Baptist and St. Peter.
(Fig. 35).
Washington D. C., National Gallery of Art (1139).
(34.3 × 24.8 cm).

According to an inscription by the engraver Carlo Lasinio (1759-1838) formerly on the back of the painting, it came from the sacristy of San Francesco in Pisa. Colnaghi and Contini Bonacossi Collections; acquired by the Kress Foundation in 1948, cf. catalogue of the National Gallery of Art, K. 1549, p. 5. Attributed to Cimabue by R. Longhi in *Proporzioni*, II, 1948, p. 16 and variously by G. Fiocco, R. van Marle, W. E. Suida, E. Sandberg-Vavalà and A. Venturi.

It could be a work done in Pisa. It has close affinities with the altarpiece formerly in the church of San Francesco now at the Louvre in which Duccio's influence is very strong. The color is very different from any of Cimabue's known works. It is perhaps later than 1285-95, the date suggested by E. B. GARRISON in *Italian Romanesque Panel Painting*, 1949, p. 100, No. 251 A. It is possibly, as Garrison suggests, the left wing of a diptych. The inscription by Lasinio, now lost, is not a reliable document.

St. Francis.
(Fig. 36).
Assisi, Santa Maria degli Angeli.
(107 × 57 cm.)

Attributed by R. LONGHI (" Giudizio sul Duecento ", *Proporzioni*, II, 1948, p. 46, Pl. 22). Reproduced in color by F. BOLOGNA, *La pittura italiana delle origini*, Rome-Dresden, 1962, Pl. 73.
It is a mediocre derivation of the portrait of St. Francis in the Lower Church of Assisi. Attributed by GARRISON (*Italian Romanesque Painting*, 1949, No. 53) to a pupil, perhaps Florentine, of Cimabue, about 1285-95.

Prophets.
Rome, Santa Maria Maggiore.

Fragments from a series of medallions on a blue ground within a decorative border which at one time probably ran around the walls of the Basilica.

The prophets are located high up on the wall of the left transept between the old high roof and the lower roof of the 15th century. A Mystic Lamb is on the facade wall near the entrance. Work of a Roman painter, influenced by Cimabue and perhaps present in Assisi.

Photographic sources: Anderson 17642-5, 31295; Alinari 28299-28301; Archivio C 1147-49.

Bibliography: A. COLASANTI in *Emporium*, Jan. 1905, V. 21; pp. 67-72; A. VENTURI, *Storia dell'Arte Italiana*, 5, 1907, pp. 127-9; WILPERT, *Römische Mosaiken und Malereien*, 1917, 2, p. 512, 4, pl. 276-8; B. BERENSON, *Art in America*, Oct. 1920, 8, pp. 266-7, 271; E. LAVAGNINO and MOSCHINI, *Santa Maria Maggiore*, Rome, 1924, p. 90-1; NICHOLSON in *Art Bulletin*, Sept. 1930, 12, pp. 298-99 (attributed to Isaac Master). M. SALMI in *Rivista d'Arte*, July-Dec., 1937, 9, p. 207-13; VAN MARLE, *Italian Schools of Painting*, I, 1923, pp. 476-9. I used the files of the Frick Library wherein the opinions of Offner (y Roman follower of Cimabue) and D. Gnoli are reported. The connection between Cimabue and Santa Maria Maggiore is demonstrated by the 1272 document.

Nativity, Last Supper, Betrayal of Christ, Last Judgment.
(Figs. 29-31).
Florence, Longhi Coll.; Washington D. C., National Gallery; Milan, Private Coll.

Attributed by R. LONGHI (" Giudizio sul Duecento ", *Proporzioni*, II, 1948, pp. 16-18, Pls. 24-27); by GARRISON (*op. cit.*, No. 668, 676, 703, 704) to a Venetian Master of 1315-1335.

Madonna Enthroned.
(Fig. 34).
Turin, Pinacoteca Sabauda (Gualino Coll.).

The Cinquecento repainting was removed about 1920; its provenance seems to be Montughi, near Florence (cf. *Illustrazione Italiana*, April, 1920). SIRÉN noted its relationship with the Madonna dei Servi of Bologna (*Toskanische Maler*, 1922, p. 293). It is, in all probability, an altarpiece for a Servite church judging from the form of the throne. It falls in the category of Cimabue's closest imitators. Cf., for the attributive history, entry no. 90, p. 289 of the *Catalogo della Mostra Giottesca*, and note 13 in C. BRANDI, *Duccio*, Florence, 1951. While it is in general held to be the work of a Florentine Master about 1280-90 (see particularly No. 39 in GARRISON's index), ROBERTO LONGHI in *Giudizio sul Duecento, op. cit.*, pp. 38, 48, recently followed by F. BOLOGNA in *La pittura delle origini*, p. 128, attributes it to the youthful Duccio, without taking into account the difficulties raised by the most recent studies of the Sienese Master, such as the irreconcilability of style between the Turin altarpiece and the Sienese Cathedral tondo which would have to be coeval.

According to James H. Stubblebine (*Guido da Siena*, Princeton 1964, fig. 96-99) the rectangular shape without an oblique point of the four small altarpieces of the Acton Coll.; San Remigio, Florence; the Galleria Sabauda, Turin; and of Sant'Andrea, Mosciano come from a Cimabuesque prototype preceding the Madonna dei Servi. They, nevertheless, apart from style, have wide iconographic variations. It seems to me they are related to the Bologna Madonna dei Servi. The Madonna formerly in the Gualino Coll. seems to use the same cartoon, reversing it (something similar to a cartoon, perhaps, would have to have been the custom — given the incised marks that can be noted in the color plate — for a better definition of the image that was to be painted in respect to the gold background); a task assigned, perhaps, to an independent artisan or an assistant. These marks are clearly visible in the prophets of the Santa Trinita altarpiece, but are general throughout.

Madonna Enthroned between St. Francis and St. Dominic.
(Fig. 33).
Florence, Contini-Bonacossi Coll.

Attributed by R. Longhi (" Giudizio sul Duecento ", *Proporzioni*, II, 1948, p. 18, Pls. 28-30);

Garrison (*op. cit.*, No. 187) attributes it to a Bolognese imitator active between 1305 and 1315.

Crucifixion.
(*Private collection*).

I have not been able to see the tablet (0.93 × 0.59 m.) recently published in *Il Vasari* (XXII-XXIII, December, 1965, pp. 5-7, plate III) with an expertise by C. Volpe, which, though not the work of the master, is the work of his direct circle, perhaps from about the time of the execution of the Crucifix of Santa Croce. Volpe dates it about 1280, and claims decisively that it is an autograph.

Madonna and Child.
Collection of Viscount Lee of Fareham.

Attributed by T. Borenius, *Catalogue of the collection*, 1923; O. Siren, *The Burlington Magazine*, 43, 1923, pp. 26-28; R. R. Tatlock, *Art News*, April 14, 1928, p. 15). It is considered a modern forgery by R. Offner (statement recorded in the files of the Frick Collection, New York).

Note: The Cimabue *Crucifix* in the Santa Croce museum in Florence was heavily damaged by the flood of November 4, 1966. The water remained in the museum almost a day, and reached such a level that the face of the *Christ* was more than half destroyed. Between 70 and 80 per cent of the central image has been lost.
At the time of this writing the *Crucifix* is in the greenhouse of Boboli Gardens, being slowly dried. The surviving painting will probably be detached from the wood. The restoration will require many months, and considering the immensity of the catastrophe it is impossible to foresee when the *Crucifix* will again be visible to the public. A new discussion of the work, with a specific analysis of its style, will be found in my pamphlet *Cimabue in Santa Croce* (Milan, 1967).

BIBLIOGRAPHY

c. 1310 DANTE, *Purgatorio*, XI, 94-96.

1328-33 *Comedia di Dante ... col Commento di Jacopo Della Lana*, ed., Bologna, 1866-67, II, pp. 130-131.

1333-34 *L'Ottimo Commento della Divina Commedia*, ed. Alessandro Torri, Pisa, 1828, II, p. 188.

1340 PETRI ALLEGHERII *super Dantis ipsius genitoris Comoediam commentarium*, ed. V. Nannucci, Florence, 1846, p. 375.

1379 *Commentum magistri Benvenuti da Imola in Comoediam Dantis*, ed. Lod. Anto. Muratori, Antiqui Ital. Medii Aevi, I, pp. 1185-86.

1400 ff. *Commento alla Divina Commedia di* Anonimo Fiorentino, ed. Pietro Fanfani, Bologna, 1868, II, p. 187.

c. 1405 VILLANI F., *De Civitate Forentiae et eiusdem famosis civibus*, ed. K. Frey, Berlin, 1892.

1455 GHIBERTI L., *Commentarii*, ed. J. Schlosser, Berlin, 1912.

1510 ALBERTINI F., *Memoriale*, ed. Schmarsow, Florence, 1886, pp. 13 ff.

c. 1516-30 *Il Libro di A. Billi*, ed. Frey, Berlin, 1882.

1520-43 *Anonimo Morelliano*, ed. Frimmel, Vienna, 1888, p. 20.

1549-55 GELLI GIOVAN BATTISTA, *Vite d'Artisti*, ed. Girolamo Mancini in *Archivio Storico Italiano*, V, XVII, pp. 38-9.

1550 VASARI G., *Le Vite dei più eccellenti Architetti, pittori, et scultori italiani*, ecc. Florence.

1568 VASARI G., *Le Vite dei più eccellenti pittori, scultori e architettori*, ecc., Florence, 2nd ed.

1584 BORGHINI G., *Il Riposo*, III, Florence, pp. 288-90.

1584 LOMAZZO G. PAOLO, *Trattato dell'arte della pittura*, Milan.

1591 BOCCHI M. F., *Bellezze di Firenze*, ed., Bocchi-Cinelli, Florence, 1677, pp. 192, 316, 334.

1593 MINI P., *Discorso della Nobiltà di Firenze*, Florence, pp. 106-7.

1604 MANDER C. VAN, *Schilder-Boeck*, Alkmaer, p. 94.

1617-21 MANCINI G., *Considerazioni sulla pittura*, ed. A. Marucchi and L. Salerno, Rome, 1957, passim.

1633 CARDUCHO V., *Dialogos de la Pintura*, Madrid, p. 29.

1642 BAGLIONE G., *Le Vite de' Pittori, Scultori et Architetti*, Rome, p. 4.

1648 RIDOLFI C., *Le meraviglie dell'Arte*, Venice, I, pp. 12-13.

1666 FELIBIEN A., *Entretiens sur les vies et les ouvrages des plus excellents peintres*, Paris, p. 95.

1678 MALVASIA C., *Felsina Pittrice*, Bologna, I, pp. 7-11.

1681 BALDINUCCI F., *Notizie de' Professori del disegno da Cimabue in qua*, Florence, I, pp. 1-17 Milan, 1811, IV, pp. 14 ff.

1684 BALDINUCCI F. *La Veglia, dialogo di Sincero Veri*, Firenze.

1704 PADRE ANGELI F. M., *Collis Paradisi Amoenitas seu Sacri Conventus Assisiensis Historiae libri II*, Montefalco.

1739-40 DE BROSSE CH., *L'Italie il y a cent ans ou lettres écrites à quelques amis en 1739 et 1740*. Paris 1836 and Dijon 1927, vol. I, p. 210

1755-62 RICHA G., *Notizie istoriche delle chiese fiorentine divise nei suoi quartieri*, Florence.

1757 LAMI G., *Dissertazione ... relativa ai pittori e scultori italiani che fiorirono dal 1000 al 1300*, in *Leonardo da Vinci, Trattato della pittura ridotto alla sua vera lezione*, a cura di Francesco Fontani, Firenze.

1764 WINCKELMANN J., *Geschichte der Kunst des Alterthums*, Dresden, p. 10.

1766 LACOMBE JACQUES, *Dicitionnaire portatif des Beaux-Arts*, Paris.

1771-4 PELLI-BENCIVENNI GIUSEPPE, *Elogi degli uomini illustri toscani*, Lucca.

1782-5 TIRABOSCHI G., *Storia della Letteratura Italiana*, Florence, IV, p. 439.

1782-6 DELLA VALLE G., *Lettere senesi di un socio dell'Accademia di Fossano sopra le Belle Arti*, Venezia e Roma, Vol. I, pp. 254-5.

1790 FINESCHI P. F., *Memorie istoriche*, I, Florence, preface, pp. 41-42.

1791 LASTRI M., *L'Etruria Pittrice ovvero Storia della Pittura Toscana dedotta dai suoi Monumenti che si esibiscono in stampa*, Florence.

1792 DA MORRONA A., *Pisa illustrata*, 2nd ed., Pisa, 1812.

1792 and 1795-6 LANZI I., *Storia Pittorica*, Bassano, ed. 1809, I, pp. 16-17.

1797 FOLLINI-RASTRELLI, *Firenze antica e moderna*, Florence, VII, pp. 245 ff.

1804-17 MORENI D., *Memorie della Basilica di S. Lorenzo*, Florence, I, p. 210.

1805 MORENI D., *Bibliografia storico-ragionata della Toscana*, Florence.

1808-11 DE MONTOR ARTAUD J. A. F., *Considérations sur l'état de la peinture dans les trois siècles qui on précédé Raphael*, Paris.

1808-23 OTTLEY W. Y., *The Italian School of Design, being a Series of Facsimiles, of scarse and curious Prints by the Most Eminent Painters and Sculptors of Italy with Biographical Notices of the Artists and Observations on their Works*, London.

1810 CIAMPI S., *Notizie inedite della Sagrestia Pistoiese*, Florence.

1810 RIEPENHAUSEN F. and J., *Geschichte der Mahlerei in Italien*.

1811-20 D'AGINCOURT SEROUX J.-B. L. G., *Histoire de l'Art par les Monumens depuis sa décadence au 4me siècle, jusque à son renouvellement au 16me*. Paris, Italian translation, Prato, 1826, IV, pp. 355.

1819 DELAROCHE H., *Catalogue des tableaux, dessins, estampes et autres objets de curiosité, composant la collection de feu M. Léon Dufourny*, Paris 1819.

1820 FEA C., *Descrizione ragionata della sagrosanta patriacal Basilica e Cappella papale di S. Fracesco d'Assisi*, Rome.

1824 BIADI L., *Notizie sulle antiche fabbriche di Firenze non terminate*, Florence, pp. 43, 89, 145, 155, 161.

1826 OTTLEY W. Y., *A Series of Plates Engraved after the Paintings and Sculptures of the Most Eminent of the Early Florentine School*, pl. IV.

1827 KUGLER F., " Anfänge der italienischen Kunst: Cimabue ", in *Kunstblatt*, pp. 109-11, 135-39, 149-50, 155-59, 193-95.

1827 RUMHOR F., *Italienische Forschungen*, II, p. 14; ed. Schlosser, 1920, p. 246.

1832 " Cimabue, Mitteilungen aus Siena ", in *Kunstblatt*, pp. 118-24, 125-27.

1833 KUGLER F., in *Museum für bildende Kunst*, p. 158.

1835 FÖRSTER E., *Beiträge zur neueren Kunstgeschichte*, Leipzig, pp. 97-102.

1835-52 NAGLER G. K., *Neues allgemeines Kunstler-Lexicon*, III, Leipzig, pp. 71-78.

1838 ROSINI G., *Storia della Pittura Italiana esposta coi monumenti*, Pisa, I, p. 183.

1841 SÉROUX D'AGINCOURT, *Storia dell'Arte col mezzo dei monumenti*, Mantua, VI, Pls. CII, CX.

1842 BROWNING R., *Dramatic Lyrics*, " Old Pictures in Florence, " XXIII.

1843 " Cimabue ", in *Album*, 10, pp. 297-99.

1843 CHALAMEL J., *Peintres primitifs, Coll. des tableaux rapportés d'Italie et pubbliés par le Chevalier Artaud de Montor*, Paris, p. 30.

1846 BONAINI F., *Memorie inedite intorno alla vita e ai dipinti di Francesco Traini*, Pisa.

1847 KUGLER F. and BURCKHARDT J., *Geschichte der Malerei*, p. 290.

1850 GUALANDI E., *Tre giorni in Bologna*, Bologna, p. 71.

1855 BURCKHARDT J., *Der Cicerone*, p. 745.

1856 " A Few Mediaeval Painters ", in *Fraser's Magazine*, March, 1856.

1861 RIO A. F., *De l'art chretien*, Paris, I, p. 179-183.

1864 CAVALCASELLE G. B. and CROWE J. A., *A New History of Painting in Italy from the Second to the Sixteenth Century*, London, I, p. 206; 1903 ed., pp. 178 ff.

1865 POONER S. S., *A Biographihcal History of the Fine Arts*, I, New York.

1872 GATTI F., *Le gallerie di Firenze*, Florence, p. 197.

1872 GUARDABASSI M., *Indice dei monumenti pagani e cristiani dell'Umbria*, Perugia.

1873 CAVALLUCCI C. I., *Notizia Storica*, Florence, pp. 16 ff.

1876 SCHNAASE C., *Bildene Künste im Mittelalter*, VII, p. 317.

1878 FONTANA G., *Due documenti inediti riguardanti Cimabue*, Pisa.

1879 THODE H., " Der eigentliche Name Cimabues ", in *Repertorium für Kunstwissenschaft*, II, pp. 234-36.

1881 FRATINI G., *Storia della basilica e del convento di S. Francesco*, Prato.

1882 PASQUI U., *Nuova guida di Arezzo*, Arezzo, p. 20.

1885 THODE H., *Franz von Assisi und die Anfänge der Kunst der Renaissance in Italien*, Berlin.

1886 PÉRETÉ ANDRÉ, " Correspondance d'Italie ", in *Gazette des Beaux Arts*, XXXIV, Oct, pp. 346-52.

1886-7 MONKHOUSE W. C., " Some Treasures of the National Gallery ", I, in *Magazine of Art*, pp. 142-44.

1888 STRZYGOWSKI J., *Cimabue und Rom: Funde und Forschungen zur Kunstgeschichte und zur Topographie der Stadt Rom*, Vienna.

1888 BODE W. VON, " La renaissance au Musée de Berlin ", III, in *Gazette des Beaux-Arts*, XXXVII, March, pp. 197-203.

1889 WICKHOFF F., "Über die Zeit des Guido von Siena", in *Mitteilungen des Instituts für österreichische Geschichtsforschung*, X, pp. 244-86.

1889 MONTAULT B. DE, " L'influence de Saint Bonaventure sur l'art italien à propos des peintures d'Utrecht et de Florence ", *Revue de l'art chrétien*, XXIX, pp. 84-5.

1890 Chiesi G., *Italiani illustri*, Milan, pp. 21-24.

1890 RICHTER J. P., *Notes to Vasari's Lives*, London.

1890 THODE H., "Guido von Siena und die toscanische Malerei des 13. Jahrhunderts", in *Repertorium für Kunstwissenschaft*, XIII, pp. 2-24.

1890 THODE H., " Sind uns Werke von Cimabue erhalten? " in *Repertorium für Kunstwissenschaft*, XIII, pp. 25-38.

1890-4 " Triptych belonging to Mrs. Wright ", *CAI Scrapbook*, 5, p. 118.

1892 " Anonimo Gaddiano ", ed. C. von FABRICZY, in *Archivio Storico Italiano*, S. Vª, XII.

1892 *Codice Magliabechiano*, ed. Karl von Frey, Berlin, XVII, pp. 17 ff., p. 119.

1893 Péreté André, " Études sur la peinture siennoise ", I, " Duccio ", *Gazette des Beaux Arts*, Feb., pp. 89-110; Sept., pp. 177-201.

1893-4 *Exhibition of Early Italian Art from 1300 to 1550,* Catalogues of the New Gallery, 6, p. 2.

1894 Wulff O., *Cherubin Throne und Seraphin, Ikonographie der ersten Engelshierarchie in der Christlichen Kunst,* Dissertation, Leipzig Univ.

1896 Trenta G., *I mosaici del Duomo di Pisa e i loro autori,* Florence.

1897 Tanfani Centofanti L., *Notizie d'artisti pisani,* Pisa.

1898 Richter J. P., " The Paintings of the Fourteenth Century ", in *Lectures on the National Gallery,* pp. 1-20.

1898 Schmarsow A., " Maitres Italiens a la Galerie d'Altenburg et dans la Collection A. de Montor ", in *Gazette des Beaux Arts,* Dec., pp. 494-510.

1899 Bertaux E., " Gli affreschi di Santa Maria in Donna Regina, Nuovi Appunti ", in *Napoli Nobilissima,* XV.

1899 Ginoux Charles, " Origine du Musée Municipal de Toulon ", *Réunion des Sociétés des Beaux Arts des Departments,* pp. 548-58.

1899 Thode H., *Giotto,* Leipzig, pp. 16 ff.

1899 Zimmermann M. G., *Giotto und die Kunst Italiens in Mittelalter,* Leipzig, I, pp. 200-07.

1901 Fry R., " Giotto ", in *Monthly Review,* December.

1901 Schubring P., " Die Primitiven Italiens in Louvre ", in *Zeitschrift für Christliche Kunst,* pp. 356-57.

1901 Cartwright J., *The Painters of Florence,* London, pp. 1-10.

1901 Wood Brown J., " Cimabue e Duccio nella Chiesa di S. Maria Novella ", in *Rassegna d'Arte,* I, pp. 97-99.

1901 ff. Mireur H., *Dictionnaire des Ventes d'art faites en France et à l'Etranger pendant les XVIIIme et XIXme siècles,* Paris, London, Vienna, *passim.* (Sales Lebrun 1810, " Portrait of a Lady ", on panel, 1000 frs.; Sale Massias, 1825 " Portrait of a Lady ", frs. 161; Sale Lefrançois, 1884 " The Madonna with Saint John ", frs. 68, Sale Woodburn, 1800 and A. D., Turin, 1860, drawings of " St. Sebastian " and " Adoration of the Kings ").

1902 Schubring P., *Pisa,* Leipzig.

1902 Bayersdorfer A., *Leben und Schriften,* Munich, p. 103.

1902 Perkins F. and Mason F., *Giotto,* London, p. 144.

1903 " Cimabue-Giotto-Buonamico-Orcagna. Peintres " in *L'Art pour tous,* XLII, no. 214-5.

1903 Cocchi A., *Le Chiese di Firenze,* Florence, p. 181.

1903 Douglas R. Langton, " The Real Cimabue ", in *Nineteenth Century,* March.

1903 Douglas R. Langton, Appendix to the *History of Painting* etc. by Crowe-Cavalcaselle, London, I, pp. 173, 189.

1903 Fry R., *Pictures in the Collection of Sir Hubert Parry at Highnam Court near Gloucester, I. Italian Pictures of the Fourteenth Century.*

1904 Supino J. B., *Arte Pisana,* Florence.

1904 Chiappelli A., " Duccio e Cimabue dinanzi alla odierna critica inglese ", in *Nuova Antologia,* CXIII, Series IV, pp. 217-26.

1904 Toesca P., " Gli antichi affreschi di S. Maria Maggiore ", in *L'Arte,* pp. 312-17.

1904 Langton Douglas and Curt L., " The Royal Collections, II, The pictures by Sano di Pietro and Duccio, in *The Burlington Magazine,* V, July, p. 349-54.

1904 Rothes W., *Die Blütezeit der sienesischen Malerei und ihre Bedeutung für die Entwicklung der italienischen Kunst,* Strasbourg.

1905 PAGLIAI L., " Appunti d'archivio. Da un libro del Monastero di S. Benedetto ", in *Rivista d'Arte*, p. 153.

1905 CHIAPPELLI A., *Pagine di antica arte fiorentina*, Florence.

1905 PERKINS F. MASON, " Pitture italiane nella raccolta Johnson a Filadelphia ", in *Rassegna d'Arte*, V, pp. 113-21.

1905 COLETTI L., " Precedenza della scuola senese sulla scuola fiorentina ", in *Rassegna d'arte senese*, p. 95.

1905 SUIDA W., " Die Madonna Rucellai ", in *Jahrbuch der Preusz. Kunstsammlungen*, XXVI, pp. 28-39.

1905 PERDRIZET P., *La peinture religieuse en Italie au XIVme siècle*, Nancy, p. 16.

1905 VENTURI A., " Dittico attribuito a Cimabue nell'esposizione di Grottaferrata ", in *L'Arte*, VIII, pp. 199-201.

1905 WOERMANN K., *Geschichte der Kunst aller Zeiten und Völker*, Leipzig, II.

1906 CAFFIN CHARLES HENRY, *How to Study Pictures*, pp. 8-19.

1906 COLETTI L., *Arte senese*, Treviso, p. 18.

1906 CHIAPPELLI A., " Notizie di Firenze ", in *L'Arte*, IX, pp. 387-88.

1907 AUBERT A., *Die malerische Dekoration der S. Francesco Kirche in Assisi : ein Beitrag zur Lösung der Cimabue Frage*, Leipzig.

1907 Review of F. M. PERKINS in *Rassegna d'Arte*, VII, p. 128.

1907 Review of F. WICKHOFF, in *Kunstgeschichtliche Anzeigen*, pp. 40-3.

1907 Review of F. HERMANIN, in *L'Arte*, X, pp. 303-4.

1907 Review of R. FRY in *The Burlington Magazine*, XII, Dec., pp. 171 ff.

1907 CRUTTWELL, M., *A Guide to the Paintings in the Florentine Galleries*, London and New York, 1907.

1907 CHIAPPELLI A., " Per la Madonna Rucellai ", in *L'Arte*, X, pp. 55-59.

1907 VENTURI A., *Storia dell'arte italiana. La pittura del 300 e le sue origini*, Milan, V, pp. 63-66.

1908 AUBERT A., in *Repertorium für Kunstwissenschaft*, XXXI, pp. 491-6.

1908 SEIDLITZ W. VON, " Cimabue in Assisi ", in *Zeitschrift für bildende Kunst*, XIX, pp. 39-42.

1908 KALLAB W., *Vasari-Studien*, Vienna-Leipzig, 1908.

1908 SIRÉN O., " Trecento Pictures in American Collections ", I, *The Burlington Magazine*, XIV, Nov., pp. 124-126.

1908 VENTURI A., *La Basilica di Assisi, Illustrazione storico-artistica*, Rome.

1909 FREY K., " Recensione ad Aubert e ad A. Venturi ", in *Repertorium für Kunstwissenschaft*, XXXII, pp. 447-55.

1909 SUIDA W., " Zur Dugento Malerei " (Review of Aubert), in *Monatshefte für Kunstwissenschaft*, II, pp. 64-67.

1909 BERENSON B., *Florentine Painters of the Renaissance*.

1909 " Cronaca " in *Rassegna d'Arte*, IX, Aug.-Sept., pp. 1-11.

1909 GOETZ, W., *Assisi*, Leipzig, pp. 79-83.

1909 GOFFIN A., *Saint François d'Assise dans la légende et dans l'art primitif italiens*, Brussels.

1910 SALMI M., " Una tavola primitiva nella chiesa di San Francesco a Pisa ", in *Rivista d'Arte*, pp. 67-72.

1910 Schlosser J., " Ghibertis Denkwürdigkeiten ", in *Kunstgeschichtliches Jahrbuch der Zentralkommission für Erforschung und Erhaltung*, pp. 127-33.

1910 SUPINO I. B., *Pisa*, Bergamo.

1910 "Cronaca", in *Rassegna d'Arte*, X, 4, April, pp. 1-11.

1911 RINTELEN F., "Die Madonna Rucellai", in *Sitzungsberichte der Kunstgeschichtlichen Gesellschaft*, VII, p. 87.

1911 MAUCLAIR C., "La peinture italienne", in *L'Art et les Artistes*, VII, 13, April, p. 1-17.

1911 DVOŘÀK MAX, "Über Rintelens Giotto", in *Kunstgeschichtliche Anzeigen*, 1911, pp. 90 ff.

1911 SALMI M., "Note sulla Galleria di Perugia", in *L'Arte*, pp. 155-71.

1911 FREY K., *Le Vite scritte da M. Giorgio Vasari mit kritischen Apparate*, I, 1, Munich, pp. 406-62.

1911 WEIGELT G. H., *Duccio da Buoninsegna*, Leipzig, pp. 37, 124-47, 153.

1912 BAUTIER P., *Aux Musées royaux de peinture et de sculpture*, pp. 83-84.

1912 GILLET LOUIS, *Histoire artistique des Ordres Mendiants, Étude sur l'Art religieux en Europe du XIIIe au XVIIe siècles*, Paris, pp. 70-80, 119-122.

1912 BAUTIER PIERRE, "I recenti acquisti del Museo di Bruxelles", in *Rassegna d'Arte*, XII, No. 7, July, pp. 107-11.

1912 KHVOSHINSKY B. and SALMI M., *Pittori toscani dal XIII al XVI, sec.*, I.

1912 WACKERNAGEL M., "Cimabue", in *Thieme-Becker*, VI, p. 601.

1913 DE RICCI S., *Peintures du Louvre*, Vol. I, Paris.

1913 DVOŘÀK M., review of F. Rintelen, "Dante über Cimabue", in *Monatshefte für Kunstwissenschaft*, pp. 200 ff.

1913 WEIGELT C. H., Résumé of a lecture on the Madonna Rucellai, in *Sitzungsberichte der Kunstgeschichtlichen Gesellschaft*, pp. 151.

1913 PERKINS F. MASON, "Appunti sulla mostra ducciana a Siena", in *Rassegna d'arte*, XIII no. 1, Jan. p. 5-9; No. 2, Feb., p. 35-39.

1913 DVOŘÀK M. "Zur Diskussion über Cimabue," in *Kunstgeschichtliches Anzeigen*, pp. 75-83.

1914 BROWN A. VAN VECHTEN and RANKIN WILLIAM, *A Short History of Italian Painting*, New York.

1915 KLEINSCHMIDT B., *Die Basilika San Francesco in Assisi*, Berlin.

1914-16 SCHLOSSER JULIUS VON, *Materialen zur Quellenkunde der Kunstgeschichte*, Vienna, p. I, 48.

1915 SIRÉN O., "The Earliest Pictures in the Jarves Collection", in *Art in America*, III, No. 6, Oct., pp. 273-83.

1916 WILPERT J., *Die römischen Mosaiken und Malereien der Kirchlichen Bauten vom IV bis XIII*, IV, Freiburg.

1916 WULFF O., "Zwei Tafelbilder des Ducento im Kaiser-Friedrich Museum", in *der Preussischen Kunstsammlungen Jahrbuch*, XXXVII pp. 78, 94-95.

1916 CARTWRIGHT J., *Painters of Florence*, pp. 1-10.

1917 RINTELEN F., "Dante über Cimabue", II, in *Monatshefte für Kunstwissenschaft*, pp. 97 ff.

1917 BENKARD E., *Das literarische Porträt des Giovanni Cimabue*, in *Beiträge zur Geschichte der Kunstgeschichte*, Munich.

1917 LAVALLÉE P., "La Collection des dessins de l'École de Beaux Arts", in *Gazette des Beaux Arts*, July-Sept., pp. 265-83; Oct.-Dec., pp. 417, 422.

1918 GARBER J., *Wirkungen der frühchristlichen Gemäldezyklen der altern Peters und Pauls Basiliken in Rom*, Berlin.

1918 PERKINS F. MASON, "Alcune opere d'arte ignorate", in *Rassegna d'Arte*, V, pp. 105-15.

1918 SIRÉN O., "A picture by Pietro Cavallini", in *The Burlington Magazine*, XXXII, pp. 45-46.

1919 WEST R., "Grünewald und Cimabue", in *Monatshefte für Kunstwissenschaft*, pp. 343-344.

1919 A. BALDINI, "Dialogo di Giotto e Cimabue" in *La Ronda*.

1920 W. M. I., JR., "Italian Paintings", in *Bulletin of the Metropolitan Museum*, July, pp. 159-60.

1920 BERENSON B., "A Newly Discovered Cimabue", in *Art in America*, VIII, pp. 251-71.

1920 MARLE R. VAN, *Simone Martini et les peintres de son école*, Strassburg.

1920 GIELLY L., "Les Fresques de la Basilique de Saint François", in *Les Arts*", XVI, No. 182, pp. 13-20.

1920 SUPINO I. B., *Giotto*, Florence.

1921 BYVANCK A. W., "Dante e Cimabue" in *Dante Alighieri 1321-1921; Omaggio dell'Olanda*, pp. 68-78.

1921 BORENIUS T., "A panel of the Crucifixion", in *The Burlington Magazine*, XXXIX, pp. 53-54.

1921 MARLE R. VAN, *La Peinture romaine au Moyen-Age, son development du VIe jusqu'a la fin du XIIIe siecle*, Strassburg, pp. 206 ff.

1921 "Assisi", in *Rassegna d'Arte Umbra*, III, No. 1, Jan., pp. 20-23.

1921 SALMI M., "Note sulla galleria di Perugia", in *L'Arte*, XXIV, No. 4, July-Aug.

1921 BROWN A. VAN VECHTEN and RANKIN WILLIAM, *A Short History of Italian Painting*, New York.

1921 "Cronaca delle Belle Arti", in *Bollettino d'Arte*, Nov., pp. 239-40.

1921 VENTURI A., "Les arts representatifs du temps de Dante" in *Societé de l'Histoire de l'Art Français, Actes du Congrès de l'Histoire de l'Art*, II, p. I, p. 3-16.

1922 SIRÉN O., *Toskanische Maler in XIII Jahrhundert*, Berlin, pp. 289-91.

1922 MARLE R. VAN, "Toskanische Malerei", in *Revue de l'art ancien et moderne*, p. 354.

1922 BAUTIEZ FILIPPO, "Esposizione d'arte antica italiana a Bruxelles", in *Rassegna d'Arte antica e Moderna*, 5-6, May-June, pp. 185-89.

1922 MARLE R. VAN, "L'origine romaine de l'art de Giotto", in *Revue de l'Art Ancien et Moderne*, XL, May, pp. 353-61; XLII, June, pp. 32-38.

1922 RUBINSTEIN STELLA, "An Annunciation Group in the Michael Dreicer Collection", in *Art in America*, X, 2, Feb., pp. 57-63.

1923 CHIAPPELLI L., "Nuovi documenti su Giotto", in *L'Arte*, Vol. 26, pp. 132-36.

1923 DEL VITA A., *Guida di Arezzo*, Arezzo, p. 85.

1923 MARLE R. VAN, *The development of the Italian School of Painting*, The Hague, pp. 313, 453 ff.

1923 MATHER F. J., *A History of Italian Painting*, New York, p. 4, 273 ff.

1923 SIRÉN O., "A Madonna by Cimabue", in *The Burlington Magazine*, XLIII, pp. 206-8.

1923 BORENIUS T., *Catalogue, Lee Collection*,

1923-7 HOLMES SIR CHARLES JOHN, *Old Masters and Modern Art: The National Gallery*, New York.

1923 ORPEN SIR WILLIAM, *Outline of Art*, New York.

1924 CHIAPPELLI A., "Nuovi studi su Cimabue e la sua opera pittorica", in *Nuova Antologia*, 16 June, p. 55.

1924 OFFNER R., "A Remarkable Exhibition of Italian Painting", in *The Arts*, p. 244.

1924 OFFNER R., *Notes from Lecture at Metropolitan Museum*, October 15, 1924, in the Frick Library, New York.

1924 SOULIER G., *Les influences orientales dans la peinture toscane*, Paris.

1924 SUPINO I. B., *La basilica di S. Francesco in Assisi*, Bologna.

1924 VITZTHUM G. and VOLBACH W. F., "Die Malerei und Plastik des Mittelalters in Italian", in *Handbuch der Kunstwissenschaft*, Wildpark-Potsdam, pp. 244 ff.

1925 BARNES A. C., *The Art in Painting*, New York.

1925 CHIAPPELLI A., " Cimabue e la critica moderna ", in *Arte del Rinascimento*, Rome, pp. 46 ff.

1925 PASQUI and VIVIANI, *Guida di Arezzo*, Arezzo, p. 142.

1925 FALCIAI M., *Arezzo, La sua storia e i suoi monumenti*, Arezzo.

1926 HAUTECOEUR L., *Musee du Louvre Catalogue des Peintures*, Paris, p. 51.

1926 CHIAPPELLI A., " S. Francesco e l'arte ", in *Nuova Antologia*, March.

1926 NEWTON F., *St. Francis and his Basilica Assisi*, Assisi.

1926 MARLE R. VAN, *Recherches sur l'iconographie de Giotto et de Duccio*, Strassburg.

1926 THURSTON C. H. PH., *Why We Look at Pictures*, New York.

1926 SIRÉN O., " Consideration sur l'œuvre de Cimabue a propos de la Coll. Gualino, Turin ", in *Revue de l'Art ancien et moderne*, LXIX, 26, pp. 73-88.

1926 VALENTINER W. R., *A Catalogue of Early Italian Paintings, Exhibited at the Duveen Gallery, New York, April to May 1924*, New York.

1926 VENTURI L., *Il gusto dei primitivi*, Bologna.

1926 VENTURI A. and VENTURI L., " Catalogo della raccolta Gualino ", in *L'Arte*, XXIX, No. 2, March-April, pp. 90-3.

1926 VENTURI L., *La collezione Gualino*, Turin-Rome, Pl. 6.

1927 DAVIDSON R., *Geschichte von Florenz. Die Früheit der Florentiner Kultur*, III, Berlin.

1927 SCHLOSSER J., *Präludien, Vorträge und Aufsätze: Zur Geschichte der Kunstbiographie*, Berlin, pp. 248 ff.

1927 ABBOT EDITH P., *Great Painters in Relation to the European Tradition*, New York.

1927 TOESCA P., *Storia dell'arte italiana: Il Medioevo*, I, pp. 1010-11, 1040 ff.

1927 BURGESS I. J., " Cimabue's Cartoons for Stained Glass Windows ", in *International Studio*, XXCVII, 364, Sept., pp. 33-38.

1927-8 PIJOAN y SOTERAS JOSÉ, *History of Art*, New York.

1927 WYZEWA TEODOR DE, " Les representations artistiques de Saint François ", in *Cousin Pons*, XI, No. 18, Jan., pp. 19-22.

1928 TAVANTI U., *Arezzo in una giornata*, Arezzo, p. 79.

1928 TIKKANEN J. J., *Den heilige Franciscus och hausfettydelse för konsten in Finsk Tidskr.*, pp. 380-97.

1928 CECCHI E., *I trecentisti senesi*, Rome, 1928.

1928 WEIGELT C. H., " Über die ' mütterliche ' Madonna in der italienischer Malerei des 13. Jahrhunderts ", in *Art Studies*, 1928, p. 195.

1928 MILESI A. LOCATELLI, " La valutazione commerciale delle opere pittoriche ", in *Emporium*, LXVII, No. 402, June, pp. 333-40.

1928 TATLOCK R. R., " Some Pictures in Lord Lee's Collection ", in *Art News*, XXVI, 28, April 14, p. 2-10.

1929 KRAUTHEIMER R., " Die Anfänge der Kunstgeschichteschreibung in Italien ", in *Repertorium für Kunstwissenschaft*, pp. 49 ff.

1929 Busuiocenanu A., *Pintura Italiana inainte de Cimabue*, Bucharest.

1929 DVOŘÀK M., *Gesammelte Aufsätze zur Kunstgeschichte*, Munich.

1929 MENCHERINI S., *S. Croce*, Florence, p. 51.

1929 KONODY P. G. and WILENSKI R. H., *Italian Painting*, London.

1929 SANDBERG-VAVALÀ E., *La Croce dipinta italiana e l'iconografia della passione*, Verona, pp. 171-72.

1929 WEIGELT C. H., " The Madonna Rucellai and the young Duccio ", in *Art in America*, XVIII, No. 1, Dec., pp. 3-25.

1929 TOESCA P., *La pittura fiorentina del Trecento*, Florence.

1930 BARRENECHEA, " Primitivos pintores italianos ", *Plus Ultra*, XV, April 30, p. 6.

1930 BERENSON B., *Studies in Mediaeval Painting*, New Haven, pp. 148 ff.

1930 CONSTABLE W. G., " Italian paintings in the Lee Collection ", in *International Studio*, Feb., pp. 21-26.

1930 NICHOLSON A., " The Roman School at Assisi ", in *Art Bulletin*, XII, pp. 270-300.

1930 CONSTABLE W. G., " Quelques aperçus suggérés par l'exposition italienne de Londres ", in *Gazette des Beaux Arts*, May, pp. 277-301.

1930-ff OFFNER R., *A Critical and Historical Corpus of Florentine Painting*, New York, 10 vol.

1930 PANOFSKY E., "Das erste Blatt aus dem Libro Giorgio Vasaris", in *Städel Jahrbuch*, VI, pp. 24-37; Engl. trans. *Meaning in the visual arts*, Turin, 1960, pp. 169-225.

1930 SMITH S. and KAINES, *The Italian Schools of Painting*, London.

1930 SALMI M., " I Mosaici del ' Bel S. Giovanni " e la pittura del sec. XIII a Firenze ", in *Dedalo*, 28, pp. 543-70.

1930 WITTGENS F., " The Contributions of Italian Private Collections to the Exhibition at Burlington House ", in *Apollo*, XI, 62, Feb., pp. 73-90.

1930 WEIGELT C. H., *La pittura senese del trecento*, Bologna.

1930 WEIGELT C. H., " The Problem of the Rucellai Madonna, Sienese Characteristics ", in *Art in America*, XVIII, pp. 115 ff.

1931 " Cronaca delle Belle Arti ", in *Bollettino d'Arte*, July, pp. 39-48.

1931 HAUTECOEUR L., *Les Primitifs italiens*, Paris, pp. 54 ff.

1931 M. JAMES MR., *The Apocalypse in Art*, London, (British Academy).

1931 FRY R., " Mr. Berenson on Medieval Painting ", in *The Burlington Magazine*, LVIII, 338, May, pp. 245-6.

1931 SCHROEDER H., *Die kunstfördernde Tätigkeit der Päpste in XIII. Jahrhundert*, Leipzig.

1931 LASAREFF, V., " Duccio and Thirteenth-Century Greek Ikons ", in *The Burlington Magazine*, LIX; 1931, pp. 154-169.

1931 TOESCA P., " Cimabue ", in *Enciclopedia Italiana*, X, pp. 245-46.

1931 ROWLAND B., JR., " A Fresco Cycle from Spoleto ", in *Art in America*, XIX, Oct., pp. 224-30.

1931-32 ORTOLANI S., "La crocefissione di S. Domenico Maggiore a Napoli", in *Bollettino d'Arte*, pp. 53-64.

1932 BERENSON B., *Italian Pictures*, pp. 149 ff.; 1936 ed., p. 129.

1932 MARTINS L., " Die Franziskuslegende in der Oberkirche von S. Francesco in Assisi und ihre Stellung in Kunstgeschichtliche Forschungen," Berlin.

1932 EDGELL G. H., *A History of Sienese Painting*, New York, pp. 44-45.

1932 MATHER F. J., *The Isaac Master: A Reconstruction of the Work of Gaddo Gaddi*, Princeton.

1932 MARLE R. van, *Le scuole della pittura italiana*, The Hague-Milan, I, pp. 489 ff.

1932 NICHOLSON A., " Cimabue: A critical study ", in *Monographs in art and archaeology*, XVI, Princeton University Press, Princeton, pp. 57-59.

1932 NICHOLSON A., " Cimabue Murals Discovered ", in *Creative Art*, XII, pp. 30-55.

1932 PROCACCI U., " Opere Sconosciute d'arte toscana ", in *Rivista d'Arte*, pp. 463 ff.

1932 SUPINO, I. B., *L'Arte nelle chiese di Bologna*, Bologna, pp. 300 ff.

1933 BENSON E. M., " Cimabue Murals Discovered ", in *Creative Art*, XII, pp. 391 ff.

1933 OFFNER RICHARD, " The Mostra del Tesoro di Firenze Sacra ", I, in *The Burlington Magazine*, LXIII, Aug., pp. 72-85.

1933 SERRA L., " Mostra del Tesoro di Firenze Sacra ", in *Bollettino d'Arte*, III, I, pp. 37-48.

1933 GAMBA C., " La mostra del Tesoro di Firenze sacra — La pittura " in *Bollettino d'Arte* IV, October, pp. 145-63 (pp. 147-50: Madonna from the Collegiata di S. Ippolito, Castelfiorentino).

1933 VENTURI L., *Italian Paintings in America*, New York, I.

1933 SHERRILL C. H., *Mosaics in Italy, Palestine, Syria, Turkey and Greece*, London.

1934 D'ANCONA P., " Un miniatore fiorentino della scuola di Cimabue ", in *Rivista d'Arte*, pp. 105-9 (Mss. Con. Soppr. 233, Biblioteca Medicea-Laurentiana).

1934 " Un ignoto miniatore fiorentino della scuola di Cimabue ", in *Bibliofilia*, vol. 36, Nov.-Dec., pp. 516-17.

1934 GOLDSMITH E. L., " Cimabue by Alfred Nicholson ", in *Art Bulletin*, XVI, Sept., pp. 306-7.

1934 KRIS E. and KURZ O., *Die Legende vom Künstler*, Vienna, pp. 33 ff.

1934 SANDBERG-VAVALÀ E., *L'iconografia della Madonna col Bambino nella pittura italiana del Dugento*, Siena, pp. 34-66.

1934 SALMI M., " Le origini dell'Arte di Giotto ", in *Rivista d'Arte*, pp. 105-9.

1934-35 CASTELFRANCO G., " Corso di Buono ", in *Bollettino d'Arte*, pp. 322-33.

1935 D'ANCONA P., *Les Primitifs italiens du XI au XIII siecle*, Paris pp. 139, 140-47.

1935 ANTHONY, E. W., *A History of Mosaics*, Boston.

1935 SALMI M., " Per il completamento di un politico cimabuesco ", in *Rivista d'Arte*, XVII, pp. 113-20.

1935 GOLZIO V., " Le dugento et le trecento ", in *L'Amour de l'Art*, XVI, No. 5, May, pp. 151-56.

1935 HOURTICQ L., " De Cimabue à Tiepolo ", in *L'Illustration*, Dec.

1935 PINGUSSON G. H., " La leçon des primitifs italiens ", in *L'Art Sacré*, V, 1, No. 2, Aug., pp. 14-19.

1935 SERRA L., " La mostra dell'antica arte italiana a Parigi, La Pittura ", in *Bollettino d'Arte*, July, pp. 30-45.

1935-6 SWARZENSKY GEORG, "Die Sammlung Böhmer und ein unbekanntes altitalienisches Bild in Städelschen Kunstinstitut ", in *Städel. Jahrbuch*, IX, pp. 112-52.

1936 BRANDI C., " Il Crocefisso di Giunta Pisano in S. Domenico di Bologna ", in *L'Arte*, pp. 71-91.

1936 LAVAGNINO E., *Storia dell'Arte Medioevale Italiana*, Turin, pp. 433 ff.

1936 CARNEGIE CORPORATION, *Catalogue of Selected Color Reproductions*, New York.

1936 WEIGELT C. H., *Die Sienische Malerei des XV. Jahrhunderts*, Munich.

1936 OERTEL R., " Notizen und Nachrichten ", in *Zeitschrift für Kunstgeschichte*, p. 349.

1936 BLUMER M. L., " Catalogue des Peintures Transportées d'Italie en France de 1796 à 1814 ", in *Bulletin de la Société d'Histoire de l'Art Français*, Num. 112.

1936 PROCACCI U., " Restauri a dipinti della Toscana ", in *Bollettino d'Arte*, Feb., pp. 364-83.

1936 PROCACCI U., " Quelques récentes restaurations des peintures de la Toscane ", in *Mouseion*, pp. 227-47.

1936 BARTOLINI P., " Ancora su Cimabue ", in *Quadrivio*, No. 30, p. 8.

1937 BARGELLINI P., " Cimabue solenne dipintore ", in *Frontespizio*, III, pp. 195-208.

1937 BECHERUCCI L., " Il restauro della Madonna dei Servi a Bologna ", in *Bollettino d'Arte*, XXXI, I, pp. 9-18.

1937 CECCHI E., *Giotto*, Milan.

1937 COLETTI L., " La mostra giottesca ", in *Bollettino d'Arte*, Aug., pp. 49-72.

1937 FILIPPINI F., " La Madonna di Cimabue nella Chiesa dei Servi ", in *Bologna*, XV, No. 6, pp. 29-32.

1937 GERRY P., " The Giotto Exhibition ", in *Magazine of Art*, XXX, 10, Oct., pp. 594-603.

1937 GIGLIOLI O., " La mostra giottesca in Firenze ", in *Illustrazione*, April, pp. 38 ff.

1937 OERTEL R., " Giotto-Ausstellung in Florenz ", in *Zeitschrift für Kunstgeschichte*, VI, 1937, pp. 218-38.

1937 KURZ O., " Giorgio Vasari's ' Libro dei disegni ' ", in *Old Masters Drawings*, XI, pp. 1-15.

1937 LOCHOFF L., " Gli affreschi dell'antico e nuovo Testamento nella Basilica di Assisi ", in *Rivista d'Arte*, pp. 240-70.

1937 MARCENARO C., " Manfredino da Pistoia ", in *L'Arte*, pp. 110-30.

1937 JACQUES R., " Die Ikonographie der Madonna in Trono in der Malerei des Dugento ", in *Mitteilungen des Kunsthistorischen Instituts in Florenz*, II, 5.

1937 OERTEL R., " Giotto ", in *Zeitschrift fur Kunstgeschichte*, pp. 148, 172, 225 ff.

1937 PAATZ W., *Werden und Wesen der Trecento Architektur*, Burg. b.fM.

1937 RAMBALDI P. L., " Vignone ", in *Rivista d'Arte*, pp. 357-69.

1937 SALMI M., " La mostra giottesca ", in *Emporium*, pp. 349 ff.

1937 SUIDA W., " Giotto-Ausstellung in Florenz ", in *Pantheon*, pp. 347 ff.

1938 " Cronaca dei ritrovamenti e dei restauri ", in *Le Arti*, I, Oct.-Nov., pp. 89-104 (Restoration of the Crucifix of S. Domenico).

1938 BOTTO C., " Note e documenti sulla chiesa di S. Trinita a Firenze ", in *Rivista d'Arte*, pp. 1-22.

1938 OERTEL R., " Italienische Malerei des Mittelalters bis zum Trecento ", in *Zeitschrift für Kunstgeschichte*, VII, 1938, pp. 263-7.

1938 MEER F. VAN DER, " Majestas Domini; Theophanies de l'Apocalypse dans l'Art Chrétien ", in *Studi di antichità cristiana*, Vatican City.

1938 LASAREFF V., " Studies in the Iconography of the Virgin ", in *Art Bulletin*, XX, pp. 61-72.

1938 SALVINI R., *Giotto, Bibliografia*, Rome.

1939 GLEIZES A. L., " Tradition et Modernisme ", in *L'Art et les Artistes*, 34 XXXVII, 193, Jan., pp. 109-15, 143-44.

1939 ALPATOV M., *L'Arte Italiana al tempo di Dante e di Giotto*, Moscow.

1939 BARGELLINI P., *Città di pittori*, Florence, pp. 13-44.

1940 BUNIM MIRIAM SCHILD, *Space in Medieval Painting and the Forerunners of Perspective*, New York.

1940 ff. PAATZ W. and PAATZ E., *Die Kirchen von Florenz, ein Kunstgeschichtliches Handbuch*, Frankfurt, passim.

1940 VILLETTE JEANNE, *L'ange dans l'art d'Occident du XIIeme au XVIeme siecle*, Paris.

1941 COLETTI L., *I Primitivi; Dall'arte benedettina a Giotto*, Novara, I, 2nd ed., 1947.

1941 NATIONAL GALLERY OF ART, *Book of Illustrations*, Washington D. C.

1941 TOESCA P., *Giotto*, Turin.

1942 BORENIUS T., " The New Giotto Panel ", in *The Burlington Magazine*, November.

1942 ROBB DAVID M., *Art in the Western World*, New York.

1942 SALMI M., " Giotto ", *Les documents Athenaeum Photographiques*, Paris.

1942 ROBERTI G. DE, " Il cantore di Frate Sole ", in *Civiltà*, XIII, 9, April, pp. 17-24.

1942 SALVINI R., " La Madonna di S. Trinita alla Galleria degli Uffizi ", in *Stile*, December, pp. 28-29.

1943 ORTWIN RAVE P. "Ramboux und die Wiederentdeckung altitalienischer Malerei in der Zeit der Romantik," in *Wallraf-Richartz Jahrbuch*, XII-XIII, pp. 231-258.

1943 SOFFICI A., *Selva Arte*, Florence.

1944 ACHENBACH G., " An Early Italian Tabernacle ", in *Gazette des Beaux Arts*, 6, 25, March, pp. 129-52.

1944 SINIBALDI G. and BRUNETTI G., *Pittura Toscana del Duecento* (Catalogue of the 1937 Giotto Mostra) Florence.

1945 TOESCA P., *Giotto*, Turin, 2nd edition.

1946 RAGGHIANTI C. L., *Miscellanea minore di critica d'arte*, Bari.

1946 CARLI E., *Vetrata Duccesca*, Florence-Milan.

1946 SALVINI R., *Cimabue*, Rome.

1947 GRONDIJS L. H., *L'Iconographie byzantine du Crucifié mort sur la Croix*, 2nd ed., Bibliotheca Byzantina Bruxellensis, I.

1948 ANTAL F., *Florentine Painting and Its Social Background; the bourgeois republic before Cosimo de' Medici's advent to power: XIV and early XV century*, London.

1948 LONGHI R., " Giudizio sul Duecento ", in *Proporzioni*, II, pp. 5-54.

1948 SANDBERG-VAVALÀ E., *Uffizi*, Florence, pp. 15-24.

1948 F. ANTAL, *Florentine painting and its social background; the bourgeois republic before Cosimo de' Medici's advent to power: XIV and early XV centuries*, London.

1949 COOR G., " Coppo di Marcovaldo, his Art in Relation to the Art of his Time ", in *Marsyas*, V, 1949, pp. 1-21.

1949 COLETTI L., *Gli affreschi della Basilica di Assisi*, Bergamo.

1949 UPJOHN E. M., *History of World Art*, New York and Oxford.

1949 GARRISON E. H., *Italian Romanesque Panel Painting, An Illustrated Index*, Florence.

1949 WEIDLÉ W., in E. Benezit, *Dictionnaire critique et documentaire des Peintres, Sculpteurs, Dessinateurs et Graveurs*, Paris.

1950 PAESELER W., *Der Rückgriff der spätrömischen Dugentomalerei auf die Christliche Spätantike, Beiträge zur Kunst de Mittelalters* (Vorträge an der I. deutschen Kunsthistorikertagung), Berlin, pp. 157 ff.

1950 KAFTAL, George, " St. Francis in Italian Painting ", *Ethical and Religious Classics of East and West*, London.

1950 OFFNER R., " Guido da Siena and A. D. 1211 ", in *Gazette des Beaux Arts*, XXXVII, pp. 61-90.

1950 VENTURI L., *Italian Painting*, I, *The Creators of the Renaissance*, Geneva.

1950 SALVINI R., " Postilla a Cimabue ", in *Rivista d'Arte*, XXVI, pp. 43-50.

1950-51 GARRISON E. H., " The Rôle of Criticism in the Historiography of Painting ", in *College Art Journal*, pp. 110-20.

1951 LONGHI R., " Splendid Trinity for the Frick ", in *Art News*, February, p. 22.

1951 BAZIN G., *History of Classic Painting*, New York.

1951 CHIARELLI R., " L'Arte nell'Aretino e la mostra di Arezzo ", in *Emporium*, pp. 3-16.

1951 HUYGHE R., *Art Treasuries of the Louvre*, New York.

1951-2 TOESCA P., " Giotto ", in *Spazio*, 3, 6, Dec.-April, pp. 1-4.

1951 BRANDI C., *Duccio*, Florence.

1951 GARRISON E. B., " Toward a New History of Early Lucchese Painting ", in *Art Bulletin*, XXXIII, 1, pp. 11-31.

1951 ROBB D. M., *The Harper History of Painting*, New York.

1951 MEISS M., " A New Early Duccio ", in *Art Bulletin*, XXXIII, p. 95.

1951 LONGHI R., " Prima Cimabue poi Duccio ", in *Paragone*, II, 23, pp. 8-13.

1951 MITCHELL C., " The Lateran Fresco of Bonifacio VIII ", in *Journal of the Warburg and Courtauld Institutes*, pp. 1-16.

1951 THOBY P., *Le Crucifixe des origines au Concile de Trente*, Nantes.

1952 SALMI M., " La miniatura fiorentina medioevale ", in *Accademie e Biblioteche d'Italia*, XX, pp. 8-23.

1952 BERENSON B., *Italian Painters of the Renaissance*, New York.

1952 SALVINI R., " Le Musées des Offices ", in *Art et Style*, pp. 1-12.

1952 HUYGHE R., *L'Art et l'Homme*, Paris; 1957-58 (with an essay by E. Carli).

1952 SCIAMANNINI R., *La Basilica di San Francesco e gli altri Santuari di Assisi*, Florence.

1953 ff. GARRISON E. H., *Studies in the History of Mediaeval Italian Painting*, Florence.

1953 OERTEL R., *Frühzeit der italienischen Malerei*, Stuttgart, pp. 44-48.

1953 MECCOLI F., " Gli affreschi del Cimabue lasciano la basilica di Assisi ", in *Giornale del Mattino*, 20 Dec.

1954 COOR G., " Dugento-Gemälde aus der Sammlung Ramboux ", in *Wallraf-Richartz Jahrbuch*, XVI, pp. 77-86.

1954 DE WALD E., " Observations on Duccio's Maestà ", in *Studies in honor of Albert Mathias Friend*, Princeton, pp. 362-86.

1954 SCHWOB LUCIEN, *Realité de l'arts*, with Preface by J. Villon, Lausanne.

1954 DE WITT A., *I mosaici del Battistero di Firenze*, Florence.

1954 FEZZI M., " Premure dell'Ist. Centr. del Restauro per gli affreschi della Basilica di San Francesco ", in *Atti dell'Accademia Properziana del Subasio*, Assisi, April, pp. 71-74.

1954 FRAUENDORFER B., *Die religiöse Kunst im italienischen Dugento und die Frage der franziskanischen Ikonographie*, Dissertation, Univ. of Vienna.

1954 SALERNO G. B., " Cimabue a Tivoli? " in *Atti e Memorie della Società Tiburtina*, pp. 159-63.

1954 SHORR D. C., *The Christ Child in Devotional Images in Italy during the XIV Century*, New York.

1954 SAMEK-LUDOVICI S., " Alta fantasia di Cimabue ", in *Prospettive*, III, pp. 53-54.

1954 VOLPE C., " Preistoria di Duccio ", in *Paragone*, pp. 4-22.

1955 CARLI E., *La Pittura senese*, Milan.

1955 FRANCASTEL G., *Histoire de la peinture italienne; Du Byzantine a la Renaissance*, Paris.

1955 LASAREFF V., " Un nuovo capolavoro della pittura fiorentina duecentesca ", in *Rivista d'Arte*, pp. 1-65.

1955 MEISS M., " Nuovi dipinti e vecchi problemi; Ancora una volta Duccio e Cimabue ", in *Rivista d'Arte*, XXX, pp. 107-113.

1955 WENTZEL H., " Antike-Imitation des 12. und 13. Jahrhunderts in Italien ", in *Zeitschrift für Kunstwissenschaft*, IX, 1955, pp. 29-72.

1955 POIRIER P., *La fresque florentine*, Paris, pp. 15-17.

1955 RAGGHIANTI C. L., *Pittura del Dugento a Firenze*, Florence.

1955 URBANI G., " Restoration of Frescoes in Rome and Assisi ", in *Connoisseur*, 136, December, pp. 155-60.

1956 MARCUCCI L., " Un crocifisso senese del duecento ", in *Paragone*, VII, 77, May, pp. 11-24.

1956 MARCHINI G., *Le Vetrate Italiane*, Milan.

1956 SUIDA, W. E. and SHAPLEY F. R., *Paintings and Sculpture from the Kress Collection*, 1956.

1956 BRANDI C. " Giotto recuperato in S. Giovanni in Laterano ", in *Scritti di Storia dell'Arte in onore di Lionello Venturi*, Rome, vol. I, pp. 55-85.

1956 EISENBERG M. J., " Un frammento smarrito dell'Annunciazione di Lorenzo Monaco nell'Acc. di Firenze ", in *Bollettino d'Arte*, pp. 333-35.

1956 NATIONAL GALLERY OF ART, *Exhibition of Painting and Sculptures from the Kress Collection Acquired by the Samuel H. Kress Foundation*, 1951-56, Washington D. C., p. 5-6, 50-5.

1956 FRANCASTEL G., " Reflexions nouvelles sur un vieux procés.", in *Annales*, XI, Oct.- Dec., pp. 481-89.

1956 ROSENTHAL E., " Una pittura di Lorenzo Monaco scoperta recentemente ", in *Commentari*, VII, pp. 71.

1956 SAMEK-LUDOVICI S., *Cimabue*, Milan.

1956 SHAPIRO M., "On an Italian Painting of the Flagellation of Christ in the Frick Collection", in *Scritti di Storia dell'Arte in onore di L. Venturi*, Rome, I, pp. 29-53, with relative bibliography.

1956 MEISS M., "The Case of the Frick Flagellation ", in *Journal of the Walters Art Gallery*, XIX-XX, pp. 42-63.

1956 WHITE J., " Cavallini and the Lost Frescoes in S. Paolo ", in *Journal of the Warburg and Courtauld Institutes*, pp. 84-95.

1957 WHITE J., *The Birth and Rebirth of Pictorial Space*, London, 1957.

1957 COOR G., " The Earliest Italian Representation of the Coronation of the Virgin ", *The Burlington Magazine*, XCIX, 1957, pp. 328-330.

1957 BEYE P., *Cimabue und die Dugento Malerei*, Dissertation, Univ. of Freiburg.

1957-9 DENIS MAURICE, *Journal*, III, Paris (notes on travel in Italy in 1904, 1910, 1934).

1957 BAZIN G., *Trésors de la Peinture au Louvre*, Paris, p. 80.

1957 GIOSEFFI D., *Perspectiva artificialis: Per la storia della prospettiva*, Pubblicazioni dell'Istituto di Storia dell'Arte Antica e Moderna, VII, Trieste.

1957 GRABAR A., " La décoration des coupoles à Karye Cami et les peintres italiennes du Dugento ", in *Jahrbuch der österreichischen byzantinischen Gesellschaft*, VI, pp. 111-24.

1957 STUBBLEBINE J. H., " The Development of the Throne in Dugento Tuscan Painting ", in *Marsyas*, VII, 1954-57, pp. 25-39.

1957 SCHÖNE W., " Studien zur Oberkirche von Assisi ", in *Festschrift Kurt Bauch*, Berlin, pp. 50-116.

1958 POMPEI A., *Guida dei santuari di Assisi*, Assisi.

1958 COLETTI L., *Gli affreschi della basilica di Assisi*, Bergamo.

1958 GNUDI C., *Giotto*, Milan.

1958 MARCUCCI L., *I dipinti toscani del sec. XIII* (Cat. delle Gallerie Nazionali di Firenze), Rome.

1958 MARIANI V., " Cimabue ", in *Secoli Vari*, Florence, pp. 227-44.

1958 CARLI E., *Pittura medioevale pisana*, Milan, 1958.

1959 CARLI E. and GNUDI C., *Pittura Italiana: Medioevo romanico e gotico*, Milan.

1959 SCHÖNE WOLFGANG, " Giottos Kruzifixus-tafeln und ihre Vorgänger ", in *Festschrift Friedr. Winkler*, pp. 49-63.

1959 GNUDI C. *Cavallini, Cimabue, Giotto. Pittura Italiana*, I, Milan, 1959, pp. 37-74.

1959 GOLFETTO A., " Italienische Zeichnungen aus dem 13. Jahrhundert ", in *Raggi*, II, pp. 15-20.

1959 MURRAY P., *An Index of Attributions Made in Tuscan Sources before Vasari*, Florence.

1959 SALMI M., " Cimabue e Jacopone ", in *Jacopone e il suo tempo*, Convegno del Centro di studi sulla spiritualità medioevale, I, Todi, pp. 57-72.

1959 THOBY P., *Le Crucifix des Origines au Concile de Trente; étude iconographique*, Nantes.

1960 BOLOGNA F., " Ciò che resta di un capolavoro giovanile di Duccio ", in *Paragone*, 125, pp. 3-31.

1960 GARRISON E. B., " Sienese Historical Writings and the Dates 1260, 1221 and 1262 applied to Sienese Painting ", *Studies in the History of Medieval Italian Painting*, IV, pp. 23-58.

1960 GRONDIJS L. H., *Autour de l'iconographie byzantine du crucifié mort sur la Croix*, Leyden.

1960 SALVINI R., " Cimabue ", in *The Encyclopedia of World Art*, III.

1960 PANOFSKY E., " Renaissance and Renascences in Western Art ", *Figura 10*, Uppsala.

1960 PREVITALI G., " Le prime interpretazioni figurate dei Primitivi ", in *Paragone*, XI, 121, Jan., pp. 15-23.

1960 BORSOOK E., *The Mural Painters of Tuscany, from Cimabue to Andrea del Sarto*, London, 1960.

1960 VIGNI G., " Duccio " in *The Encyclopedia of World Art*, IV.

1961 BERLINER R., " Ein Beitrag zur Ikonographie der Christusdarstellungen ", in *Munster*, XIV, pp. 89-104.

1961 CARLI E., *Duccio di Buoninsegna*, Milan, 2nd ed.

1961 HENTZEL R., " Les ' Possessions diaboliques' ", in *Aesculape*, Nov., pp. 3-33.

1961 LONGHI R., " Il Maestro del Farneto ", in *Paragone*, CXLI, pp. 3-7.

1961 LONGHI R., " Un dossale italiano a St. Jean Cap-Ferrat ", in *Paragone*, CXLI, pp. 11-19.

1961 PARRONCHI A., *Studi sulla dolce prospettiva*, Milano, 1961, pp. 100-101.

1961 LUDECKE, HEINZ, " Vasari und die Wiedergeburt der Künste ", in *Bildende Kunst*, pp. 513-18.

1961 MARETTE G., *Connaissance des Primitifs par l'Ètudes du Bois*, Paris, 1961 (No. 564).

1961 DE WALD E. T., *Italian Painting 1200-1600*, New York.

1961 G. MARETTE, *Connaisance des Primitifs par l'étude du Bois*, Paris.

1962 BOREA E., " I ritrovati affreschi medioevali della cappella Minutolo nel Duomo di Napoli ", in *Bollettino d'Arte*, XLVII, February, pp. 11-12.

1962 HUECK I., *Das Program der Kuppelmosaiken in Florentiner Baptisterium*, Munich, Dissertation, Univ. of Munich.

1962 HAGER H., *Die Anfänge des Altarbildes in der Toskana*, Veröffentlichung der Bibliotheca Hertziana, Munich, 1962.

1962 FRUTAZ A. P., *Le Piante di Roma*, I, scheda 141, pp. 114-15; II, Pl. 141, Rome.

1962 KAUFFMANN GEORG, " Review of The Mural Painters of Tuscany by E. Borsook ", in *Zeitschrift für Kunstgeschichte*, XXV, 1, pp. 279-81.

1962 BOELL H., *Assisi im Spiegel der Jahrhunderte*, München.

1962 JANSON H. W., *History of Art*, Englewood Cliffs, New York.

1962 MEISS M., " Reflections of Assisi, A Tabernacle and the Cesi Master ", in *Scritti di Storia dell'Arte in onore di M. Salmi*, I, Rome, pp. 75-111.

1962 MEISS M., " Scusi, ma sempre Duccio ", in *Paragone*, pp. 63-64.

1962 TINTORI L. and MEISS M., *The Painting of the Life of St. Francis in Assisi with notes on the Arena Chapel*. New York.

1962 BOLOGNA F., *La Pittura italiana delle origini*, Rome-Dresden.

1963 SÄNDSTROM S., " Levels of Unreality ", *Figure 4*, Uppsala.

1963 GIOSEFFI D., *Giotto architetto*, Milan.

1963 BERENSON, B., *Italian Pictures of the Renaissance, Florentine School*, London.

1963 SCHULTZE J. "Zur Kunst der Franziskus Meisters," in *Wallraf -Richartz Jahrbuch*, XXV, pp. 109-150.

1963 FRUGONI A,. "Sui Flagellanti del 1620," in *Bull. Ist. Storia del Medio Evo*, 75, pp. 211-237.

1963 CHASTEL A. " Giotto coetaneo di Dante ", in *Studien zur Toskanischen Kunst, Festschrift für Ludwig Heinrich Heydenreich zum 23. März 1963,* pp. 37-44.

1964 CECCHINI G. and CARLI E., *S. Gimignano*, Milan.

1964 PALLUCCHINI R., *La pittura veneziana del Trecento*, Venice-Rome, pp. 29, 73, 74.

1964 PARRONCHI A., " Sul luogo d'origine dell'Annunciazione Mond ", *Paragone*, 179, Nov., 62-66.

1964 PREVITALI G., *Early Italian Painting*, New York.

1964 PREVITALI G., *La Fortuna dei Primitivi dal Vasari ai Neoclassici*, Turin (with bibliography).

1964 *Panel discussion of the present volume at the Libreria Einaudi*, Rome, March 16. Panel members: A. GALVANO, H. HAGER, A. MARABOTTINI MARABOTTI, R. SALVINI.

1964 SCHRADE H., *Franz von Assisi und Giotto*, Köln.

1964 STUBBLEBINE J. H., *Guido da Siena*, Princeton, N. J.

1964 HERTLEIN E., *Die Basilika San Francesco in Assisi. Gestalt. Bedeutung. Herkunft* (Pocket Library of Studies in Art, XVI) Florence 1964.

1964 VOLPE C., " Review of *Cimabue* by E. Battisti ", in *Paragone*, XV, 173, May, pp. 61-74.

1965 BOLOGNA F., " Cimabue ", in *I Maestri del Colore*, 113, Milan 1965.

1965 CARLI E. "Ricuperi e restauri senesi. Nella cerchia di Duccio," in *Bollettino d'Arte*, pp. 94-99 (A new interpretation of the Youth of Duccio).

1965 BATTISTI E., " Dante e la situazione delle arti fra duecento e trecento ", in *Atti del Convegno Dantesco a cura della Casa di Dante*, Rome, pp. 264-69.

1965 " Schede. Pittura Italiana del Duecento ", in *Il Vasari*, XXII-XXIII, December, pp. 5-7 pl. III.

1965 NATIONAL GALLERY OF ART, *Summary Catalogue of European Paintings and Sculpture*, Washington D. C., p. 28.

1966 SHAPLEY F. R., *Catalogue of the Italian Paintings in the National Gallery of Art*, Washington, D. C.

1966 SMART A., " Roger Fry and Early Italian Art ", in *Apollo*, April, pp. 262-71.

1966 " L'anno dantesco a Roma ", in *Palatino*, 1966, 1, pp. 84-86.

1966 MONFERRINI A., " L'Apocalisse di Cimabue ", in *Commentari*, XVI, n. 1-2, 1966, p. 3-33.

1966 VOLBACH W. F., " Byzanz und sein Einfluss auf Deutschland und Italien", in *Byzantine Art - An European Art, Lectures given on the occasion of the 9th Exhibition of the Council of Europe*, pp. 91-120.

1966 CÄMMERER-GEORGE MONIKA, *Die Rahmung der Toskanischen Altarbilder im Trecento*, Strasbourg.

1966 OERTEL R. *Die Frühzeit der Italienischen Malerei*, Stuttgart (2nd Edition).

1967 BATTISTI E. *Cimabue in Santa Croce*, Milan.

ACKNOWLEDGMENTS

ALINARI, Florence: *Plates 15, 26, 42, 45, 47, 48; Figs. 2, 11, 34, 37, 38.*

ARCH. FOT. PROF. LONGHI, Florence: *Figs. 29, 31.*

CARLO BEVILACQUA, Milan: *Plates 3, 4, 5, 6, 49, 54, 61, 62, 63.*

FRICK COLLECTION, New York: *Fig. 28.*

DE GIOVANNI, Assisi: *Plates 11, 12, 13, 14, 16, 18, 19, 20, 21, 23, 24, 27, 28, 29, 31, 32, 33, 34, 35, 36, 37, 38, 39, 40, 41, 42, 43, 44, 46; Figs. 10, 15, 16, 17, 18, 20, 21, 23, 24, 25.*

GABINETTO FOTOGRAFICO DELLA SOVRINTENDENZA ALLE GALLERIE, Florence: *Plates 1, 2, 50, 51, 52, 53, 55, 56, 59, 60, 64, 65, 66; Figs. 1, 5, 6, 7, 12, 27, 33.*

GABINETTO FOTOGRAFICO NAZIONALE, Rome: *Figs. 9, 13, 14.*

ISTITUTO CENTRALE DEL RESTAURO, Rome: *Fig. 4.*

ISTITUTO GEOGRAFICO DE AGOSTINI, Novara: *Plate 7.*

KRESS COLLECTION, Portland: *Fig. 30.*

MUSÉE DU LOUVRE, Paris: *Plate 67.*

NATIONAL GALLERY OF ART, Washington: *Fig. 36.*

PEROTTI, Milan: *Fig. 32.*

SOC. SCALA, Florence: *Plates 8, 9, 10, 17, 22, 25, 30, 57, 58, 68.*

SOPRINTENDENZA ALLE GALLERIE DEL PIEMONTE: *Fig. 35.*

VILLANI, Bologna: *Fig. 3.*

INDEX